A HANDBOOK OF
ROMAN ART

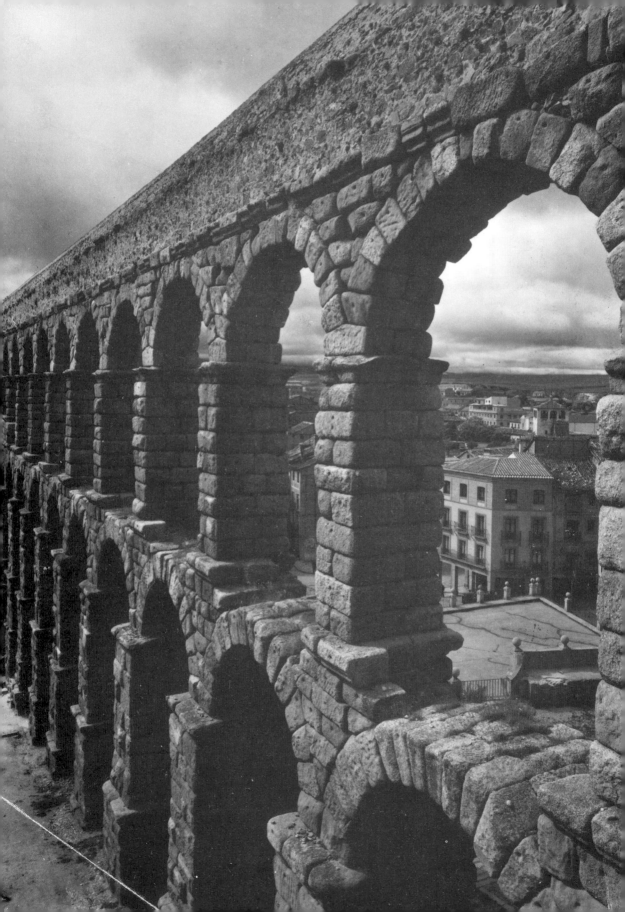

A HANDBOOK OF
ROMAN ART

A comprehensive survey of all the arts of the Roman world

Edited by
MARTIN HENIG

Cornell University Press

Ithaca, New York

Acknowledgements

I would like to thank all those who have contributed to this book and dealt so obligingly with editorial requests and queries. A number of friends have helped in various ways, notably Anthony King, Julian Munby and Julian Ward. At Phaidon I have been greatly assisted by Linda Proud, who did the picture research, and Dr I. Grafe, whose scholarly comments on the text were invaluable. But my greatest debt has been to Marie Leahy, who drew together manuscript and illustrations and helped immensely with the editorial work, both in and out of office hours.

M.H.

© 1983 Phaidon Press Limited
Text © Martin Henig

For information address Cornell University Press,
124 Roberts Place, Ithaca, New York 14850.

First published 1983 by Cornell University Press
First printing, Cornell Paperbacks, 1983

International Standard Book Number (cloth) 0–8014–1539–x
International Standard Book Number (paper) 0–8014–9242–4
Library of Congress Catalog Card Number 82–071591

Printed in Great Britain

Contents

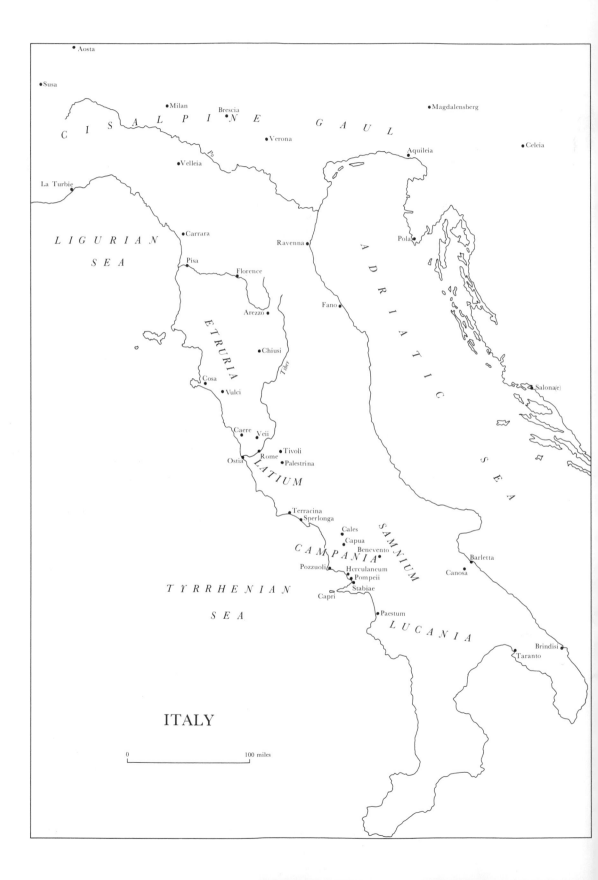

Aosta

Susa

CISALPINE GAUL

Milan
Brescia
Verona
Velleia
Magdalensberg
Celeia
Aquileia
La Turbie

LIGURIAN
SEA

Carrara

Pisa
Ravenna
Pola
Florence
ADRIATIC
Arezzo
Fano

ETRURIA
Chiusi
Tiber
SEA

Cosa
Vulci
Salona(e)

Caere
Veii
Tivoli
Rome
Palestrina
Ostia
LATIUM

Terracina
Sperlonga
Cales
SAMNIUM
Capua
Benevento
CAMPANIA
Barletta
Pozzuoli
Herculaneum
Canosa
Pompeii
Stabiae
Capri

TYRRHENIAN

SEA
Paestum
LUCANIA

Brindisi
Taranto

ITALY

0 100 miles

Introduction

Excudent alii spirantia mollius aera/(credo equidem), vivos ducent de marmore vultus,/orabunt causas melius, caelique meatus/describent radio et surgentia sidera dicent:/tu regere imperio populos, Romane/,memento/(hae tibi erunt artes), pacique imponere morem,/parcere subiectis et debellare superbos.

Others, doubtless, will mould lifelike bronze with greater delicacy, will win from marble the look of life, will plead cases better, chart the motions of the sky with the rod and foretell the risings of the stars. You, O Roman, remember to rule the nations with might. This will be your genius – to impose the way of peace, to spare the conquered and to crush the proud. (Vergil, *Aeneid*, VI. 847–51)

Despite the importance of Rome's achievements, her prowess in the visual arts is often underestimated. At best her sculpture and painting is regarded as derivative, although recognized as a vital bridge between lost Greek masterpieces and posterity. At worst it is described as little more than the vulgar ostentation of an essentially 'barbarian' power. There are several reasons for this. The first is that Latin writers of the 'golden age' were themselves modest about the Roman achievement. But it should be realized that there is an element of deliberate artifice here: Cicero, Vergil and the elder Pliny were true artists. When Vergil wrote the above lines in the midst of his greatest poem he was surely at his most disingenuous, for the disclaimer of a Roman *aesthetic* mission presumably applies no less to his own polished art or to that of Cicero, the greatest advocate of antiquity, than to sculpture. Similarly it is not hard to discern a deliberate rhetorical device in Cicero's contrast of Greek 'delight in works of art and artistry, in statues and paintings' (*Verr.*, II. iv. 132) with a more disinterested Roman view. Cicero was prosecuting C. Verres, who had been accused of extortion and theft in Greek Sicily, and he naturally wished to exhibit the ex-governor's offences in the worst possible light. His argument that such depredations are less serious to his listeners (Romans) than to Greeks, works best in a milieu avid for culture. The jury, already stirred to indignation by the iniquity of a notorious thief, is asked by the prosecutor to redouble its ire against the offender because his crimes were *even worse* if seen through Greek eyes.

If there was a certain reticence in the attitudes and aspirations of the ruling families of Rome, aware of the City's cultural debt to Greece and to the Greeks of the past, modern art-historians should not forget Greek artists of the Imperial period, for example Zenodorus, who

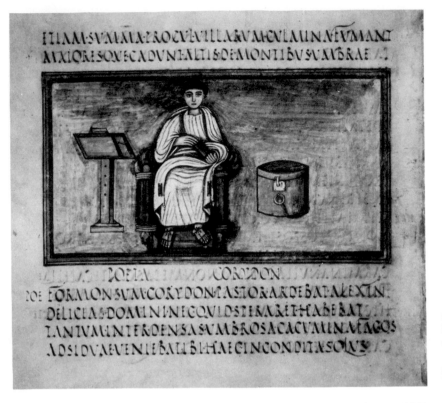

FIAAA·SVAIAIA·FROCVIVIILA·KVMICVLAIINAIVMAXI
ALXICRI·SOVECADVNIALTISDEMONTIBVSVAIBRAE·/

·ror · FORAIONSVMCORYDONFASTORARDEBATALEXIN·
DELICIA·DOAINNINIGOVLOSTERARETHABEBAT·
LANIVAUNIERDENSASVMBROSACACVAIINAFAGOS
ADSIDVAEVENIEBALI·BIHAECINCONDITASOLVS·/

1. 'Portrait' of Vergil
and the beginning of the
Second Eclogue, from
the Vergilius Romanus
(fol. 3v). Late 4th, or 5th
century AD. Vatican
Library.

could command huge sums for his work even in Gaul (Pliny, *NH*,
XXXIV. 45). However much the contemporary art of the provinces,
produced by Gauls, Syrians and others, was neglected by the
aristocracy of ancient Rome, it should not be overlooked by us.
Consequently the field of artistic achievement surveyed in this hand-
book is wider than anything that could have been envisaged in anti-
quity by either a Greek or a Roman.

It is evident that the study of Roman art suffered after the redis-
covery of Greek art at the end of the eighteenth century; gradually the
primacy of Rome, whose civilization had been a paradigm for excel-
lence in the Middle Ages and Renaissance, began to be questioned,
especially as many Roman 'masterpieces' of the past could be shown to
be indifferent copies.[1] Lord Clark cleverly combines a moral revulsion
against Roman civilization in general with a specific criticism of
Roman copies and of what he sees as a conservative attachment to the
past.[2] 'No civilization' he writes, 'has been so artistically bankrupt as
that which, for four hundred years, on the shores of the Mediterranean
enjoyed a fabulous material prosperity. During those centuries of
blood-stained energy, the figure arts were torpid, a kind of token
currency, still accepted because based on those treasures of the spirit
accumulated in the fifth and fourth centuries before Christ.' Lord
Clark touches on the nature of artistic development in the ancient
world and if he had written 'satiated' instead of 'bankrupt' and toned
down the Tacitean polemics, perhaps he would have had a point. For
the Romans were not able to match the scale of achievement implicit

in the progression of Greek art from Archaic in the sixth century BC to High Classical in the fifth. Ancient art achieved its full potential in a cumulative fashion and without an intervening 'Dark Age': what had once been learned was not forgotten. Except for the sub-Etruscan period of the early Republic, the art of Rome could not be other than complex, highly sophisticated and inherently concerned with choices between possibilities. In other words, like post-Renaissance art in Western Europe, it was eclectic.

Roman art can only be understood in the light of the 'Hellenistic' culture that flourished throughout the eastern Mediterranean, in the lands originally won from the Persians by Alexander the Great and subsequently formed into a number of independent states. Rome was the legatee of the diverse cultural life of Alexandria, Antioch and Pergamum. For example, the fine mosaic decorated with Nilotic scenes from Praeneste and others like it betray an Alexandrian taste. The statuary found in the Tiberian grotto at Sperlonga and the animated mythological scenes that decorate second-century sarcophagi are developed from the Hellenistic sculptural traditions of Asia Minor. In the Roman period the so-called 'school of Aphrodisias' was especially notable, and artists from this city were even employed on the basilica and forum of Lepcis Magna in Libya by the Emperor Septimius Severus. Arguably the most 'Roman' of all the monuments mentioned in this book is Trajan's Column, which records the triumph of the *optimus princeps* and the legions over the Dacians in the wars of AD 101–6, yet it was almost certainly conceived by Apollodoros of Damascus, the Emperor's architect, and like the Forum of Trajan itself it mirrors the decorative and architectural exuberance of the baroque architecture of the East.

Even the copies, which are especially prevalent in the late Republic and the early Empire, are best seen as an expression of artistic choice; Augustus' neo-classical taste was responsible for the design of the Ara Pacis (Altar of Peace), whose friezes are much influenced by those of the Parthenon, and for his imperial forum with its sculptures, including copies of the Erechtheum caryatids. Augustus' personal seal-cutter, Dioskourides, also worked in a neo-Attic manner, as surviving gems cut by him attest. Such work is, in large measure, the legacy of the sculptor, metalworker and theoretician, Pasiteles (*fl.* first half of first century BC). His highly eclectic work very properly closes most books on Hellenistic art and his influence was immense. A statue of a youth by 'Stephanos, pupil of Pasiteles' was found outside the Porta Salaria, Rome, and also from Rome is an eclectic statue, perhaps of Orestes and Electra, signed by 'Menelaos, pupil of Stephanos'. The Pasiteleans evolved a quick, but mechanical, process of copying sculpture and it is to them and to their influence that we owe so many statues which preserve the forms of lost Greek masterpieces.[3]

It is sometimes difficult to assess the importance of the Hellenistic tradition in the development of Roman art. In part this is a reflection of the much better survival of, for instance, painting from Roman times; in part it is actually the result of enhanced creativity – silver plate was certainly more often ornamented with figural scenes during

the late Republic and the early Empire than earlier in the Greek East. Paintings of major importance have recently been recovered from Macedonian royal tombs of the fourth century BC at Vergina.[4] These paintings do have some resemblance to frescos recovered from Rome and also from Campania, where the eruption of Mount Vesuvius in AD 79 destroyed Pompeii, Herculaneum and Stabiae. The problem is to decide whether the Campanian frescos are to be regarded merely as copies of, say, third-century paintings or as witnesses to a living South Italian tradition. I believe that the latter view is the right one, as it is not possible for a house-decorator to copy painting mechanically; the fine brush-strokes of the Dionysiac Mystery scenes in the Villa of the Mysteries just outside Pompeii demonstrate real painterly skill. In any case, Pliny's praise of the landscape artist Studius (*NH*, XXXV. 116–17) and of Famulus, the chief painter of Nero's Domus Aurea (*NH*, XXXV. 120), which still in part survives, shows that fresco was held in high esteem. Although we find both classical and baroque tendencies in painting, it is often better not to employ such rigid categories, as more interesting distinctions emerge in the differing attitudes to space displayed by various artists. The cool elegance of the shrubbery, providing an illusion of the open air in Livia's underground summer retreat at her Prima Porta villa, is in sharp contrast to the essentially urban, theatrical confection of the Domus Aurea, painted (or supervised) by Famulus. Certainly real personalities emerge, even in paintings executed outside Rome, especially in the Campanian cities.

Relatively little figured silver survives from the Greek world that can be dated before the first century BC, but increased supplies of silver mined in Spain (and later in Britain) meant that plate became much commoner under the Empire. Hoards have been found in every province and the circumstances of burial frequently suggest ownership by a member of the urban middle class or of the minor country gentry rather than by a great magnate. Thus the situation must have been similar to that in England in the seventeenth and eighteenth centuries, when there was widespread appreciation of fine plate; as in England, there were imitations, generally of bronze but in Roman Britain of pewter, for those who could not afford silver.

Pottery also displays considerable variety. Arretine and other early samian ware has the same neo-classical elegance as much of the plate. In the middle and later Empire, however, some of the best pots were ornamented with coloured slips, *en barbotine*, to produce an effect of vigorous (but non-classical) energy.

The high standard of taste is well exemplified by the rich houses of Pompeii and Herculaneum and luxury villas throughout the Empire, with their frescos, mosaics, statuary and well-designed gardens – the Romans were pioneers in garden planning and delighted in the Natural World (Pliny the Younger, *Ep.* II. 17). It is also evident in the public art of Rome disseminated directly by the State or through its encouragement (Tacitus, *Agricola*, 21) and indirectly by the general use of a plentiful well-designed coinage. There were even some tourists eager to admire buildings and works of art, the majority no doubt in

the first instance pilgrims to the shrines of the eastern Mediterranean. Pausanias wrote a guidebook, the first extant, to the monuments of Greece, which catered for the needs of such discriminating travellers. Needless to say, this work is now an invaluable source for the art-historian.

A handbook of Greek art can concern itself with a homogeneous Hellenic culture until the time of Alexander, confined for the most part to Greece, Asia Minor and South Italy. Roman art is much harder to define. Certainly the provincial contribution is immense although we are only beginning to appreciate its true quality. As recently as the 1930s, R. G. Collingwood could dismiss Romano-British art as hardly ever rising above the level of dull, mechanical imitation to that of even third-rate artistic achievement.[5] Now we can appreciate in the Carlisle school of sculptors a style as lively and attractive as that of any medieval workshop, while across the Channel in Belgium and the Mosel valley the scenes of daily life carved on tombstones are well worth detailed study. Along the Eastern frontier there are artistic traditions even further removed from the mainstream of Roman art, but few scholars would now deny the distinction of the art of Palmyra and Dura Europos. The mosaicists of various parts of the Empire including North Africa and Britain have been the subject of detailed monographs, and we now know a great deal about work-shops and have a much greater sympathy with the skill of the indivi-dual craftsmen than would have been possible a decade ago.

The attitude to artists under the Empire is a subject in itself. Essentially it was not very different from what it had been throughout classical and Hellenistic times, especially in the East. Particularly interesting is the short autobiographical essay, *The Dream or Lucian's Career*, by the Antonine satirist Lucian, who came from Samosata in Syria. Here he contrasts the rival claims of *paideia* (literary culture) and the *technē* of sculpture, his ancestral calling, entirely to the latter's disadvantage. His reasons are ones which would have been accepted throughout antiquity as self-evident: work done by means of the intellect was by its very nature nobler than labour performed with the hands and body.[6]

Painting and drawing (including the design of buildings) did not require heavy labour, and were therefore more respectable, although even here there were limits to social approbation. It was not fitting for Titedius Labeo, onetime proconsul of Narbonese Gaul, to be over-proud of his own paintings (Pliny, *NH*, XXXV. 20); still less are we meant to admire imperial painters and sculptors Nero (Tacitus, *Annals*, XIII. 3) or Hadrian (Aurelius Victor, *de Caesaribus* (epitome), XIV. 2) for their talents, which were not those fitted to government. Nevertheless, Augustus did allow a ward of his who was mute and thus not able to take part in public life to learn painting (*NH*, XXXV. 21). There is considerable evidence that the painter's skill was especially appreciated in the Greek East; we have, for instance, the writings of the Philostrati in the third century, who match their own verbal skills to the vivid colours and the expressiveness of the painted image.[7]

The Roman Empire does not represent one single episode in art

history but at least three. This handbook is therefore introduced by a chapter on early Rome, as one of many city states in Italy influenced directly and indirectly (via Etruria) by Greece. The following chapters treat later Republican and Roman Imperial art thematically by medium. However, significant changes in art and society from the second century AD onwards lead to that strange period, Late Antiquity, a vestibule to the vast 'double basilica' of Byzantium and the Middle Ages, which has been assigned a chapter to itself.

Books on Greece usually (and quite properly) single out the fifth century BC as a climax. Brilliant as were the achievements of the Archaic age and of the Hellenistic world, neither has the sublimity of the decades after the Greeks had broken the offensive power of Persia, and despite the terrible and wasteful war between Athens and Sparta, the buildings and sculpture of Periclean Athens testify to the splendour of the classical achievement. In the Roman world, the quickening change in art and the development of literature during the late Republic took place against the background of a series of political crises even more menacing than those of the Peloponnesian War. Unlike Pericles, Augustus was no democrat. He saved the Roman state by creating a monarchy (in all but name) on the Hellenistic model. But although in politics *libertas* vanished, artistic freedom remained, supported by increased patronage and the experience of artists from the conquered kingdoms of the Hellenistic world. A reign that saw the creation of the Ara Pacis, the Maison Carrée, the Gemma Augustea and the frescos of Livia's Prima Porta villa on the one hand and the floruit of such great poets as Vergil, Horace and Ovid on the other must rank as one of the most glorious episodes in the cultural history of man.[8] Like Louis XIV, Augustus may have been less than admirable as a person (often indeed he deserves condemnation as a capricious and cruel despot), but moral failings have nothing to do either with art or with a handbook of art. Of course, much happened after the Augustan age and the great scholar Jocelyn Toynbee has especially singled out the reign of Hadrian; but by then, in the opinion of the editor of this work, the classical moment of Roman culture had passed.[9]

It is with great respect that we dedicate these studies to the memory of the author of the *Handbook of Greek Art*, Gisela M. A. Richter. Her interest in Roman art was considerable, as some of her monographs (for example those on furniture and gems) testify. She was perhaps less inclined to credit the artists of the Roman period with that originality of spirit which, after long reflection, I believe to be theirs. Her memoirs reveal a writer deeply immersed in the beauties of ancient art and anxious to share her erudition with others.[10] It is with this in mind that I have approached a number of scholars, each of them fully conversant with recent work in his or her special field of study, to write this companion volume.

<div style="text-align: right">

MARTIN HENIG
Institute of Archaeology, Oxford
25 November 1981

</div>

Early Roman Art

TOM RASMUSSEN

EARLY ROME, GREEKS AND ETRUSCANS

According to tradition Rome was founded in 753 BC. Her beginnings
were modest: for some generations Rome was one of the many villages
of Latium, whose Latin-speaking communities were a branch of the
numerous and widely spread Italic tribes. During this period the first
civilizations of Italy were created by the Greeks around the southern
coasts and by the Etruscans to the north, and it was their proximity to
Rome that was the determining factor in her early cultural develop-
ment.

Greek colonies were established in South Italy and Sicily (Magna
Graecia) from the eighth century BC. The artistic achievements of the
Greeks in this region[1] were on a level with those of Aegean Greece, but
the size of the cities and their opulence were often greater. Here there
are many impressive remains of limestone temples of the archaic
period and later, for example at Paestum and Agrigentum; and there
were important schools of sculpture, too, at such centres as Tarentum
and Selinus. The relevance of Magna Graecia and of Greece itself to
the early art of Rome is twofold. Firstly, there is a very strong Hellenic
influence in the arts of the Etruscans with whom the Romans had long
and close contact during the early centuries. Thus their first experience
of Greek culture was mainly indirect, channelled through Etruscan
art; though recent excavations in Rome have yielded evidence of some
direct commerce with Magna Graecia already from the eighth cen-
tury.[2] Secondly, Rome came into conflict with the Greeks during the
military conquests of the last centuries BC, and the first-hand contact
with Greek art which then resulted made an almost overwhelming
impact on Roman taste.

The Etruscans were ethnically and linguistically distinct both from
the Greeks and from the Italic peoples. Their origins are obscure, but
at the end of the eighth century BC they began to grow wealthy from
exploiting on a huge scale the mineral deposits in their territory, which
they traded with the Greeks and others. Under heavy Greek influence
the arts suddenly began to flourish in Etruria. The Etruscans were not
great artistic innovators, their craftsmen required constant external
stimuli to set them in motion, stimuli which Greek art provided
(especially in the form of painted pottery); but they had a lively sense
of colour and of decorative effect. It is also clear that there were Greek
artists actually settled in Etruria, working for new and rich patrons
and training local apprentices. The phenomenon of Greek artists

working abroad is known also in other non-Greek regions at this time,
particularly in the eastern Mediterranean, but nowhere else did the
ensuing blend of Greek and native ideas produce such brilliant and
long-lasting results. Etruscan art follows Greek styles so closely that it
too can be divided, broadly speaking, into archaic, classical and
Hellenistic phases; and its highpoint is the archaic period from the
seventh to the first half of the fifth century BC. Early in this period the
Etruscans were the first people of Central Italy to adopt Hellenic
standards of civilization, the first to build cities with all their trappings
of urban life, the first to produce a monumental funerary architecture;
they were also the first to adopt a system of writing – the Greek
alphabet, which they later passed on to the Romans. The civilizing
influence of the Etruscans was certainly one of the most important
contributions to the early development of Central Italy, and of
Latium and Rome in particular.

The early history and archaeology of Rome itself are not easy to
unravel. Most of the details will never be known, partly because the
earliest levels of the city have been so much disturbed by the constant
replanning of the city-centre in later periods, partly because of a
complete lack of contemporary written records. For early Roman art
the elder Pliny's chapters on art history in his *Natural History* are our
best literary source, while the historian Livy provides some incidental
information and a chronological framework.

Archaeological remains show that Rome began as a cluster of
villages set on the hills, the settlement on the Palatine hill being earliest
and dating well back into the eighth century. The valleys in between
(including what was later to become the Forum Romanum) were used
as burial grounds. Foundations and postholes of the huts belonging to
these villages have been excavated. But contemporary terracotta
models of huts, which were a favourite type of cinerary urn among the
Latin peoples, give the clearest idea of what these habitations looked
like (Ill. 2). The walls were of wattle-and-daub, the roofs of thatch
supported by sloping wooden rafters. This rustic existence continued
until, towards the end of the seventh century, Rome was drawn into
the Etruscan orbit and for a century or more was ruled by Etruscan
kings. All the various aspects of city life were now established in Rome
for the first time. The valley of the Forum was properly drained and
became the civic centre, the first temples and monumental public
buildings were constructed, tiled houses took the place of thatched
huts, and Etruscan goods as well as much Greek pottery were im-
ported. The Tarquins, the Etruscan ruling family, were finally
expelled from the city in the late sixth century,[3] but Etruscan
culture continued to exert considerable influence at Rome for
long afterwards.

The most spectacular manifestations of the new sophisticated style
of living were the temples now built in Rome in the Etruscan style.
Unlike Greek temples stone was usually used only for the lower parts of
the building; the superstructure was of wood and mud-brick. The
exposed outer surfaces of the wooden beams were protected with
terracotta sheathing often decorated with lively figured friezes in

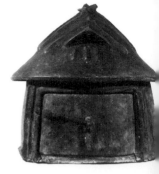

2. Hut-urn with
removable door. From
Monte Albano, south of
Rome. Terracotta.
Height 33.5 cm. 9th or
8th century BC. London,
British Museum.

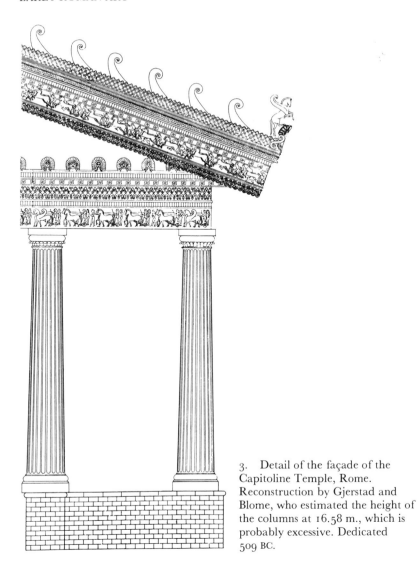

3. Detail of the façade of the
Capitoline Temple, Rome.
Reconstruction by Gjerstad and
Blome, who estimated the height of
the columns at 16.58 m., which is
probably excessive. Dedicated
509 BC.

painted relief (Ill. 3). The columns showed influence from both Greek
Doric and Ionic columns, without being slavish imitations of either.4
The temple stood on a substantial base or podium and the archi-
tectural emphasis was very much on the front of the building for the
colonnade did not run round the back. This Etrusco-Italic style of
temple remained popular throughout the period of the Republic (cf.
Ill. 4), and a late version of it is described in some detail by Vitruvius
(*De Architectura*, IV. vii. 1–5). Indeed, some of its features, such as the
tall podium and the emphasis on the frontal elevation, were retained
in Roman temple architecture to the end of the Empire.

The grandest of these temples at Rome was erected on the
Capitoline hill in the later sixth century and finally dedicated to
Jupiter, Juno and Minerva in 509 BC, the first year of the Roman
Republic. To bring it to completion craftsmen were summoned to
Rome from all over Etruria (Livy, I. lvi. 1). There were three rows of

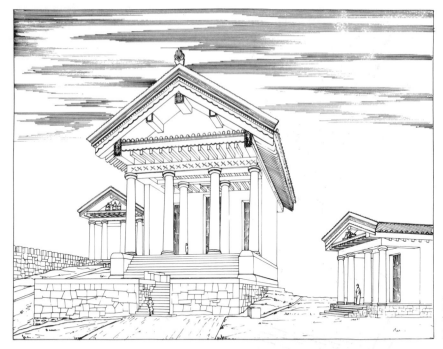

4. The Capitolium at Cosa. Reconstruction. Width of podium 23.24 m. Mid–2nd century BC.

six columns in the front, behind which were three chambers or *cellae*, of which the central one was dedicated to Jupiter.[5] In size this building ranks with some of the largest Greek temples: it was over 210 Roman feet long and some 180 feet wide (*c*.62.25 × 53.30 m). The great width in proportion to the length is a characteristic of most Etruscan temples. Little remains of it today except for parts of the substructure, and in the reconstruction drawing (Ill. 3) a number of details have been taken from a different temple in the Forum Boarium (Cattle Market), including one of the sets of terracotta frieze plaques showing chariots in procession. The Capitoline Temple was rebuilt later several times, and became the model for other *capitolia* throughout the Roman world (Ill. 4).

Pliny writes (*NH*, XXXV. 157, quoting Varro) that the cult statue of Jupiter for the Capitoline Temple was made of terracotta by the Etruscan sculptor Vulca who came from Veii, an Etruscan city only nine miles north of Rome. The actual date of Vulca's activity is disputed: he may have made the statue long before the temple itself was completed. Above the apex of the temple's gable there was a terracotta sculpture of a *quadriga* (four-horse chariot) which was also a product of Veientine craftsmen (Plutarch, *Publicola*, 13). As well as the Jupiter, Pliny mentions a terracotta Hercules made by Vulca at Rome, and this dual reference provides one of the first records of statues of gods made in Rome. Indeed, Varro (quoted by St Augustine, *de Civitate Dei*, IV. 31) expressly stated that the Romans did not make any images of gods for the first 170 years of the city's existence. The making of anthropomorphic sculptures of gods was a Greek tradition which the Etruscans early adopted – along with many of the Greek gods

5. Apollo from Veii. Terracotta. Height 181 cm. Late 6th century BC. Rome, Villa Giulia.

themselves, which they assimilated into their own religion. It is probable that, in turn, the assimilation by the Romans of not only the Greek pantheon but also Greek mythology was a process learned originally from the Etruscans. And so the three gods to whom the Capitoline Temple was dedicated had all the attributes of the Greek Zeus, Hera and Athena (and of the Etruscan Tinia, Uni and Menrva).

The use of terracotta for monumental sculpture was very common in Central Italy where there was little available stone suitable for carving. Of great fame today are several terracotta statues of gods which were unearthed at a sanctuary at Veii;[6] and these, being works of high quality from Vulca's city and roughly contemporary with the Capitoline Temple at Rome, surely give us some idea of the style of the sculptural decoration of the latter. They were made to be set up along the ridgepole of a temple, and are shown in swift motion as if engaged in an energetic ballet on the roof. One of the best preserved is Apollo (Ill. 5), an especially fine example of an Etruscan interpretation of the Greek archaic style.

Like pottery, architectural terracottas are virtually indestructible and are often among the best-preserved remains of Etrusco-Italic temples. From archaic temples in Rome[7] there are antefixes in the form of female heads and heads of sileni and gorgons. One beautiful

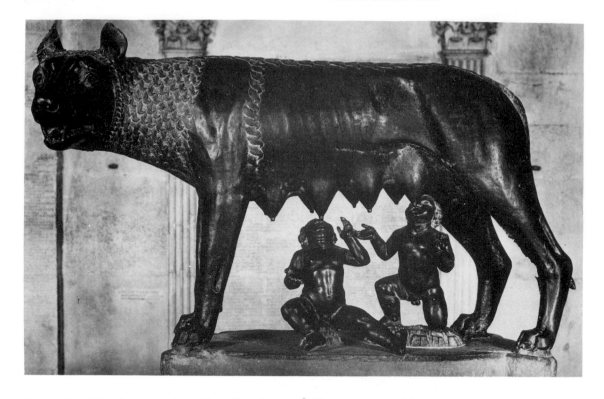

female head is of pure archaic East Greek style.[8] The revetment friezes
are either figurative or else have floral or geometric designs. The
former show various subjects: single horsemen, galloping horsemen,
banqueting scenes. Most of them are also found elsewhere in Central
Italy, though one frieze of a Minotaur in among a procession of
panthers (or leopards; below, Ill. 157) is so far unique to Rome. The
friezes with chariots have identical counterparts at both Veii and
Velletri (20 miles south east of Rome) and it is clear that identical
moulds were used, showing just how close were the artistic links at this
time between Etruria and Latium.[9] Among the *akroteria* from Rome
are two three-quarters lifesize figures of high quality: the head and
upper body of a helmeted Minerva, and a headless Hercules.

The other favoured material for sculpture was bronze. Bronze-
casting was highly developed in the cities of South Etruria and bronze
was also used for early statues set up in Rome. The earliest surviving
large-scale hollow-cast bronze so far known from Central Italy is the
Capitoline Wolf (Ill. 6) which was made perhaps in the early fifth
century, but uncertainties surround both its precise original location
(though it is likely that it was somewhere in Rome) and the artistic
background of its creator, whom some authorities have believed to be
Etruscan, others Greek. In this work of supreme skill there is a marked
contrast between the realism and close observation of the defiant
stance and the stylized treatment of the fur, which is left completely
smooth on the flanks but rendered in delicate symmetrical curls else-
where. Pliny mentions a number of bronze statues erected in honour of
famous citizens of early Rome, including one of Horatius Cocles who is

7. Warrior from Capestrano. Limestone. Height 223 cm. 6th century BC. Chieti, National Museum.

said to have defended the bridge against Porsenna's forces after the expulsion of the Etruscan kings (*NH*, XXXIV. 22); but there is no means of knowing whether these were set up contemporaneously with the men they honoured or were made at a later date.

In the early decades of the Republic the building of temples at Rome continued apace, with temples to Saturn (dedicated in 496 BC), Mercury (495), Ceres (493), and the Dioscuri (484). These no doubt showed many of the features of the Capitoline Temple, but it is of special interest that the temple to Ceres is recorded as being decorated by two Greek artists who were painters and modellers in clay (*NH*, XXXV. 154). Whether they came from South Italy or from Greece itself we are not told.

From this time on the Romans were long occupied with a series of wars against neighbouring peoples, including the Aequi, Sabines and Samnites. These inland regions were more remote from Greek and Etruscan influence, as the Capestrano Warrior (Ill. 7) illustrates.

This is a sixth-century limestone statue from a cemetry in Picene
territory which is remarkable for its stiff frontal attitude and distinc-
tive headgear.[10] Such native Italic sculptural traditions, which pro-
duced works that are far removed from Greek styles and proportions,
were never totally erased in the Italian peninsula. A later product of
this tradition is the figure of a mother-goddess from a sanctuary near
Capua (Ill. 8), where the forms are both simplified and greatly
exaggerated to give all possible emphasis to the aspect of fertility.
Indeed, the Italic element was to remain an important undercurrent
in Roman sculpture throughout the period of the Empire.

8. Statue of a mother
or mother-goddess.
Limestone. Height 105
cm. 3rd or 2nd century BC.
Capua, Museo
Campano.

By the third century BC Rome had gained control of the whole of
Etruria, and it was then the turn of South Italy, Sicily and Greece itself
to give way before victorious Roman armies. This period witnessed a
great influx of Greek and Etruscan works of art into Rome. So we hear
of statues of Etruscan gods being removed from Veii in 396; of 2,000
statues (no doubt of bronze) being taken to Rome from Etruscan
Volsinii in 264; of large-scale pillaging of Greek art after the sacking of
Syracuse in 211, Tarentum in 209 and Corinth in 146.[11] By the mid-
first century BC the position was such that ambassadors visiting Rome
from Greece and Asia could view all the plundered images of their own
gods in the Forum and contemplate them with tears (Cicero, *Verr.*, II. i.
59). Not all Romans approved of this, and the elder Cato, for one,
believed that the importation of Greek marble sculptures had a cor-
rupting influence on his fellow citizens and caused them to scoff at
their own traditional religious figures of terracotta (Livy, XXIV. iv.
1–4). The passion for Greek art had begun. To satisfy it Greek artists
themselves came to Italy, and in the last centuries BC the situation
at Rome was not unlike that which had occurred long before in
archaic Etruria: that of numerous Greek artists working for wealthy
foreign patrons and passing on their skills to local craftsmen.

ROMAN ART: FIFTH TO SECOND CENTURIES BC

The development of Roman art is least easy to follow during this
period, due to lack of material evidence. The sequence is clearest in the
case of architecture, which is fortunate for it is here that the Romans
showed most originality.

With regular town-planning they were not first in the field. The
Etruscans had employed a formal layout for new foundations, as at
Marzabotto, and they no doubt learned it from the Greeks of South
Italy and Sicily where such planning is found in the sixth century and
even earlier. But the Romans refined and regularized this basically
Greek system still further, especially with regard to the orderly disposi-
tion of temples and public buildings around the forum. The first
evidence of Roman planning is in the *coloniae* of the fourth and third
centuries BC, founded in key areas of newly conquered territory to
house veterans of the army. Cosa is typical, with its regular grid of
streets laid out in 273.[12]

More innovatory is the use of new architectural techniques and
materials. The true arch had in fact been employed long before in

Greek city architecture and in Etruscan city gates of Hellenistic date, but only Roman architects realized its true potential. Arches in series were found to provide the most economical and structurally sound means of building aqueducts and bridges. Already by 140 BC the Aqua Marcia was carrying water to Rome on six miles of arches (Frontinus, *de Aqu.*, 7). The arches of the Pons Aemilius over the Tiber were completed in 142, and in 109 the Pons Mulvius was rebuilt with arches of stone. Similarly barrel-vaults are not unknown in later Greek architecture, but are there virtually confined to subterranean chambers and tombs. In later Republican Italy they are exploited on a larger scale, especially to form imposing platforms and substructures both for large public buildings and for private residences. The truth is that although the Greeks were aware of the structural principles of arches and vaults, these principles had almost no part to play in the design of the Greek temple with its prop-and-lintel system, and it was the temple which was the dominant feature of Greek architecture. The skill of Roman architects lay in their ability to make more consistent use of these techniques, and in this they showed themselves less tied to tradition and more open to new methods of construction. They may also have got some inspiration from the Etruscans who were possessed of a similar architectural mentality, as much concerned with engineering and practical applications as with aesthetics. Just as some of Rome's finest architectural successes were to include aqueducts, harbour installations, market-halls and warehouses, so from an early date Etruscan architects and engineers excelled in grappling with problems of land-reclamation and drainage, water-supply, sewer-construction and the cutting of roads through difficult terrain.[13]

A real advance in Roman construction occurred when the principles of the arch and vault were combined with the use of new building materials. In early Rome itself progressively finer building stones were used, poor quality local tufas giving way to hard limestones quarried some distance away. Rubble-and-mortar work was also common, especially for foundations. Its use was revolutionized by the discovery in the third century BC or earlier that a lime mortar containing volcanic sand, when poured over the rubble (*caementa*), produced a concrete that set with exceptional strength. One early large-scale use of this material is in the Porticus Aemilia (193 BC, restored 174 BC; Ill. 9), a huge warehouse complex nearly 500 metres long built near the Tiber, consisting of vaulted chambers constructed of concrete and faced with irregular facing stones (*opus incertum*). The same technique was used later for the great vaulted substructures of the sanctuaries at Palestrina and Terracina. The quality of Republican concrete was relatively poor compared to that of the later Empire: both the concrete mixture and the nature of the facing were to undergo significant developments over the centuries.

Two of the most characteristic of Roman buildings – the basilica and the public bath – achieve their most monumental form in the later Empire, but both have their origins in the Republican period. The basilica,[14] an aisled hall often with an apse at one or both ends, was a

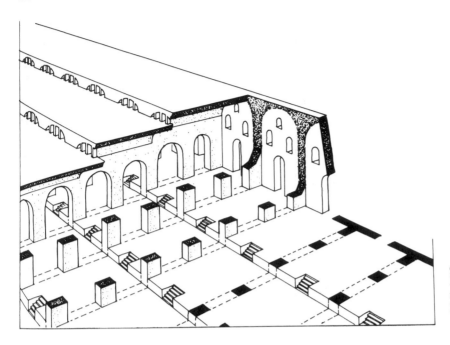

9. Porticus Aemilia,
Rome. Partial
reconstruction. Original
length 487 m. First built
193 BC, restored 174 BC.

necessary adjunct of most Roman fora. Three examples at Rome were
built in the first half of the second century BC, and the one at Pompeii
goes back to later in the same century. Also at Pompeii the Stabian
baths in their second century BC form show a complex unit of hot and
cold rooms with an exercise area enclosed by porticoes. The Roman
hypocaust heating-system, where hot air circulates beneath a floor
raised on pillars of bricks, was almost certainly an invention of Hellen-
istic Greece, despite what Pliny (*NH*, IX. 168) says to the contrary.

Also of Greek origin, of course, were the Doric, Ionic and
Corinthian orders, which Roman architects began to adopt whole-
heartedly, especially for temples. That they soon made themselves
expert in this area is suggested by Vitruvius' admiration for the
Roman Cossutius, who was employed in Greece in the first half of the
second century to work on the completion of the Athenian Temple of
Olympian Zeus, where perhaps for the first time in classical archi-
tecture Corinthian was used as an exterior order on a major building.[15]
At this time, too, begins the importation of Greek marble to be used for
columns and for facing walls of inferior materials.

Most information about Republican domestic architecture comes
from Pompeii and Herculaneum. The earliest type of house here is of
modest size with rooms grouped around a central hall or *atrium*. The
origin of the atrium, which is a basic feature of early Roman houses, is
ascribed by Varro (*Lingua Latina*, V. 161) to the Etruscans. It is difficult
to match this with known remains of Etruscan houses, but some
Etruscan rock-cut tombs, made to resemble houses, do occasionally
contain halls that are not dissimilar. In the second century BC the
houses of Pompeii had their interior walls painted and stuccoed in
simple horizontal patterns to look as if they were faced with expensive
marbles. This style of Pompeian wall-decoration (Style I) was a

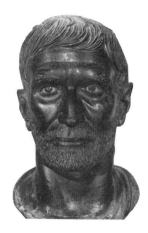

10. 'Brutus' (Lucius Junius Brutus, legendary founder of the Roman Republic). Bronze. Height 32 cm. Probably 3rd century BC. Rome, Capitoline Museum.

11. Statue of Aulus Metellus (the inscription naming him is in Etruscan). Bronze. Height 170 cm. 2nd century BC. Florence, Archaeological Museum.

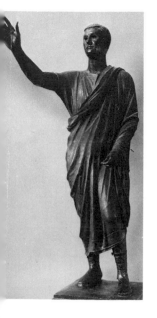

development of Aegean Greece,[16] and from this area, too, the idea of colonnaded courtyards and gardens was brought to Pompeii where Greek-style columns were also employed to embellish the atria.

By the first century BC Roman architects had become acquainted with Greek design and had also developed new materials and techniques. It would be wrong, however, to think that these advances had spread evenly over all of Roman Italy. Late Republican Cosa, for example, showed a remarkable conservatism in techniques of construction, and all its temples were of the old Etrusco-Italic type with terracotta decorations. But elsewhere important steps had been taken which would lead on to the architectural achievements of the Empire.

Turning to sculpture, it is clear from Pliny's Book XXXIV that in early Republican Rome bronze was the most important medium for statuary, that the Romans (like the Etruscans) preferred their statues draped, and that like the Greeks they chose to set up statues of public figures – consuls, magistrates and generals. A famous head in the Capitoline, the so-called 'Brutus' (Ill. 10) is possibly from such a figure. The casting of this stoical-looking individual may have been carried out in the third century BC, although it could have been as late as the early first century BC when there was a vogue for creating lively imaginary 'portraits' of early Roman celebrities. A similar uncertainty of chronology surrounds the statue of Aules Metelis (Aulus Metellus), called the 'Orator', in Florence (Ill. 11), a life-size bronze from Romanized North Etruria whose pose – that of a leader addressing the crowd – is one that is popular in later periods, especially for figures of Roman emperors. The dress worn here is the toga, a garment with a curved hem that can be traced back in Etruscan art to the archaic period (cf. Ill. 5). According to Pliny (*NH*, XXXIV. 27), some commemorative statues at Rome were placed on top of columns as a mark of special honour. A coin struck in the later second century BC shows just such a figure: the man honoured was a magistrate in 439.[17]

The origins of Roman portraiture are not clear. Of particular interest are two passages in Pliny and Polybius (below, p. 82) which describe the carrying of portrait heads or masks in funeral processions at Rome, though it is clear that some of these must have been imaginary portraits of remote ancestors. This custom was an old one, for Polybius is writing in the second century BC and implies that the tradition reaches back further. But one must not forget that there was a Hellenistic Greek tradition of portrait sculpture of considerable power and realism, especially in the representation of Hellenistic monarchs. There may also be a connection with Etruscan sculpture, much of which consists of representations of the deceased for the tomb, from the early heads of the so-called canopic urns of Chiusi[18] to the full-length figures reclining on the Hellenistic ash-urns (Ill. 12). Many of these are strikingly un-idealized and unclassical in style, though very few can be portraits in the true sense. Nevertheless, these Etruscan sculptural traditions may go some way towards explaining the emphasis on the head in Roman portraits (often to the exclusion of the

body), and the growing demand at Rome for portraits of private
citizens (whereas in Greece portraits were mainly of public figures).

Most of the sculptors working at Rome from the second century BC
onwards were Greek, as is clear from the literary sources. As well as
bronze, terracotta continued to be an important medium. A terracotta
head from Rome, now in Oxford,[19] seems to be of fine Greek work-
manship of the later fourth century, and can be compared in style with
Athenian grave reliefs. Greek artists may also have been responsible
for the terracotta pediment figures from San Gregorio in Rome,[20]
which are later by a couple of centuries and the subject represented – a
sacrifice in the presence of Roman deities – is Roman.

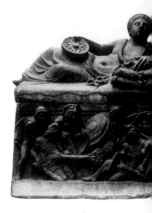

12. Ash-urn from
Chiusi with relief
showing the death of
Eteocles and Polyneices.
Alabaster. Length 85 cm.
3rd or 2nd century BC.
London, British
Museum.

For relief sculpture the Hellenistic Etruscan ash-urns provide the
largest body of early Italian material. Most of the scenes on these show
episodes from Greek mythology (cf. Ill. 12); none are historical in the
sense of relating to contemporary events, though a few do illustrate the
exploits of early Etruscan heroes.[21] The earliest surviving Roman
historical relief is from the monument of Aemilius Paullus set up at
Delphi to commemorate his victory over the Macedonians in 168 BC.[22]
It is no surprise that in style and composition this battle-scene is pure
Greek, but for the history of Roman art it is important as standing at
the head of a very long line of Roman reliefs that deal with specific
historical occasions.

One of the very few extant fragments of early Roman figurative
painting also portrays historical scenes (Plate 1). It is from a tomb and
is arranged in several horizontal registers showing sequences of
fighting and of generals negotiating. The figures are labelled and
it is clear that actual events are here being unfolded, no doubt from
one of the wars fought between the Romans and their Italic
neighbours in the fourth or third century BC. Here, too, there is
an Etruscan parallel in the painting from the François Tomb at Vulci
which shows named Etruscan warriors fighting in episodes from
Rome's regal period, and includes a depiction of Macstrna (Mastarna,
who according to one tradition was identified with the Roman king
Servius Tullius) and the slaying of one Cneve Tarchunies Rumach
(Gnaeus Tarquinius of Rome).[23]

The Etruscan tomb-paintings begin in the sixth century and con-
tinue until Etruscan culture is finally extinguished in the first century
BC. There is also a growing body of Italic tomb-painting, of less
sophisticated style, from Lucania and other parts of South Italy.[24]
Whether there was any awareness at Rome of these traditions is not
known, though Pliny (NH, xxxv. 18) once makes a tantalizing refer-
ence to 'very old paintings at Caere' in Etruria. He also mentions
(xxxv. 19) two men of Roman birth who painted at Rome: Fabius
Pictor who decorated the Temple of Salus in 304 BC, and the dramatist
Pacuvius who painted in the Temple of Hercules in the second half of
the second century BC. But they were certainly far outnumbered by
immigrant Greek painters, some of whom no doubt executed the 'war-
paintings' about which we hear from the third century BC onwards
(NH, xxxv. 22–3). These were commissioned by Roman generals to

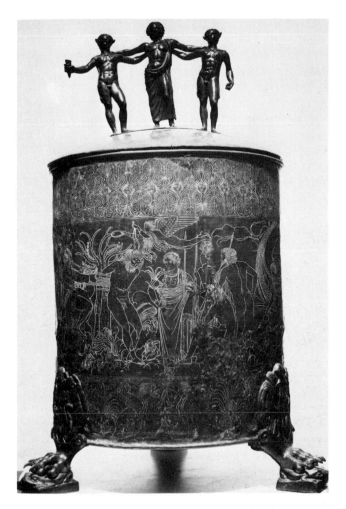

13. The Ficoroni *cista*. From Palestrina. The engraved scene shows King Amykos being bound to a tree by Polydeukes (Pollux). On the lid: Dionysos with two satyrs. Bronze. Height 77 cm. 2nd half of 4th century BC. Rome, Villa Giulia.

illustrate their successful campaigns abroad and were put on public display – indeed it may be this tradition which lies behind the long Roman involvement with historical narrative. But the greatest influence on the development of painting at Rome was exerted by the large numbers of Old Masters brought in from Greece itself, paintings which were bought for enormous sums by wealthy collectors. It is likely that an adaptation of such a painting is to be seen on the engraved Ficoroni *cista* showing exploits of the Argonauts (Ill. 13), found at Palestrina (Praeneste) but made in Rome by Novios Plautios according to the inscription on it.[25] Later, many Pompeian paintings offer paler reflections of lost Greek works.

By the end of the second century BC Rome was the most powerful state in the Mediterranean. The cities of Greece and Asia had long been in political decline and had gradually ceased to be the great centres of artistic patronage that they once were; a process which was quickened when Pergamum passed into Roman hands in 133. The centre of patronage was now beginning to be Rome itself: Roman ideas and Roman taste were to mould the future development of art in the Mediterranean world.

CHAPTER TWO

Architecture

THOMAS BLAGG

Tot aquarum tam multis necessariis molibus pyramidas videlicet
otiosas compares aut cetera inertia sed fama celebrata opera
Graecorum.
With such an array of indispensable structures carrying so many
waters, compare, if you will, the idle pyramids or the useless, though
famous, works of the Greeks!

> Julius Frontinus, *De Aquis Urbis Romae*, I. 16
> (trans. C. E. Bennett, Loeb Classical Library)

The aqueducts which served Rome and other cities of the Empire may
indeed be counted among the most impressive surviving monuments of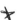
Roman architecture. That is not to say that any one of them could
seriously be proposed as its crowning achievement; but there was only
one Pantheon, for example, and there were many aqueducts. As rather
more typical than exceptional, then, these structures may serve as an
initial illustration of some of the more important characteristics of
Roman architecture which distinguish it from the architecture of
earlier civilizations which the Romans knew.

In the first place, they represent technical evolution: the mastery of
new construction techniques and new uses of building materials, of
which the combination of the arch and the vault in a structure of
brick- or stone-faced concrete is the most important. Secondly, they
illustrate the architectural responses to Rome's social and economic
evolution; the demands were met by new types of building, among
which may be counted the basilican hall, the baths, the amphitheatre,
monumental arches, granaries, apartment blocks and grand country
houses. Thirdly, they were the product of an administrative structure
of empire, which made possible the transmission of ideas, the financing
of large-scale building programmes, the organization of craftsmen
and the supply of materials over a wider area and with more
permanent overall results than had been achieved by any previous
civilization (Frontispiece).

Frontinus was writing, not as an architectural historian, but as one
whose distinguished career of public service had included a term as
governor in Britain and, later, in AD 97, appointment as curator of
Rome's water supply. Not all his contemporaries would have sym-
pathized with his adverse comparisons with structures which, what-
ever their social function, could not be described as utilitarian. In the
pyramidal tomb of C. Cestius outside the Porta Ostiense, or in such a
'useless' monument as the recently completed Arch of Titus, he might
have found examples rather closer to Rome.

0 500m
0 1500ft

Mausoleum of Constantina
(Santa Costanza)

Mausoleum
of Augustus

Camp of the
Praetorians

Mausoleum of Hadrian
(Castel Sant'Angelo)

Column of
Antoninus Pius

Ara Pacis

Baths of
Diocletian

AURELIAN
WALLS

Column of Marcus
Aurelius

Campus Martius

Baths of Nero

QUIRINAL
HILL

Stadium of
Domitian

Pantheon

Baths of
Agrippa

Imperial
Fora

Theatre of
Pompey

Temple of
Apollo Sosianus

Temple of
Jupiter Stator

CAPITOLINE
HILL

Basilica of
Maxentius

APPIAN
HILL

Nymphaeum o
(Temple of Minerva Medica)

Temple
of Venus
and Rome

Baths
of Trajan

Tiber

Theatre of
Marcellus

Temple of
Castor

Site of Golden
House of Nero

PORTA
MAGGIORE

PONS AEMILIUS

Colosseum

Baths
of Titus

Temple of Apollo

Palace of
Domitian

Palace of
Septimius
Severus

Temple of Claudius

CAELIAN HILL

Circus Maximus

AVENTINE HILL

Tiber

Porticus Aemilia

Baths of
Caracalla

Pyramid of Cestius

PORTA
LATINA

Via
Latina

PORTA
OSTIENSE

PORTA
APPIA

Via Appia

1 Arch of Constantine
2 Arch of Septimius Severus
3 Arch of Titus
4 Palace of Tiberius
5 Round Temple
6 Temple of 'Fortuna Virilis'
7 Temple of Jupiter
 Optimus Maximus

Imperial Rome (showing buildings and monuments mentioned in the text: see also plan, p. 33).

The elder Pliny, however, who had died some twenty years before Frontinus was writing, has far more to tell us about contemporary attitudes to art and architecture. For him, 'the most beautiful buildings that the world has ever seen' were the Basilica Aemilia, the Forum of Augustus and the Temple of Peace in Rome. What he chiefly admired was their magnificence (*NH*, XXXVI. 102). Nearly three centuries later, the Forum of Trajan made an equally favourable impression on the Emperor Constantius II when he first visited Rome in AD 356 (see Chapter 12, p. 242). Despite the majesty of their planning and the lavishness of their marble decoration, none of these buildings was in any sense revolutionary. The extent of the conservatism and respect for tradition which they reflect is as important a factor in our understanding of the nature of Roman architecture as the innovations in technique, design and scale which were mentioned above. The most typical feature is the retention and elaboration of the Greek Orders of architecture, predominantly the Corinthian, in the external treatment of buildings, many of which were actually constructed on totally different principles from the column and lintel with which the Orders were originally associated. As is shown by Vitruvius' extended discussion of temples and of the Doric, Ionic and Corinthian Orders (*De Arch.*, III and IV), this traditionalism, academic as it might be, was strongly implanted at the beginning of Rome's great period of architectural achievement, and remained so until Late Antiquity.

Vitruvius was writing in the early years of the principate of Augustus, in many ways the most critical and formative stage in the development of the architecture of the Romans, as for much else in their Empire. As has already been implied, that is not so much because the period was one of outstanding innovation in design, as because it saw an enormous increase in building activity. Most spectacularly, this took place in the city of Rome itself, as Augustus in his *Res Gestae* was proud to acknowledge;[1] but its extent in the western provinces was to effect an equal transformation.

The results of this great expansion in building were manifold. In the first place, it gave a much greater significance to the developments in constructional practice which had been pioneered in Italy during the last two centuries of the Republic. Secondly, although marble had already been used occasionally in Rome, in such buildings as the Round Temple in the Forum Boarium in the first half of the first century BC,[2] it was under Augustus that its use became so widespread as to set a whole new standard of magnificence in public building. This was directly connected with a third effect of the scale of Augustan building; for since Italy could not provide the number of skilled marble masons required, the need had to be supplied from the East Mediterranean. To those Greek craftsmen is due the establishment at this time of the particular form of Roman architectural ornament which was to be maintained with remarkably little fundamental change until the fourth century. Fourthly, the intensified exploitation of the Carrara marble quarries and of sources of coloured marble from other parts of the Empire stimulated a new trade, which significantly altered the extent to which, both in Rome and elsewhere, architects of major buildings were restricted by having to use materials which were locally available. Finally, a pattern of imperial patronage was established. This did not entirely or immediately supersede the long tradition of aristocratic munificence which was its basis; but it was to dominate the architecture of the city of Rome until the death of Constantine, and would influence profoundly the development of provincial architecture, particularly in the West.

Augustan Rome was thus pregnant of numerous architectural offspring, and many of them were of complex ancestry and had long been in gestation. Foremost among them were the late Republican and early Imperial developments in construction and design, and these may now be considered in more detail.

CONSTRUCTION AND DESIGN

Other chapters in this book emphasize the enormous Hellenistic influence on Roman art which followed the conquest of mainland Greece and a large part of Asia Minor during the second century BC. Architecture, however, was better placed than were some branches of Roman art to respond to that cultural impact in a manner which was creative rather than derivative and eclectic. In part, that was the result of long-established traditions of craftsmanship, and of sound knowledge of local building materials and what could be done with them.

14. *Tepidarium* of the Stabian Baths, Pompeii. 2nd century BC.

Influences from the Greek-speaking world had also been reaching Roman architecture in a less dramatic way, and from closer at hand, than the cargoes of looted sculpture and silverware which arrived at Rome from the conquered East. It has become increasingly clear that Campania, closer than Rome to the long-established Greek colonies in Southern Italy and Sicily, was an area of remarkable architectural fertility in the time of the late Republic. The Forum basilica at Pompeii was constructed at about the same time as the earliest such buildings at Rome, the Basilicas Porcia, Aemilia and Sempronia, built between 184 and 169 BC. Pompeii's amphitheatre belongs to the period of the foundation of the Sullan colony, and its theatre was converted to Roman form at the same time, some twenty years before Pompey built the first permanent theatre in Rome in 55 BC. It seems highly likely that the Roman bath building was first developed in the cities of Campania (Ill. 14); and it was Puteoli which gave its name to *pulvis puteolanus (pozzolana)*, the volcanic sand deposits of the area, which were so vital an ingredient in the development of Roman concrete.

The Romans did not invent lime mortar, nor did they invent the arch or the barrel vault. The last two had long been features of the mud-brick architecture of Mesopotamia by the fourth century BC, when they began to be used occasionally in stone buildings in Ionian and mainland Greece. It was presumably through the Greeks that the knowledge of lime mortar first reached Italy. The Romans' achievement, and their outstanding contribution to architectural history, was that they realized the potential which lay in the combination of those three elements.

The most important factor in this combination was the gradual discovery of how to make a mortared rubble which was strong enough

not merely to serve as an inert filling material between the facing
stones of a wall or vault, but to stand up on its own and to carry great
weight: though in practice, a Roman concrete wall was normally faced
with stone or brick. The Romans called a construction of this material
opus caementicium, from the aggregate of stones (*caementa*) which were
laid in the lime mortar. It will here be called simply 'concrete', but it
should be understond that this Roman concrete was laid and not
poured, and in that sense is not identical with the modern building
material.[3]

The earliest datable use of it is in the superstructure of the walls of
Cosa, the lower courses of which are of polygonal masonry. The walls
were built shortly after the foundation of the colony in 273 BC. Its first
use in Rome itself, and as a vaulting material, seems to be in the large
warehouse by the Tiber which, if correctly identified as the Porticus
Aemilia, is that which was rebuilt in 174 BC.[4] It consisted of three pairs
of barrel vaults on descending levels, carried on walls faced with
irregular rubble (*opus incertum*) and pierced laterally by arches.

During the second century, if not earlier, it was realized that
concrete made from *pozzolana* had the particular property that it
would set hard under water, and would also be much stronger than one
made from sea or river sand. This appreciation could only have been
made after much trial and error, and in fact not every type of pit sand
(*harena fossicia*, as Vitruvius calls it) had the high silica content to give
the chemical reaction which empirical observation had discovered.

The early stages in the development of concrete construction are
still obscure in many of their details. By the beginning of the first
century BC, however, we have in Latium a number of buildings in
which it is used with remarkable assurance on a large and imaginative
scale. They are religious sanctuaries, constructed on enormous vaulted
platforms built out from a hillside, characteristic examples of the
Roman appreciation of how the natural landscape and the architect's
creation might complement one another.

The Sanctuary of Fortuna Primigenia at Palestrina, the ancient
Praeneste, is one of the most impressive surviving instances of this
talent (Ill. 15). It consists of two main groups of buildings. At the foot
of the hill, a temple with a triple *cella* stood in front of a long narrow
basilican hall with a columnar façade of two storeys, Corinthian
above, Doric below. A rectangular building projected from each end,
that on the right containing an elaborate Nilotic mosaic (p. 117 and n.
6), and niches for statuary. The upper part started with two
terraces revetted in polygonal masonry, from the second of which two
ramps, beginning at each end of the terrace, ascended to meet at the
foot of a central staircase, at the level of the lowest of the porticoes
which decorated the upper terraces. The triangle formed by the ramps
led the eye up to the very centre of the structure, and to the theatre-like
exedra which surmounted the portico at the top. The curvature of the
exedra was repeated on a smaller scale in the two hemicycles of the
portico above the ramps. The curved barrel vaults of the hemi-
cycles, supported on Ionic columns at the front and on walls of *opus
incertum* at the back, show a surprising, though well-placed, confidence

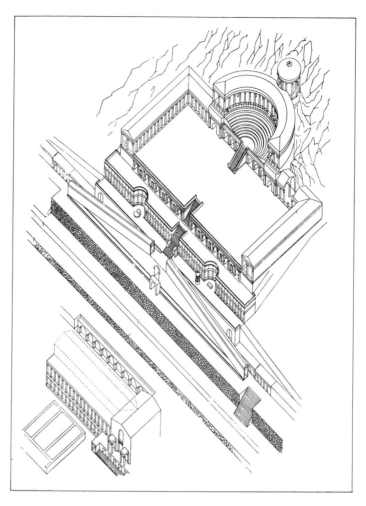

15. Axonometric reconstruction of the Sanctuary of Fortuna Primigenia, Palestrina (Praeneste).

in their capacity to bear the weight of the structure above. In the upper terraces, arches set between engaged Doric columns provided visual contrast with the rhythm of the porticoes. Even for the latest of the dates which have been suggested for it, which range from the mid-second century to the early 70s BC, the Sanctuary is an outstanding achievement, both in its size and in the complexity of its design. The vaulted platforms and porticoes of the temples of Jupiter Anxur at Terracina and of Hercules Victor at Tivoli show, on a smaller if still impressive scale, how thoroughly these new ideas and new skills were becoming assimilated in building practice by the middle of the first century BC, and to what effect they might be exploited.[5]

In Rome itself, the full impact of what has been described as the Roman architectural revolution was not to be felt until after the death of Nero. The one notable forerunner of later developments there is the Tabularium, the State Archive dedicated in 78 BC. It was built to fill the gap between the Arx and the Capitolium, the two summits of the Capitoline hill, forming a new and monumental background to the Forum Romanum (Ill. 16). The facing of the concrete superstructure is a gaunt ashlar wall built from the grey-green tufa of Gabii. It is

relieved only by six narrow rectangular windows, which light a long
vaulted corridor from which a staircase leads up to the arcaded
gallery. This is a series of cross-vaulted chambers, each corresponding
with one of the arched openings. The arches, of which all but three are
now blocked, have half-columns attached to their supporting piers,
with Doric capitals and an entablature of white travertine limestone.
The upper gallery no longer survives; the three storeys of
Michelangelo's Palazzo dei Senatori stand in its place.

Travertine limestone, from the hills round Tivoli, came into use in
Rome during the last years of the Republic. It was better suited to
carving with crisp detail than were most of the local volcanic tufas,
and its greater load-bearing capacity was also appreciated. It is an
interesting comment on the relative lack of confidence in concrete at
this stage that for the Temple of Castor in Rome, rebuilt between 7 BC
and AD 6, piers of travertine were embedded in the concrete podium to
bear the thrust of the columns.[6] It was still a time of experiment; and
the advantage of concrete was probably not that it was self-evidently
superior, but that it was cheaper.

Augustus' great building programme in the city of Rome had as its
starting-point the fulfilment of projects begun or planned by Caesar.
Wholesale redevelopment of the Forum area involved the rebuilding
and renaming of the Basilica Sempronia as the Basilica Julia; the
restoration of the Basilica Aemilia; and the construction behind the
Senate House of what was to be the first of a whole complex of imperial
fora, the Forum Julium (Ill. 17). Augustus added his own forum,
surrounding the Temple of Mars Ultor (the Avenger) which comme-
morated his victory over Brutus. The Forum Augustum was a great
dynastic sculpture gallery of the heroes of Roman history and the
ancestors of the Julii. Caesar's intended expansion of the city on the
Campus Martius was brought to fruition under the charge of Au-
gustus' friend Agrippa, and included the predecessor of today's
Pantheon and the Baths of Agrippa, the first public baths in Rome.[7]

Fora, basilicas and temples were all buildings of a well-established

16. Rome: view across
the Forum to the
Capitoline hill; in the
foreground, the Temple
of Castor.

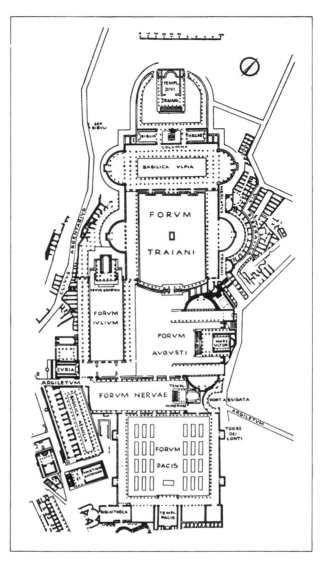

17. Rome: plan of the
Imperial Fora.

type. Radical innovation in their design was scarcely to be expected at a time when Augustus was claiming to have restored the Republic and was trying to re-establish Rome's traditional religious virtues. Architecture reflected the contemporary ideology in combining conservatism with new splendour. The innovation of concrete construction found its place in baths, theatres and amphitheatres, for which there were fewer hallowed precedents, and even then, the new techniques were made acceptable by being dressed in familiar and conventional clothing. Evidently, the outside of a Roman building should still appear to be supported by columns, whether it was so or not. Engaged columns had already been used for purely decorative effect on the Sanctuaries at Praeneste and Terracina and on the Tabularium. Whereas the exteriors of such early buildings of their type as the amphitheatre at Pompeii and the mid-first century gate, the Porta dei Leoni, at Verona had plain arched openings with, at most, a simple

string course, later examples were elaborately decorated to harmonize
with the traditional appearance of temples and basilicas (Ill. 18).

As we see from such buildings as the Porta dei Borsari at Verona, the
gate of Hadrian at Athens and the amphitheatre at El Djem (Ills. 19,
40 and 21), this decorative treatment is so commonplace a feature of
imperial architecture that it now seems almost inevitable. Those who
are not impressed by the unadorned drabness of concrete office blocks
may think that this was no bad thing. If, on the other hand, it is argued
that the external appearance of a building should be a logical reflec-
tion of its construction, then the Roman convention, which was still
only at a formative stage at the time when the Tabularium and the
great sanctuaries of Latium were built, must be seen as standing in the
way of any serious attempt by Roman architects to come to terms with
the latent possibilities of their material, and with the inherent
problems which were awaiting solution. In a sense, perhaps, they
solved the problems by not recognizing that they existed.

Where, however, they did succeed in breaking new ground was in
the architecture of interior space. It was not in public architecture, but
in the more private domain of the imperial palaces, that there was
freedom to explore the new possibilities. In both of Nero's palaces in
Rome, the Domus Transitoria, which was destroyed in the great fire of
AD 64, and the famous Domus Aurea (the Golden House), which
followed it, we may note the growing fascination with the
interplay of curves on vaults, domes, arches and walls and with the
contrasting spaces which they enclosed or defined.[8] The luxurious
Golden House was built on the slopes of the Oppian hill, overlooking a
huge landscaped park around an artificial lake, which within fifteen
years was to be the site of the Colosseum. Severus and Celer, the
architects (Tacitus, *Annals*, XV. 42), created in the heart of the city a
particularly splendid version of the aristocratic suburban and seaside
villas which, with their elegant façades and spacious surroundings, are
such a familiar feature of the wall paintings of Pompeii and
Herculaneum. Nero's reaction was to say, 'Now I can begin to live like
a human being' (Suetonius, *Nero*, XXXI).

Part of the residential wing survives, having been incorporated in
the substructure of the Baths of Trajan, and the walls and roof of the
domed octagonal hall which occupied the centre of the east wing are
still intact. The room was lit from the top by a large oculus, and since
the dome was free-standing within the building, light slanted down
above it into the higher rectangular chambers which radiated from
five sides of the octagon.

By this time brick had largely replaced stone as a facing material for
concrete, and brick-faced concrete also formed the structure of the
great new house which the Emperor Domitian's architect Rabirius
built for him on the Palatine hill (Martial, *Epigrams*, VII. 56). The site
gave the building its informal name, the *Palatium*, the original 'palace'.
The irregular topography of the hillside was extended by constructing
great vaulted platforms; that on the west side was built out to overlook
the Forum, to carry the State apartments arranged round a peristyle
courtyard; the private apartments on the east side had a south façade

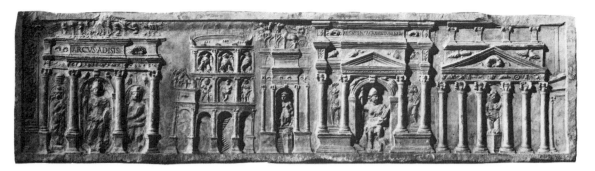

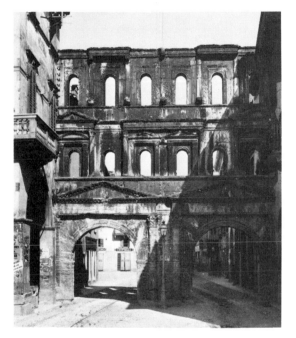 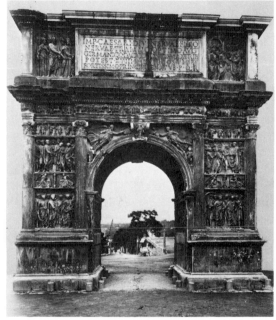

18. Relief from the Tomb of the Haterii, Rome, showing monumental arches, an amphitheatre (centre left) and a temple (right). AD 100–10. Rome, Lateran Museum.

19. Porta dei Borsari, Verona. Later 1st century AD.

20. Arch of Trajan, Benevento. AD 114.

21. Amphitheatre, El Djem (Thysdrus). Date uncertain (late 2nd to mid-3rd century AD?).

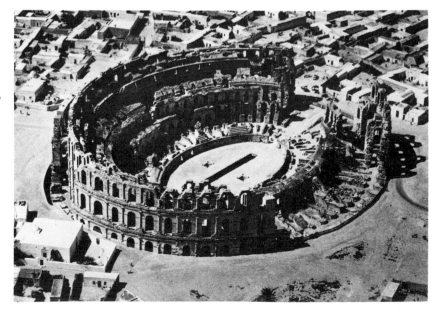

overlooking the Circus Maximus. Impressive as its remains still are, imagination is necessary to replace the marble veneer upon the brick-work and the vaults and ceilings above the walls, and so to recreate the shining and many-coloured surfaces, the lofty spaces, the intri-guing vistas, the contrasting shapes of solid structure and contained space, which provided the setting for empire so long as there were emperors in Rome.

The interior of the great Audience Hall had a shallow central apse for the Imperial throne, opposite the main entrance in the middle of the Forum façade. The rest of the walls was divided into alternating curved and rectangular bays, with fluted columns of Phrygian marble projecting between them. Set inside the bays were the doorways, and decorative *aediculae* for statuary. The whole effect was to enliven the surface of the great mass of the walls with reflected light and shadow, in much the same way as the illusions of recesses and projections in the wall paintings of the Pompeian Style II. The hall is over thirty metres wide, and the roof structure was probably of timber; it is thought unlikely that the walls, solidly built as they were, could have supported the enormous weight of a barrel vault of that width.[9] The *triclinium* on the opposite side of the peristyle was almost as wide, and its un-buttressed walls could only have carried a timber roof. Here, by contrast, Rabirius converted another illusion of earlier wall paintings into reality, by opening up the walls to views of what was outside. Indeed, on the side facing the peristyle, there was no wall as such, but a screen of six columns of Egyptian granite; the walls to right and left were pierced by doorways and windows through which could be seen oval niched fountains clad in marble, and beyond them the curved colonnades of the courtyards which surrounded them.

The interest of the Flavian palace lies essentially in its interiors; its site, constricted both by the topography of the Palatine and by existing buildings, gave the architect little room for manœuvre in creating external effects. In Hadrian's Villa at Tivoli, however, we have what is probably the finest combination of Roman architecture's particular virtues: the varied and ingenious treatment of interior space; the highly accomplished, indeed, in this case daring, use of concrete construction; and an appreciation of the mutual enhancement of buildings and their landscape setting which would not be rivalled until the eighteenth century. The unknown architect created, below the hill of the ancient town of Tibur, a sprawling complex of living-rooms, baths, pavilions, temples and libraries, pools and courtyards. The names given to the constituent parts – the Lyceum, the Stoa Poikile, Tempe, Canopus, for example – were intended to evoke some of the most celebrated places of the Hellenic culture to which Hadrian was so devoted, but the spirit of the architecture was one of originality, not of imitation.

The colonnade which surrounded the 130 metre long pool of the Canopus had arched architraves, the first appearance of this Eastern feature in Roman monumental architecture. At one end of the pool, the fountain which fed it was housed in a remarkable building, the Serapeum, which was covered with a semi-dome composed of nine

alternately flat and concave segments, decorated with mosaic. The vestibule of the so-called Piazza d'Oro (the Golden Square) had, as its basic plan, a circle inscribed in a square, with eight semicircular and rectangular projections, the latter extending to the sides of the theoretical square, the former placed diagonally. This idea is present in the rooms of the west wing of the Flavian Palatium. In the Tivoli vestibule, however, the rear walls of the rectangular projections were not extended to complete the enclosing square, and the exterior thus follows the logic of the interior in not hiding the semicircular domed projections. The building was roofed with a dome divided internally into eight concave segments. On the opposite side of the Piazza was a pavilion, its central courtyard defined by a colonnade which was laid out as eight alternately projecting and re-entrant arcs, so as to form a cruciform plan. It has been shown that this structure could not have been vaulted in concrete, but it might have carried a lighter covering.[10] An even more elaborate use of curvilinear walls, recesses and screens of columns is to be found in the building on the central island of the circular Maritime Theatre (Ill. 22).

If the time of Augustus was characterized above as a formative period for Roman architecture, that of Hadrian could with equal justice be described as one of crowning achievement. He travelled widely throughout the Empire, and more will be said below about some of the provincial buildings associated with his name, which include his library and arch at Athens, his temple at Ephesus, and his wall in Britain. It is, however, in the Pantheon at Rome, rebuilt by Hadrian from its foundations and still standing virtually intact, that we may come closest to recapturing the contemporary experience of that architectural achievement (Ills. 23 and 24).

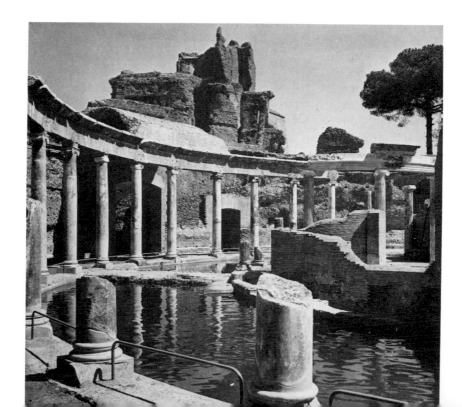

22. Hadrian's Villa, Tivoli: the Maritime Theatre. AD 118–25.

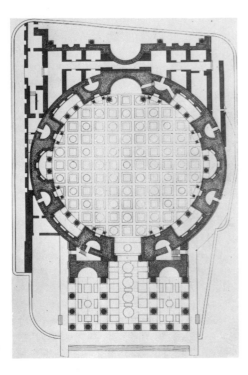

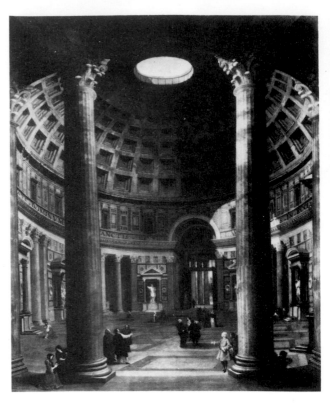

When the Pantheon was built, the surrounding buildings concealed much of what we can now see of the rotunda's exterior. The view of the temple, approached from the front, was dominated by a very conventional porch, its pediment carried on eight columns of Egyptian granite. The inscription records only the original construction by M. Agrippa, but the architectural ornament is all Hadrianic, and the brickstamps of the rotunda date it to between AD 118 and 128.[11] The traditional nature of the porch in no way prepares the visitor for the exhilaration of entering the great domed space of the interior. Its geometry is elegantly simple: a cylinder, crowned by a hemispherical dome, such that the total internal height of 43.20 metres (142 feet) is equal to the diameter.

The brick-faced concrete walls are six metres thick, but the deep rectangular and semicircular recesses of the inside wall create, in effect, a series of piers which carry the weight of the superstructure down to the massive ring of the foundations, which extend to a depth of 4.5 metres (15 feet). The relieving arches of tile which are visible from the outside extend through the concrete core, and were primarily necessary to transmit the thrusts during the process of construction. Very careful attention was paid to the choice of materials for the aggregate of the concrete, in making use of the strength of travertine in the lower part, for example, and of the lightness of tufa and pumice in the dome.

The interior of the dome is lightened by deep coffering (which was probably gilded originally), in five diminishing rows of twenty-eight

23. *(Above, left)* plan of the Pantheon. AD 118–28.

24. *(Above, right)* interior of the Pantheon, Rome, showing the original wall decoration just below the dome. Painting by G.P. Panini. Copenhagen, State Museum of Art.

compartments.[12] The factor of seven in that number contrasts with the eightfold layout of the recesses in the wall and of the *aediculae* between them, a subtle variation in the rhythm of the decoration which seems to detach the dome from the cylinder upon which in fact it rests. The oculus at the top, the sole source of light, draws the eye upwards, but there is also a discreet note of axiality which runs across the rotunda from the entrance to the apse on the opposite side. There is no feeling of rigid enclosure within this building: the whole impression is one of soaring space. Even the weight of the concrete structure, so solid in its external appearance, is belied within by the variety of surface, of light and shade, in the recesses, the *aediculae*, the fluted granite columns and pilasters and the rich colours of marble and porphyry in the floor and the wall-panelling. The stucco decoration between the first cornice and the dome was added in the eighteenth century, but part of the original has been recreated from earlier illustrations.[13]

Hadrian is known to have had a well-developed amateur interest in architecture, and certainly tried his hand at designing. He was once confident enough to interrupt an architectural discussion between Trajan and his architect Apollodorus of Damascus, who rudely told him to go and draw pumpkins (Dio Cassius, LXIX. 4). The story has added point if the 'pumpkins' were in fact Apollodorus' way of referring to segmental domes of the kind which Hadrian would later, when emperor, have the satisfaction of seeing built at Tivoli. So far as the Pantheon is concerned, however, it owed much, both in its lavishly decorated interior and in the assurance of its concrete construction, to what Apollodorus himself had previously achieved.

The most famous of his buildings in Rome is the Forum of Trajan, which reveals his masterly use of traditional materials for an effect of outstanding grandeur. That he was equally at home with the contemporary architectural idiom is clear from the curvilinear elements and the use of large windows in the Baths of Trajan, which he built between AD 104 and 109. It seems likely that he was also the architect of Trajan's Market, to judge from the close integration of its design with that of the Forum though it is not among the buildings which Dio (LXIX) specifically mentions as his (Ill. 17). In planning the market there was no room for the rigid axial symmetry of the Forum and the Baths. No one who was not a thorough master of concrete construction could have contemplated, still less achieved, the effective and imaginative solution to the problems which the site presented, which included the need to hold up that part of the Quirinal hill which had been cut back to accommodate the Forum, and then to build over the steep slopes of the hillside on three main levels.[14]

At the bottom, a two-storey semicircle of shops follows the curve of the exedra in the outside wall of the Forum. That wall no longer stands, so we have a much better view of the Market now than was ever possible in antiquity. The lower storey has doorways of travertine, and the arches above them were originally walled in. The arched windows in the upper storey are framed by very shallow pilasters and crowned by curved, triangular, or half-triangular, pediments. The delicacy of this decorative treatment, which is all executed in moulded brickwork,

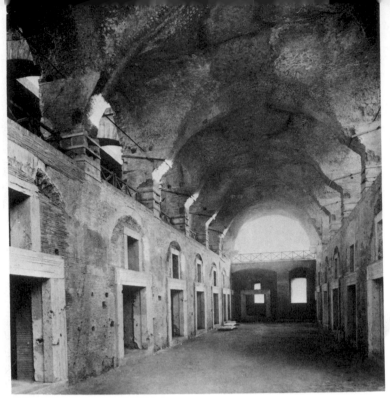

25. Trajan's Market, Rome. *c.*AD 100–12. Interior of the market hall.

has more affinity with the fantasy architecture of Pompeian Styles III and IV wall painting than with the use of full-scale columns and entablatures on the Tabularium and the Theatre of Marcellus; here, the veil of decoration is transparent, and the true nature of the structure behind it is clearly perceptible.

The wall at the north end of the semicircle is equally remarkable for the starkness of its eight great windows. The room behind was itself semicircular, and covered with a half-dome. The shops in the two levels immediately above are also built round curved terraces or courts, the curvilinear forms being the most efficient structural means of resisting the thrust from the hillside and the buildings higher up. This ingenious layout gave an architectural unity to a part of the site which was both steep and cramped behind the apse of the Forum basilica. The other main levels include the frontage along the winding Via Biberatica and a market hall with two tiers of shops. The latter was roofed by six cross-vaults, in such a way that light could enter the hall from the side galleries which gave access to the upper tier of shops (Ill. 25).

It is a measure of the complete acceptance of unadorned brick-faced concrete structures by the early second century that two such contrasting buildings as the Forum and the Market of Trajan could have been built next to one another at the same time, and probably by the same man. The harbour town of Ostia shows, better even than the metropolis, how successful the Roman architectural revolution had been. Most characteristic of the town are the *insulae*, the rectangular apartment blocks built round a courtyard, with self-contained shops along the ground-floor frontages, their entrances shaded by the continuous balconies of the upper storeys (Ill. 26). The same basic plan

26. Courtyard of the warehouse of Epagathius and Epaphroditus, Ostia. *c.*AD 145–50.

served equally well for warehouses (*horrea*) and market buildings. The architecture is essentially functional: decoration is limited to an occasional brick portico round a doorway or a string course above the large rectangular glazed windows. The texture of the brickwork and the pattern of relieving arches above the openings now seem to enliven the exteriors, but were probably originally concealed beneath a stucco rendering. The large windows and doorways had come to give the main visual interest to an exterior, as well as much more light to the interior. The Ostian *insulae* were very different from the ill-lit inward-facing *atrium* house, but they may not have differed quite so much, save for being incomparably more solidly built, from the timber and mud-brick *insulae* of Republican Rome which, like the later Ostian buildings, may have risen to at least three storeys (Livy, XXI. lxii. 3). They certainly had similar disadvantages, in that the upper floors lacked heating and running water, though they did occasionally have lavatories.

MATERIALS AND DECORATION

Obviously, the primary factor which determines a choice of building materials is what is locally available; upon those materials depend both the nature of a construction and the character of its decoration. Most Roman architecture before the first century BC depended on local resources. Thereafter, as will be seen, there are many and varied exceptions.

Unfired clay was still in extensive use for domestic building in the late first century BC, when Vitruvius was writing. Augustus' boast that he found Rome a city of sun-dried brick and left it as marble is true

only in conveying a panoramic but cursory impression of its changed appearance (Suetonius, *Augustus*, XXVIII. 3). It would be more accurate to say that marble and travertine replaced tufa, and that sun-dried brick was being replaced with rubble- and, later, brick-faced concrete. It was not until the great fire of AD 64 that many of the old tenements of sun-dried brick were swept away. That material had long been used for building in the Mediterranean and Asia Minor, and the survival of houses built of it in such towns as Karanis in Egypt shows that the tradition was maintained, at least to some extent. It may well have been more common, even in major buildings, than the surviving evidence allows us to prove, for of its very nature it is much less permanent than stone and fired brick. It was less well suited to the damper climate of the western provinces, but several towns in Britain, including London, Verulamium (near St Alban's), Colchester and Canterbury had clay-walled houses with plastered and painted walls in the first century AD. Excavations of the late Republican villa of Sette Finestre in Tuscany have shown that it was not out of place for a building of some luxury to have walls of sun-dried brick (Ill. 27). They were set on stone footings and covered in painted plaster, with stucco mouldings in some rooms. Stucco fluting and mouldings were also added to the columns of the peristyle, which were built up from pieces of tile. The eaves were decorated with architectural terracottas.[15]

Terracotta revetments, antefixes and other roof furniture adorned the earliest Etruscan and Roman temples. Among later buildings, the Capitolium at Cosa has produced one of the best series of architectural terracottas; an original scheme of decoration in about 150 BC was followed, over no more than a century, by three periods of repair and a wholesale redecoration of the façade, each in a slightly different style.[16] This period saw the last major flowering of the perennial formal designs of lotuses and palmettes, which during the second half of the first century BC were replaced on revetments by the mythological subjects of the Campana reliefs (Chapter 9, p. 192). The Capitolium at Cosa and the Temple of Apollo Palatinus in Rome (36–28 BC) were decorated with these later terracottas.[17] It was becoming normal, however, for public buildings to have superstructures of hard stones like travertine and marble, which could be carved with a detail and finesse comparable with terracotta ornament, but which made redundant the function of the latter in protecting roof timbers from the weather. More often, terracottas were used on houses and tombs, a reflection of the increasing luxury of private architecture. They were made occasionally in the western provinces, predominantly at military sites with timber buildings.[18]

At the same time, with the increasing use of fired brick as a facing material, it came also to be used for decorative purposes. Initially, as in the columns of segmental tiles in the late second-century BC Forum Basilica at Pompeii and in those of the Sette Finestre villa, this might be no more than a basis for finer detail executed in stucco. There, the use of brick, as brick, was merely structural. Later, even Corinthian capitals and the dentils and ovolos of cornice mouldings, as well as

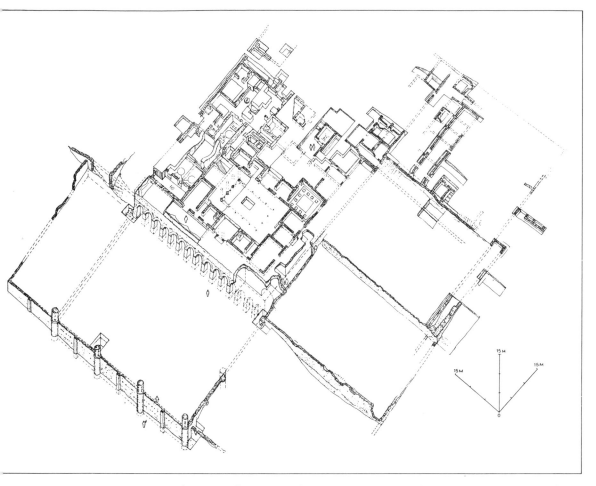

15 M

15 M

15 M

0

27. Villa at Sette Finestre. Early 1st century BC. (Drawing by Sheila Gibson.)

columns, pilasters, string courses and pediments, were built up from moulded or carved fired brick. As such well-known examples as the entrance to the Horrea Epagathiana et Epaphroditiana at Ostia show us with especial clarity, this was essentially a translation into brick of the manner of architectural decoration proper to other materials: stone structures, in some cases; in others, as was noted above in the exedra of Trajan's Market, the non-structural ornament of stucco and wall painting. It is often said that this decorative brickwork was covered in stucco. In some cases, the stucco survives to prove it; in most, it is no longer possible to decide. In one important group of buildings, however, erected in and around Rome during the second century AD, the use of red brick for pilasters and other decorative features, in contrast with the yellow and orange bricks used for the rest of the walls, is meaningless unless the brickwork were left exposed. Among these buildings are parts of the villas of Le Mura di Santo Stefano, near Anguillara, and Sette Bassi, and the tomb of Annia Regilla and others on the Via Appia (Ill. 28). The decoration is elaborate, with Corinthian capitals and considerable detail in the cornices, which were composed of specially moulded bricks.[19]

Brick was also used with stone in ways which, at least in origin, were

structural, but might incidentally or alternatively be decorative. Quoins and levelling courses of brick were combined with *opus reticulatum* (for which, see below) in first-century AD buildings in Ostia, for example, and the practice was revived in Hadrian's villa at Tivoli (Ill. 22). The primary function of this *opus mixtum* was to give strength: much of it may have been stuccoed over. At Chieti, Pompeii and Ostia, however, there are instances where the tufa blocks of the reticulate were also laid in alternating courses of different colour, and a decorative effect was probably intended.[20]

In northern Italy, a version of *opus mixtum* was developed in which levelling layers of two or three courses of brick were laid at vertical intervals of about a metre in a wall of coursed rubble masonry of small blocks, *petit appareil*. One of the earliest datable instances is in the Vespasianic capitolium at Brescia, but once established, it long remained the fashion in the western provinces, and it found particular favour in the third-century fortifications of Gaul and Britain. In the town walls of Le Mans and those of the fort at Richborough, there was also geometrical patterning in stones of different colours. The amphitheatre at Bordeaux had pilaster capitals and cornices of brick in addition to levelling courses. The circular Temple of Vesunna at Périgueux had, for its window arches, voussoirs which were alternately of tile and stone, and the brick courses in its masonry were not at regular intervals, but limited to one below the windows and two at a higher level. In all these cases, the contrast of brick and stone was clearly intended for visual effect.

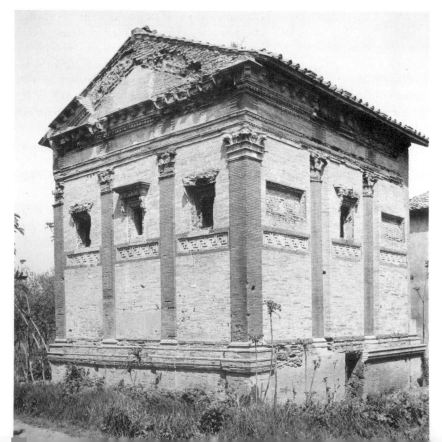

28. Tomb of Annia Regilla, Rome. Third quarter of 2nd century AD.

29. Aula Palatina, Trier. Early 4th century AD.

The exclusive use of brick as a facing material for concrete was rare outside Italy. The well-preserved Aula Palatina at Trier is exceptional, because its walls were not just faced, but were built entirely of brick (Ill. 29). This type of construction had been anticipated in the East, which had acquired the idea of fired brick from Italy. The enormous central hall of Kizil Avlu at Pergamum, the Temple of Sarapis built early in the third century, had walls built entirely of brick, as did the Harbour Baths at Ephesus and the upper part of the pressure-towers of the aqueduct at Aspendos. Courses of brickwork were also used in conjunction with rubble masonry in the baths at Ankara and the third-century walls at Nicaea (Iznik).

In the East, brick was also used instead of concrete for vaulting; the precedent was long established in Mesopotamia and Egypt in the medium of sun-dried brick. Fired bricks were 'pitched', that is, laid end to end across the upper part of the vault, not side by side like the voussoirs of an arch, which was the practice in the West. The substructure of the basilica at Aspendos is one of the few surviving examples. The Temple of Asklepios Soter at Pergamum, dated to just before the middle of the second century, was built in apparent imitation of the Pantheon, but with a drum of ashlar masonry and a dome of radially-laid bricks (Ill. 37).

Of the two main forms of monumental masonry in Republican Italy, polygonal and ashlar, the former fell out of use during the first century BC. Among the latest instances are the lower terraces of the Sanctuary of Fortuna at Praeneste, and the walls of Fiesole near Florence, dated to about 100 BC. Early concrete buildings were faced with *opus incertum*, a diminutive version of the massive polygonal

blocks: small blocks of rubble were laid close together without forming
any regular pattern. From about 40 BC and throughout Augustus'
reign this was largely replaced in central Italy by *opus reticulatum*. This
consisted of pyramidal blocks laid with their square ends outwards,
aligned so as to form a diagonal net-like pattern in the wall surface,
and with their apexes engaged in the concrete core. By the reign of
Nero it had almost entirely been superseded by brick facing (*opus
testaceum*) though there was a minor Hadrianic revival. Reticulate
work is rarely found outside Italy; its occurrence on Herodian build-
ings at Jericho is clearly due to the Italian influence which is also to be
seen in the stucco facing of the walls of Herod's palace at Masada. In
the provinces, coursed rubble masonry, usually of small squarish
blocks but with many variations dependent on the sort of stone locally
available, was used where the facing was not of brick or ashlar.

Ashlar masonry, large squared stone blocks laid in horizontal cour-
ses, was widespread throughout the Empire except where stone which
could be dressed with the required accuracy was unobtainable. It is
necessary to mention only some special features associated with this
opus quadratum. One is rusticated masonry, that is, blocks squared and
laid like ashlar, but with an outer face left with its rough quarry
dressing, save usually for the drafting of chiselled margins to define the
edges. It is thus, in a technical sense, unfinished, but it was inten-
tionally left in this state on some monumental buildings, to which it
gives an appearance of rough-hewn robustness. There are Republican
precedents in Italy, and a brief vogue for it in Rome in the mid-first
century AD, where it was used in the lower part of the Porta Maggiore
and on the terrace arcades of the Temple of Claudius. The influence of
such buildings on Renaissance architects was far greater than their
significance in the context of Roman architecture as a whole. Rustica-
tion is found occasionally in the provinces; the aqueduct of Segovia
(Frontispiece) and the lower part of the pressure tower of that at
Aspendos provide suitable examples of the structures to which it added
a rugged dignity.

The aqueduct of C. Sextilius Pollio at Ephesus, the bath buildings at
Miletus, the theatre at Caesarea and the rotunda in the Sanctuary of
Asclepius at Pergamum, are all examples of the successful use of
concrete for vaulting in the East, but in general it proved difficult to
make a concrete strong enough. Dressed stone, though expensive,
could provide an alternative; the radial vaulting of the *cavea* of the
theatre at Side is a notable example. Hemispherical domes of dressed
stone were constructed for the West Baths at Jerash and the *cella* of the
'Temple of Venus' at Baalbek (Ill. 30).

It is most unusual to find dressed stone used for vaulting in imperial
buildings in the West. In the best-known example, the so-called
Temple of Diana at Nîmes, the decision to give it a stone barrel-vault
did not result from any local problems in making concrete: one could
not hope for more solid denials of that than the statements of two
witnesses from the neighbourhood, the Pont du Gard and the best-
preserved amphitheatre in Gaul at Nîmes itself. The reason must have
been aesthetic, and a further clue is given by the baroque interior

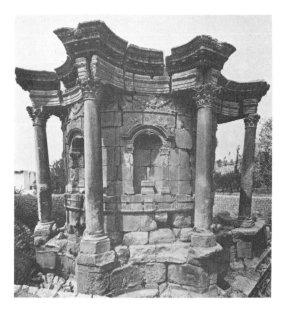

30. 'Temple of Venus',
Baalbek. Date uncertain
(2nd to mid–3rd century
AD?).

decoration of the walls with columns set against them and pedimental
aediculae in between, very much in the manner of the Temple of
Dionysos at Baalbek, a strong indication that the architect was a
Syrian Greek. This building at Nîmes, so little bound by the conven-
tions of local architectural practice, is a remarkable instance of how
ecumenical Roman architecture could be.

Nowhere is this more clearly to be seen than in the enormous
prestige associated with the use of exotic marble in buildings of the
highest quality. It is no accident that it was the conqueror of
Macedonia, Q. Caecilius Metellus, who erected in 146 BC the first
marble building in Rome, the Temple of Jupiter Stator. Romans of his
generation and their immediate successors, brought up in archi-
tectural surroundings of sun-dried brick, stuccoed tufa and painted
terracottas, were captivated by the glistening magnificence of the
Greek cities they had captured. Greek architecture had, however,
been created from the rock of its native land. For the Romans to
emulate its appearance, if not its reality, at home, it was necessary to
redistribute the geological wealth of the Mediterranean basin; each
area, according to its resources, supplied marble to Romans, according
to their means.[21]

One notorious early example illustrates the scale of the transforma-
tion. In 58 BC the aedile M. Aemilius Scaurus constructed a temporary
theatre in Rome, accommodating an audience of 80,000. Its stage
building was decorated with no fewer than 360 columns, arranged in
three storeys. The lowest storey had a wall of marble (it is uncertain
whether that was veneer or solid throughout), in front of which were
columns of black marble from Chios, thirty-eight feet high. This lavish
building was dismantled after little more than a month. Some of the
huge columns were then installed in the *atrium* of Scaurus' house on the
Palatine. (Pliny, *NH*, XXXVI. 5–6, 49–50, 113–15).

There were those who considered that this new extravagance in

building materials was truly immoral, but the cause of modesty and restraint was to be lost. Private architecture set and maintained the pace. Lucius Crassus, consul in 95 BC, was the first to have columns of foreign marble in his house. M. Aemilius Lepidus, consul in 78 BC, was the first to import the yellow Numidian marble from North Africa, for his door-sills. Thirty-five years later his house, the finest of its time, was not to be counted among the top hundred (Pliny, *NH*, XXXVI. 7, 49, 109). By then Mamurra, who had made a fortune while chief engineer for Julius Caesar in Gaul, had built a house in which the columns were of solid marble throughout, the green-veined Carystian from Euboea and the white Carrara marble of Italy itself. The palace at Fishbourne in Britain illustrates the influence of these standards upon provincial architecture. The white and coloured marbles used for wall veneers and flooring came from the Pyrenees, the Garonne, Burgundy, Carrara, the Greek islands and Turkey.[22] In Britain, Fishbourne may be exceptional; in the Empire, it is not so extraordinary.

In Augustus' reign, Carrara (or Luna) marble, from northern Tuscany, came to be used extensively for public buildings in Rome, and from there its use spread to other parts of Italy and the western provinces. The Temple of Divus Julius in the Forum, begun in 42 and dedicated in 29 BC, was entirely built of Carrara marble, as was the Temple of Apollo on the Palatine, dedicated in the previous year. In general, however, it was exceptional for imported marble to be used for a whole building. The Capitolium of Narbonne, in which Carrara marble was used throughout, is the only such example in Gaul. In being built of solid Proconnesian marble, Hadrian's Temple of Venus and Rome, at Rome, and the Temple of the Severan Family in the Forum at Lepcis Magna, are the results of a munificence which only emperors could display. The principal use of foreign marbles was for columns, often imported ready-worked and in standard sizes, and their varied colours made an immensely opulent contrast with the basic material of the buildings. In the Forum and Basilica at Lepcis, for example, the main building-material was the local yellow lime-stone. The grey-veined white Proconnesian marble of the Temple was the background for its columns of red Egyptian granite, and the colonnades of the surrounding Forum had column shafts of green Carystian marble and glistening white Pentelic capitals and bases. The many-columned stage buildings of theatres made them particularly apt for such polychrome enrichment in exotic materials.

An equal richness of appearance could be achieved with greater economy by the use of marble veneer. This might be applied to the outside of a building, as on the great four-way arch (*quadrifrons*) at Richborough, which had fluted columns and pilasters, casings, mouldings and bead-and-reel ornament, all executed in Carrara marble.[23] More commonly, veneer was a feature of the interior decoration of wall-surfaces, as in the palace at Fishbourne, where panels and mouldings of different types of marble were fitted together, presenting on a smaller and more intimate scale the rich variety of colour of the theatres and imperial fora. A similar use of inter-locking pieces of marble was applied to floor surfaces (Chapter 5,

p. 138). This *opus sectile* differs from mosaic in that the geometrical composition was made up of marble of different colours cut to the shapes which formed the pattern.

It is not necessary to repeat what is said elsewhere in this book about other aspects of interior decoration: wall painting, stucco, and floor- and wall-mosaic. The point must be made, however, that Roman interiors were conceived as entire and integrated designs. The predominantly black-and-white geometrical patterning of late Republican and early Imperial mosaics provided the counterpart to the rich and dominating colours and mythological imagery of contemporary wall painting. Only a few buildings, such as the Pantheon and a number of houses in the Vesuvius region, including the Samnite House at Herculaneum, allow us to see a Roman interior more or less as it was meant to be seen.

The Romans derived the Doric, Ionic and Corinthian Orders from Greek architecture, but they treated them in their own fashion. There was no distinctive form of Greek Corinthian entablature; Vitruvius wrote that either the Doric or the Ionic might be used with a Corinthian capital (*De Arch.*, IV. i. 2); the Arch of Augustus at Aosta provides a Corinthian-Doric example, and there are several instances of the use of a pure Ionic entablature. At the same time – that is, in the years immediately following Julius Caesar's death – the first buildings in which Carrara marble was extensively employed show the distinctive Roman Corinthian in an already developed form, with its characteristic way of carving the leaves on the capital, and modillions on the cornice.[24] These were a series of brackets, usually scrolled, regularly spaced beneath the projecting part of the cornice as if to support it. The precedents lie not in monumental architecture so much as in the stucco interior decoration of buildings in Rome and Campania, which was itself inspired by Hellenistic models. This was the main feature in which the Ionic entablature was modified, and another was the highly ornate decoration of the cornice. More than one Augustan style is apparent. The Forum of Augustus and its Temple of Mars Ultor were decorated with motifs copied directly from classical Athens, as well as such major elements as replicas of the Caryatid columns of the Erechtheum. The Temples of Apollo Sosianus and of Castor had a more luxuriant and florid ornament.[25]

Since the necessary experience in carving marble was not widespread in Italy at the time, much of this work must have been executed by Greek craftsmen. The canons of ornament which were established in Rome within this very short period, after the death of Caesar and through Augustus' reign, were to prove remarkably resilient. Despite well-marked distinctions in technique, the highly decorated ornament of Flavian buildings and the more classicizing decoration of early Hadrianic architecture are little more than variations on the themes current in Augustan Rome (Ill. 31).[26]

The Corinthian capital, as the most ornate, was the Roman favourite for monumental buildings. The Ionic was rather sparingly used during the Roman period, even in the Greek East; one well-preserved western example is the small rectangular 'Temple of

Fortuna Virilis' near the Tiber in Rome. More often, Ionic columns
formed one of the tiers which decorated theatres (such as that of
Marcellus) and amphitheatres (such as the Colosseum). Roman Ionic
bases normally had plinths, which were not usual in Greek archi-
tecture. The Composite capital was a Roman invention, probably
originating a little before Augustus' reign, and certainly well-
developed before his death, the very time when the Roman version of
Corinthian was being established. Its composite nature was that Ionic
volutes were combined with the lower tiers of Corinthian acanthus
leaves (Ill. 32). Classical Doric had been the basis for the type of
column used in Etruscan architecture. The Roman version of Doric
differed in having a smaller capital with a more elaborate profile; a
short necking and a bead-moulding separating the capital from the
shaft; a more slender shaft without fluting; and a moulded base.
Renaissance architects named this version the Tuscan column; it was
most commonly used for the smaller-scale architecture of domestic
peristyles, verandahs and porches.

One further distinctive feature of the Roman treatment of the
classical Orders was the use of engaged columns on a façade in a
manner which was not structural, but decorative. The placing of free-
standing columns immediately in front of a wall, with projections of
the entablature above them to connect them with the superstructure, is
not attested in monumental architecture in Rome before the Flavian
period, though there are precedents in interior decoration, partic-
ularly in the architectural schemes depicted in wall painting. An
early instance in the East is on Hadrian's Library at Athens: the
columns were given added height by being set on free-standing ped-
estals, a practice rare in the West before the building of Christian
basilicas; the Temple of the Severan family at Lepcis Magna provides
one such example, and was certainly the work of Greek craftsmen.
These buildings are instances of the great range of provincial variation
in architectural ornament in stone, which has only been described here
in the most general terms. Few of these regional styles have been
studied in detail, but is is clear, even in those western provinces which
did not have indigenous traditions of stone-carving, that there was
room for originality.[27] In the East, the contributions of much
longer-established traditions in matters of design and decoration were
influential well outside their native regions; some of them will be
discussed in more detail in the following section.

ARCHITECTS AND ARCHITECTURE

Few surviving Roman buildings can be attributed to a known archi-
tect. Those already mentioned were recorded because they were in
Rome and were built for emperors, whose biographers found some-
thing worth mentioning in incidents connected with the architects. In
such cases we can match the names of the men with the evidence for
some, at least, of their achievements. Otherwise, we may have the
names, but not the buildings. Cicero's letters, for example, mention
both his own architect Vettius Cyrus (e.g. *Ad Atticum*, II. iii. 2) and the
rather incompetent Diphilus who worked for his brother (*Ad Quintum*

31. Arch of Titus,
Rome. Entablature and
keystone. Late
1st century AD.

32. Arch of Septimius
Severus, Rome.
Composite capital.
AD 203.

Fratrem, III. 1). The names and professions of others, but not their
buildings, are recorded on tombstones. More rarely, a stone inscrip-
tion records a particular building project, one important example
being the contract of C. Blossius for work in front of the Temple of
Sarapis at Puteoli which was specified in minute detail.[28] The reason
for our ignorance is simple. In Roman society, the credit for a building
was thought to be due to those who had conceived, commissioned and
financed it, rather than to the technician who converted the patron's
intention into bricks and mortar. The architect C. Iulius Lacer, named
in the dedicatory inscription of the bridge which he built for Trajan
across the Tagus at Alcántara, is one of the rare exceptions.[29]

It is true that Roman administrators, aristocrats, and even such
emperors as Hadrian, might have their own decided, well-informed
and practical views about architecture. The elder Pliny, particularly
in Book XXXVI of his encyclopaedic *Natural History*, and Frontinus in
his treatise *On Aqueducts*, are examples of men of that class whose
writings on architectural matters are an immensely valuable source of
information. Others, like Cato, Columella, Varro, Faventinus and
Palladius, were more concerned with that aspect of building practice
which was relevant, and the knowledge of which was essential, for the
competent management of a landed estate.[30]

It is somewhat ironical that Vitruvius, the Roman architect whose
name is most familiar to us, is not known to have been connected with
any of the outstanding buildings of his time, although he was working
at a time of great architectural fertility in Rome. The only building of
his own about which he tells us anything, and in which clearly he took
much pride, was a basilica in the small Italian town of Fano. His
reputation depends on the complete survival of his ten books on
architecture. Vitruvius had been employed both by Julius Caesar and
by Augustus, but the experience which he distilled in his treatise was
that of a general practitioner rather than that of one who was in the
forefront of metropolitan fashion; it is all the more useful for that.

He intended his work to be comprehensive: he discussed the educa-
tion of the architect and fundamental principles of architecture;
building materials; temples and, in their context, the proportions of
the classical Orders of architecture; theatres and other types of monu-
mental building; domestic architecture; stucco and wall painting;
water and hydraulics; astronomy; and a variety of siege engines and
other mechanical devices. The range of knowledge and skill which
Vitruvius expected of a Roman architect may now seem surprising, in
an age of much greater professional specialization. The Romans did
not, however, draw firm dividing lines, between an architect and an
engineer, for example. The varied application of the talents of such
Renaissance men as Michelangelo, Leonardo da Vinci and Benvenuto
Cellini was in much the same tradition. Apollodorus of Damascus had
served on Trajan's campaigns in Dacia as a military engineer, and had
constructed a timber bridge across the Danube; and the reputations of
Severus and Celer depended as much upon the mechanical marvels
which they installed in Nero's Golden House (like the revolving roof
above the main circular dining-room) as on the design of the building

itself (Suetonius, *Nero*, XXXI). Furthermore, when Vitruvius wrote that an architect should have a knowledge of geometry, history, philosophy, music, medicine, law and astronomy, this was not some fanciful aspiration to recruit academic polymaths to the profession, but was for sound practical reasons; knowledge of medicine was desirable if buildings were not to be sited in unhealthy places; knowledge of astronomy was necessary for the construction of sundials which told the right time.

Vitruvius was very keen to lay down rules, and it must be emphasized that many of them were not universally acknowledged, even at the time and place of his writing. More important, however, are the principles behind the rules, and in that respect he is a faithful representative of Roman architecture. He was much concerned, for example, with matters of proportion. By *ordinatio* (order) he defined the symmetrical agreement which parts of a building should have to the whole, achieved by the selection of particular parts as modules and the calculation of other dimensions from them. By *dispositio* (arrangement) he meant the harmonization of ground-plan, elevation and perspective, for all of which drawings were to be prepared in the course of working out the design (*De Arch.*, I. ii. 2). Subsequently, he prescribed in detail the modular proportions of columns, entablatures and the arrangement of temples of varying size and type.

It matters little that other architects chose different prescriptions, for the same approach to the principles is often discernible. The basis of the Vitruvian module was the diameter of the column shaft at base. A recent study of the Maison Carrée at Nîmes has shown that two quite different modular dimensions were employed in its design: the height of the architrave, which determined those of the whole entablature and of the podium of the temple; and the spacing of the columns, which determined the longitudinal dimensions, the height of the columns (equal to the square of the intercolumniation) and that of the frontal elevation. The column diameter was not a primary unit in this sophisticated scheme; it was equal to the difference between the two modules.[31]

Vitruvius wrote little about the training of architects, and nothing about their organization. Many must have learned and practised their trade in small family workshops: thus Cicero's architect Cyrus had a freedman, Chrysippus, who also worked for Cicero. From the early Empire onwards, with almost continuous building projects in Rome, the emperors maintained large permanent teams to work on them, mainly slaves and freedmen of the imperial household, and many probably acquired their practical experience from that source. Thirdly, the army had a regular need for architects, and military service was certainly part of Vitruvius' career. The younger Pliny, when governor of Bithynia, asked Trajan to send him an architect or surveyor to supervise the cutting of a canal near Nicomedia. He was authorized to apply to the governor of Lower Moesia, on the Danube frontier, and it is implicit that his request was to be met by the secondment of a legionary expert (Pliny, *Ep.*, X. 41–2).

On another occasion, Pliny requested that an architect be sent from Rome to help retrieve building projects in Nicaea and Claudiopolis from local ineptness. This time Trajan refused the request, with the rather unhelpful reply that Pliny could not possibly lack an architect, because skilful men were to be found in every province: 'do not think that they can be sent more quickly from Rome, since it is from Greece, after all, that they usually come here' (Pliny, *Ep.*, x. 39–40).

The comment is interesting, for there were certainly architects in the West with Greek names; and Cicero tells us that he spoke Greek with Cyrus. It must be remembered, however, that slaves and others of Greek extraction were also born in the West and given Greek names; and that much of the building work in the West before the second century AD, notably any construction in concrete, followed a Roman rather than a Greek tradition. There are exceptions: the Round Temple by the Tiber in Rome was made of Pentelic marble, without the typical Roman podium, and with Corinthian columns of purely Greek form, and must have been the work of a Greek architect and Greek masons.[32] The dramatic Augustan increase in the use of marble also involved the importation of skilled marble-workers from the East along with the material upon which they worked. Thereafter, however, the architectural current seems for a time to have flowed in the opposite direction, especially with the introduction to the East of Roman types of bath building, aqueduct and theatre construction. This must have involved the movement of architects from Italy, and an early instance is the strong Campanian influence which has been noted on Agrippa's rebuilding of the Odeion at Athens.[33]

Certainly, architects and masons might travel widely, but in the absence of written record, the confirmation that they did so depends on the evidence of work which is not only different from prevailing local convention, but can also be identified as the style of another region. Trajan ought to have been in a position to know the usual origins of architects who came to Rome, and by Greece we may take it that he meant the Greek-speaking world, not just the mainland. There

33. Basilica, Lepcis Magna. Dedicated in AD 216.

is little obvious sign of architects from this area, however, in contemporary buildings in Rome; nothing in the work of Apollodorus of Damascus betrays his origins. Later in the second century, however, the influence of Eastern architects and masons in the West becomes increasingly apparent. One such case, the Syrian features of the 'Temple of Diana' at Nîmes, has already been noted. An even more spectacular example, in its context, is the Temple of Venus and Rome which Hadrian dedicated at Rome in AD 135. It is ironic that it was this building, with its strong Eastern influences, which occasioned the Syrian Apollodorus' fatal quarrel with the Emperor. Proconnesian marble (from Marmora) was used for the superstructure, the traditional Roman podium was lacking, and the architectural ornament has a strong similarity with that of the Temple of Trajan at Pergamum.[34]

It is in the buildings with which the Emperor Septimius Severus endowed his home city of Lepcis Magna that the influence of the East is most strikingly to be seen. Proconnesian marble was used extensively, and in the absence of a native tradition in working such material, the craftsmen had to be brought from Asia Minor.[35] The layout of the forum might be entirely Western, with the temple of the imperial family on an enormous podium at one end, and a transverse basilica, but the architectural vocabulary of these Severan buildings is equally Eastern (Ill. 33). The granite columns of the temple stood on massive sculptured pedestals, never a feature of temples in the West, but common enough on such buildings as the Temple of Artemis at Ephesus. The confident arcaded entablature of the forum colonnade, the rich sculptured decoration of the pilasters in the basilica, the papyrus leaves of the column capitals, all have perfect parallels in Asia. One might add the broken half-pediments of the four-way triumphal arch, very much in the Syrian tradition, the street colonnades, and the nymphaeum, a type of building which was one of the distinctive contributions of the East to Roman architecture.

34a, b. Panoramic view of Palmyra. A: Temple of Bel. B: Temple of Ba'alshamin. (From R. Wood, *The Ruins of Palmyra*, London, 1758.)

The aggrandizement which Lepcis received as the reward for having unexpectedly nurtured a future emperor gives it a unique distinction. If we place the Severan monuments and their Eastern splendour alongside the Augustan theatre and market buildings, the aqueduct, the amphitheatre, the arches of Tiberius and Trajan, the Hadrianic and the Hunting Baths, and if we do not forget the private houses, public lavatories, fountains and tombs, then we can see in Lepcis a prism which transmits a greater part of the spectrum of Roman architectural achievement than any city in the Empire, even than Rome itself.

THE CITY CENTRE: FORUM, BASILICA AND COLONNADE

The monumental Roman town centre integrated three elements: a temple; a basilica; and the forum, an open piazza surrounded by a colonnade in front of a row of shops. The temple, centrally placed in front of one end of the forum, provided a dominant axiality; exemplified early, in the forum at Pompeii, and fully assimilated, in the fora of Caesar and Augustus at Rome. The situation of the basilica might vary. Such newly-planned North Italian cities as Velleia added symmetry to axiality, in placing the basilica broadside to the forum, opposite the temple. This type of forum was introduced to Gaul, as at Augst and St-Bertrand de Comminges, and to Britain, where the temple was normally omitted.[36] Less regular schemes persisted, notably in North Africa. In Djemila, Timgad, and the Old Forum at Lepcis Magna, a curia or further temples were added, and the plan was not always rectilinear. Even in the Severan Forum at Lepcis, so distinctively Western in the axial siting of the temple on an enormous podium, the basilica opposite was placed at a marked angle to the axis of the forum.

The basilica was one of the most influential innovations of Roman architecture, in Roman terms, and in later history, as one of the two main building types adopted by the Christian church. It was a long

covered hall, with a roof supported on columns and piers round all four sides, in most cases. It was ideally suited to any large assembly, particularly for lawsuits and commercial exchange. The axiality implicit in its length might be enhanced by the addition of apses at the ends: most magnificently, in the Basilica Ulpia which adjoined Trajan's Forum. The Severan basilica at Lepcis Magna has even more dominant apses, since the internal colonnades of the sides were not continued across the ends. The imperial audience halls of the Flavian Palatium and at Trier were entered from one end and had an apse at the other; this version of basilica, with its focal concentration, was the direct antecedent of the early Christian churches of Rome and Ravenna: the altar replaced the imperial seat.

Although the basilica was never common in the East, it was perhaps the main Roman contribution to the often haphazard arrangement of the agora, as we find at Corinth, for example. Nevertheless, the orthogonal planning of Hellenistic towns had already produced, in such cities as Miletus and Priene, the rectangular colonnaded agorai which were, in fact, the model for the fora of late Republican and early Imperial Italy. Smyrna combined the two traditions in its mid-second-century AD rectangular agora with, at one end, a very long and narrow basilica (160 × 27 metres; 525 × 90 feet). In Augustus' principate, Syria contributed the street colonnade as a further monumental aspect of the Roman city. Palmyra is its best example, though later: Hadrianic, at the earliest (Ill. 34a, b). The splendid colonnaded street from the harbour to the agora at Ephesus illustrates its rapid assimilation in Asia Minor. Timgad evokes its effect in the West.

TEMPLES

The form of the Roman temple followed the Etruscan; it was placed on a podium, or raised platform, approached by a flight of steps at one end, which led through a columnar porch to the *cella* at the back. The Roman version was influenced by Greek temple architecture to the extent that columns were added along the sides and, less often, at the ends; sometimes they were attached to the walls of the *cella*, sometimes free-standing. This version of classical temple was propagated successfully in the western provinces, and examples survive virtually intact in the Maison Carrée at Nîmes, the Temple of Augustus and Livia at Vienne (Ill. 35), and that of Rome and Augustus at Pola. Outside Italy, Roman architectural forms were applied to buildings which continued to serve the requirements of local cults. In Gaul, Germany and Britain the characteristic of the Romano-Celtic temple was a square *cella* surrounded by an ambulatory. Occasionally the plan was circular or polygonal. Columns, masonry walls, painted plaster, mosaic and statuary provided a setting which was Roman in technique and appearance, however unclassical the plan and purpose might be. At Sanxay and many other rural sites, complexes of temples, baths, theatres and ancillary buildings gave monumental expression to the continued sanctity of the site. Bath, with its classical temple dedicated to Sulis Minerva, and the Great Bath built around the thermal spring, illustrates the enormous importance of these sanctuaries, which con-

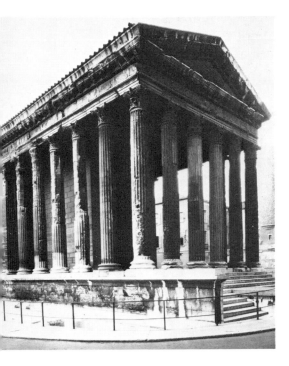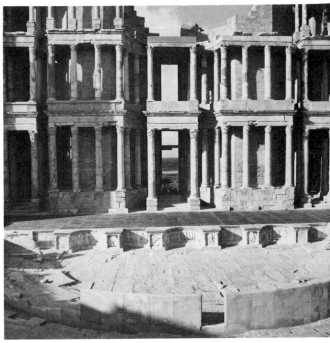

35. Temple of Augustus and Livia, Vienne. Early 1st century AD.

36. Stage building of the theatre at Sabratha. Late 2nd century AD.

tained some of the finest buildings in the western provinces.[37] The same phenomenon occurs in the East. The Sanctuary of Asclepius at Pergamum had a Roman theatre, a temple which was a small version of the Pantheon, and a vaulted rotunda with deep apses radiating from its sides. The rectangular enclosure with porticoes on three sides was built round the sacred spring of the god (Ill. 37). At Baalbek, a monumental façade gave entrance to a courtyard, at the rear of which was the enormous Temple of Jupiter, with columns 20 metres (65 feet) high. Within the courtyard, tower-like platforms provided the essential high places for sacrifice. However much they were dwarfed by the surrounding buildings, these platforms, like the spring at Pergamum, were the real focal points of the sanctuaries.

FOUNTAINS, THEATRES AND AMPHITHEATRES

While architects in the West explored the new possibilities which could be achieved in concrete, those in the East experimented with new combinations of the existing architectural forms and traditional materials. One result was the development of a highly baroque façade architecture, with superimposed tiers of projections and re-entrants decorated with columns, entablatures, pediments and statuary. This is seen to greatest effect in the nymphaea, enormous ornamental fountains like that of Miletus or Herodes Atticus' nymphaeum at Olympia, in the façade of the libraries of Celsus at Ephesus and of Hadrian at Athens, and especially in the stage buildings of theatres. Whether in new buildings, as at Aspendos, or in existing Greek theatres converted to Roman form, the emphasis of the Eastern versions of these permanent architectural stage sets remained predominantly rectilinear.

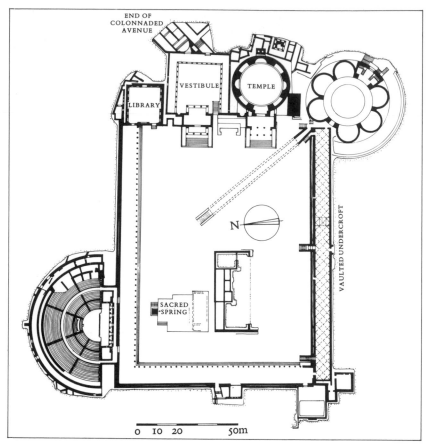

END OF
COLONNADED
AVENUE

VESTIBULE TEMPLE

LIBRARY

N

VAULTED UNDERCROFT

SACRED
SPRING

0 10 20 50m

37. Plan of the
Sanctuary of Asclepius,
Pergamum. c.AD 140–75.

The curved recesses in the façade which were more favoured in the
West have splendid examples at Lepcis Magna and Sabratha
(Ill. 36). The other main feature which distinguished the Roman
theatre from the Greek was that the orchestra was semicircular. The
cavea of the seating might still, where the local topography admitted,
be cut into a hillside. In such a case the opportunity for external
decoration was limited, as the very plain street frontage of the theatre
at Orange shows. Where the *cavea* was built on a series of radial
concrete vaults, the external arches were enlivened by attached col-
umns and horizontal mouldings. It was natural, in view of the similar-
ity in construction and curved exterior, that the same decorative
treatment should have been given to the amphitheatre (Ill. 21). That
was one Roman building type which never became established in the
East: that at Pergamum is one of the few known examples.

Amphitheatres with masonry vaulting are among the most sub-
stantial remains of Roman architecture in the West. Those at Verona,
Pola, Nîmes, Arles and El Djem, despite minor variations in planning
and decorative treatment, are all direct descendants of the type de-
veloped in central Italy. Some early amphitheatres, like those at
Mérida and Syracuse, were partially dug into the ground, and in
Britain, at Cirencester and Caerleon, for example, the wooden seating
was carried on earth banks with stone retaining walls. In northern

France and in Britain (at Verulamium for example) a distinctive Romano-Gallic type of theatre is found, which had a small stage building and an orchestra or arena which was almost circular.[38] Some amphitheatres have underground chambers beneath the arena to house men, beasts or materials for the spectacles; these are found in relatively simple form at Pozzuoli, El Djem, Sarmizegetusa in Romania and Mérida in Spain, and as a veritable labyrinth in the Colosseum.

BATHS

The Roman bath-building, which appears first to have taken its characteristic form in Campania, was a leading influence in the development of concrete construction. The range of variation, both in size and layout, is enormous, running from such vast recreation centres as the Baths of Caracalla (Ill. 38) and Diocletian in Rome, with their libraries, meeting halls, swimming pools, gardens and fountains, down to the domestic bath suites which provided the basic requirements of a cold, a warm and a hot room: *frigidarium*, *tepidarium* and *caldarium*. A keynote of the great public baths was their symmetrical planning around an axis which ran from the main entrance, across the *palaestra*, or exercise courtyard, and through the centre of the principal *frigidarium* and *caldarium*. The early fourth-century Imperial Baths at Trier (Ill. 39) stand at the end of a line which stretches back at least as far as the Baths of Titus in Rome, and which finds other provincial examples in the Hadrianic Baths at Lepcis Magna, the Antonine Baths at Carthage, and those of Timgad and Ephesus. The interiors were sumptuously decorated with mosaic floors, marble columns and veneers, and vaulted ceilings, though in contrast the exterior was usually completely unadorned.

The Hunting Baths at Lepcis Magna, well known for the stark roofline of their concrete vaults, which survive complete, illustrate one of the many more informal arrangements of rooms. In the Forum and Stabian Baths at Pompeii and the Suburban Baths at Herculaneum, a simple range of rooms adjoined a *palaestra* secluded behind the shops on the street frontage. As at Lepcis, the vaulting is intact; much of the stucco decoration is preserved (Ill. 14). We see the attractive but modest surroundings of everyday-life in an ordinary Roman town.

The baths were a notable Roman introduction to the East, where they were combined with the established functions of the hellenistic *gymnasium*. A distinctive feature of public baths in such cities as Ephesus and Pergamum is a large rectangular room fronting the *palaestra*, its walls decorated internally with columns and statuary in the manner of the theatre and nymphaeum façades. In many western provincial towns, the baths were second only to the forum and basilica in architectural importance, and notable bath buildings are also a feature of rural religious sanctuaries in Gaul. The city of Bath was also an important sanctuary, and unique in Britain in having, in addition to the normal bath suites, a great vaulted hall which covered the rectangular pool fed by the sacred thermal springs.

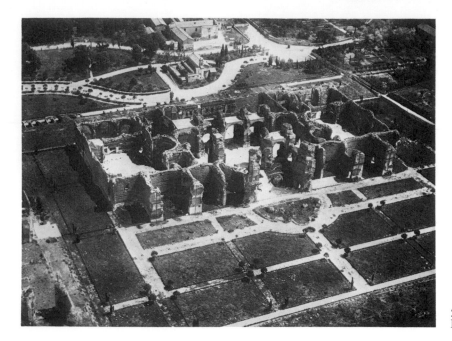

38. Baths of Caracalla,
Rome. AD 212–16.

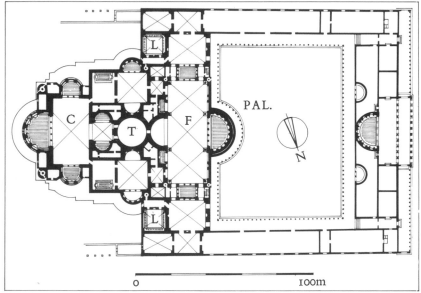

39. Plan of the
Imperial Baths, Trier.
Early 4th century AD.
C - *caldarium*; T - *tepidarium*;
F - *frigidarium*; L - lavatory;
PAL. - *palaestra*.

ARCHES, GATES AND FORTS

Among the most solidly preserved of all Roman architectural inventions are the monumental arches, buildings of a type devised purely for display. This conversion to monumental form of the temporary structures erected for the occasion of military triumphs in Rome is yet another instance of rapid evolution in Augustan architecture. The main arch passage, and any side passages, as on Trajan's Arch at Timgad and that of Septimius Severus in Rome, was flanked by columns, usually in pairs. The intervening spaces might contain *aediculae* or relief sculpture relevant to the arch's commemorative purpose,

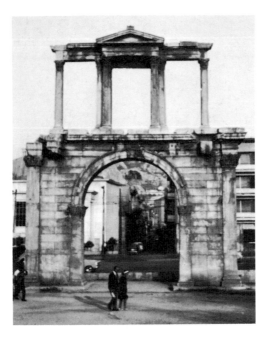

40. Arch of Hadrian,
Athens. Probably erected
shortly after AD 138.

as on Trajan's Arch at Benevento (Ill. 20) and the Arch at Orange.
That purpose was made explicit by a prominent inscription on the
attic storey above the archway. The whole was surmounted by groups
of sculpture, usually in bronze.

The arched gate through a city wall might take much the same
form, but its function required that it should have guard chambers at
the sides, often contained in projecting towers, and a gallery above, to
allow passage across the gateway. The window openings in the gallery
might be given additional architectural distinction by schemes of
engaged pilasters or columns, with pediments, as on the Porta dei
Borsari at Verona (Ill. 19), or with a continuous entablature, as on the
gates of Nîmes and Autun.

Hadrian's Arch at Athens, which led from the old city to the new
quarter, is unusual in the combination of its decorative elements
(Ill. 40). The columns and pilasters of its upper storey do not continue
the vertical lines of the pilasters which flanked the archway below,
which were taken up by the statuary which stood in the openings of the
upper storey. Some second-century and later arches and gates were
highly elaborate, with a façade architecture of niched figures framed
by luxuriantly decorated pilasters, as on the Porte Noir at Besançon
and the London Arch.[39] In contrast, the Porta Nigra at Trier, with
quadruple tiers of regularly-spaced columns framing arched openings,
is reminiscent of the exteriors of theatres and amphitheatres. The
Porta Aurea of Diocletian's Palace at Split, with arcaded entablatures
above the entrance, owed more to the traditions of the East, as is
emphasized by the great arcades and the Syrian pediment of the
ceremonial courtyard within.

There is a clear military influence in the Palace's massive four-
square walls, external towers, and the T-junction formed by its colon-

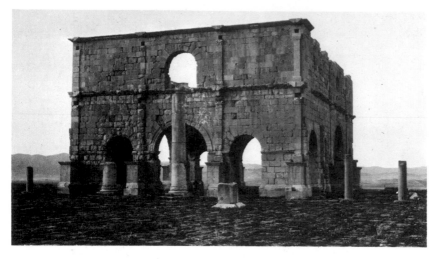

41. *Praetorium*, Lambaesis. Early 2nd century AD.

naded streets. Colonnades, and the peristyles of officers' houses in military forts, were derived from what was familiar in civilian building. The plan of the headquarters, with its courtyard and basilican hall, evolved in parallel with the north Italian and Gaulish forum which it so much resembles.[40] The decoration of the most important buildings in some legionary fortresses, like Neuss and Lambaesis (Ill. 41), gave them some architectural distinction. Hadrian's Wall, by contrast, had the solid unembellished serviceability which characterized much military building.[41]

PRIVATE HOUSES

The traditional Italian town house, with rooms arranged around the *atrium*, a hall with a rectangular opening in the roof to provide the main source of light, was not of much significance in the provinces (Ill. 42). The dominant note in much domestic architecture was provided by the Hellenistic peristyle courtyard, which was an additional feature of the larger *atrium* houses of Pompeii and Herculaneum. Vaison, in Gaul, provides an illustration of what was to be found in many provincial towns (Ill. 43). A peristyle layout might also be a feature of rural villas, as at Sette Finestre (Ill. 27), at Fishbourne, and in the palatial fourth-century villa at Montmaurin, where the approach lay through a great semicircular courtyard. Characteristic of the north-western provinces was a colonnaded façade with a projecting wing at each end. Buildings of this type range from the relatively humble winged-corridor villas with half a dozen rooms to such great aristocratic country houses as those of Nennig and Otrang. Mosaics from Tabarka in Tunisia show a variation which has towers at the ends and an arcaded gallery running between them. Tacitus describes how, after the Roman conquest, Britons were encouraged to build temples, fora and houses (*Agricola*, XXI). The rural villa, in all its variety, with its mosaics, painted wall-plaster, columns and baths, shows how widespread was the adoption by western provincials of the Roman manner of living.

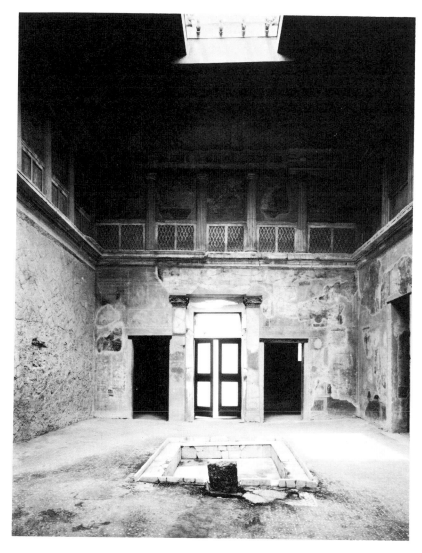

42. Atrium of the
Samnite House,
Herculaneum, showing
Style I decoration. 2nd
century BC.

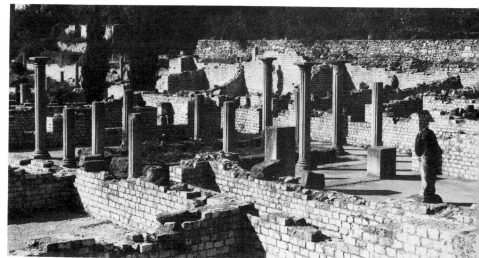

43. Peristyle of the
House of the Silver Bust,
Vaison-la-Romaine. Later
1st century AD.

The planning of many of these buildings shows an almost Palladian regard for symmetrical arrangement and axiality. At Fishbourne, this was enhanced by the formal layout of hedges and shrubs in the garden enclosed by the four wings of the palace, imposing a man-made order upon nature. Elsewhere, garden pavilions like the so-called Temple of Minerva Medica in the Licinian Gardens at Rome provided architectural counterpoint to the informality of their surroundings. The landscape setting of villas like Chedworth in Gloucestershire was carefully chosen, frequently the fold of a hillside overlooking a valley. Such was the situation of the villa of Piazza Armerina in Sicily, built early in the fourth century for some great landowner.[42] It is remarkable for the ingenuity of its design, with its varied combinations of curved and rectilinear elements in the rooms and courtyards, changes of floor level, and the several different axes of its component parts. Here, luxury and studied informality provided an ideal setting for aristocratic relaxation.

FUNERAL MONUMENTS

The commemoration of the dead provided almost limitless opportunity for the varied architectural treatment of funeral monuments. In the Vatican necropolis beneath St Peter's at Rome, and in the Isola Sacra cemetery outside Ostia, houses of the dead erected on family

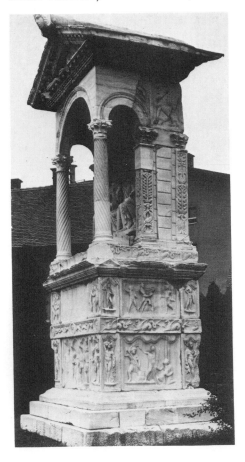

44. Funeral monument of C. Spectatius Priscianus, Šempeter (Celeia). Early 2nd century AD.

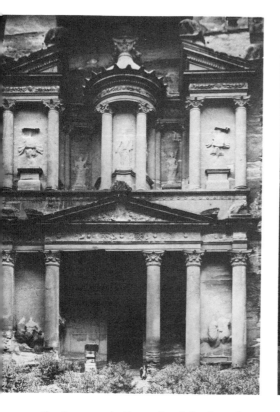

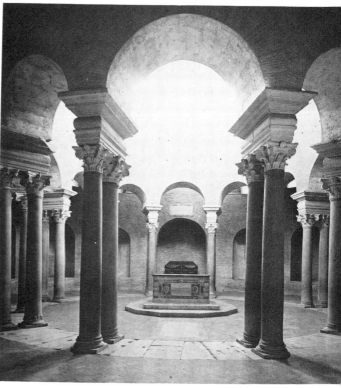

45. Rock-cut tomb, Petra (the Khasne).
1st century BC.

46. Mausoleum of Constantina (now the church of Santa Costanza), Rome. Second quarter of 4th century AD.

burial plots fronted the streets in the same way as the houses of the living. The Tomb of Annia Regilla (Ill. 28) and the building shown on one of the reliefs from the Tomb of the Haterii (Ill. 79) were decorated in a manner which does indeed have its counterparts in domestic architecture (see above, p. 43). The pedimented *aedicula* sheltering relief carvings of the deceased was also common in Italy and the western provinces (Ill. 44). Both in the East and in the West, there are varied examples of free-standing towers decorated with sculpture and attached columns or pilasters; they include those outside Palmyra, the 'Tomb of Absalom' at Jerusalem, the 'Tomb of the Scipios' near Tarragona, the Monument of the Julii at Glanum and the Igel Monument in Germany. The rock-cut façades of the tombs at Petra are the most remarkable illustrations of the baroque tendencies of Roman architecture in the East (Ill. 45).[43] Possibly the most important tomb type was the circular or polygonal centrally-planned mausoleum. It is represented at its grandest by those of Augustus and Hadrian (now the Castel Sant' Angelo), both in Rome, and that of Diocletian at Split. Its significance is perfectly illustrated by what was the mausoleum and is now the church of Santa Costanza in Rome (Ill. 46; see Chapter 12, p. 248), for it was this type of building which was adopted by the Christian church as the model for western baptisteries and Byzantine churches. At Ravenna, the Mausoleum of the Gothic king Theodoric, the Neonian and Arian baptisteries, and the brick-built basilican churches, show both the continuity of Roman architecture's finest traditions, and their adaptation to the needs of a new age.

Sculpture
ANTHONY BONANNO

In the historiography of ancient art, the essence of Roman art is a much discussed problem. In the past, largely as a result of Winckel-mann's idealization of Greek classic sculpture, Roman art was considered an extension in time and space of the Greek and by some even a debased version of it. Others have tried to evaluate it as an independent art with its own distinguishing features and original contributions. Most of this debate has centred on sculpture, since architecture and painting present different sets of problems. The structural elements of Roman architecture are funda-mentally different from those of Greek architecture, and the Greek orders are mostly borrowed for embellishment; our knowledge of Greek painting is extremely limited, due to the loss of practically all the Greek originals, and is based on Roman versions and Greek vase-painting. Roman sculpture, however, is essentially hybrid and its character is quite impossible to define. Several stylistic trends, the product of diverse social and ethnic strata, contributed towards the formation of a multi-faceted corpus of artistic manifestations.

Within the metropolis itself a clear distinction can be made between upper-class or patrician taste and the indigenous Central-Italic tradi-tions associated with the middle-class and plebeians. The former was cultivated in the Greek manner, characterized by such works of art as the relief sculpture of the Ara Pacis and the portraits of the Emperor Hadrian. The latter manifested themselves in the funerary portraiture of the late Republic and in such works as the frieze on the tomb of the baker Eurysaces.

The encounter of classical civilization with different native artistic traditions, started by Alexander's conquests, continued on a larger scale and with greater intensity in the Empire. This produced such essentially diverse artistic expressions as the 'Gallo-Roman' lion of Chalon-sur-Saône, with its strong Celtic component (Ill. 47), the puppet-like figures in the relief on the Arch of Augustus at Susa, and the hieratic, rigidly frontal funerary sculptures of Palmyra.

In Asia the tradition of the great Hellenistic schools of sculpture prepared the soil for a great development in plastic art. The new centres of production operating in the regions of the old Hellenistic ones held fast to the rationality and naturalism of traditional Greek art. Aphrodisias was one of the most productive centres, favoured by the presence of quarries of white marble of the finest quality. Works

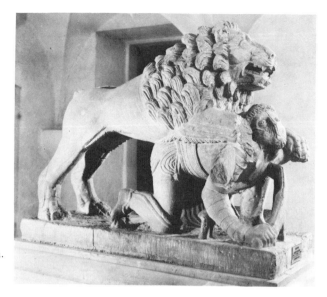

47. Statue group of a lion assailing a gladiator. Limestone. Height 110 cm. 1st century AD. Chalon-sur-Saône, Musée Denon.

signed by Aphrodisian sculptors have been discovered in Greece, Rome and North Africa. Further to the East, namely in Parthian art, the Graeco-Roman influence is manifest in dress and general typology, but the style is oriental in its undeviating frontality, flatness of relief and hieratic composition (Ill. 48). The representation is analytical, symbolical an decorative.[1]

Turning to the northern provinces of Europe, we pass from a part of the world where classical culture had long been established to one where it was new and alien. The architectural sculpture of Gallia Narbonensis was imbued with Hellenism already in the first century AD (Ill. 49), but it is not certain whether this was due to a pre-existing Greek tradition or to the strong Hellenistic component in Roman imperial art.[2] Under Trajan, new relations were established with these

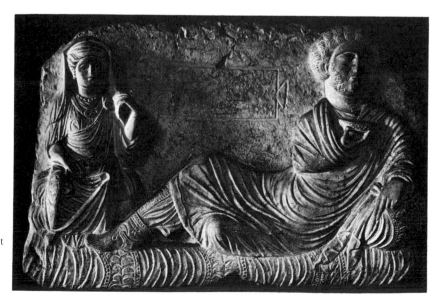

48. Funerary relief from Palmyra with reclining deceased and sitting consort. Limestone. Height 43 cm. Mid–2nd century AD. Paris, Musée du Louvre.

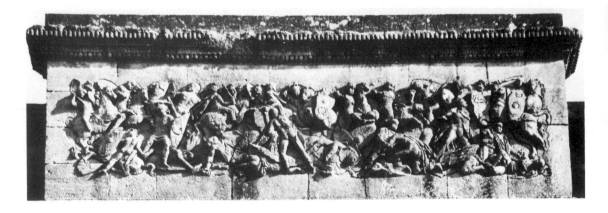

provinces and Roman influence became deeper and more extensive in Spain, Gaul and Germany. In the peripheral regions inhabited by barbarians it hardly managed to penetrate. The helical frieze of Trajan's Column is in complete contrast with his Trophy at Adamklissi (Ill. 50).[3] Both were set up to celebrate the Dacian victories but one is the product of Roman metropolitan art, the other of barbarian provincial taste. The fifty-four metopes of the Trophy, carved in local limestone by sculptors of provincial training, reveal a lack of experience in figurative representation, inorganic structure and a naive idiom that remains detached from the classical current.

The African provinces have yielded sculpture that is, in many aspects, of Roman official character and exhibits traditionally classical features. Much of it is imported even if carved on the site, the work of foreign artists. Excellent examples have been found in Volubilis, Cuicul (Chercel) and Lepcis Magna. This phenomenon is very probably due to the absence of an indigenous culture which was strong enough to influence the process of romanization. The Berbers lacked real artistic traditions, and Punic influences are only apparent in a few works of a religious nature.

The origins of Roman sculpture have already been discussed in Chapter 1. The main problem arises from the contrast between the written evidence we have of the existence of several pieces of sculpture, including honorific statues, in public places in Rome in the second century BC and before (Pliny, *NH*, XXXIV. 15, 20–34), and the fact that not one of these sculptures survives today. The only masterpiece of portraiture dated to the third century BC which appears to contain the hallmarks of the Roman character, the Capitoline bronze head of 'Brutus', has been variously attributed to Etruria and, more recently, to Central Italy. Central-Italic is a newly identified artistic *koine* under which have been grouped several sculptures mostly in local stone and terracotta datable to the third and second centuries BC.[4] It was influenced in varying degrees, both iconographically and stylistically, by Greek Hellenistic art, but its artistic idiom was inspired by the austerity and uncouth character of the rustic mountain communities. Its development was located in the central part of the Italian peninsula, the regions occupied by the Apulians, Picentenes, Campanians,

49. North frieze on the attic of the Arch of Tiberius at Orange, with battle scene. Limestone. Height 150 cm. *c*.AD 25.

50. Battle between a Roman soldier and barbarians. Metope from the Trajanic Trophy at Adamklissi. Limestone. Width 116 cm. *c*.AD. 110. Adamklissi, Museum.

Samnites and Latins. Workshops employing this style must have existed in Rome itself. Examples of this art are the statue of Orpheus surrounded by animals discovered near Porta Tiburtina (Ill. 51) and the sculptural fragments from the tomb of the Flute-Players on the Esquiline. The iconography of the Orpheus is typically Hellenistic, but the naturalistic forms are marred by lumpy modelling and lack of refinement.

Only from Trajan's time onwards can one really speak of a truly new, basically 'Roman' art, as distinct from Greek and Etruscan art, and apart from sporadic manifestations of local genius. Only then, as Hellenistic eclecticism gradually disappeared, did Roman monumental art start to follow its own independent path. The sculpture of the first century BC and first century AD, barring certain classes of portraiture, had been overwhelmed by the influence of Greek sculpture either directly from the Hellenistic centres or indirectly from Etruscan and South-Italian Greek art. This was largely the result of an intense desire to possess Greek originals or at least faithful copies which almost became a mania amongst Romans of the upper- and middle-classes in the last two centuries BC.

Between the third and first centuries BC Rome subjugated and annexed the whole of the Greek world as well as most of the Hellenized East. The Greeks in Magna Graecia, Sicily and Greece itself enjoyed a much more advanced civilization than the Romans, and their new masters did not hesitate to assimilate it and make it their own. Thus the Roman victors carried to Rome as war booty the works of art of the captured Greek cities and placed them in their temples and public buildings as well as in their private palaces. When this immense source of Greek art was exhausted, the need of the Roman middle-classes to possess similar works of art made it necessary to reproduce these originals in copies. These reproductions naturally differed in quality according to the abilities of the copyists. Soon variations on the original themes were introduced and changing tastes and new sculptural techniques also left their marks on the copies.

The fusion of Greek and Roman culture resulted in the adoption by Roman religion of the Greek pantheon and its iconography. Thus the iconography of the Greek Zeus was adopted for the Roman Jupiter, Athena became Minerva, and Mercury assumed the attributes of the Greek messenger of the gods, Hermes.

Judging from the quantity of sculptures found during excavations or fished up from the sea (for example from the shipwrecks of Mahdia on the Tunisian coast, and at the Piraeus), the export to Rome of Neo-Attic works of art must have been enormous. The Neo-Attic school flourished in Athens in the second half of the second century BC. Pliny (*NH*, XXXIV. 52) dates its origin around 150 BC. It specialized in copies and re-elaborations of well-known classical masterpieces and in refined ornamental works, such as sculptured marble vases and candelabra.

Pasiteles and his pupils, together with other Greek sculptors (mostly known only by name) such as Archesilaos, Evander, Glykon and Apollonios, were the chief representatives of the Neo-Attic school in

51. Statue group of Orpheus surrounded by animals. Peperino. Height 90 cm. End of 2nd century BC. Rome, Palazzo dei Conservatori.

52. 'Orestes and Electra'.
Marble statue group. Height
150 cm. Late 1st century BC.
Naples, Museo Nazionale.

Rome itself at the end of the Republic. Their principal characteristic
was eclecticism (see page 9). The eclectic and academic tendencies of
the school of Pasiteles are recognized in numerous works, including the
group of Orestes and Electra in the Museo Nazionale of Naples (Ill.
52).

One of the fundamental elements of the formation of a new, Roman
art was the search for optical effects of light and shade. They had
begun to permeate Roman sculpture by the time of Claudius and
became an essential stylistic trait under the Flavians. Both this optical
illusion and the quest for motion and deepened space in relief sculp-
ture were not unknown in Hellenistic art, but in Roman sculpture they
constituted two determinant factors in giving it its own independent
identity. The exploration of optical effects ('Impressionism') reached
its apogee under the Antonines and Severans. There followed a total
break with the basic, rational and humanistic tenets of classical Greek
sculpture and the triumph of the abstract, transcendental view of
reality of Late Antiquity.

State and Private Sponsorship. Sculptural monuments in the Roman
repertory were either commissioned by the State or sponsored pri-
vately by individuals, families or groups. During the Republic it is far
from easy to draw a separating line between the two. Any cult statue
commissioned by a consul or general for a temple or public place was
set up to advance the reputation of that state official as much as to

commemorate a historical event of national importance, such as a victory. The few surviving historical reliefs of this period, such as that on the monument of Aemilius Paullus in Delphi and the reliefs from the 'Altar of Domitius Ahenobarbus', had the same dual purpose though the medium was much more direct and explicit. After all, such works of art could be paid for and set up in public and religious places because of the position held by the official commissioning them. Similarly, although Republican statesmen intended their individual portraits to enhance their own personal status it is hard to explain the proliferation of copies of these portraits in different parts of the Empire except as the result of official political influence.

From the time of Augustus onwards, with some anticipation during the dictatorship of Caesar, the Emperor and the State became synonymous. Whatever monument was set up to propagate the idea of the power of Rome (be it a frieze, statue, or sculptured arch), it was in some way linked to the name and image of the ruling Emperor or his family. A portrait of the Emperor (or of a close member of his family) or a relief celebrating his achievements also served to assert Rome's central and omnipresent power and the Empire's invulnerability to outside forces.

All Roman sculpture which does not fall under any of the categories mentioned above can be considered to be the result of private sponsorship. Prominent among these are the portraits, whether busts or statues, of private individuals, funerary sculpture including sarcophagi, and miniature statuary, both in stone and in bronze. This type of sculpture was intended for private use, whether it was purely decorative, religious or even commemorative.

Historical Reliefs. Historical, or commemorative, reliefs were set up to commemorate specific events or achievements of Roman statesmen. They invariably formed part of monuments, mostly architectural, commissioned either by the protagonists of the historical events or by some official body in their honour and that of the Roman people. The Greeks had used this art-form to celebrate important historical landmarks, but they preferred to hide the factual element under the veil of myth or allegory. Thus in the fifth century in order to celebrate the victory of the Greeks over the Persians traditional and legendary themes were chosen, such as the Amazonomachy, Centauromachy and Gigantomachy.

Roman commemorative reliefs, therefore, as factual representations of historical events, did not have predecessors in Greek art. On the other hand, battle-scenes from the history of Central Italy are found in Etruscan art (see Chapter 1, page 24), though only in painting not in sculptural relief. From the third century BC onwards there is evidence of the existence in Rome itself of paintings illustrating episodes from war campaigns, the so-called 'Triumphal Paintings' (Livy, XXIV. 16; XLI. 28; Pliny, *NH*, XXXV. 22, 23, 135; Josephus, *Bellum Judaicum*, VII. 139–52; Festus, *De Verborum Significatione* (ed. C. O. Müller, Leipzig, 1880) p. 209; Appian, VIII. 66). These were displayed in triumphal processions and exhibited in public places.

Perhaps the famous fragmentary painting from a tomb on the Esquiline showing military scenes (Plate 1) was inspired by these paintings, none of which have survived.[5]

Whether these triumphal paintings gave rise to, or somehow influenced, the development of Roman commemorative reliefs has not been established. It is certain, however, that both testify to the same sense of history and to the Romans' deep-rooted passion for factual detail. It is perhaps not a coincidence that the first surviving historical relief illustrates such a war episode and that it was erected by L. Aemilius Paullus, the man who asked the Athenians for a painter to commemorate his victory over the Macedonian king, Perseus (Pliny, *NH*, XXXV. 135).

This relief consists of a long frieze running round the top of a tall rectangular pillar supporting an equestrian statue of Aemilius Paullus which stood close to the temple of Apollo at Delphi. In four scenes, distributed on the long and short sides of the pillar, the relief shows episodes from the battle of Pydna (168 BC). The theme and the composition of the *mêlée* against a neutral background are essentially Hellenistic and have much in common with the 'Alexander Sarcophagus' from Sidon. Together with the style and technique of the carving they suggest that the relief was designed and sculpted by a Greek or Hellenistic artist. It is hard to conceive of a Roman artist producing anything of this standard either in the second century BC or for a long time afterwards. It has been suggested that one of the horsemen should be identified with Paullus himself.[6] If so, this is the first extant Roman portrait in relief.

The earliest historical relief from Rome itself is that belonging to the so-called 'Altar of Domitius Ahenobarbus', now in the Louvre. It was found in Rome in the seventeenth century together with a frieze representing the marriage of Poseidon and Amphitrite with a retinue of Tritons and Nereids (now in Munich). Both reliefs belonged to the same monument, now thought to be the base for a group of statues in a temple (perhaps the temple of Neptune *in circo Flaminio*) rather than an altar. The connection with the Domitii family has now been dropped.[7]

The subject of the Louvre relief (Ill. 53) is a census, on the left, combined with a *suovetaurilia* (the sacrifice of a pig, sheep and bull), on the right. The presence of soldiers on both sides and of the god Mars in the centre suggests a censorial *lustrum* made in connection with the enrolment or disbanding of troops. The naval connotation of the

53. Census and *lustrum*. Frieze from the so-called 'Altar of Domitius Ahenobarbus'. Marble. Height 82 cm., width 559 cm. *c.* 100 BC. Paris, Musée du Louvre.

54. Marine *thiasos*.
Frieze from the so-called
'Altar of Domitius
Ahenobarbus'. Marble.
Height 78 cm., width
559 cm. *c.*100 BC.
Munich, Glyptothek.

marine *thiasos* in Munich (Ill. 54) suggests that the sacrificing priest of
the Louvre frieze may be Marcus Antonius, the orator, who was
entrusted with the reorganization of the fleet for a campaign against
the pirates. This he did successfully and celebrated a triumph. He was
later elected censor in 97 BC and the reliefs are thought to date from
around that time.

There is a remarkable difference in both content and form between
the two friezes. The Louvre relief depicts a typically Roman event in
factual, typically Roman, fashion. The Munich relief, on the other
hand, portrays a Greek mythological subject in the conventional late-
Hellenistic style. The composition is symmetrical on both reliefs, but
the *lustrum* scene, in contrast to the other, is broken up in paratactic
groups without any real link between them. The execution of the
stocky figures is unskilful and clumsy. The proportions of the various
parts of the bodies and the relations of the figures to one another and to
the animals are far from naturalistic.

The co-existence of two distinct languages of imagery and style on
the same monument appears to be typical of the Roman insensibility
to the jarring incoherence often produced by such combinations.
Similar antithetical arrangements occur repeatedly in later sculptured
monuments.

One of the earliest of such monuments is the Ara Pacis, the monu-
mental altar voted by the Senate to celebrate Augustus' return from
Spain and Gaul in 13 BC and the peace that followed the civil wars. [8]
The altar stood in a walled enclosure with two entrances. The lack of
uniformity in the relief-decoration of the altar, however, lies neither
in the quality of the sculpture, which is executed to the highest
standards, nor in the style and technique, but in the subject-matter
itself. The four panels flanking the entrances show purely allegorical
or mythological scenes heavily influenced by the landscape reliefs of
Hellenistic art. Together with the rich floral decoration both on the
inner surfaces of the enclosure and on the lower dado of the outside,
the same monument has a long frieze depicting a Roman historical
subject. This is a procession of Roman officials, priests and members of
the imperial house (Ill. 55) including the Emperor Augustus himself.
It is generally agreed that this procession is the very one which took

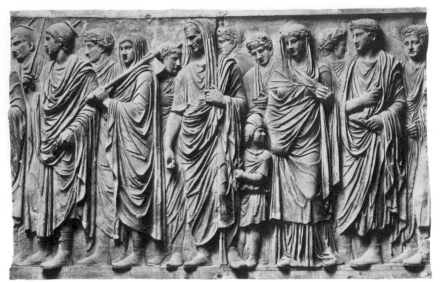

55. Procession of priests and members of the imperial family. Detail from the south side of the frieze of the Ara Pacis Augustae. Marble. Height (frieze only) 55 cm., width of entire frieze 10.16 m. 13–9 BC. Rome.

place on the day of the consecration of the altar site, 4 July 13 BC (*Res Gestae*, XII. 2; *CIL* 12. 244, 247, 320). Thus a specific event of contemporary history is recorded with anecdotal detail in three-dimensional relief and the participants of that same even are skilfully portrayed.

The classical character of the frieze with its elegant simplicity and clarity of style is certainly due to the design and execution of Greek sculptors, whose art had now found favour with official state patrons. They belonged to that late Hellenistic artistic current, the Neo-Attic movement, which looked back to the traditional classical models of the fifth and fourth centuries BC. It is in fact on a fifth-century Athenian monument that this processional frieze is modelled: the Panathenaic procession depicted on the Parthenon. On the Ara Pacis, as in the Athenian frieze, the procession is made to travel in the same direction along the two sides of the building. The two sections of the procession were envisaged as meeting at the main entrance on the west front.

Though we observe the same paratactic arrangement of the figures as in previous reliefs of Roman pedigree, such as the *lustrum* in the Louvre and the frieze showing a triumphal procession from the temple of Apollo *in campo*, here the figures are disposed on two, rarely on three, planes of relief.

The date of the frieze decorating the internal entablature of the Basilica Aemilia in the Roman Forum is uncertain. Stylistically it seems to fit in the restoration of that building of 55–33 BC, or even the Tiberian restoration of AD 22. The frieze does not fall strictly within our definition of historical reliefs since it does not portray instances of contemporary or quasi-contemporary history, but recalls episodes from the legendary origins of Rome (for example, the Punishment of Tarpeia and the Rape of the Sabine Women).

Of the several commemorative reliefs produced in the first century AD, the Frieze of the Vicomagistri (Ill. 56)[9] deserves a special mention because, like the Severan Arch of the Argentarii, it must have

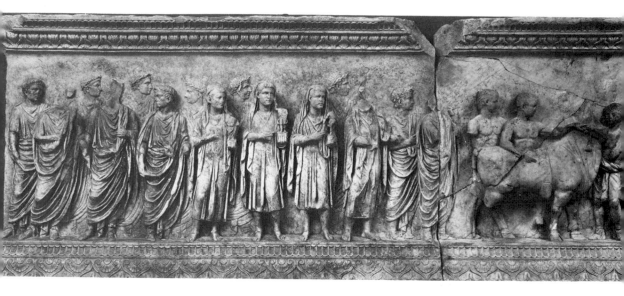

56. Frieze of the Vicomagistri. Procession of street wardens, youths carrying the *lares*, sacrificial animals, musicians and lictors. Marble. Height (entire frieze) 105 cm., width 472 cm. Mid-1st century AD. Vatican, Museo Gregoriano Profano.

been privately commissioned, even though in this case the sponsors were themselves city magistrates. What survives is only one side of a rectangular monument, perhaps an altar. Altars of a similar type, but smaller in size, appear to have been often commissioned by such street wardens and examples are found in various museums.

The frieze, which from the style and facial type of the figures appears to be datable to the late Julio-Claudian period, shows a procession of magistrates, priests and *camilli* together with three sacrificial victims and their attendants. The figures are rather stocky and one of the surviving heads of the magistrates has all the requisites of portraiture and is very representative of the homely, plebeian Italic character of the *vicomagistri*, who were normally of freedman status.

Unlike those of the Ara Pacis, the figures are given some free space above their heads, and some background figures are raised on higher levels than the foreground ones while their feet are kept on the same level. This can only be interpreted as a naive attempt to give an illusion of spatial depth. The break from the neo-classical convention of isocephalism (i.e. heads on the same level) is here complete and heralds the increasing mastery of space in later historical reliefs. But the problems created by such a novelty were not solved logically and naturalistically until the reliefs on the Arch of Titus and the Column of Trajan were carved, since not even the designer of frieze B of the Flavian Cancelleria reliefs succeeded in eliminating such anomalies.[10]

The affinity to the less Hellenized composition and formal treatment of the late Republican *lustrum* relief in the Louvre has caused the Vicomagistri frieze to be regarded as another example of plebeian art: in part a reaction against the official style of the court and in part derivative from it. In many of its aspects, especially the stockily proportioned figures, plebian art continued to be employed – for instance in the narrow attic friezes of the triumphal arches of Titus, Trajan and Septimius Severus – until it flowed into the mainstream of

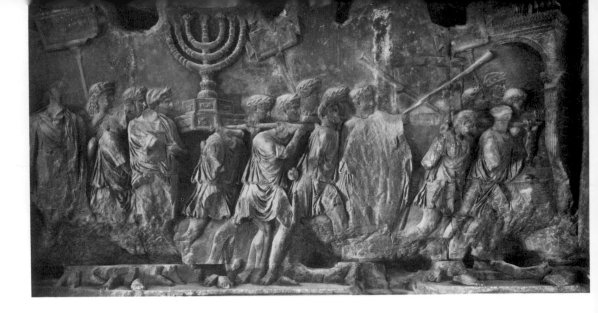

officially recognized and officially sponsored art in the fourth-century reliefs of the Arch of Constantine.

Since the beginning of this century, the two relief panels, one on either side of the passageway of the Arch of Titus, have been the centre of gravity of Roman art history. They assumed this important role when Wickhoff, in his introduction to the *Vienna Genesis*, discovered in them the culmination of one of Roman sculpture's most original achievements, 'spatial illusionism'.[11] The two panels show two successive moments of a triumphal procession. The triumph is that celebrated by Titus in AD 71. after his victory over Judaea and the capture of Jerusalem the previous year. One panel shows Titus on a chariot preceded by a crowd of lictors; the other (Ill. 57) shows the spoils from the temple of Jerusalem.[12]

The illusion of space produced in the two reliefs, together with the pictorial qualities of contemporary Flavian portraiture, is the first full-blooded expression of Roman 'impressionism'; in the view of many, a basically new concept of visual interpretation. The problem of representing human forms bathed in air and light is here resolved. The thick, fast-moving, human crowd is organically related to the background. The illusion of depth and space is enhanced by the spoils of the temple, the *tituli* and the fasces, which stand out of, or merge into, the open ground above the participants. The figures recede gradually into the background through four different planes of relief. Only in a limited area are the heads made to rise step-wise on three levels. Furthermore, the background of both panels is made to curve slightly inwards from sides to centre, while the figures stand out progressively in higher relief the nearer they are to the centre. Thus the spectator standing in the passageway between the two reliefs is given the impression of a direct experience, of physical participation in the triumphal procession.

Trajan's reign is the richest in monumental relief sculpture. Two of these monuments, the historiated Column and the Great Frieze (which now, separated into four panels, embellishes the Arch of

57. The triumphal procession of Titus carrying the spoils from the temple of Jerusalem. Relief panel on the south side of the gateway of the Arch of Titus. Marble. Height of panel 204 cm., width 385 cm. AD 80–5. Rome.

Constantine) adorned the Forum of Trajan in Rome. The third is the arch at Beneventum, the sculpture of which falls into three groups: the panels on the side facing Beneventum, and therefore Rome, show events of Trajan's reign connected with Rome; those facing the countryside show events connected with the provinces (Ill. 58); and the panels in the passageway those concerned with Beneventum itself.[13] In these reliefs the cartoonist follows closely on the lines of the master of the Arch of Titus in his quest for the illusion of space, and the figures remain more or less on the same level, though carved at different depths of relief. They carry a range of good portraits both of the Emperor and of other important officials, amongst whom Trajan's successor, Hadrian, has been identified.

The Column of Trajan was designed to form an integral part and focal point of that magnificent architectural programme that was the Forum of Trajan. It stood behind the Basilica Ulpia and was flanked by the two famous libraries, the Greek and the Latin, from which one enjoyed a better view of the upper courses of the relief.

The relief decoration takes the form of a spiral frieze running round the shaft of the Column, and depicts in the 'continuous' narrative style the events of Trajan's campaigns of 101–2 and 105–7 against the Dacians (Ill. 59).[14] The narration of the two campaigns is separated by a Victory writing on a shield and flanked by two trophies. The scenes are either directly linked to each other without the slightest break, or separated by means of some landscape element (for example a tree or a rock) indicating a turning-point in the narration.

On the Column the human figures dominate the surrounding landscape, which is consequently reduced in scale and seen from a bird's-eye view by means of a pictorial 'map' technique, whereby the ground seems to have been tilted forwards. The figures at the back are thus

58. (Below, left) a kneeling province submits to Trajan. North-eastern relief panel on the attic of the Arch of Trajan at Benevento. Marble. Height of panel c.230 cm. AD 114–17. Benevento.

59. (Below, right) adlocutio: the emperor addressing his troops. Part of the spiral relief of Trajan's Column. Marble. Height (average) 100 cm. AD 110–13. Rome.

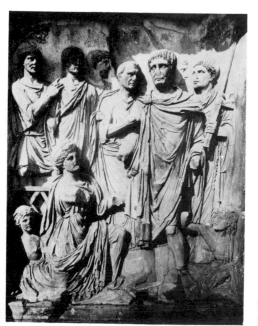

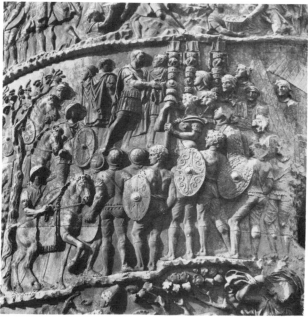

raised above those in front to give a pictorial illusion of perspective. The relief itself remains very low throughout – it rarely exceeds 2 cm. ($\frac{3}{4}$ in.) – in order not to break the contour of the shaft. In the background the details are often merely incised and the figures in very low relief are offset by an outline groove.

The Great Trajanic Frieze is carved in the 'continuous' style, having at least two different scenes following one another without any separation.[15] One shows the advent of the Emperor in the city and the other a widely spread battle scene with the Emperor on horseback charging the enemy. The Frieze differs greatly from the Column both in concept and in composition. Whereas on the Column the spectator views a more or less faithful episodic narration of the Dacian Wars unfolded on an imaginary scroll round the shaft of a column, in the Frieze he is presented with an ideal synthesis of the war and the ensuing triumphal celebrations on the same historico-allegorical lines as those of the Arch of Beneventum.

The monumental dimensions of the Frieze allow for a much higher relief than in the Column and consequently we find on it a much greater variety of planes, ranging from foreground figures almost standing out in the round to figures merely designed on the background. The step-wise superimposition of heads receding gradually into the distance is different from that of the Column, where the figures are cut on the same height of relief and recede into the background in the map-like technique.

The short-lived renaissance of classicism which began with the accession of Hadrian, nicknamed *Graeculus* – the 'Greekling' – pro-

60. North façade of the Arch of Constantine. (*Above*) two of Hadrian's medallions (from a lost monument). Repose after a lion hunt and Sacrifice to Hercules. Marble. Diameter 236 cm. AD 130–8. (*Below*) Constantinian frieze showing a *largitio* (distribution of largesse). Marble. Height 102 cm., width 538 cm. *c*.AD 315.

duced the famous hunting tondi later placed by Constantine on his arch (Ill. 60),[16] and the panel reliefs, now in the Palazzo dei Conservatori, one showing the apotheosis of Sabina and the other a public address (*adlocutio*).[17] The style is eclectic on both sets of relief but whereas the Conservatori panels lack inspiration and energy, the roundels are vigorous compositions and more decidedly Greek in character. The background is either neutral or resembles a backdrop. There is no suggestion of depth.

More interesting are the reliefs on the base of the now destroyed Column of Antoninus Pius and Faustina I, especially for their internal contrast between the anachronistic, classicizing representation of the apotheosis of the imperial pair, generally felt to be too academic and even cold and lifeless, and the lively, 'surprisingly Late Antique', *decursio* (cavalry parade) scenes on the sides.[18] In the latter, with total disregard for the rules of perspective, the designer disposed all figures on the same plane and placed them on separate projecting ledges. Scale and space are treated irrationally. The combination of the courtly, academic style and the spontaneous plebeian one on the very same monument is yet another instance of the prevalent Roman taste for such contrasts.

A long frieze of the type of the Great Trajanic Frieze, now in Vienna, was probably set up to commemorate Lucius Verus' victory over the Parthians in the wars of AD 161–5.[19] Although it was discovered in a provincial town, Ephesus in Asia Minor, there is almost nothing provincial about it. On the contrary, it is very traditional and metropolitan in style and technique when compared with the large panels of Marcus Aurelius in Rome. The use of the running drill and the plastic indication of the eyes are completely absent in some slabs. The only provincial trait, typical of the eastern provinces, is the almost hieratic frontal representation of the imperial portrait group of Hadrian and his Antonine adoptive successors, an anticipation of the frontality of later metropolitan relief sculpture.

Eight of the panels of Marcus Aurelius were built into the Arch of Constantine and three are in the Conservatori (Ill. 61).[20] There are some clear differences of style between the two groups but the dimensions and shape of the panels are identical. Besides, though the Emperor's head is missing on the Arch panels, the appearance of the same portrait figure, identified as Pompeianus, in a similar style on both groups further confirms their close relations.

The sculptors responsible for these panels accepted some of the traditional conventions of plastic art established in official commemorative programmes of previous emperors, and introduced new ones. Foremost among the latter is the negative modelling produced by the running drill, which can best be appreciated in the rendering of the hair and beard of Pompeianus, the Emperor's close friend. This impressionistic technique contributed further to the departure from objective naturalism and organic cohesion of forms in traditional Graeco-Roman art.

This disintegration of organic form reached an advanced stage in the Column of Marcus Aurelius, where the human body became

clumsy and ill-proportioned, either too elongated or too short and dumpy.[21] The heads are almost without exception too large and very cursorily worked. These are all characteristics of Late Antique sculpture. One other later Roman stylistic element which appears on the Column is hieratic frontal representation not only in the composition but also in the disposition of individual figures, in particular that of the Emperor (Ill. 62).

Of Septimius Severus' monumental sculptures, the reliefs on his arch at Lepcis Magna in North Africa are carved in the tradition of Marcus Aurelius' panels, but with flatter, less plastic modelling and a wider use of the drill.[22] So in many ways is the arch commissioned in Severus' honour by the Roman silversmiths, in which frontal representation prevails.[23] The large panels on Septimius' triumphal arch in the Roman Forum (Ill. 63), which illustrate his campaigns in the East, follow on the tradition of the Aurelian helical Column, but the 'continuous' illustration is distributed on registers separated by projecting ledges.[24] The human figure is stocky and deprived of all grace. Within the scenes the bird's-eye perspective, or tilted-ground view, of the Column is maintained. The figures are carved in a much higher relief than on either of the Columns, and in several instances rows of figures are superimposed step-wise on different planes.

After Septimius Severus very little monumental sculpture was produced in the third century. Sculpture was in fact mostly confined to portraits, sarcophagi and small decorative reliefs. This was certainly due to the political troubles and economic ruin of the times. The

61. (*Above, left*) Marcus Aurelius sacrificing in front of the temple of Jupiter on the Capitol. Relief panel from a lost monument. Marble. Height 314 cm., width 210 cm. AD 176–80. Rome, Palazzo dei Conservatori.

62. (*Above, right*) *adlocutio*: Marcus Aurelius addressing his troops. Part of the spiral relief of the Column of Marcus Aurelius. Marble. Height (average) 130 cm. AD 180–92. Rome.

soldiers who rose in rapid succession to imperial power had neither the time nor the financial resources to carry out historiated monuments such as those of previous centuries. A new surge of production rose with the Tetrarchic rule at the beginning of the fourth century.

In 303, on the occasion of the *decennalia* of the reign of Diocletian, five columns were erected in his honour in the Forum Romanum. The base of only one of these survives. One side of it is decorated with a scene of sacrifice in relief.[25] In it the carver has made the maximum use of negative modelling, that is to say gouging deeply the surface of the marble with the running drill to create the illusion of surfaces modelled in the round.

A contemporary monument, the Arch of Galerius in Thessalonika, is in many ways more conservative in the modelling techniques, though the drill is used extensively.[26] The background figures are in negative relief while the foreground ones are in very high relief. The most eye-catching quality of the various scenes is the mechanical unity of composition achieved by symmetry and hierarchical proportions. In the *adlocutio* scene the large and centrally placed figure of Galerius tops the whole pyramidal composition.

This compositional organization reflects the new concept of Im-

63. Relief panel on the south-west face of the Arch of Septimius Severus in the Forum Romanum. Episodes from the Parthian campaigns. Marble. Height 400 cm., width 490 cm. AD 203. Rome.

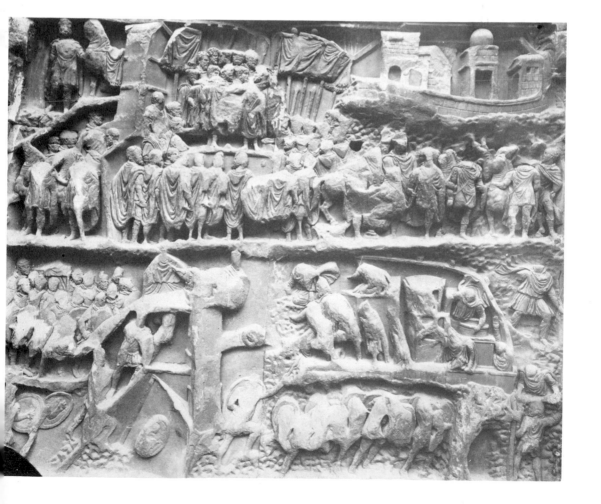

perial rule, consequent on the transformation of the Principate into
the Dominate. In parallel to the rigid re-organization of the State
following the reforms of Diocletian, the unruly natural forms in art
were arranged according to the strict lines of a mechanical order
imposed from above on people and objects. This new vision is best
illustrated in the genuinely Constantinian frieze on the Arch of Con-
stantine in Rome (AD 312–15).[27]

The two reliefs on the east façade represent Constantine addressing
the people of Rome and presiding over the free distribution of money
to Rome's citizens. Here everything is in strict symmetry, subor-
dinated to the dominating figure of the Emperor at the centre. The
figures are not gathered in free, natural groups but arranged as
uniform elements side by side in regular rows.

The dumpy proportions of the puppet-like figures derive from the
popular narrative stream of Roman art. The mechanical, trans-
cending vision of the universe, however, ushers in the art of
Byzantium.

Republican Portraiture. The origins and originality of Roman portraiture
have been the focus of serious debate among historians of ancient art.
For a long time it was held that the realism which constitutes the
essential characteristic of Roman portraiture of the Republic was
derived from the death-mask practice, vivid accounts of which have
been handed down to us by Polybius (VI. 53) and Pliny the Elder (*NH*,
XXXV. 6, 8). Death-masks were images 'reproducing with remarkable
fidelity both the features and the complexion of the deceased'. These
ancestral images were kept in special cupboards in the house, near the
atrium, and were paraded in public on special occasions.

It is now generally believed that the late Republican portrait was
produced by the convergence of a number of varied and sometimes
unrelated currents:[28] firstly, the ideology behind the typical Roman
portrait came from the ancestral cult of the Roman patrician class as
expressed in the *ius imaginum* and in funerary portraiture. The stark
realism of some of the most typical portraits of the period betrays their
derivation from the ancestral wax-portraits. Secondly, Egyptian por-
trait art, with its love of faithful physiognomic rendering, undoubtedly
influenced the development of the Roman realistic portrait directly or
indirectly. In the third place, the contribution of Hellenistic art in this
sphere is mostly stylistic. While realism is not absent in Hellenistic
portraiture, its formal modelling almost always raises it above a slavish
adherence to reality. Finally, intensity of expression, when it occurs, is
due to the influence of the Central-Italic milieu. This expressionism is
a dominant feature in the 'Brutus' and in the bronze head of a young
man in the Cabinet des Médailles, Paris (Ill. 64).

The typical honorific portrait (as opposed to the purely funerary
one) of the Republic developed between 90 BC (the patrician return to
power) and the last triumvirate (43–32 BC). Several examples of it
have been identified with historical persons. Some identifications, such
as the portraits of 'Sulla', are tentative, but others are firm through
comparisons with inscribed coin portraits, for example Pompey and

64. Portrait of a young
man. Bronze. Height 27
cm. 3rd–2nd century BC.
Paris, Bibliothèque
Nationale.

65. Head of Pompey.
Marble. Height 28 cm.
Posthumous – probably
an imperial copy.
Copenhagen, Ny
Carlsberg Glyptotek.

Caesar. Of these, the beautifully modelled head of Pompey (Ill. 65) with its accentuated plasticity has all the qualities of the work of a Hellenistic artist, probably Greek. The portraits of 'Sulla' and Caesar are inspired by those of Hellenistic princes. The modelling of the facial features is drier and is more concerned with expressing the *ethos*, the personality of the statesman, than with the merciless reproduction of skin defects.

The extant portraits of unknown private individuals in the same period constitute a class of portraiture quite distinct from those of politicians. Compared with the latter, this type of portrait presents itself as the closest heir of the wax-portrait tradition. Verism (that is, exaggerated realism) is the dominating trait in these portraits. It is hard to identify Hellenistic influence on them, but some early specimens discovered in the Greek East suggest that even this class of portrait could very well have been the work of Hellenistic sculptors. Two representative specimens are the veiled head in the Vatican and the head in the Albertinum at Dresden, with its lined, emaciated face. Both illustrate magnificently the typical gnarled features of the countryman: there was a strong peasant strain in the middle-class, which formed the backbone of Roman society. The rendering of the wrinkled skin in the latter is exceptionally fine, but the realism of the head does not stop there. It penetrates beyond the skin into the bone-structure, which is accentuated by the thin layer of flesh clinging to it. The expression is grim and hauntingly death-like.

In the portrait of the old, boorish, leather-faced patrician in the Museo Torlonia, on the other hand, no effort is spared in the reproduction of every wrinkle of the face (Ill. 66). In the forehead the wrinkles are rendered by deep line-drawing whereas a little more plasticity is moulded into the cheeks and mouth. This outstanding portrait seems to capture the essential character of a late Republican bourgeois.

Two different generations are represented by the portrait busts held in the arms of a togate statue now in the Conservatori Museum (Ill. 67). They are both in the naturalistic tradition, of Hellenistic derivation, assimilated by the artists of central Italy. One is a reproduction of a portrait created around 50–40 BC; the other is a generation younger. The statue itself is dated to the earliest years of the first century AD, though the head is not original.

66. Portrait of a Roman patrician. Marble. Height (head only) 35 cm. 80–50 BC. Rome, Museo Torlonia.

Imperial Portraiture. The realistic, Italian strain of Roman Republican portraiture does not seem to have survived as a living tradition into the Empire – even in privately commissioned sculpture. The veristic type of portrait recurring from Augustus' principate onwards is a descendant of the other class of late Republican portraiture, the Hellenized type, of which the portraits of identified statesmen (e.g. Caesar and 'Sulla') are good examples.

In the Imperial age, privately commissioned portraits generally followed the main lines of development of official portraiture both in form and content. The Emperor and his wife were undoubtedly pace-

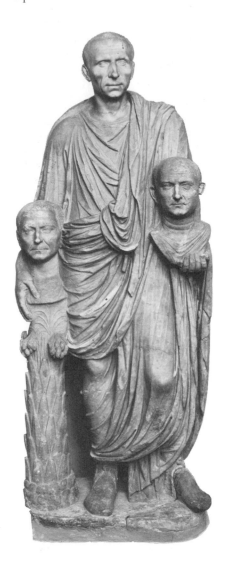

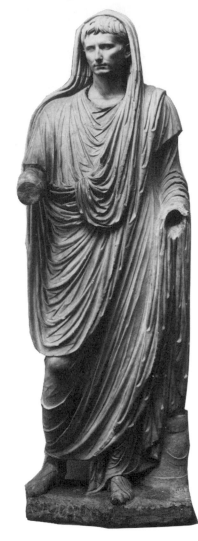

67. Statue of a Roman
patrician carrying two
portrait bust of ancestors.
Marble. Height 165 cm.
End of 1st century BC.
Rome, Palazzo dei
Conservatori.

68. Statue of Augustus
as Pontifex. Marble.
Height 217 cm.
c.10 BC–AD 10. Rome,
Museo Nazionale
Romano.

setters in iconographic matters (such as hair-styles), and in the diffu-
sion of particular styles. The student of ancient art should, however, be
careful not to take this generalization too far. Different schools, or
workshops, representing different stylistic trends, no doubt operated
simultaneously in Rome itself. Differentiation in style is much more
evident when comparing provincial specimens with their metropolitan
contemporaries. The fact that the Emperor favoured one particular
school or workshop at any given time almost certainly influenced the
tastes of the Roman market, and this in turn probably exerted pressure
on other Roman workshops to modify the style of their products
accordingly.

A study of portraits on Roman historical reliefs, however, reveals
that in the past too much emphasis has been given to official imperial
portraiture as a yardstick for dating free-standing, private portraits.

The method is not unreasonable since not much else provides a chronological gauge. But if one analyses the great differences, in iconography and treatment, between imperial portraits and those of other personages appearing on the same relief, one wonders whether this approach to dating is always the correct one. The point is best illustrated by a comparison of the portrait of the so-called 'Quietus' with that of Trajan on the same relief in the Arch at Beneventum; the heads of the Caesernii brothers in the Hadrianic tondi with Hadrian's usual portraits; and of Pompeianus with Marcus Aurelius in the latter's relief panels. Furthermore, an examination of the stereotyped heads on the Flavian and Trajanic commemorative reliefs suggests that the beard was probably worn by the ordinary soldiers and individuals long before Hadrian made it officially fashionable.

The relatively long reign of Augustus (27 BC-AD 14) saw the revival of Greek classical ideals through the explicit patronage of the Neo-Attic style in official imperial monuments. Of the two most renowned and typical portrait statues of Augustus, one, the cuirassed statue from Prima Porta, is modelled on the Doryphoros of Polykleitos. The other, the togate and veiled statue from the Via Labicana, is of a purely Roman type. But there is no doubt that both are the product of the same classicizing trend and executed by Greek, perhaps even Attic, artists.

The Prima Porta statue, which still preserves some of the original polychromy, represents Augustus 'addressing the army' (*adlocutio*) with right hand raised in the traditional attitude of an orator.[29] The heroic nudity of the Polykleitan model is suppressed in conformity with the Roman traditional concepts of dignity (*dignitas*) and sobriety (*gravitas*). Instead, the rich panoply of symbols and personifications that decorate his cuirass refers to the establishment of peace (*pax Augusta*) in the Empire and to Augustus' role as *restitutor orbis* (restorer of world order). The head is idealized but cold. It is a virtuoso exercise in academic correctness, with clear, definite contours, and lacks the plastic modelling and psychological insight of Hellenistic portraiture. The formal treatment is also inspired by the ideal standards of Greek fifth-century art.

The veiled head of Augustus as Pontifex on the togate statue from the Via Labicana (Ill. 68) is much more alive spiritually, even though the Emperor's old age is only suggested by slightly hollow cheeks. The modelling is extremely sensitive, expressed by a restrained chiaroscuro effect derived from the soft transitions of a few simple planes. The spirituality of the wise, benevolent father of the State and restorer of traditional morality emanates from the shaded deep-set eyes.

This spiritual, psychological quality is much more pronounced in the few surviving portraits of Augustus' favourite general and son-in-law, Agrippa. Underneath the strong, disciplined and energetic qualities suggested by the sturdy muscles of the face, the tragedy of Agrippa's private life emerges from the dark gaze of the shadowed eyes. His portrait seems to descend directly from the Hellenistic tradition, which had dominated official portraiture before Augustus. For the portrayal of his image, Agrippa seems to have preferred a

workshop or artist working in a style different from that of the more
prolific Neo-Attic school favoured by the Emperor.

The successors of Augustus, the Julio-Claudian emperors (AD
14–68),continue to appear in sculpture more or less in the same style as
the first Emperor.[30] Their hair-styles vary very little and they all have
the features of physiognomy which are characteristic of their dynasty,
namely a pronounced triangularity of the face and projecting ears.
These characteristics also appear in a considerable range of child
portraits, most of them of Julio-Claudian princes. With Claudius,
however, a pictorial and colouristic sensitivity in the modelling starts
to emerge on official portraits, timidly at first, more decidedly in
Nero's images, and reaching its full development in the images of the
Flavians. These also show a strong tendency towards the return to late
Republican realism best illustrated in the heads of Vespasian (Ill. 70)
and Titus. In some private portraits of the Flavian period (AD 69–96)
this realism is so strong as to make them difficult to distinguish from
their Republican counterparts.[31]

Female portraits underwent the same development from the dry
realism of Republican portraiture to the maximum, often ageless,
idealization of the Julio-Claudians. Like their male counterparts, the
female members of the Imperial family were pace-setters in popu-
larizing certain hair-styles and a great number of portraits of private
women (Ill. 71) reproduce or imitate imperial coiffures. In non-
official portraiture, however, the deeply rooted realism of the previous
age survived with greater vigour in female as well as in male images,
especially in funerary art. Through the revival of realism in official
portraiture under the Flavians the two separate trends, the official and
the private, came together again.

By adopting Trajan as his son and successor, Nerva (AD 96–8) put an
end to the hereditary succession practised under the Julio-Claudian
and Flavian dynasties, and thus inaugurated an era of wise emperors
who succeeded each other by adoption. Trajan's reign (AD 98–117)
was remarkable for the peace and security at home and the territorial
expansion on the north-eastern frontiers. He was a consummate ad-
ministrator and an indefatigable soldier. He considered himself as the
princeps, the first among equals. He inspired confidence in the members
of the Empire and deterred the restive barbarians. Trajan embodies
the Empire at the peak of its expansion. All these qualities and
attributes are reflected in Trajan's portraits, in particular those carved
on his commemorative reliefs.

There are several versions of the Emperor's likeness which were
issued on different occasions during his reign.[32] They are known from
numerous copies scattered over the Empire. One of the best known
and most representative is the bust in the British Museum issued in AD
108 for the *decennalia*, the tenth anniversary of his accession to power.
Another masterpiece is a posthumous head (between AD 120 and 130)
found at Ostia (Ill. 69).

In the Ostian portrait the stern, vigorous head, with a low, sloping
forehead, is set on a thick powerful neck. There are none of the marks
of age and fatigue which tend to characterize the portraits of the last

69. Colossal head of Trajan. Marble. Height 38 cm. AD 120–30. Ostia, Museum.

70. (*Far right*) Head of Vespasian. Marble. Height 40 cm. AD 69–79. Rome, Museo Nazionale Romano.

71. Portrait head of a Flavian lady. Marble. Height (head alone) 38 cm. AD 80–100. Rome, Museo Capitolino.

72. (*Far right*) Bust of Hadrian. Marble. Height 43 cm. AD 117–18. Ostia, Museum.

years of his life, as in the bronze bust from Ankara. The planes of the forehead and cheeks have a rich but subdued movement of the muscles with a subtle play of light and shade which becomes more sustained in the folds on either side of the mouth. The features are idealized and the Emperor appears as a god even though the human personality of the disciplined soldier and able administrator palpitates within the marble.

Under Hadrian, the philhellene Emperor (AD 117–38), Roman art experienced a nostalgic return to Greek classical ideals, not merely in style but also in content. It is enough to examine the bust, also from Ostia (Ill. 72), datable to the early years of his reign.[33] The hair-style and the cut of the beard are reminiscent of works produced in the Periclean age. Compare it, for instance, with the portrait of Pericles attributed to Kresilas and with some of the bearded heads in the frieze of the Parthenon.[34]

An important iconographic innovation introduced by Hadrian into imperial portraiture is the prominent beard, which remained a fundamental characteristic of the image of all adult emperors for almost a century, until Caracalla and his Severan successors introduced a more close-cropped style. Another change, this time of a technical nature, which was introduced in portraiture and other types of marble sculpture half-way through the reign of Hadrian, is the plastic rendering of the iris and pupil in the eye. Whereas this device had been in use in other media, such as bronze and terracotta, in stone and marble the details of the eyes had been merely indicated by the use of colour. Traces of this survive on the statue of Augustus from Prima Porta and on Caligula's and Livia's heads in Copenhagen.

Also officially commissioned were the numerous statues and busts of Antinoüs (Ill. 73), the Bithynian youth beloved by Hadrian, who met a mysterious death in the Nile.[35] The style of these images was inspired by the classic canons of such masterpieces as the Athena Lemnia by Phidias (c.440 BC) and the so-called 'Eubouleus' from Eleusis (c.350–330 BC).

The portraits of the female members of the imperial house, for example Hadrian's wife Sabina, retain the plain and serious features of the effigies of Plotina, Trajan's wife, and Matidia, his niece. But the hair-style tends to depart from the elaborate, picturesque coiffures of Flavian and Trajanic women and takes a simpler form with a central parting over the forehead and a diadem. Later on, the hair-style of Faustina the Elder, wife to Antoninus Pius, becomes slightly more complicated by the addition of a plaited bun in several tiers over the crown of the head. The sternness of Trajan's images is reflected in the sober style and serious expression of busts of Plotina, while the classicism of the portraits of Sabina and the two Faustinas deprives them of most, if not all, of their individuality.

The age of the Antonines ushers in both a definite, though gradual, break from Greek classic ideals and a crisis in the Hellenistic tradition itself. A new formal language and new technical devices, or rather their more extensive use on portraits created striking contrasts between the shiny, polished, almost porcelain-like surfaces of flesh areas, and the colourful turbulence of light and shade in the hair.[36] It is highly probable that this new colouristic principle in the treatment of the hair, extensively worked over with the drill, was inspired by the same effect produced in soft clay models with the modelling spatula.

Even in content there is a significant transformation. The faces assume transcendental, languishing expressions, imparted mostly by upturned, side-glancing eyes coupled with very thick upper eyelids.

73. Colossal statue of Antinoüs. Marble. Height 326 cm. c.AD 130. Vatican, Museo Gregoriano Profano.

74. (*Below*) Bust of Commodus as Hercules. Marble. Height 118 cm. c.190–2. Rome, Palazzo dei Conservatori.

The portraits of Antoninus Pius (138–61) serve more or less as the stepping-stone in the process of this transformation. His beard and hair-style are similar to those of Hadrian, but they are more pictorial, as in the head in the Museo Nazionale in Rome. Here the marks of old age, such as the baggy eyelids and the crow's-feet at the outer corners of the eyes are quite evident. A bust in the Capitoline Museum of Marcus Aurelius, his adoptive successor, as a youth, shows the same pictorial treatment in the thick mass of hair.

The transcendental element as well as the rich colouristic effect in the heavily drilled hair and beard reach their peak in the portraits of Marcus Aurelius, the Emperor-philosopher (161–80) and in those of his successors, Commodus (180–92) and Septimius Severus (193–211). But while Marcus Aurelius displays the noble, meditative type, Commodus (Ill. 74) reveals both sensuality (he performed as a gladiator) and arrogance (he had himself represented as Hercules). Septimius Severus did his best to assert his claim to be the direct heir of the Antonine dynasty and his portraits are so close, in iconography and

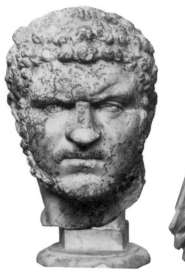

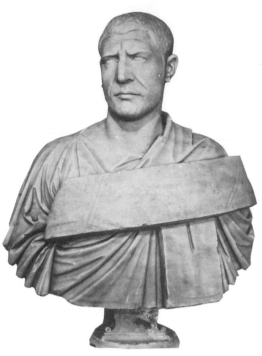

75. Head of Caracalla.
Marble. Height 28 cm.
c.AD 215. Rome, Palazzo dei
Conservatori.

76. Bust of Philip I
('the Arab'). Marble.
Height (entire bust) 71
cm. AD 244–9. Vatican,
Museo Gregoriano
Profano.

style, to those of Marcus Aurelius that they are often not easily distinguished. Severus was a native African from Lepcis and his portraits betray his alien origin.[37]

Although he clung to the claim of Antonine succession by his name, Marcus Aurelius Severus Antoninus, nicknamed *Caracalla* (211–17), did not hesitate to abandon the long iconographic tradition sustained by that dynasty, and instead adopted the fashion of close-cropped hair and beard (Ill. 75). The treatment of the short thick curls, however, remained the same. The contraction of the features, the angry eyes and the sharp, vigorous turn of the head concur to express the ferocity and brutality of the Emperor's character.

The break from Greek classical and Hellenistic ideals in figurative art is further emphasized in the sculpture of the third century AD. Late Antiquity in Roman art can be said to start with the military anarchy and the economic and spiritual crisis which came to a head in the turbulent decades between the fall of Caracalla and the accession of Diocletian. In sculpture there is the total abandonment of Hellenistic plasticism, already begun in the portraiture of Marcus Aurelius. The structure of the head is more and more simplified until it becomes virtually cuboid in Constantinian portraits. The hair and beard (in life generally close-clipped with scissors) are rendered by short and shallow incisions made by a pointed chisel or burin. Several portraits of youthful third-century emperors show their subjects partially or totally clean-shaven.[38]

On male heads the physiognomy is no longer well integrated; they express most vividly the transience of power and the interior torment of a deeply troubled age. On the other hand the female portraits, both official and private, maintain substantially the classicizing tradition.

These stylistic changes are evident in the portraits of Alexander Severus (222–35) and Gordian III (238–44). The plastic treatment of the hair is renounced. The expression is concentrated in the eyes, cast upwards and brooding.

Occasionally there are nostalgic throw-backs to the past, such as in the portrait of Pupienus, who reigned only for a few months in 238. The style of the beard is derived from that of the Antonines, but the close-cropped hair is typical of contemporary fashion. A more decisive, even if ephemeral, rebirth of Hadrianic classicism is seen in the portraits of Gallienus (253–68) with his longer, more voluminous hair and curly beard. Both beard and hair are plastically modelled by the chisel rather than grooved by the running drill.

The drill was hardly, if at all, used in the female portraits of the period, whether of empresses or private ladies. A wig-like hair-style was fashionable, mainly derived from that worn by Julia Domna, Septimius Severus' Syrian wife. The mature age and physical decay of the subject is evident on a number of these portraits, but throughout the course of the third century the classicizing tradition is substantially preserved in female portraiture. These female portraits stand out for their decorous gravity and calm in contrast with the choleric expression of such male portraits as the Vatican bust of Philip the Arab (244–9; Ill. 76) and the nervous and care-worn character suggested by the bust of Maximinus Thrax (235–8) on the Capitol. The portrait of Decius (249–51), also in the Capitoline Museum, gives a vivid insight into the tormented soul of the age.

Some scholars believe that the official imperial portraiture of the time was not, as has been repeatedly asserted, affected by the artistic currents of the provinces.[39] Rather it was influenced by the deep social transformation of the Empire, a transformation which led members of the lower classes to the highest rungs of imperial power. This phenomenon had its precedents in the first century when Emperors like Claudius used provincial slaves as their closest counsellors. The process reached its fullest development in the third century with the various legions supporting their own generals as candidates for the imperial throne. The parvenus from the lower strata of Roman society carried with them to the official sphere the plebeian artistic tradition which had always existed alongside the Hellenistic, or Hellenized, current kept alive by imperial sponsorship.

There are few examples of Roman portrait sculpture of the second half of the third century. However, the new style can none the less be traced down to Diocletian. The effigies of this Emperor, together with those of the other Tetrarchs, Maximinus, Constantius and Galerius (285–305), mark the almost total disappearance of physical likeness in the portrait (Ill. 77). The organic, anatomical structure is lost and the expressive function of the eyes is accentuated. Roman Egypt may have had a great influence in the formation of the Tetrarchic style because it provided the hard porphyry reserved for imperial sculpture and, presumably, the sculptors experienced in carving it.

Definitely originating from the eastern provinces of the Empire are the influences, both ideological and stylistic, on the new concept of the

77. Statue group of
four imperial figures (the
Tetrarchs). Porphyry.
Height 130 cm. Early
4th century AD. Venice,
Piazza San Marco.

divine essence and untouchable sacredness of the absolute ruler as
opposed to the humanistic conception of him as the *princeps* in earlier
times. The result of this influence is the gradual suppression of the
personality and physiognomic features of the individual and the
reassertion of the typological portrait: the image of the absolute
sovereign. Severe frontality dominates and the few simplified planes of
the head are subjected to rigid symmetry.[40]

The most noteworthy examples of this type of dynastic portraiture
are the portraits of Constantine the Great – such as the colossal head in
the Palazzo dei Conservatori (Ill. 204, see Chapter 12). The modelling
has become simple and monotonous. The eyes are unnaturally magni-
fied and surrounded by hard outlines. The eyebrows are exaggeratedly
arched. The hair is rendered as a low, compact mass with schematic,
conventional lines. However, the agelessness of the head and the
massive build of the face still evoke the portrait types of Trajan.

Funerary Sculpture. The commonest manifestation of Roman private
portraiture was in funerary art, in the form of funerary busts or statues
and tombstones (stelae). The latter bear images of the deceased in high
relief, generally as busts but occasionally in full figure. Some represent
single persons, others a husband and wife with or without children; yet
others portray an entire family (Ill. 78) – even on occasion including
servants and freedmen. The husband is draped in the typical Roman
garment, the toga, and the wife is shown as the virtuous Roman
matrona, often with her hand raised to her chin in the *pudicitia* gesture.
In the first century AD stelae are sometimes replaced by small altars
showing, besides the portrait busts of the deceased, scenes borrowed
from the Greek funerary repertory or else capturing some great
moment from the life of the deceased. The sepulchre of the Haterii
family represents a grandiose sculptural monument of this nature.

78. Grave stele with busts in relief of members of the same family, the Furii. Marble. 62 × 212.5 cm. Late 1st century BC. Vatican, Museo Gregoriano Profano.

On it the designer has included reliefs depicting Roman buildings of the Flavian period and an interesting picture of a Roman treadwheel crane (Ill. 79). The portraits of a male and a female member of the Haterii family are enclosed in columned niches.

The ever-increasing popularity of inhumation instead of incineration after the beginning of the second century AD led to the widespread use of marble sarcophagi adorned with rich and varied relief decoration. Whereas grave stelae were produced throughout the Roman Empire, the production of white marble sarcophagi was, it seems, limited to a few centres, the most important of which were Rome, Athens and Asia Minor. These centres often exported sarcophagi in half-finished condition to be completed at their destinations by the sculptors accompanying them.

The 'Attic' sarcophagi were decorated on all four sides with episodes from Greek mythology carved in high relief and in the more sober, traditional style of Hellenistic Attic production. The most representative of the 'Asiatic', more heavily decorative sarcophagi, are the 'columnar' ones, with figures carved almost in the round against an architectural background of columned niches. Also typical are the Proconnesian and other 'garland' sarcophagi. Miniature mythological episodes are exquisitely carved above garlands supported by maidens. The 'Rome' sarcophagus was decorated only on three sides, the fourth being intended to stand against the wall. In most cases the mythological theme is limited to the front while the sides contain purely decorative motifs carved in very low relief.

Eventually, and certainly by the end of Marcus Aurelius' reign (AD 180), the portrait of the deceased might appear in the figured frieze as a victorious general in a conflict between Romans and barbarians. Two examples of this type are the Portonaccio Battle sarcophagus (Ill. 80) and the Ludovisi Battle sarcophagus, both in the Museo delle Terme, Rome. The former was destined for some unknown general of Marcus Aurelius, but the face of the general was left unfinished, as the portrait features were meant to be carved in at a later stage. In this sarcophagus the deceased and his wife appear also in the narrow frieze on the lid, joining hands together in the centre, and singly on each side.

Later still the portrait of the deceased returned to the enlarged bust form enclosed in a centrally placed tondo or shell-niche. Much of the

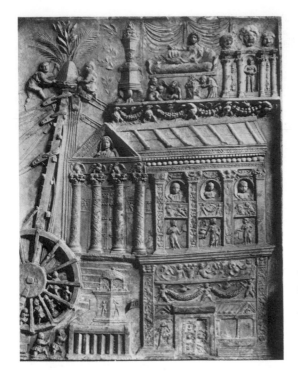

79. Relief slab from the
Tomb of the Haterii
showing a Roman
treadwheel crane.
Marble. Height 104 cm.
AD 100–10. Vatican,
Museo Gregoriano
Profano.

80. The Portonaccio
sarcophagus showing a
battle between Romans
and barbarians. Scenes
from the life of the
deceased on the lid.
Marble. Height 150 cm.
AD 170–80. Rome,
Museo Nazionale
Romano.

sculptural repertoire of the different types of sarcophagi was exploited
on early Christian examples from the late third century onwards.
Compositions, patterns and figurative inspiration were derived from
classical models but the themes were drawn from episodes from the
Bible and centred on the figure of Christ.

Bronzes. Large-scale bronze statuary was predominant in Greek sculp-
ture. Most of the great Greek sculptors are known to have excelled in

81. Equestrian statue of
Marcus Aurelius. Gilt
bronze. Height 352 cm.
AD 166–80. Formerly
Capitoline Square,
Rome.

this medium even if their works have only come down to us in marble
copies. Due to the constant need for this metal, the great majority of
ancient bronze statues have ended up in the melting-pot. Bronze was
also a widely used medium among Roman sculptors, some of whose
masterpieces have survived. The Central-Italic 'Brutus' has already
been mentioned; to it one should add the Capitoline She-wolf, the
emblem of Rome (see Chapter 1). Large-scale bronze statuary of the
Imperial period includes many portraits of emperors, such as a head of
Augustus discovered at Meroë in the Sudan, a Hadrian from London,
and a Trajan in Ankara. One of the best known of all Roman
masterpieces is the gilt bronze statue of Marcus Aurelius on horseback
which until recently dominated the Capitol square designed by
Michelangelo (Ill. 81); the horses adorning St Mark's, Venice, are also
now generally assigned to the Middle Empire, probably to the reign of
Severus.[41] Amongst Late Antique statuary, a colossal image of
Constantius II survives in fragments, including the head and a few
limbs, in the Palazzo dei Conservatori (see Chapter 12).

The small-scale bronzes form a class of art-objects of their own and
deserve separate treatment.[42] With the spread of Hellenic culture
after the conquests of Alexander, masterpieces of Greek sculpture
started to be reproduced both to scale and in greatly reduced versions.
Among the latter were statuettes in various materials, including
bronze, which were in increasing demand as cabinet pieces for rich
connoisseurs. This custom was taken up by the Roman upper- and
middle-classes soon after the Roman conquest of the Greek East. At
first statuettes in bronze were copies and adaptations both of Hellen-
istic motifs and of Greek originals of the fourth, fifth and even sixth
centuries BC. Several of the statuettes found in Pompeii and
Herculaneum are either Hellenistic products (such as the Isis with

silver incrustations from Herculaneum) or else Roman reproductions (one of the most popular types being that showing Aphrodite removing her sandals). Later, perhaps as a result of the artistic revival under Augustus, Roman bronzes made their appearance. They include all those statuettes whose subjects are patently Roman, such as Lares, priests dressed in toga, priestesses, religious attendants and gladiators. The Capitoline Triad found in a small niche in the *Casa degli Amorini Dorati* at Pompeii is a very good example of the Roman assimilation of the Greek pantheon. The iconography is of Greek inspiration but the character is decidedly Roman. Other bronzes qualify as Roman because of certain technical characteristics which constitute a distinct Roman style: a certain hardness in the rendering of the eyes, eyelids and hair, and a noticeable angularity and stiffness in the drapery. Most of the effects were produced by chasing after the bronze had been cast.

A special class is made up of portraits, mostly busts of Roman emperors. Small bronze portraits follow the development of the large-scale portraits both in style, content and size of bust. The bust includes the collar-bone in the Julio-Claudian period, the shoulders and pectoral line in the Flavian period, the upper arms and lower chest in Hadrianic and Antonine periods, and the whole upper part of the body in the third century.

The Lares were normally produced in pairs with their outer arms raised. They are shown as youths with long hair, short tunic and boots or sandals (Ill. 82). The *Lares Familiares* represented the spirits protecting the household and were kept in special shrines in the house, sometimes in the company of other gods. Men and women offering a sacrifice were veiled and held a *patera* in one hand. Gladiators generally served as knife-handles.

82. Statuette of a Lar. Bronze. Height 21.6 cm. 1st century AD. Oxford, Ashmolean Museum.

In contrast to the uniform academism of the large bronzes, bronze statuettes show qualities which reflect the varied tastes of different social strata and different provincial traditions.[43] Few of the small Roman bronzes are of first-class workmanship compared with Greek and Hellenistic ones. The best specimens stand at the head of a large quantity of inferior ones. Some of the latter were little better in quality than the cheap figurines of plaster or clay that crowd so many mantelpieces today. In the late Empire small bronzes underwent a clear evolution: the pictorial style of the Antonine period gave way to a taste for flatter and more compact surfaces, greater frontality, and more defined details achieved by the use of the burin.

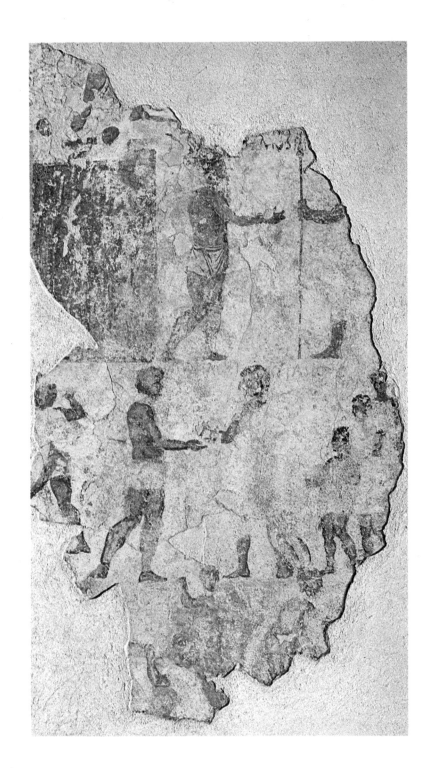

Plate 1. Fragment of a
tomb-painting from the
Esquiline, Rome. Height
87.5 cm. 3rd century BC.
Rome, Palazzo dei
Conservatori.

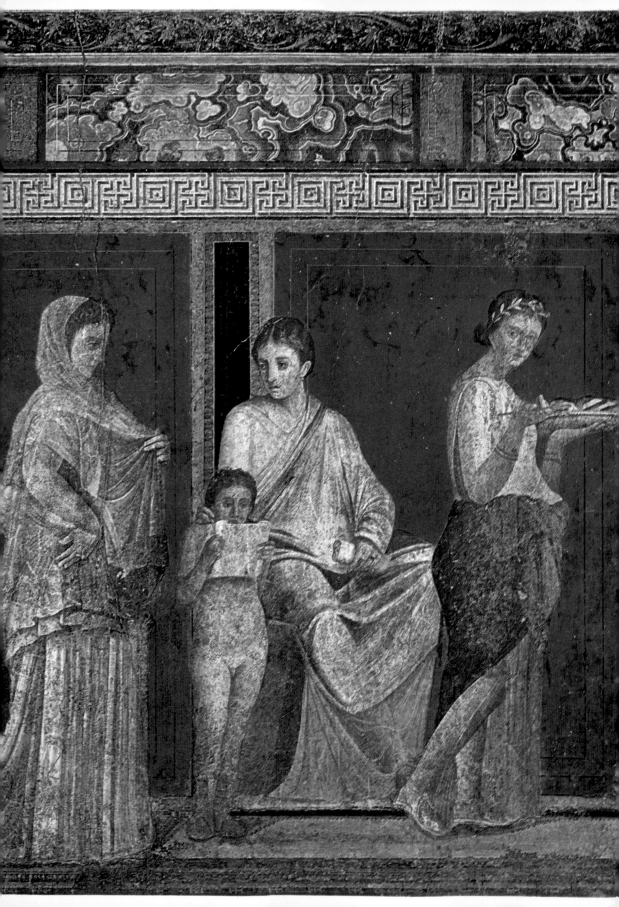

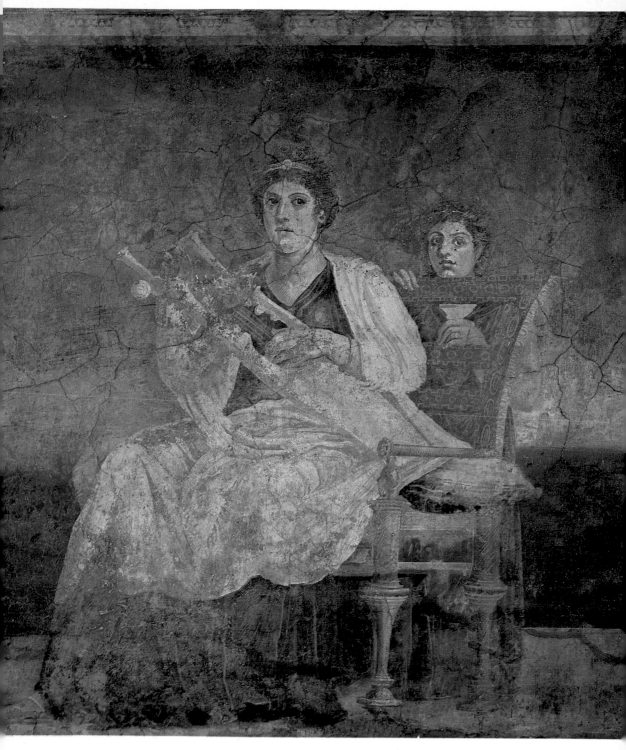

Plate 3. Girl playing the cithara from the Villa of P. Fannius Sinistor, Boscoreale. Fresco. Soon after mid–1st century BC. New York, Metropolitan Museum.

(*Left*) Plate 2. Detail of the frieze in the Hall of the Mysteries, the Villa of the Mysteries, Pompeii. Fresco. Mid–1st century BC.

Plate 4. Garden painting. House of Venus Marina, Pompeii. Fresco. Between AD 63 and AD 79.

Plate 5. Wall painting with still life including bluish-green glass vessel used as a fruit bowl. From the House of Julia Felix, Pompeii. Height of panel 74 cm. 1st century AD. Naples, Museo Nazionale.

Plate 6. *cubiculum* of the Villa of P. Fannius Sinistor, Boscoreale. 1st century BC. New York, Metropolitan Museum (reconstruction).

Plate 7. Detail of wall painting with candelabrum. Fresco. Cologne, Römische-Germanisches Museum.

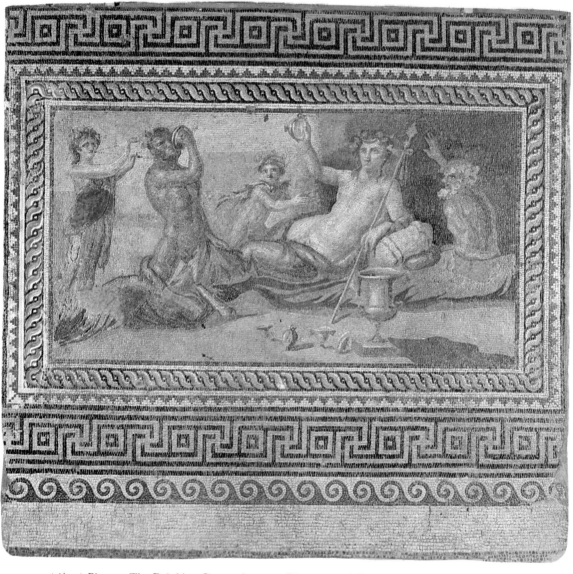

(*Above*) Plate 9. The Drinking Contest between Dionysos and Herakles. Mosaic *emblema* in *opus vermiculatum*. From Antioch-on-the-Orontes, Turkey. 183.5 × 186.7 cm. *c*.AD 50–115. Worcester, Mass., Worcester Art Museum.

(*Left*) Plate 8. The Drinking Contest between Dionysos and Herakles. Mosaic panel. From Antioch-on-the-Orontes, Turkey. 526 × 527 cm. overall. *c*.AD 250–300. Princeton, N.J., Princeton University, The Art Museum.

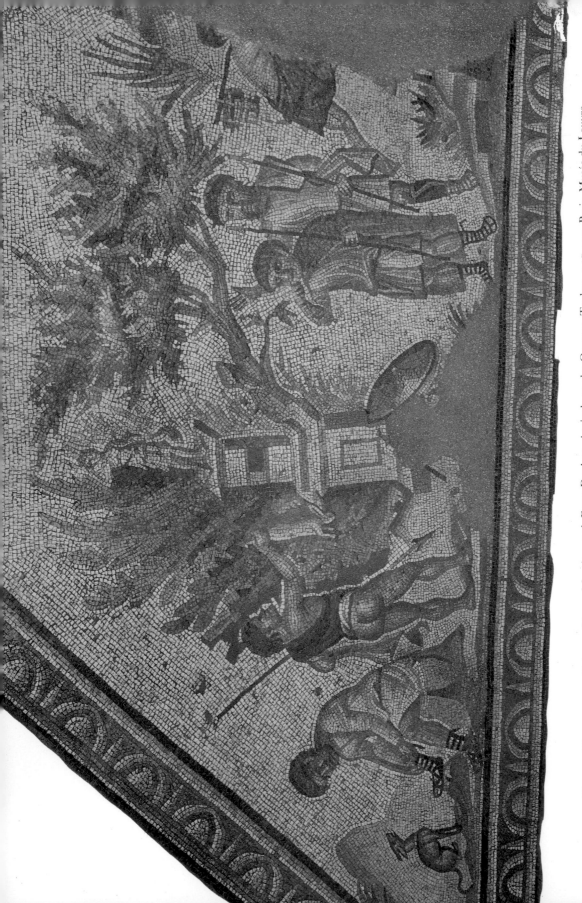

Plate 10. Huntsmen sacrificing to Diana. Mosaic panel. From Daphne, Antioch-on-the-Orontes, Turkey. *c.*AD 350. Paris, Musée du Louvre.

Plate 11. Huntsmen sacrificing to Diana in the 'Mosaic of the Small Hunt', Piazza Armerina, Sicily. *c.*AD 310–30.

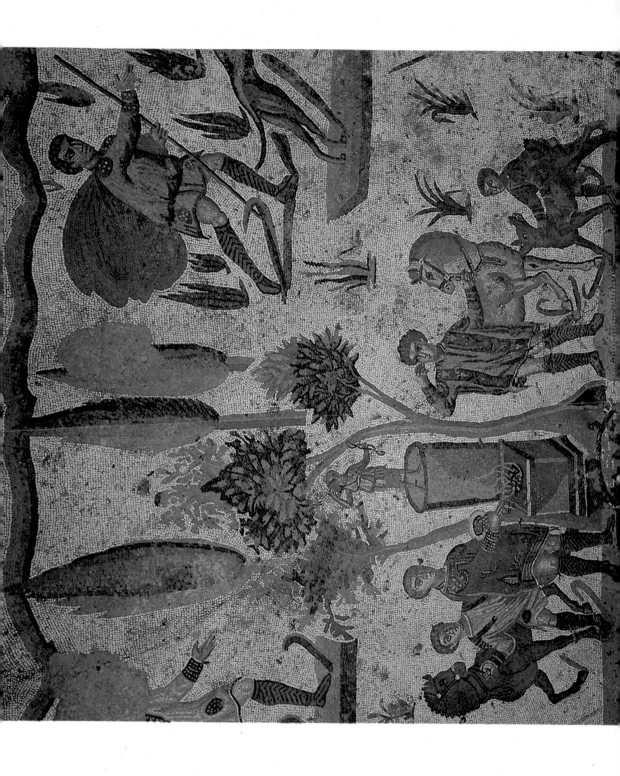

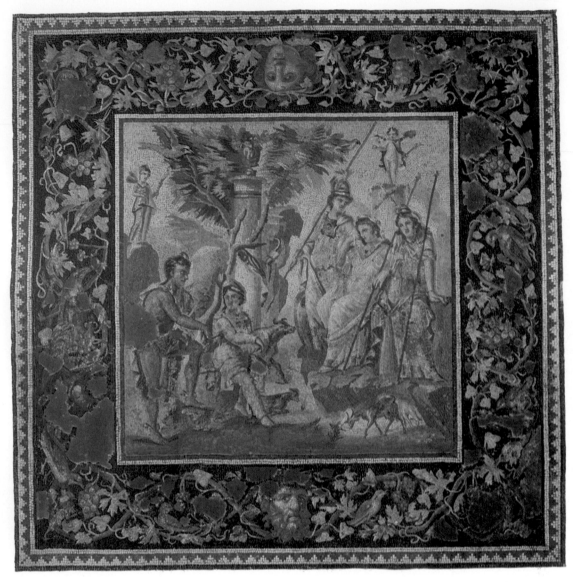

Plate 12. The Judgement of Paris. Mosaic *emblema* in *opus vermiculatum*. From Antioch-on-the-Orontes, Turkey. 186 × 186 cm. *c*.AD 50–115. Paris, Musée du Louvre.

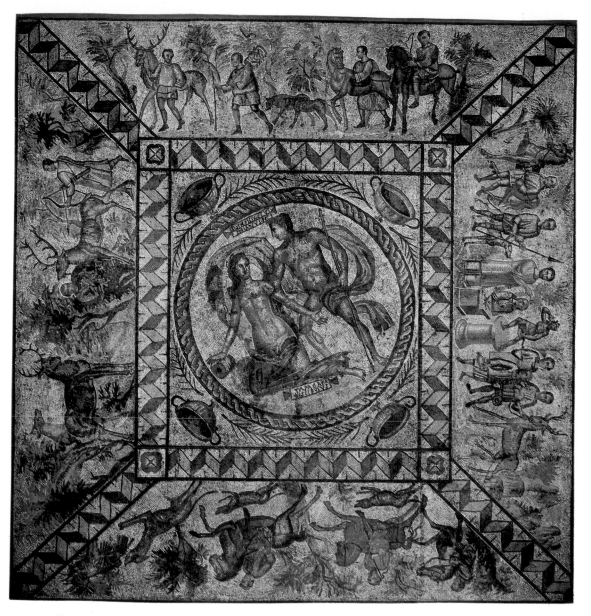

Plate 13. Mosaic depicting Apollo and Daphne and hunting scenes, signed by T. Sennius Felix of Puteoli and his local apprentice Amor. From Lillebonne, France. 593 × 573 cm. *c*.AD 250–300/300–50. Rouen, Museum of Antiquities.

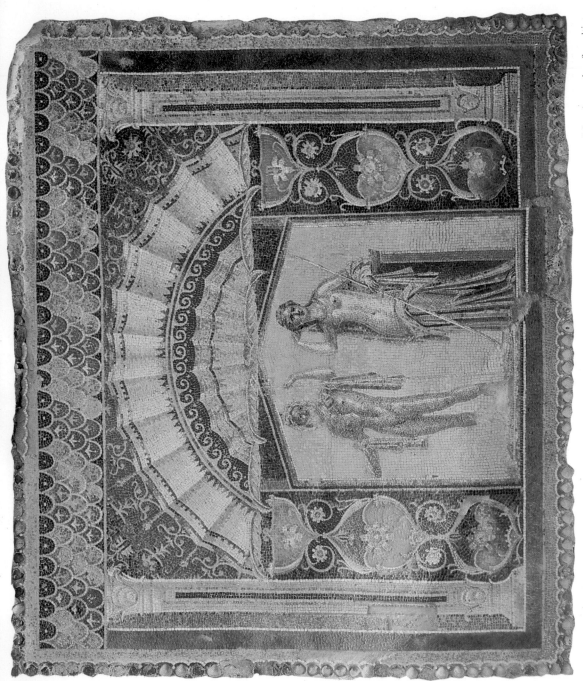

Plate 14: Neptune and Amphitrite in an *aedicula* in the House of Neptune and Amphitrite, Herculaneum. Mural mosaic of *smalti*. Height 150 cm. *c*.AD 62–8 (?)

CHAPTER FOUR

Wall Painting and Stucco

JOAN LIVERSIDGE

By the mid-first century BC the taste for interior decoration which is a feature of many Roman sites was already widespread. Painted scenes and stucco work consisting of plaster modelled in low relief appeared on the walls and ceilings of buildings of any pretensions, combined with imitation or actual marble wall veneers, often accompanied by floors of black and white or polychrome mosaic. This love of colour also manifested itself in the use of painted or inlaid furniture, gay cushions, curtains and covers known both from the interiors depicted on the walls and from the occasional fragments which still survive. So when studying the development of wall painting it is helpful to re-member the furnishings as a whole. Practical factors such as the size of rooms, the area available for decoration, and the whereabouts of doors, windows and sources of light, all affected planning.

The evidence available for study mostly comes from town and country houses, including palaces (such as the Domus Aurea), public buildings, temples and tombs. Outside Italy soldiers on the Empire's frontiers also found painters to enliven fort or fortress buildings. In the first centuries BC and AD Rome and the Campanian cities provide most of the material. After the eruption of Vesuvius, Rome is of major importance with examples from other sites, notably Ostia. Meanwhile current research is revealing wall paintings of great interest in the provinces although this material is still little known.

The preparation layer by layer of surfaces for painting and the methods used have been carefully described by Vitruvius (*De Arch.*, VII. 3), and the elder Pliny (*NH*, XXXV).[1] After a rough rendering coat had been applied, Vitruvius recommended three coats of mortar made up of lime and sand or the volcanic pozzolana found in Campania. Then came three coats of lime mixed with powdered marble of increasing fineness. When dry the surface was polished with pieces of marble, glass cylinders and cloths. How far these directions were followed varies, but they were certainly adhered to for walls in the House of Livia in Rome. Pompeian walls tend to omit one layer of each type. The colours were applied when the wall was still damp (fresco), but tempera, paint applied to a dry surface and mixed with a binding agent is sometimes used for details, and liquid wax might also be added. Fresco was the basic technique usually employed in the catacombs, where the rock would normally only take one undercoat, and a top coat of lime and powdered marble. By the fourth century only a single coat of lime and pozzolana is found, whitened with a lime solution. Portraits painted on wood (such as the Egyptian mummy

Plate 16. Fresco from the *cubiculum* of the Villa of P. Fannius Sinistor, Boscoreale. 1st century BC. New York, Metropolitan Museum (detail).

portraits) might be done in the encaustic technique in which the colours were dissolved in hot wax and applied with a spatula.

The pigments employed are usually earth colours and a wide variety of shades was recovered from a paint shop at Pompeii.[2] The pigments were ground up, carefully mixed, and kept in little pots. Sometimes scenes were lightly sketched in red ochre. It is presumed that artists worked from copy books although none have survived.[3]

Some writers see in Roman painting mere copying of Greek pictures but, when the originals are known, later versions are rarely exact replicas of them. The earliest Roman wall paintings were based primarily on Hellenistic antecedents, and the selection of subjects was increasingly affected by Roman assimilation of Greek myth and legend. There was ever greater emphasis on the religious significance of the subjects, particularly as the interest in the Dionysiac (or Bacchic) and other mystery cults grew. Items of temple furniture such as tripods appear as small details, and some still-life panels may represent sacrificial offerings. In large measure the home was decorated as though it was itself a shrine.

The great influx into Italy of works of art brought from Greece and elsewhere, and displayed in temples and houses, made a powerful impression. Italic and Etruscan ideas can also be identified. Most typically Roman are a few paintings showing gladiatorial games. Pliny (*NH*, XXXV. 52) tells us that the first was commissioned by C. Terentius Lucanus, and dedicated in the sacred grove of Diana in honour of his grandfather. Such scenes inspired many later pictures, mosaics, and decorations on glass and pottery. Several are known from Pompeian houses, notably from the House of the Priest Amandus.[4]

THE FOUR 'POMPEIAN' STYLES IN ROME AND CAMPANIA TO AD 79

A survey of Roman painting usually begins with the four Pompeian Styles distinguished by Mau in 1882.[5] These overlap. In Italy they can be roughly dated, but earlier characteristics tend to survive or re-appear with later work. Style I probably dated from the beginning of the second century BC, and here the Hellenistic influence is still very strong. In the Samnite House at Herculaneum (Ill. 42) the Italian version can be seen with the marble slabs, a characteristic feature of this 'incrustation' style, imitated in paint. The wall has the threefold division which continues to be typical of Roman painting, with a dado at the bottom; a middle section (consisting in this case of large imitation marble slabs); and the upper part of the wall with a cornice, a frieze and another cornice. The slabs are outlined with stucco, which is also used for the cornices. Rooms in Roman houses are often small, and this colourful but heavy decoration seems, to our eyes, rather claustrophobic.

With Style II, the 'architectonic', originating in Rome c.90 BC, comes a great change. An illusion that the walls have receded is produced by means of an architectural screen incorporating such features as columns and a horizontal architrave. So far the earliest

example of Style II comes from the House of the Griffins on the
Palatine in Rome.[6] In the foreground are the stalwart columns with
Corinthian capitals of a portico apparently standing on the dado.
Between them are glimpsed painted panels of rich marbles set between
smaller columns which support an architrave. At the end of one room
two griffins modelled in stucco appear at frieze level.[7].

A later development replaces the painted marble by figure or
landscape scenes. A striking example of this are the scenes probably
illustrating the initiation of a bride into the mystic cult of Dionysos
(Plate 2), occupying a whole room in the Villa of the Mysteries just
outside Pompeii.[8] The action apparently took place on a low stage.
Architectural details are largely omitted, but narrow vertical strips
divide the space into panels below cornices, perhaps to gain depth by
the effect of a portico in the background. These figures with their
varied expressions are far more alive than any of their Hellenistic
predecessors. Some could well portray local types. The Campanian
artists were now increasingly visualizing their subjects as real people.

The Hellenistic influence is stronger at the suburban villa of P.
Fannius Sinistor at Boscoreale, dating soon after the mid-first century
BC.[9] Figure scenes in one room portray an old man, possibly the
philosopher Menedemos, Dionysos, Ariadne, Venus and Adonis. A
striking richly dressed girl about to play the cithara may represent a
known individual or some historical character (Plate 3). The meaning
of such scenes is obscure. They are probably inspired by Greek stage
sets, and this particularly applies to a bedroom in the same villa where
masks of satyrs occur, usually at the top of panels (Plate 6). Although
the bed does not stand in the customary alcove, its position is indicated
by the change from patterned to plain mosaic. The paintings on the
side walls near the bed both show a round temple standing on a
podium inside an enclosure wall. Behind it, nearer the top of the wall,
are glimpses of a colonnade. The rest of the left-hand wall consists of
three scenes. Attention is directed to the central panel, where the use of
perspective indicates a scene in a temple with a statue of the goddess
Diana enclosed by a scarlet precinct wall. Cult objects, including gold
vessels placed on marble benches, appear in the foreground. The
panels on either side show buildings in perspective (Plate 16), painted
in pastel colours, and piled one above another, perhaps on a hillside.
In the foreground is an imposing entrance with a fine panelled door
divided into two leaves. Its upper panels are decorated in a scale
pattern, the lower ones possibly inlaid with tortoise-shell, and with
lion's head handles with rings in their mouths.

The decoration of the Boscoreale villa has much in common with
the Villa of the Mysteries, but here the emphasis may be on the cult of
Venus and Adonis. At Boscoreale the replacement of the walls by the
great panels with views on several planes, cleverly rendered in per-
spective, is a new development. Much of it is rooted in Hellenistic and
Near Eastern prototypes, but the architecture may well depict con-
temporary Campanian buildings. In this rich and fantastic decoration
reality gradually shades into illusion.

At Oplontis, in a recently discovered villa at Torre Annunziata,

wall paintings of both Styles II and III occur. The Style II material has
much in common with Boscoreale, featuring the same elaborate doors
for example. Between the columns of the porticoes are charming
details including large bunches of grapes, and a tall wicker basket, full
of fruit, covered by a gauzy veil.

In the last thirty years of the first century BC the Style II painters
tended to direct attention to the central portion of the wall where a
panel with a landscape or a mythological scene appeared as if seen
through an open window or recessed into an *aedicula*. On either side
appear smaller pictures placed higher up the wall, in fact the house
now suggests a museum or art gallery with the artist giving the
impression that separate framed easel pictures or larger panels
(*pinakes*) were hung on the walls, although in actual fact they are an
integral part of the wall decoration. Representations of sculpture or
other precious objects also occur, while the architectural framework is
no longer realistic.

The so called House of Livia on the Palatine hill illustrates these
features. On one wall the central theme depicts Io, beloved of Jupiter,
tethered by the jealous Juno under the care of Argus. Mercury ap-
proaches to the rescue on Io's right. Columns festooned with acanthus
are shown on either side of this painting. Smaller pictures depict a
religious ceremony, and probably a Roman street scene. The
decoration of another room shows a portico of Corinthian
columns behind which are magnificent swags of fruit and flowers
entwined with coloured ribbons.[10]

In the Museo Nazionale in Rome are preserved the fine decorations
from the Farnesina House, dating from *c*.20 BC.[11] The frieze of a room
with black walls had multicoloured figures illustrating the judgements
of King Bocchoris – a very Solomon; proof of the owner's interest in
Graeco-Oriental ideas. Below this frieze wreaths of vine-leaves hang
between columns so slender that they seem to look ahead to the
candelabra motifs of Style III. Another room has a large central
painting of the nymph Leucothea with the baby Dionysos. Smaller
framed pictures adorn the panels on either side. Although the main
scene is set in an *aedicula*, the characteristic depth and architectural
features of Style II are missing from the rest of the wall and are
replaced at frieze level by a mass of detail. The artist may have been an
Asiatic called Seleukos.

The stucco reliefs from the vaults of the Farnesina House show
landscapes and sacred scenes (Ill. 83) still under Alexandrian in-
fluence. Dionysiac elements are also apparent in such details as a
Bacchic pinecone and sacred trees. The panel illustrated here shows
two women sacrificing at a rural altar; behind it are buildings with
sacred trees, a Priapus herm and a bridge. In the foreground on the
right an angler stands on a rock, about to cast his line into the stream. A
panel in another vault shows a sacrifice in greater detail. On the right is
a youth playing the double pipes; a woman lights torches at a blazing
altar while to the left Silenus holds a decorated *thyrsus*, again symbolic
of Bacchus. Even minor details of the vault decorations are executed
with style and panache. A Victory (Ill. 84) adorns yet another ceiling:

83. Sacro-idyllic landscape from the Farnesina House, Rome. Stucco relief. *c.*20 BC. Rome, Museo Nazionale.

she stands on tiptoe as though just alighting, her draperies swirling around her ankles; in her hands she holds a plumed helmet. The panel may be compared with contemporary Campana reliefs. The visual effect of such a vault may be judged from the illustration of the Stabian Baths at Pompeii (Ill. 14).

The House of Livia and the Farnesina House foreshadow the appearance of Style III, the 'ornamental', when the substantial architecture of Style II is replaced by frameworks of fantastic invention which make no serious pretence at solidity. As in Style I the walls again 'enclose' the room, and there is a preference for strong colours especially black, red and yellow. The new fashion developed first in Rome under Augustus, and soon spread to Pompeii where the *triclinium* in the House of the Centenary shows a transitional phase from the Farnesina House, with elongated candelabra tending to replace columns.[12] These motifs, decorated with increasing elaboration, are one of the features of Style III. Such innovations were strongly criticized by Vitruvius (*De Arch.*, V. 3–7).

At Oplontis early Style III survives well in the baths. In a recess at the end of the *caldarium* appears Hercules in the Garden of the Hesperides, with plain panels on either side. In the frieze above him is a cithara player,[13] and on either side there are small scenes of country life. On each stands a magnificent peacock. In the centre of the ceiling is a Nereid riding a sea-horse, with a veiled woman standing in an *aedicula* surmounted by a candelabrum on either side.

During the first century AD Style III developed with increasing elaboration. Its decorative schemes were rigidly symmetrical, with one or two narrower side panels directing attention to the central one. The panels show large expanses of plain colour, usually with smaller

84. Victory from the
Farnesina House, Rome.
Stucco relief. End of 1st
century BC. Rome, Museo
Nazionale.

central pictures. A well-known example of mature Style III occurs in
the House of Lucretius Fronto where small landscapes, apparently
attached to stalwart candelabra, occupy the side panels.[14] In the
centre is a larger picture of the Triumph of Bacchus set in an uncon-
vincing *aedicula*. The top part of the wall is decorated with fantastic
structures shown in perspective, but still delightfully improbable, with
a gay use of contrasting colours. Other mythological pictures from this
period include Perseus rescuing Andromeda, and Daedalus and the
disastrous fall of Icarus in the House of the Priest Amandus, parti-
cularly remarkable for its light effects and use of perspectival diminu-
tion. It has been pointed out that these artists had not mastered a
technique of perspective with a single vanishing-point – in fact they
used several.[15]

After the earthquake of AD 62 the rebuilt Pompeian houses were
decorated in Style IV. Some architectural vistas reminiscent of Style
II recur and the walls again lose solidity. Style III also survives, with

plain panels alternating with *aediculae* in which rather larger central pictures apparently hang on screens. Elaborate scenes in improved perspective continue at frieze level. Paintings characteristic of this period are found in the House of the Vettii.[16] The *oeci* leading off the peristyle are particularly splendid. One room is decorated with scenes of Pentheus assailed by the Bacchantes, the punishment of Dirce and the infant Hercules strangling the serpents (Ill. 85); other panels display architectural conceits. Another *oecus* has a geometric dado of painted marbles below a picture of Ixion bound to the wheel in the centre of an *aedicula*. More pictures of Daedalus showing the wooden cow to Pasiphae, and Dionysos surprising Ariadne, appear on the walls to right and left, placed in the centre of red panels with delicate garlands above. Most of the remaining decoration is painted on a white ground, and includes maenads and satyrs in the centre of panels with delicate floral borders, and seascapes or still-life pictures among the smaller architectural scenes. Everywhere there is a mass of fine detail, which is also to be seen in other rooms. The well-known Cupids, busy with a variety of occupations, appear in borders below panels. Similar Cupids have been found in houses at Herculaneum. Another Style IV development gave over an entire wall to a picture of a Roman stage, raised on a podium, with scenery and curtains. In a bedroom in the House of Pinarius Cerialis a play on the theme of Iphigenia in Tauris is shown taking place.[17] A more elaborate stage-setting can be seen in the House of the Hunt.[18]

In addition to major works, small scenes of family life occur at Pompeii, while others poke fun at the gods, burlesque the *Aeneid* or show pygmies hunting with varying success. (These last were probably originally inspired from Alexandria.) Pictures of the busy Pompeian forum, a baker's shop and men playing dice have all been preserved.

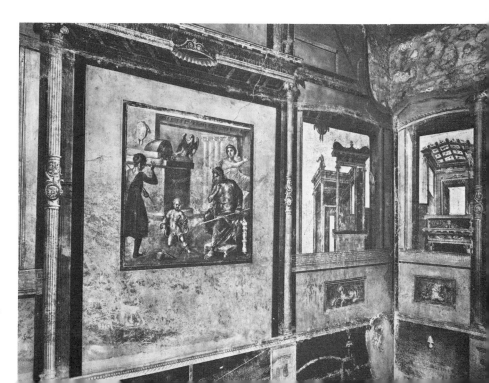

85. *Oecus* in the House of the Vettii, Pompeii. Panel showing the infant Hercules strangling serpents. Fresco. Between AD 63 and AD 79.

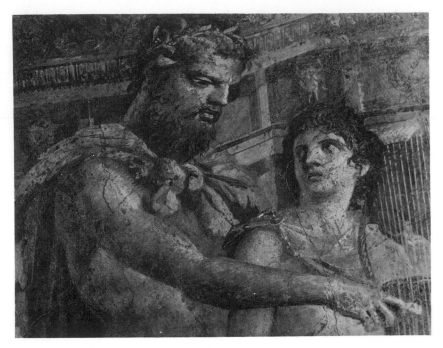

86. Achilles and Chiron (detail), from the basilica at Herculaneum. Fresco. 1st century AD. Naples, Museo Nazionale.

On the walls outside the workshops of Verecundus, a cloth-maker, paintings call attention to his craft. On one side a sprightly Mercury carrying a purse steps gaily out from his temple. On the other a splendid Venus, patron goddess of Pompeii, appears in a chariot drawn by elephants. Below is a narrow band, painted in monochrome, showing Verecundus' employees at work. Many paintings decorate the *Lararia*, the numerous household shrines, and portray the household gods and the *Genii* depicted as the great serpents of the underworld.[19] There are also numerous attractive still-lifes, for instance in the House of Julia Felix (Plate 5).

At Herculaneum, besides a range of paintings from private houses, the basilica provides fine examples of mural decoration. Around the interior walls shallow niches held large panel pictures depicting myths concerning Hercules, the patron deity of the city, and other heroes. Pictures surviving in the Museo Nazionale in Naples include Chiron teaching the young Achilles (Ill. 86), Hercules and Telephus, and Theseus victorious over the Minotaur. It has been suggested that these are by the hand of a painter called in from Naples, the 'Herculaneum Master', well-versed in Hellenistic traditions but with his own original ideas.[20] Also in the Museo Nazionale are pictures from Stabiae found in the eighteenth century, including the famous 'Spring'.[21] Now a programme of planned excavation is uncovering treasures from rich Stabian villas which can be dated between AD 63 and 79. Several different master-painters have been identified, and one of them was responsible for the great ceiling of an upper gallery in the Villa San Marco, inspired by the work of Famulus in the Domus Aurea.[22]

In Rome, meanwhile, by the time of Claudius, painted decoration

grew less formal and more naturalistic. Flowers, animals and still-lifes were special favourites for the walls of vaults and tombs such as the columbarium in the via Taranto or the Neronian columbarium of Pomponius Hylas.[23] Nero's palace, the Domus Aurea, uses Style IV designs for some of its rich decorations. Many of the walls were planned for deep dados of real marble and in some cases were never finished. An important trend developed here was the use of the white background for friezes and panels adorned with delicate architectural motifs, candelabra, garlands and small central panels reminiscent of Style III (Ill. 87). These designs also covered the vaults. Such decoration on a white ground became increasingly popular, and occurs widely until the late fourth century. Much of the most important work of Famulus, mentioned by Pliny as the chief artist, has not survived well. A scheme of vault decoration, now destroyed, showed the Domus Aurea at its most magnificent. This 'volta dorata', so called because its reliefs were encrusted with gold leaf, had in the centre a large medallion with a mythological painting set in a square. The rest of the space was filled in with small figures or pictures which were set in circular or rectangular panels framed in stucco stamped by moulds in low relief. Other reliefs, mostly animals and candelabra, survive only as faint imprints.[24]

87. Detail of Style IV fresco from the Domus Aurea, Rome. Mid-1st century AD.

Landscape and Garden Paintings in Rome and Campania. Brief allusions have been made to the appearance of landscape paintings from Style II onwards, and this important subject needs further consideration. Most remarkable are the paintings from the Via Graziosa (now Via Cavour) in the Esquiline district of Rome, now in the Vatican Library. They form a monumental frieze depicting eight scenes from books ten and eleven of the *Odyssey* in an uninterrupted landscape setting which remains unique in Roman art (Ill. 88). Impressionistically painted, their impressive effects of light and shade strongly influenced later works; the fact that the characters' names appear in Greek suggests a Greek artist or copybook. So far, however, no Greek prototypes have been found.[25]

Slightly later more landscapes appear. Some, on a much smaller scale, are believed to be the work of the school of Studius, an artist working during the Augustan period. He was described by Pliny (*NH*, XXXV. 116–17) as introducing small, attractive scenes with buildings (sometimes religious) in country or seaside settings enlivened by countryfolk carrying on their everyday pursuits.[26] His work has been described as 'bringing to perfection the whole genre of peopled architectural landscapes'.[27] Early examples, often in monochrome, occur at Boscoreale and Oplontis. A yellow frieze depicting an Egyptian landscape with pygmies and animals (including a camel) from the House of Livia betrays Alexandrian influences, as does the frieze already

88. The Laistrygones attacking the ships of Odysseus. Wall painting from a house on the Esquiline. Fresco. Mid–1st century BC. Vatican, Museo Gregoriano Profano.

described from the Farnesina House. Other examples form part of the Style III decorations at Boscotrecase.[28]

Landscapes on a much larger scale, sometimes covering whole walls, include the underground room from Livia's Villa at Prima Porta, now reconstructed in the Museo Nazionale in Rome.[29] Separated from the onlooker by low fences is a continuous painting of a large garden. On the sky-blue background appear trees, fruit and flowers of all seasons. Birds nest and fly around. Even insects are depicted. The painting is impressionistic with sketchy brushwork. It shows an acute observation of nature akin to the work praised by Pliny the Younger in his Tuscan villa (*Ep.*, V. vi. 22).

The Campanians obviously loved their gardens so that Livia's Garden Room is frequently echoed at Pompeii by, for example, two rooms in the House of the Fruit Orchard,[30] and most notably in the villa at Oplontis. When, after the earthquake of 62, building was resumed at the unfinished House of Venus Marina, the garden had to be reduced in size, so it was continued in part on the end wall of the peristyle even before some of the rooms were rebuilt. Here is the famous painting of Venus reclining on a shell. One one side of her is a statue of Mars on a pedestal with a garden in the background. On the other side is more garden with a fountain (Plate 4). Herons, pigeons and thrushes appear as well as oleanders, myrtle and other identifiable plants, some still blooming in the now restored garden.[31]

ROME AND OSTIA

In AD 79 the eruption of Vesuvius ended developments in the Campanian cities and as a result the amount of later wall painting available for study is considerably smaller. Style IV continued in Rome, and the Domus Aurea influenced the decoration of Flavian buildings. Under Trajan the repertoire of the decorators showed growing restraint and simplicity. The importance of painting diminished in favour of real marble veneers and wall and vault mosaics (see Chapter 5). With Hadrian came an increased neo-classicism, but evidence is limited except from his villa at Tivoli. Here several fine white stucco ceilings survive, mostly decorated with geometric and plant designs in low relief.[32] Later on, very delicate work is found, again in white, and including charming mythical creatures (for example in the Tomb of the Valerii dated to *c.* 159).[33] The Tomb of the Pancratii (Plate 30), however, dated a few years earlier combines the use of stucco with colour, the white reliefs often appearing on a coloured background.[34] The magnificent cross-vaulted ceiling has a central medallion of Jupiter on the back of an eagle. On either side are scenes from the Trojan War and in the foreground Hercules, Bacchus, Minerva and Diana.

The gap left by the Campanian cities is partly filled from Hadrianic times onwards by discoveries at Ostia, which mostly come from large multi-storeyed blocks let as flats. More opulent houses tended to use marble veneers up to quite a high level, so little painting survives. Evidence is also scarce from public buildings. Compared with

Pompeii, technique has declined with little true fresco surviving. The middle-class customers wanted quick and economical work generally painted in tempera on a dry surface, and this survives badly. Most of the walls are of brick and are dated by their stamps, but the paintings may, of course, be later. Many reminiscences of Styles II to IV are found, but the architectural motifs become increasingly unimportant and gradually disappear. Framed panels containing one or two figures occur, with much use of red and yellow grounds. Occasionally mythological scenes are also found.

One of the wealthier inhabitants must have owned the House of the Muses. Above a black dado in one room the wall is divided by slender columns reaching to frieze level. Besides these, delicate architectural pilaster strips outline the panels on which appear the figures of the Muses. More architecture and single, smaller figures occur on the upper half of the wall. A rather insubstantial Style IV has provided the inspiration here. A corridor in the House of Ganymede, also built under Hadrian, originally had red and yellow decoration on a white ground. By 170–80 this was replaced by the increasingly popular red, with garlands and other details in yellow, green, blue and grey. The tablinum walls are covered with panels of various sizes, arranged not only side by side but also one above the other, three or four deep. Some are framed figure-scenes, including the Jupiter and Ganymede after which the building is named. Decorative motifs comprise birds with candelabra and some are apparently recessed or show buildings in perspective. The *aedicula* has now vanished from the scene; these walls are dynamic, but restless and distracting. Another room, however, provides a complete contrast with architectural detail evolved from Styles III and IV with fine white lines shaded in red on a yellow ground. Tiny landscapes occur in the centre of the panels.[35]

More paintings survive from the Ostian cemeteries, especially those of Isola Sacra. On a smaller scale, and dating from the mid-second century they reflect the tendency to emphasize space and depth for their figures. Motifs such as masks, garlands, birds and garden scenes occur, with dancing satyrs and such mythological characters as Hercules, Orpheus and Proserpina.

Lack of published material makes it difficult to trace later second-century developments. As Hadrianic classical tendencies weaken, figures painted with a luminous effect grow in importance, architectural motifs get simpler, and there is less variety in decorative ideas. Realism causes the retreat of fantasy. White grounds and strong colour contrasts, especially red and yellow, are found with multicoloured frameworks defining panels. Reminiscences of earlier styles, however, sometimes still prevail, affected by the individual preferences of client and atelier. At Ostia a room in the House of Menander converted towards the end of the second century into a Mithraeum provides a good example of white walls divided into large panels, each framed by bands of three different colours and divided from each other by a wider band. Small landscapes reminiscent of Style III appear. The dado has been destroyed, but above the panelling was a stucco cornice.[36]

An innovation is the appearance of scenes on a larger scale which ignore the old threefold division of the wall. A painting from the *triclinium* of a house in the Via dei Cerchi shows the lifesize figures of slaves occupied in serving dinner in front of a series of tall columns, perhaps a portico, perhaps a stage setting.[37] Still more striking is the remarkable scene from a house underneath the church of St John and St Paul in Rome (Plate 29). The date has been disputed, and so has the subject. The beginning of the third century seems possible and the scene shows two women reclining on a rock and being greeted by a man. They are surrounded by blue water on which Cupids are gaily boating and the painting may have continued on adjacent walls. One interpretation believes the picture to be of Proserpina returning from Hades, another suggests Peleus and Thetis.[38] Other such scenes found at Ostia show Venus rising from the sea accompanied by Cupids (from the Baths of the Seven Sages) and Europa and the Bull with various fish (from the Pharos baths)[39].

The third century was a period of change and unrest for the Roman Empire. Men searched for a more personal religion in which a good life was rewarded after death, and paintings from tombs and temples record these aspirations. By this time followers of the cult of Mithras had a number of small temples in Rome, Ostia and elsewhere, normally adorned with statues, reliefs or paintings. The most important scene shows Mithras slaying the bull from whose blood sprang the life-giving forces needed by mankind.[40] A painting from the Villa Barberini has this theme with small scenes depicting Mithras' life on either side. Near him is a semi-circle adorned with the signs of the zodiac and above this the busts of sun and moon.[41] A Mithraeum under the church of Santa Prisca in Rome showed seven masked men representing the Mithraic grades, accompanied by servants or devotees. Earlier paintings found underlying these included passages from Mithraic hymns.[42]

Catacomb Painting. Some interesting descriptions of later paintings occur in the works of the Philostrati, particularly in Fabius Philostratus' *Life of Apollonius of Tyana*.[43] Otherwise, from the third century onwards much of the surviving evidence comes from the Christian catacombs. These continue the linear style already found in the second century, the area to be painted being split up into various geometric shapes by fairly fine lines. This lends itself well to the decoration of vaults and recesses in the cemeteries. The two-dimensional figures are painted (sometimes carefully, sometimes merely sketched) on a white ground, by artists with a wide range of skills. Older traditions survive side by side with a less serene style in which illusionism tends to replace naturalism. Originally the Christians seem to have disapproved of representational art, but by now certain pagan subjects were being converted to their use.[44] In any case before the Edict of Milan in 313 representations could not be too explicit as Christians were still liable to persecution. Jewish sources play an important part in catacomb art,[45] and there may have been influences from the East, notably from Dura Europos.

Before 313 the symbol of the cross seems to have been avoided. One theme was deliverance shown by such Old Testament scenes as Daniel in the Lion's Den, or the three youths in the Fiery Furnace. An early painting in the Catacomb of Priscilla showing Moses striking the rock was symbolic both of deliverance from thirst and also of the Sacrament of Baptism. Again Jonah and the Whale, a favourite subject, means not only deliverance but also suggests the Fall of mankind, the Redemption, and Paradise (Jonah sleeping peacefully in the shade of the gourd tree). New Testament scenes at first emphasize prophecies of Christ's Coming, his Baptism, the Redemption and Salvation of mankind, and miracles such as the Raising of Lazarus and the Healing of the Paralytic. Scenes from the Catacomb of Callixtus of the early third century include Jonah, Christ as the Good Shepherd (a theme developed from scenes of Orpheus and the animals), Christ and the Woman of Samaria, and the miracle of the Loaves and Fishes.

From the Catacomb of Priscilla comes a mid-third-century figure scene[46]. On the left is a group of three: a seated man, believed to be a bishop, is looking at a girl who is reading from a scroll. Behind her stands another man, probably a deacon. The ceremony is probably the Conferment of the Veil upon a Virgin, who appears again in the centre in the characteristic attitude of prayer. On the right is a seated woman nursing a baby, probably Mary and Jesus. The faces are impressionistically rendered by strong touches of colour, with marked highlights on the veil and in the ecstatic expression of the eyes of the praying girl. On the ceiling a medallion of the Good Shepherd appears surrounded by linear decoration and various birds including a fine peacock. The lighter side of catacomb painting is exemplified by the vault of the crypt of St Januarius in the Catacomb of Praetextatus.[47] Here, divided by horizontal red lines, are bands with birds, flowers and leaves, including nests of fledglings. This is decoration pure and simple, having a vigorous life of its own.

If during the third century tastes swayed between earlier classical ideas and a more restless style using rapid brush-strokes for a vivid but less finished result, the reigns of Diocletian and Constantine brought changes. So far little secular evidence of this period has been found; but by the end of the century, the lower levels of the walls are again faced with marble veneers – a fashion which becomes increasingly important in the fourth century as illustrated by the houses of Cupid and Psyche and the Nymphaeum at Ostia.[48] The linear system continued, but seems to have died out by the time of Constantine. From Diocletian onwards architectonic schemes with columns recall Pompeian Style II, but a very ill-digested Style II, lacking its original illusionistic coherence. In the catacombs the linear divisions are replaced by heavier frames. Under Constantine classical motifs reappear and in the cemetery of Panfilus elegant garlands, flowers and birds survive.[49] Figures tend to be less individual and to lack expression. Secular scenes occur like those of the Hypogeum of Trebius Justus showing his various activities,[50] as well as a larger variety of Christian themes. Later in the fourth century more realistic human figures return. The bust of Christ in the centre of a ceiling in the

Catacomb of Commodilla exemplifies this (Ill. 89) with its carefully drawn face conveying a new and powerful expressiveness.[51]

One factor which affects the understanding of catacomb painting is the lack of comparative material from early churches and houses. Such churches as existed were in fact usually rooms in houses obliged to keep secret their real purpose. From 313, once the threat was over, large churches were built by Constantine and others, but by this period Christian painting is often supplanted by wall and vault mosaics (see Chapter 12).

WALL PAINTING IN THE PROVINCES

Little evidence has yet been found for wall painting in Northern Italy, but the Villa of Sette Finestre near Cosa has produced important Style II decoration of first century BC date.[52] Meanwhile, about the same time at Magdalensberg in Austria the exceptional quality of the local iron attracted traders from far and wide. A Celtic *oppidum* was joined by a trading settlement with buildings decorated with paintings influenced by Style II. Here the Hellenistic influence was strong. Columns with Ionic capitals, and figure scenes with Iphigenia, Minerva and Dionysos suggest Greek or Asiatic artists.[53] After Noricum became a Roman province, a Roman city grew up at Virunum nearby. This also produced interesting interior decorations.

By 40 BC Style II had spread to Gallia Narbonensis. At Glanum it occurs in several buildings, notably in the Maison à deux alcoves. Here wall J in a bedroom (Room 2) had a white dado strippled in red and black, divided up by black vertical lines which act as stems for double volutes. Above the dado was a horizontal yellow band decorated with fine brown undulating lines apparently imitating the grain of wood. Then came panels decorated with slabs of imitation marbling, framed by red borders and separated by a pilaster strip with green laurel leaves

and yellow spots and discs painted on a black ground. Above the panelling was a brown frieze with green leaf scrolls. Other walls in the same room show columns among the panelling. From several walls, including J, there is evidence that the original dado had been re-plastered and freshly painted c.35–30 BC.[54]

The decoration at Glanum is a mixture of Pompeian ideas incompletely carried out and several motifs peculiar to this site. The double volutes occur at three other Glanum sites and at Ensérune and Martizay. Outside France the best parallels come from the House of the Masks on the Palatine, and Masada. The fluted columns in Room 2 recall early Style II examples at Pompeii, but here they are suspended in space and instead of a podium they stand on the band of grained wood. This latter feature so far has only been found at Glanum. Such material illustrates the problems that occur with much provincial wall painting. Mme Barbet observes that the work was done either by an incompetent artist or by one who had failed fully to assimilate Italian models. Yet the shading and highlights of the fluted columns and the garland design used for pilaster strips show that this artist was a master of his craft. Possibly questions of depth and perspective did not interest him and he was fascinated by the purely decorative motifs.

Evidence for the influence of Style III comes from French sites such as Vienne, Périgueux and the temple at Champlieu, and also from Commugny (Switzerland).[55] Pompeian influences persist into the second century. Exceptional discoveries include the villa at Keraddenec (Finistère) with paintings of three periods – mid-second, late second and third century, and also stucco work.[56] Multicoloured geometric bands decorated with sea-shells have been found in Vienne, Carnac (Finistère) and other sites.[57]

In Britain excavations at Verulamium (outside modern St Albans) have revealed wall painting dating from the mid-first to the fourth centuries in a number of houses. Several fragments pre-date AD 60, including one piece showing a skilfully painted lyre and a quiver on a very good quality red ground. One reconstructed wall has a dado and panels imitating large-grained marbles. Columns covered with scale pattern between the panels suggest a colonnade reminiscent of Style II. This wall can be closely dated to AD 125–30. Decoration of Antonine date includes motifs such as elegant candelabra, a peopled acanthus scroll and part of a corridor ceiling.[58] Paintings of c.AD 75 at Fishbourne include a small seascape resembling one found at Stabiae.[59]

More elaborate second-century walls from Leicester are decorated with candelabra, human figures and friezes with theatrical masks. Britain is unusually rich in fourth-century painting from military sites like York, and villas like Rudston, Winterton and Kingscote.[60] Research is still incomplete on the unique Christian material from a probable house church at Lullingstone, Kent. Here one wall depicts six praying figures and the others include scenes associated with the Chi Rho monogram.[61]

From the Netherlands, Germany, Switzerland, Austria and across Central Europe to Pannonia, there are sites where fine painting and

90. Portrait of (?) Constantia from the ceiling of the Constantinian Palace, Trier. Fresco. Before AD 326 Trier, Bischoffliches Museum.

sometimes stucco work from the mid-first and second centuries have been found. These are influenced by Style III with memories of Styles II and IV. A typical design was found near Cologne Cathedral (Plate 7). Later work is not so well represented, but a fourth century hunt scene is another recent Cologne discovery [62] Many wall painting finds from Trier include the coffered ceiling from the palace which underlies the double cathedral, a great treasure dated c.320. Here, painted on a blue ground, are Cupids at play and larger rectangles containing over-lifesize portraits of the ladies of Constantine's family, including a fine portrait of his half-sister Constantia, formerly identified as his mother Helena (Ill. 90).[63]

On the other side of the Mediterranean fine painting as well as splendid mosaics survive, notably at the villa of Dar buc Ammera (Zliten) near Lepcis Magna.[64] A large section of the vault of the cryptoporticus datable c.AD 50–75 has been reconstructed showing a design with Dionysos riding the panther in a central rectangle, surrounded by a fantastic framework of delicate garlands and arabesques, and incorporating smaller pictures of heads crowned with olives, and animals. One small rectangle shows a delightful impressionistic

village scene (Ill. 91), painted with heavy shadows in soft ghostly colourings. This decoration has much in common with landscapes from Stabiae and designs from the Domus Aurea. Also from the villa come scenes of pygmies reflecting the strong Alexandrian influence only to be expected here. Other treasures include material from the rich house of the Tragic Actor at Sabratha,[65] fine hunting scenes of the third or early fourth century found in the baths at Lepcis Magna[66] and portraits of the deceased from a fourth-century tomb at Ghirgaresh near Sabratha, guarded by two richly clad attendants holding lighted candles.[67] In Egypt paintings recorded from the Temple of the Imperial Cult inserted into the Temple of Ammon at Luxor have much in common with the Ghirgaresh tomb. Four figures in a niche probably depict the Emperors Diocletian and Maximian and the Caesars Galerius and Constantius Chlorus.[68]

In the eastern provinces Hellenistic traditions persist later. This is shown in third-century tomb paintings at Palmyra. Temples were also much decorated, and the Temple of Bel reflects Graeco-Oriental influences in what is known as the Parthian style, characterized by static frontal poses and stiff drapery.[69] A treasury of religious painting has been recovered from Dura Europos on the Euphrates, a Parthian town occupied by the Romans from AD 165 to 256. Material comes from the temples of the Palmyrene gods and of Zeus, as well as from a Mithraeum, the baptistery of a Christian house church and a synagogue (Ill. 92). Old and New Testament scenes with elements recalling catacomb painting come from the baptistery, and numerous Old Testament incidents arranged in three registers of figures from the synagogue dated to c.245.[70] Again the static frontal poses are present and the scenes lack perspective and are only two-dimensional al-

91. Village scene from the ceiling of the Villa of Dar buc Amméra, Zliten. Fresco. c.AD 70. Tripoli Museum.

92. West wall of Synagogue, Dura Europos. c.AD 245. Yale University Art Gallery (reconstruction).

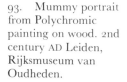

93. Mummy portrait from Polychromic painting on wood. 2nd century AD Leiden, Rijksmuseum van Oudheden.

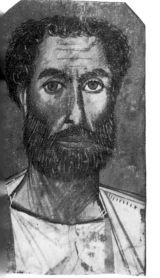

though brilliantly coloured. In the centre of the west wall was the Torah shrine and on the right of it scenes showing the destruction of the temple of Dagon by the Ark which appears on its eventual way back to Israel (I Sam. 5:6), and of Pharaoh ordering the murder of Hebrew male children. Further left appears Moses saved by Pharaoh's daughter (Exodus 1:6; 2:3–10).

It would seem therefore that far from simply copying Greek traditions, Roman wall painters were affected by many influences which they assimilated in varying degrees. The Egyptian mummy portraits, for example, may have affected figures at Dura Europos, but they arose in Roman centres in Egypt carrying on earlier customs. The ideas spread by armies, traders, administrators or itinerant artists were received with varying enthusiasm in developing provinces. The flood of new discoveries from these areas may not only help us to assess the strength of such Roman influences. It may also fill gaps where Italian material is lacking.

PORTRAIT PAINTING

No reference has so far been made to portrait painting, although a few examples occur on the walls of Pompeii.[71] In a class of their own are some portraits placed on Egyptian mummies (Ill. 93). Painted on wood or sometimes linen and dating from the first to the fourth century, they are very individual works, produced, if not in life, at least by an artist acquainted with his subject. Details, particularly hair-styles, enable their close dating and they are believed to belong to well-to-do Hellenized families who settled in Egypt and adopted local burial customs.

There is a theory that some portraits were displayed in the house before being attached to the mummy, but this is disputed. However, one exceptional discovery is a portrait medallion painted on wood which shows Septimius Severus, Julia Domna and their two sons, also found in Egypt. Evidence for such medallions occurs on a painted sarcophagus from Kerch in South Russia which depicts an artist in his studio with two completed roundels on the wall.[72]

CHAPTER FIVE

Mosaics

D. J. SMITH

INTRODUCTION

This chapter is essentially confined to the first four centuries AD and concerned with decorated pavements of *opus tessellatum*: that is, made with tesserae (or tessellae), more or less roughly shaped cubes of *c*.0.5–1.5 cm. ($\frac{3}{16} - \frac{9}{16}$ in.) cut from various materials. Mostly these are black, white and coloured marbles and other stones and tile, but occasionally also clear and coloured glass and *smalto* – opaque glass (plur, *smalti*: 'glass paste') and sometimes pottery. Smaller tesserae and other shapes were cut for details. The tesserae were set as closely together as possible in a bed of fresh, fine mortar, on a firm foundation or base. When the bed had set the interstices between the tesserae were grouted (filled) with fine liquid mortar: and when this had set the mosaic was cleaned and polished.[1]

Recorded Roman mosaics run into thousands, but distribution and publication are both far from even and these aspects are inevitably reflected in this chapter. Moreover, except at Ostia, few have been closely dated on independent evidence. For the overwhelming majority, therefore, dating must rely on analytical comparison with dated mosaics and, if justifiable, with relevant dated works in other media. Since this process must involve subjective factors, as well as knowledge and experience, it is not surprising either that opinions may differ or that the reassessment of even long accepted opinions is a continual and necessary activity.

What is certain is that there can never be a history of Roman mosaics in the sense of a demonstrably lineal evolution of a single or universal style. The Empire was too vast and communications were too slow and intermittent for such an evolution to be possible. At most one can identify traditions, plot their diffusion, and study their interaction. This becomes increasingly difficult with the rise of regional and even local schools from *c*.AD 150 onwards. Furthermore, the character of fourth-century mosaics in Italy and the European provinces differs significantly from that of the earlier mosaics.

First, however, it is fundamental to the chapter to recall the origin and types of mosaic which preceded, developed into, and permanently influenced the repertory and character of Roman mosaics.

THE HELLENISTIC FOUNDATIONS

Opus Tessellatum and *Opus Vermiculatum*.[2] Pavements of *opus tessellatum* with borders and motifs in black or colour on a white ground, and

sometimes incorporating a polychrome centrepiece or figured panel, developed in the Hellenistic world (possibly in Sicily) in the third century BC[3] and were well established before 100 BC.[4] The most ingenious and skilled Hellenistic mosaicists, however, saw their medium as a means of copying or imitating paintings. This they achieved by reducing the size of the tesserae to 4 mm. ($\frac{5}{32}$ in.) cubed or less (even to 1 mm. [$\frac{1}{32}$ in.] cubed!), and employing the widest possible range of coloured marbles and *smalti*. The result was the so-called *opus vermiculatum*, in the finest examples of which the tones are as subtly graduated as in painting; and colour may even be mixed with the grouting, or the grouting may be painted, to blend with the adjacent tesserae.

It was certainly in *opus vermiculatum* that the 'most celebrated' Sosus (*c.*150–100 BC), of Pergamum in Asia Minor (Turkey), executed the two famous subjects for which his name has been immortalized by the elder Pliny (*NH*, XXVI. 184). One depicted doves perched on the rim of a bowl of water and reflected therein, the other an 'unswept floor' littered with remnants of food from a banquet. Versions of both subjects are preserved in *opus vermiculatum* and also in *opus tessellatum* of the later Hellenistic and the Roman period;[5] and many other subjects in the Roman repertory must likewise be versions of renowned Hellenistic masterpieces, whether of painting or of *opus vermiculatum*.[6]

Remains have survived of a few pavements of *opus vermiculatum* ranging in date from *c.*100 BC to *c.*AD 100 (Ill. 97). The execution of such pavements would have been extremely time-consuming as well as demanding the most gifted and skilled craftsmen, and they were presumably rare showpieces.

Emblemata. From *c.*200 BC, therefore, the typical examples of *opus vermiculatum* were relatively small rectangular panels, some only *c.*40 cm. ($15\frac{3}{4}$ in.) square, but others considerably larger. These could be composed in workshops either on a slab of marble or in a terracotta tray with raised edges (Ill. 94); or they could have been made by gluing the tesserae face-down on a sheet of suitable material on which the subject had been painted in reverse, the material and glue being removed with hot water when the panel had been bedded *in situ* with the tesserae face-up. Such panels could be transported and inserted – hence their name, *emblemata* (singular, *emblema*) – into otherwise plain or simply decorated pavements, or they could be affixed to walls.[7]

Emblemata, also, were copies of paintings[8] or of mosaics imitating painting in *opus vermiculatum*: a well-known example of *c.*100 BC is that from Hadrian's Villa at Tivoli (Italy) which closely reproduces the doves of Sosus.[9] They range in date from perhaps before 200 BC to *c.*AD 200[10] and have been found in Hellenized lands and territories from the eastern Mediterranean to southern Italy, southern France, Spain, and North Africa (see below). Re-use of some in later pavements, as in the case of the above-mentioned *emblema* from Hadrian's Villa, indicates that they were valued as *objets d'art* from generation to generation.[11]

The most accomplished *emblemata* date from the second century BC. Thereafter, although pavements in *opus vermiculatum* were still made

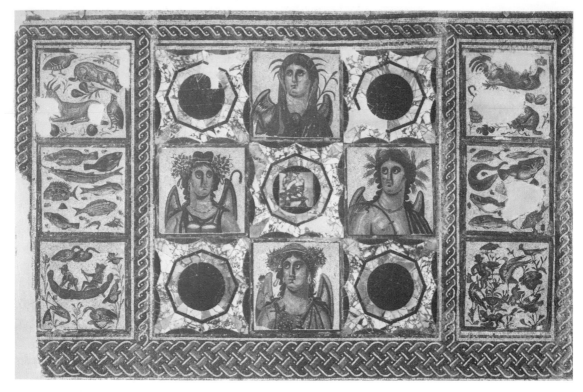

until *c*.AD 100 (see below), and *emblemata* and unframed figured centre-pieces in *opus vermiculatum* until as late as *c*.200, *emblemata* in *opus vermiculatum* were generally superseded from *c*.150 by framed subjects in panels composed of tesserae little or no smaller than those of the surrounding *opus tessellatum*. These, however, were not necessarily laid *in situ*: like the original *emblemata* they could have been prefabricated in a workshop and inserted into a pavement.[12] If so, the term '*pseudo-emblemata*' sometimes applied to such panels is both inappropriate and misleading. These are equally *emblemata*; but for the sake of simplicity an *emblema* not in *opus vermiculatum* (i.e. of tesserae over 4 mm. [$\frac{5}{32}$ in.]) will henceforth be called a panel, however it was made.

94. The Seasons and Nilotic subjects. Pavement of *emblemata*. From Zliten, Tripolitania. 333 × 230 cm. *c*.AD 100. Tripoli, Archaeological Museum.

THE HELLENISTIC LEGACY

Although relatively few mosaicists' names are preserved in 'signed' pavements of the Roman period, it must be significant that Greek names predominate,[13] for this implies that the craft remained largely in the hands of Greeks, and goes far to explain how the Hellenistic techniques and repertory were passed on.[14] In brief, mosaicists of the Roman Empire inherited the tradition of the decorated pavement of *opus tessellatum* with a white background, and developed from the *emblema* in *opus vermiculatum* the panel in *opus tessellatum*, the subject being necessarily simplified; they inherited a world of subjects derived from Greek mythological paintings which permanently dominated Roman figured mosaics; and they inherited and ceaselessly exploited a repertory of patterns and motifs, naturalistic, conventionalized,

and geometric, of which three-dimensional representation was a characteristically Hellenistic feature.[15]

This legacy is naturally most evident on the Hellenized eastern shores of the Mediterranean and in Magna Graecia (southern Italy and Sicily). Further afield, however, and with the passing of time, the Hellenistic tradition lost momentum. For example, although the mosaics of the Roman north-western provinces perpetually reveal Hellenistic contributions and the memory of the *emblema*, 'three-dimensional' patterns and motifs are extremely rare and apparently never reached Britain.

It is to Roman mosaics that the rest of this chapter must be devoted; and the obvious point of departure is Antioch (now in Turkey). This metropolis of the province of Syria has yielded some 300 mosaics representative of several centuries of the continuing Hellenistic tradition in the eastern Mediterranean.

ANTIOCH AND THE HELLENISTIC TRADITION

There was a pre-imperial Hellenistic Antioch but unfortunately no mosaics earlier than *c*.50–115 have been recovered.[16] Nevertheless, these clearly reveal Hellenistic ancestry in their employment of *opus vermiculatum* to copy or imitate paintings of mythological subjects,[17] namely the Judgement of Paris (Plate 12), Aphrodite and Adonis, and the drinking contest between Dionysos and Herakles (Plate 9).[18] Moreover, the first two are surrounded by naturalistic scrolls on a black ground, that surrounding the Judgement of Paris being a most realistic vine-scroll in which are eleven birds, three grasshoppers, two lizards and a butterfly.[19] Both scrolls proceed from two male heads, axially 'above' and 'below' the picture. Here the scrolls may have been prefabricated with the pictures,[20] making *emblemata* of the exceptional size of 1.86 m. (6 ft.) square. In another mosaic antedating 115 were found several relatively small *emblemata* depicting birds.[21]

In a figured panel of 98–115 the linear frame within the geometric border is noteworthy in that its sides are slightly prolonged to intersect.[22] The result recalls the form of a wooden picture-frame from Egypt[23] and of frames depicted in a painting of an artist at his easel from Kerch in the Crimea.[24] In other words, the frame in this mosaic supports the appearance of the subject within as a copy or imitation of an easel-painting; and such frames, although rare in mosaics elsewhere,[25] enclose other figure-scenes at Antioch.[26]

The Hellenistic traditions attested by the earliest-known mosaics of Antioch continued to flourish throughout the second and third centuries.[27] A pavement of *c*.115 preserved part of a design of two concentric circles in a square, the outer circle radially divided into twelve panels depicting personifications of the months, the angles of the square portraying the Seasons as winged female busts on a blue-black ground; all the figures are named in Greek.[28] Again, the detail and modelling, in very small tesserae, and the dark backgrounds, suggest painting. An adjacent panel depicted Oceanus and Thetis amid a profusion of marine creatures, also in very small tesserae, those

of the background and parts of the drapery being of green and blue glass to enhance the aquatic character of the subject.[29]

At Daphne, five miles south of Antioch, a mosaic of c.250 at the earliest preserved a notable combination of Hellenistic illusionism and the bird's-eye viewpoint in the form of a 'three-dimensional' representation of a U-shaped table laden with silver vessels and delicacies for a banquet, the table itself being 'executed in brown with greyish highlights, to indicate the polished and lustrous wood'.[30]

Most striking of all, however, is the pavement of c.250–300 depicting again the drinking contest between Dionysos and Herakles (Plate 8).[31] Now, the pastel tones and painterly chiaroscuro of the earlier version have given way to bold contrasts heightened by the vivid colours of *smalti*, and the panel here is represented as a wall painting in a remarkably 'three-dimensional' architectural setting with 'projecting' plinths, columns, and coffered vault above, immediately recalling late 'second-style' Italian wall-paintings of the first century BC (see Chapter 4). Although surrounded on three sides by conventional geometric patterns such a panel is wholly inappropriate to a floor and perfectly illustrates the Hellenistic mosaicists' striving for illusory effects, even if ill-conceived. In this scene the gathered curtain evokes the theatre, as do other figured scenes in mosaics from Antioch.

There were similar pavements at Antioch, earlier and contemporary; and the local fashion that these evidently represent – such mosaics are as yet unknown elsewhere – is attested in another well-preserved mosaic which must be contemporary with that just described. This depicted Dionysos and Ariadne, with a satyr and a maenad in narrower flanking panels, in a tripartite 'three-dimensional' architectural setting even more reminiscent of late Republican wall-painting in Italy.[32] Presumably, therefore, such mosaics are imitations of a style of wall painting in vogue in the Hellenistic world in the third century AD.[33]

One outstanding example suffices to illustrate the continuing momentum of the Hellenistic tradition – such was its force at Antioch – at least as late as c.350. It is, of course, the best known mosaic of the so-called 'Constantinian Villa' at Daphne.[34] This was centred on an octagonal basin from which radiated four trapezoidal panels forming the design of a Maltese cross. Surrounding the design is a luxuriant acanthus scroll on a black ground in which are clusters of grapes, other fruits, flowers, and, axially on each side, a human head. Between the arms of the cross stand winged female personifications of the Seasons, their feet hidden in clumps of acanthus in the angles of the scroll. Two of the trapezoidal panels illustrate mounted huntsmen attacking wild beasts, while another depicts huntsmen sacrificing to Diana (Plate 10),[35] and the fourth portrays Atalanta (or Diana?), Meleager attacking the Calydonian boar, and a lion. An imitation of a gilded egg-and-tongue moulding frames each panel and also the entire design; and there is an outer border of 'three-dimensional' swastika-meander enclosing 'three-dimensional' oblong panels, like shallow boxes, in which are representations of rustic scenes, groups of cupids, and birds in confronted pairs.

The scroll is of a kind familiar from other mosaics of Antioch, including one of the earliest already noted, and typically Hellenistic.[36] The stately Seasons, however, have no known precedent here. The hunting scenes were also apparently a novelty at Antioch, and, if so, herald the succession of hunting mosaics which were to become a characteristic feature of later mosaics at Antioch and elsewhere in the eastern Mediterranean.[37] Executed in tesserae of marble and *smalti* almost comparable with those of *opus vermiculatum* (c.3–6 mm. [$\frac{1}{8} - \frac{1}{4}$ in.]3), the panels preserve through masterly effects of colour and perspective the illusion of depth and atmosphere developed in Hellenistic painting.

ITALY

Hellenistic traditions were inherited by the Greek communities in southern Italy and Sicily and also entered Italy through Adriatic ports, notably Aquileia.[38] In mosaics these took the form of *opus vermiculatum*, *emblemata*, which undoubtedly came to be made in Italy[39] as well as imported, and also pavements of white *opus tessellatum* relieved by simple patterns and motifs in black such as would have been known to the Italian mercantile community on Delos.[40] These pavements evidently appealed to taste in Italy, and were developed there into a 'black-and-white tradition' which dominated Italian mosaics from the earlier first century to the later third.[41] It is represented everywhere; but at Ostia its entire history is spanned by nearly 450 mosaics, mostly dated.[42] To turn from the mosaics of Antioch to these is like stepping out of dazzling sunlight into shade: it takes time to adjust one's vision and to recognize that many of the Italian black-and-white patterns and motifs are versions of poly-chrome geometric patterns and motifs at Antioch and elsewhere in the Hellenized world.[43]

Moreover, the Italian black-and-white pavements are emphatically two-dimensional; and, although the first-century mosaics of Pompeii and Herculaneum include a few simple representations of figures[44] the contemporary pavements at Ostia were strictly geometric. In fact, they developed little there before the time of Hadrian (117–38), and the unpretentious character of the repertory prevailing c.120 is well represented by those of the House of the Painted Vaults[45] and that of c.130 by the pavements of the House of the Yellow Walls[46] and the House of the Muses.[47] Both houses of c.130 include patterns of a new type, lighter and livelier, formed of elegant foliate as well as geometric filigrees, which are characteristic of the Hadrianic period and found in Hadrian's Villa at Tivoli itself.[48] In the Caseggiato of Bacchus and Ariadne this style was developed to include birds in a mosaic of c.120–30 and also, in another part of the same pavement, as an all-over circular composition with winged figures in silhouette;[49] and in another contemporary pavement it formed a 'carpet' pattern with an un-framed central mythological scene.[50] In a circular composition of c.130 in the Baths of the Seven Sages it took the form of silhouettes of huntsmen and wild beasts in an all-over scroll.[51] Mosaics such as these were unknown in contemporary Antioch.

As early as *c*.40–50 a panelled black-and-white mosaic at Ostia depicted dolphins in silhouette and profiles of heads personifying provinces and the Winds,[52] but full-length figures of human form did not appear until the second century;[53] and from the beginning, again unlike any contemporary mosaic at Antioch, they were freely distributed about the floor. The earliest of such representations are those of *c*.115 in the Baths of Buticosus which depict mythological marine figures and Buticosus himself.[54] Although obviously something of a caricature the latter is the first portrayal of an actual human being in *opus tessellatum*; and an interest in human beings and their daily life appears again in a pavement of *c*.120. This depicts mule-carts with their drivers, in the bath-house of whose guild the mosaic was laid.[55] Accompanying them are marine figures again, here including Neptune himself driving two sea-horses, a forerunner of the great triumphal processions of the god and of his consort and their mythological and marine retinue which sweep across two of the three pavements of *c*.139 in the Baths of Neptune (Ill. 95).[56] These, clearly the products of an Ostian school, represent the apogee of the black-and-white figured mosaics; and with them the life and mythological world of the sea was established as a theme which remained popular in the black-and-white tradition until *c*.250–300.[57] Translated into colour this theme became widely fashionable in the western Empire from

95. The Triumph of Neptune, in the Baths of Neptune, Ostia. Black-and-white mosaic. 18.10 × 10.40 m. *c*.AD 139.

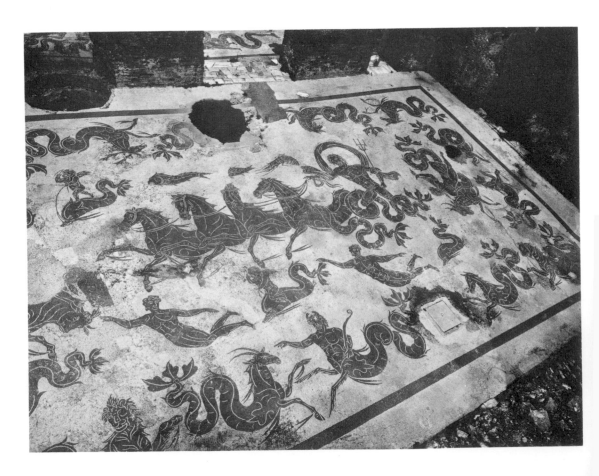

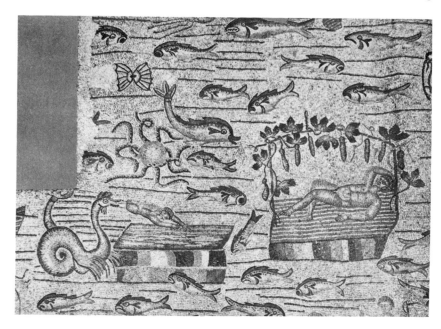

96. Part of the mosaic depicting the story of Jonah, in the Basilica of Bishop Theodore, Aquileia. AD 308–19.

Antonine times until the later fourth century (see below). It must not be forgotten, however, that mosaics of the black-and-white tradition also included other themes from Greek mythology and subjects related to ordinary life.

The Italian black-and-white tradition was a unique contribution to the art and history of Roman mosaics; but concurrently with that tradition there were also in Italy polychrome pavements deriving obviously from the Hellenistic tradition.[58] Indeed, even in Ostia there was a polychrome mosaic of *c.*127, in *opus tessellatum*, which was designed as a grid enclosing sixty-eight square panels each depicting a bird or still-life; and particularly interesting, because more overtly suggesting Hellenistic influence, is its border of 'cuboids' ('three-dimensional oblongs') depicted vertically as so often in borders and patterns at Antioch.[59] A little later, *c.*150, two other mosaics incorporated polychrome panels, four in one portraying busts of the Seasons and surrounded by a 'three-dimensional' swastika-meander,[60] and one in the second, associated with black vine-scrolls on a white ground, depicting two birds pecking at fruit in a basket between them.[61] There are later examples of a combination of the black-and-white and the polychrome traditions, the most instructive being one of *c.*200–10 near Rome in which a craftsman evidently trained in the black-and-white tradition attempted – and dismally failed – to render in colour a marine subject typical of that tradition.[62]

This mosaic presumably reflects an incipient preference for polychrome pavements. Not until the beginning of the fourth century, however, did polychrome pavements become firmly established in Italy; and these now included types which, having originally sprung from the Italian black-and-white tradition in the second century and been developed in colour in North Africa, were becoming widely accepted in the western Mediterranean.[63] Such is the marine mosaic of

308–19 at Aquileia (Ill. 96), adapted to a Christian context by intro-
ducing scenes from the story of Jonah in which the whale is simply a
traditional representation of a sea-monster (*ketos*);[64] such also are
scenes from the hunt and the arena in Rome; and such is the popular
late African theme of the marine birth of Venus which is illustrated in
an Ostian mosaic of *c*.350–400.[65]

THE AFRICAN TRADITION

In the present context the African provinces are those from
Tripolitania westwards, among which Africa Proconsularis is pre-
eminent in the study of mosaics. An estimate of 2,000 known mosaics
in these provinces cannot be an exaggeration. Inevitably, therefore, it
will be possible only to sketch in the barest outline their history,
general characteristics, and significance.[66]

First, it must be emphasized that Hellenistic culture had already
been implanted in certain parts of North Africa. It is accordingly not
surprising to encounter Hellenistic features in the African mosaics.
They are nowhere more patent than in Tripolitania. There the villa at
Zliten has alone yielded twenty-four *emblemata* in terracotta trays
(9–15 tesserae per square centimetre) as well as pavements of *opus
vermiculatum*, possibly all of *c*.100.[67] The *emblemata* include rural scenes
and representations of winged female busts personifying the Seasons
(Ill. 94). At one extreme the pavements depict the earliest scenes from
the arena (15–18 tesserae per square centimetre) and at the other a
most naturalistic acanthus scroll (16–63 per square centimetre!) in
which are flowers, fruit, birds (one feeding three chicks in a nest),
grasshoppers, a butterfly, a chameleon, a lizard, a mouse confronting a
snail, and a diminutive goat: Hellenistic work *par excellence* (detail,
Ill. 97) which invites comparison with the sculptured scrolls of the Ara
Pacis (see Chapter 3).

Hellenistic work is also apparent in the earliest *opus tessellatum* known
in Africa, a pavement of *c*.115–20 of Acholla (Tunisia) in the style of
decoration found in painted and gilded stucco of the mid-first century
in Italy (see Chapter 4).[68] This pavement also depicted female busts of
the Seasons, in 'three-dimensional' circular frames; but in a square
frame was a subject which came to be one of the most characteristi-
cally African, namely the Triumph of Dionysos (see below).

Thereafter, African schools emerged.[69] Their astonishingly rapid
development can be seen in mosaics such as that of *c*.130–50 from La
Chebba (Tunisia) with its portrayal of the Seasons again and a frontal
representation of the Triumph of Neptune,[70] and the Dionysiac
mosaic of *c*.150 from Djemila (Algeria).[71] Another pavement of *c*.150,
from Lambaesis (Algeria), is signed by a Greek and is a magnificently
polychrome version in *opus vermiculatum* (tesserae of 3 mm. [$\frac{1}{8}$ in.]
cubed) of the black-and-white marine compositions of contemporary
Italy.[72] These and many more clearly reflect the influence of painting.

It must be noted that black-and-white geometric mosaics of Italian
character were also laid in Africa at least well into the second century
(the Antonine Baths of 145–62 at Carthage had no others),[73] while the
distinctively African 'flowered style' which reached its zenith *c*.160

97. An 'inhabited
scroll'. Part of a mosaic
in *opus vermiculatum*. From
Zliten, Tripolitania.
c.AD 100. Tripoli,
Archaeological Museum.

obviously developed from the Italian filigree patterns of the Hadrianic
period.[74]

Two mosaics of *c*.140–60 from El Djem (Tunisia) are further
reminders of the continuing copying or imitation of painting;[75] both
are panels of *opus vermiculatum* depicting animals attacking animals in
simplified counterparts of *emblemata* of *c*.130–8 (or earlier?) from
Hadrian's Villa.[76] These, too, are forerunners of countless scenes
characteristic of later African pavements.

A hunting scene involving mounted huntsmen and another the
mythological huntsman Meleager appear perhaps as early as *c*.160–80
(or as late as *c*.200–20?) in a well-known mosaic from the House of the
Laberii at Oudna near Carthage, together with representations of
other rural activities and a farmhouse.[77] Here the principle of registers
(arrangement of scenes in superposed rows) emerges in Africa for the
first time. Interest in rural subjects, which was to grow,[78] also pro-
duced in a mosaic of *c*.180–90 from Sousse (Tunisia) a representation
of race-horses pasturing at the foot of rugged hills.[79] This appears to
have been an attempt to depict an actual rather than an imaginary
landscape:[80] if so, the attempt is unparalleled in Roman mosaics.

Greek mythological scenes and figures nevertheless remained fash-
ionable and, again, generally betray their derivation from Hellenistic
painting. For example, the portrayal of Dionysos in mosaics of
c.200–10 from Lambaesis[81] and Sousse (Ill. 98)[82] immediately recalls
that in the famous *emblema* from the House of the Masks at Delos.[83] In
the pavement from Lambaesis the god is nimbed and, like the accom-
panying busts of the Seasons, portrayed as at Delos against a black

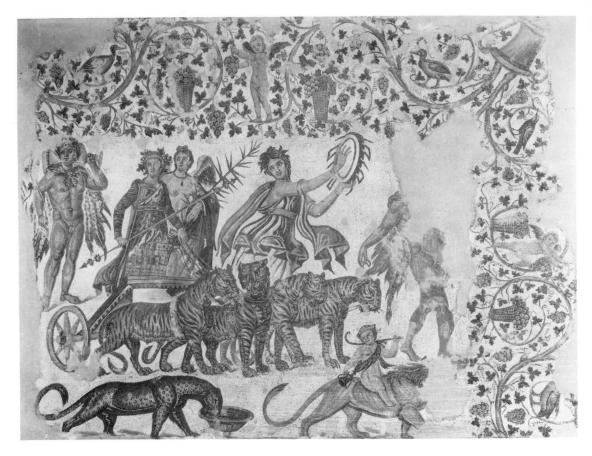

ground, while that from Sousse depicts him with attendants in trium-
phal procession.

To revert again to the geometric repertory it is noteworthy that
sumptuous polychrome 'carpet patterns', developed from the
Hadrianic filigree patterns of the Italian black-and-white tradition,
became characteristic of Africa. They were especially typical of third-
century Timgad (Algeria).[84]

Comparison of the mosaic of the Months and Seasons of c.350–400
from Carthage[85] with its counterpart of c.115 at Antioch (p. 119), and
the reproduction of Greek mythological subjects throughout the third
and fourth centuries, attest the continuing influence of the Hellenistic
tradition in Africa.[86] At the same time, however, other themes which
now came to the fore must be regarded as characteristically African:
hunting scenes[87] (of which over 100 are recorded in Proconsular
Africa alone), scenes from the arena and circus,[88] rural,[89] genre,[90] and
marine subjects,[91] still-life (xenia),[92] the marine birth of Venus,[93]
triumphs of Neptune[94] and, especially, triumphs of Dionysos.[95] In
scenes from the hunt, the arena and the circus, a frequent and typi-
cally African feature is the naming of men and animals, and there are
even obvious portraits of individuals.[96] Only a few of the masterpieces
can be mentioned: the great hunting mosaics of c.240–60 from El
Djem,[97] of c.280–90 from Althiburus (Tunisia),[98] and of c.310–30

98. The Triumph of
Dionysos. Centre of a
mosaic. From Sousse,
Tunisia. c.270 × 220 cm.
c.AD 200–10. Sousse,
Museum.

from Hippo Regius (Bône, Algeria),[99] the remarkable representation of the arena of *c*.240–50 from Smirat (Tunisia),[100] the fascinating illustrations of agricultural activities of *c*.200–10 from Cherchel (Algeria),[101] the fortified villa and scenes of work and leisure on the estate of Lord Julius of *c*.380–400 from Carthage (Ill. 99),[102] and the majestic triumph of Neptune and Amphitrite of *c*.325 from Constantine (Algeria), in which vivid blue *smalti* are employed with striking effect (Ill. 100).[103] The mosaic from Smirat includes a text commemorating the munificence of the sponsor of the bloody sport depicted and illustrates a retainer bearing the bags of prize-money for the *bestiarii*, who have clearly been portrayed from life. Such features, as well as the repertory and style, are unparalleled in Antioch.

As it happens, for an epitome of the African tradition no single site surpasses that of the palatial villa at Piazza Armerina in southern Sicily. Here the period of the mosaics, based on comparative studies, seems now widely accepted as *c*.310–30; but while some may date from *c*.310, others may be or are certainly later, for more than one style is recognizable and at least one pavement has been laid on another.[104] Nevertheless, almost all readily evoke African parallels; and, in addition to suggestions in certain mosaics of prefabrication of large sections,[105] the tesserae include African stones, raising the possibility of prefabrication in Africa itself. The total area of decorative paving was 3,500 square metres (almost 11,500 square feet), and among the mosaics are several portraying members of the family and staff, a representation of the circus (with a salami-seller amid the spectators),[106] a 'Small Hunt' with representations of the customary sacrifice to Diana (Plate II and Ill. 101) and of the picnic after the

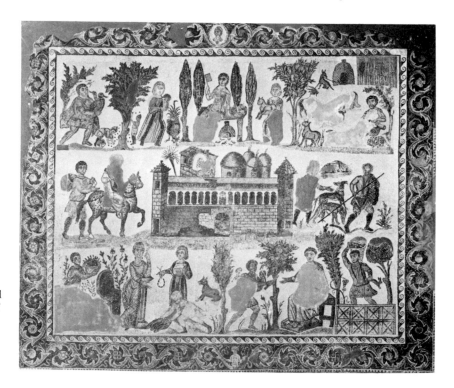

99. 'Mosaic of the Lord Julius', with allegories of the Seasons. From Carthage. *c*.AD 380–400. Tunis, Museum of the Bardo.

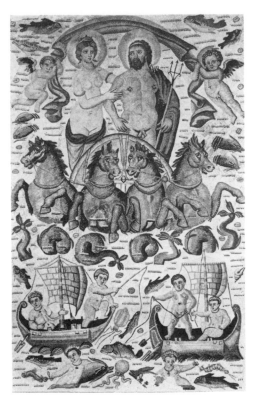

100. The Triumph of
Neptune and Amphitrite.
Mosaic panel. From Koudiat
Ati near Constantine. 310 ×
196 cm. *c.*AD 325. Paris, Musée
du Louvre.

101. (*Below*) The Small Hunt. Mosaic paving. Piazza
Armerina, Sicily. *c.*AD 310–30.

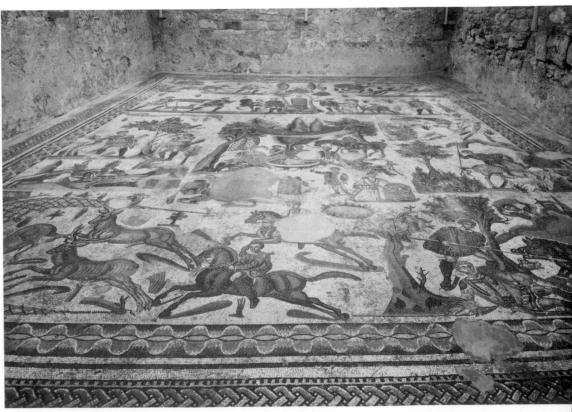

hunt,[107] a 'Great Hunt' running the length and breadth of an immense portico (c.60 × 4.5 m. [197 × 14¾ ft.]), a children's circus, a children's hunt, marine scenes and dramatic mythological scenes including a veritable 'painting in stone' of the Sicilian theme of Odysseus in the cave of Polyphemus.[108] The 'Great Hunt' illustrates the capture of wild beasts for the arena, with tamed animals as decoys, and cages and vessels for their trans-shipment, and in several respects recalls particularly the hunting mosaic of Bône.[109] Amongst the mythological scenes are fantastic figures of dying giants, and a superb representation of a charging bull which is modelled in a style that was to become widespread in the Mediterranean during the next two-and-a-half centuries (Ill. 102).[110] Derivation from paintings or from painted cartoons is especially obvious in these figures.

The Greek mythological scenes, influence of painting, 'three-dimensional' borders and polychromy, recall the Hellenistic tradition; but here the figures and accessories, although coloured to suggest form and even occasionally foreshortened, are generally depicted either frontally or in profile on a white ground in all-over compositions evoking recollection of those first developed in Italy in black and white. One has only to compare the sacrificial scene in the 'Small Hunt' with its counterpart at Antioch a generation later (Plate 10) to see at once the difference between the Hellenistic and the African traditions in the fourth century. At Antioch the pictorial tradition still prevailed, creating depth and atmosphere by long established con-

102. Part of the mosaic depicting the Labours of Herakles at Piazza Armerina, Sicily. Width c.450 cm. c.AD 310–30.

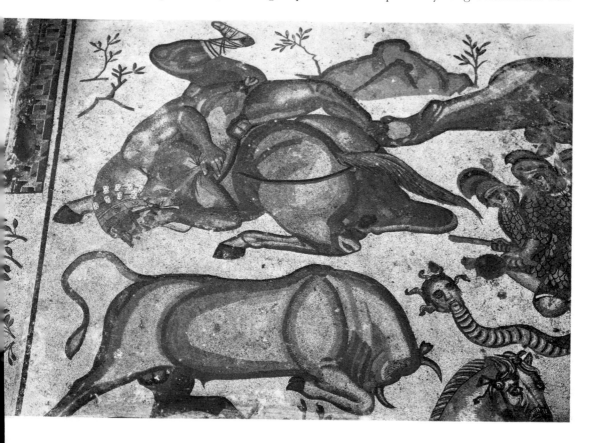

ventions such as the figure in the foreground with his back to the
spectator (so that both are looking *into* the picture) and the im-
pressionistically rendered vegetation in the background. At Piazza
Armerina, on the other hand, the same scene is essentially and un-
ashamedly two-dimensional and part of an all-over composition of
polychrome figures and accessories on a white ground. It is difficult not
to conclude that such a mosaic illustrates a style which had developed
by drawing freely from both the Hellenistic and the Italian black-and-
white traditions, combining aspects of both to create an equally
distinctive African tradition.[111] It may be added that study of the
geometric and naturalistic repertory of the mosaics of Piazza
Armerina prompts the same conclusion.[112]

It has been remarked that the mosaics of Piazza Armerina represent
acceptance of the African style and repertory by aristocratic society
outside Africa, that hunting and gladiatorial mosaics of African type
(the gladiators named) also appeared in Rome in the early fourth
century, that amongst these the hunting mosaics of Constantine's
Esquiline palace signify that the African style had now won Imperial
patronage, and that this explains its adoption for the vault-mosaics of
326–37 in the mausoleum of Constantine's daughter (now the Church
of Santa Costanza; see Chapter 12).[113] The designs of the latter are
essentially those of pavements.[114] Two, which depict brilliantly col-
oured birds, silver and glass vessels and other motifs, amid fruitladen
boughs, have an early third-century antecedent in a pavement at
Carthage;[115] but it is fascinating to observe that, while characteristi-
cally African, these two panels in Rome not only appear to preserve
the tradition of the 'unswept floor' originated by Sosus of Pergamum
four-and-a-half centuries earlier but also depict as a centrepiece a
version of his famous drinking doves.[116]

THE EUROPEAN PROVINCES[117]

To c.260/275. In Spain and southern Gaul ancient Greek settlements
ensured the eventual introduction of the Hellenistic tradition in
mosaics.[118] Generally, however, from the first century AD to *c.*150–250
the mosaics of the Roman provinces in Europe were derived more
or less directly from the Italian black-and-white tradition, with
characteristic marine motifs reaching Spain[119] and southern Gaul[120]
*c.*100–50, as far north as Fishbourne (Britain) by *c.*160 or later,[121] and
as far east as Aquincum (Budapest) by *c.*200–10.[122] Polychrome
developments of the Italian repertory dominated, however, from
*c.*150–200 in Britain,[123] *c.*190–240 in Pannonia,[124] and
*c.*100/150–260/275 in the other provinces.[125] In fact, the repertory of
the European mosaics represents diffusion, through Italy, of the Hel-
lenistic tradition; and the European preference for figured panels
rather than large-scale compositions, as in Africa, perhaps reflects an
enduring memory of the prestige of the *emblema* (see below).

Moreover, at Mérida in southern Spain and in several mosaics in
France, the most northerly being from Sens, Hellenistic influence is
conspicuously evident either in the subject and style or in the employ-

ment of *opus vermiculatum*, or both. That of Mérida, a remarkable
pavement of *c*.150–200 (or *c*.200?), depicts personifications with Latin
names of topographical features of the Empire and of natural pheno-
mena on a greenish-black ground suggestive of painting.[126] Analogies
are known only in the eastern Mediterranean. The example from
Sens, of (?) *c*.225–50/250–75, has an even more distinctly Hellenistic
character.[127] It portrays Sol, his horses and nimbed female busts of the
Seasons, on a black ground, in a panel of '*opus quasi-vermiculatum*'. This
was the showpiece in a large design of square polychrome and black-
and-white geometric panels, a late representative of the multi-panel
designs of Italian origin termed 'mosaïques à décor multiple'. The
earliest in Gaul, in Orange, dates from the first half of the first
century;[128] and the widely influential Rhône school of Lyons and
Vienne developed them to the full in the period *c*. 200–50.[129]

In north-eastern Gaul the city of Trier has yielded a series of
polychrome mosaics from *c*.100–260/275, and here a school of quite
different character also flourished from *c*.200–50.[130] Typical of this
school is the pavement of *c*.230–40 of the villa at Nennig (Ill. 103), the
heavily geometric pattern of which incorporates octagonal panels
illustrating scenes from the arena.[131] These include a representation of
a two-man band, one of them playing an organ. Later, *c*.250, a certain
Monnus signed a pavement in Trier portraying and naming writers,

103. Part of the mosaic
with panels depicting
scenes from the
amphitheatre at Nennig,
Germany. *c*.AD 230–40.

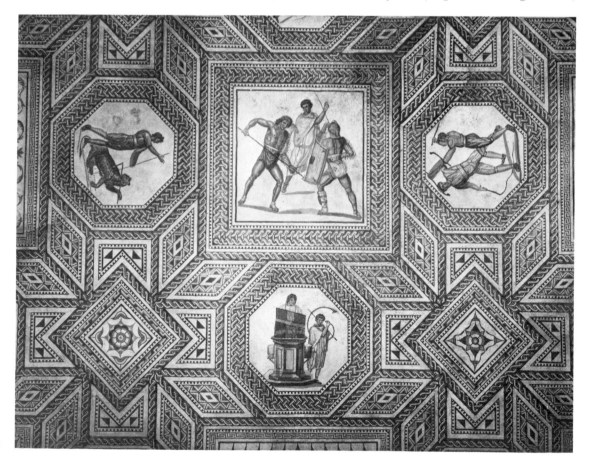

the Muses and cupids personifying the Seasons;[132] and his work has
been recognized in a very different mosaic at Bad Kreuznach depict-
ing animals fighting animals and gladiatorial scenes.[133] Elsewhere in
northern Gaul a pavement at Rheims illustrated gladiators and beasts
individually, each in a square panel, a characteristic if extreme ex-
ample of the European tendency to dissect figured scenes in order to
create and multiply 'emblemata'.[134]

In the German provinces a typically Italian black-and-white geo-
metric pavement in Cologne dates from as early as c.25–50;[135] but here
the most striking mosaic is that of c.220 depicting Dionysos and
Dionysian figures and motifs in polychrome, the colours heightened by
employment of smalti.[136] Later, (?) c.250–75, an elaborate geometric
pavement incorporated five portraits of Greek philosophers, each
named in Greek.[137] In fact, in eastern Gaul and the German provinces
two conflicting spirits seem to dominate the mosaics, one Greek and
intellectual and the other, represented by the illustrations of the arena
and the circus, very reminiscent of contemporary African develop-
ments.[138] To the first can also be attributed the pavement of c.250 from
Münster-Sarmsheim in which a frontal portrayal of Sol in a chariot
with four rearing horses on a black ground was encircled by the signs of
the zodiac.[139] It is interesting that this, again, was the showpiece in a
'mosaïque à décor multiple', suggesting influence of the Rhône school.

During the third century in Britain the demand for mosaics seems to
have suffered a serious reduction,[140] and from c.240–300 in
Pannonia[141] and c.260/275–300 in the other Continental provinces it
may have lapsed altogether. Moreover, in wide areas production
apparently never recommenced; and where it did the degree of revival
and the character of the fourth-century pavements vary greatly.

The Fourth Century. In the Iberian peninsula African and even east-
Mediterranean influences are very evident in the fourth century.[142]
Especially notable are the circus-mosaics of Gerona and Barcelona,
the latter (Ill. 104) of c.310–40 and recalling that of Piazza
Armerina,[143] and both with named horses; but surrounding one of two

104. Mosaic depicting a
circus. From Barcelona.
803 × 360 cm.
c.AD 310–40. Barcelona,
Archaeological Museum.

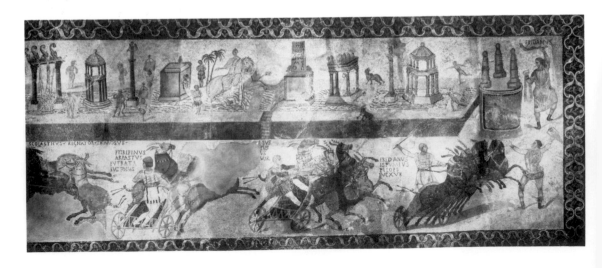

Constantinian hunting scenes from El Hinojal near Mérida is a scroll
on a dark ground with axial heads of the Seasons, again named,
immediately reminiscent of scrolls noted at Antioch.[144] A hunting
scene and full-length figures of the Seasons from the repertory of
pavements were also depicted with Biblical subjects in the mosaics of
c.350 in a dome of the mausoleum, an Imperial property, at Centcelles
near Tarragona.[145] Later, mosaics such as that from El Ramalete
(Tudela, Navarre) portraying a huntsman named Dulcitius,[146] that of
c.350–400 from Mérida depicting charioteers, Dionysian figures, and
the Winds,[147] and another from Mérida of c.400 illustrating Dionysos
discovering Ariadne,[148] reveal distinctly local and deteriorating styles.
Indeed, the last, although proudly signed 'from the workshop of
Annius Ponius', is a travesty of the traditional scene.

In southern Aquitania the fourth century produced a rich and
unique style,[149] but except at Trier there appear to be only three
notable pavements in the whole of the rest of Gaul. One is that of
c.300–50 from Blanzy-lès-Fismes, twelve miles north-west of Rheims,
portraying Orpheus in a style which has been attributed to southern
Gaul, Italy, or Africa.[150] The second was the mosaic with mytholo-
gical and hunting scenes at Villelaure (Vaucluse) in the extreme south
which, although quite different, must also have been the work of
Mediterranean mosaicists.[151] The third, of c.250–300/300–50 and
similar to the second, is that of Lillebonne near Le Havre (Plate 13).
This is signed by 'T(itus) Sen(nius) Felix the Puteolan', i.e. of Puteoli
(Pozzuoli) near Naples, and (apparently) also his local apprentice
named Amor.[152] Here the hunting scenes illustrate the sacrifice to
Diana and use of a tame stag as a decoy[153] in a pictorial style closer to
that of the same scene at Antioch than to that at Piazza Armerina.
Furthermore, the signature of an Italian master-mosaicist here ap-
pears to imply that Gallic mosaicists were not now available. Among
Roman mosaics this is certainly one of the most intriguing.

Trier became an Imperial capital from 293,[154] but the presumably
consequent prosperity is not fully reflected by mosaics until
c.350–80.[155] Most are geometric, one interestingly including patterns
of 'vertical cuboids';[156] but among the few figured pavements are one
depicting five Muses[157] and the strange 'Mysteries Mosaic' of
c.364–83. In the former the quantity of glass tesserae is exceptional
and unparalleled in Trier. The latter illustrates rituals and named
devotees of a Graeco-Egyptian syncretistic cult: it has been suggested
that it must have paved the floor of the meeting-room of 'a kind of
Theosophical Club'![158]

In remarkable contrast to her Continental neighbour, fourth-cen-
tury Britain produced hundreds of mosaics, with an exceptionally high
proportion of figured pavements depicting Greek – and also a few
Roman – mythological subjects.[159] In fact, six schools have been
identified, two in Corinium (Cirencester) alone.[160] Here was invented
a British type of mosaic portraying Orpheus;[161] and apparently the
work of a Corinian mosaicist can be recognized even in Trier.[162]
Another school, with its workshop apparently at Durnovaria (Dor-
chester, Dorset), produced the earliest-known mosaic portraying

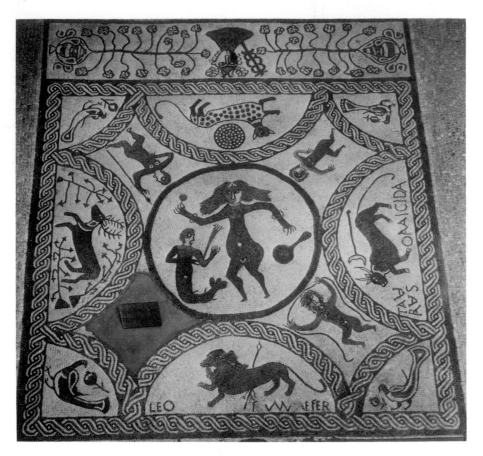

Christ.[163] This school, however, specialized in mythological, marine and hunting scenes,[164] and among these it seems that influence of the African tradition can be detected; for they include a representation of the marine birth of Venus[165] and also a motif from a hunting scene[166] paralleled in mosaic only in North Africa and Piazza Armerina.

In this context, however, by far the most interesting British pavement is one of (?) *c.*350 from the northernmost fringe of the Empire. This is the mosaic of Rudston which, debased as it is, recognizably illustrates again a marine Venus, as her attendant triton indicates (Ill. 105)[167]. Furthermore, associated with her are four *bestiarii* and four beasts, two of the latter – a lion and a bull – named. The name of the bull (*Omicida*) is also that of a bear represented in a contemporary mosaic of Carthage;[168] but, most significant of all, above the bull is depicted a 'crescent-on-a-stick' – symbol of one of the African guilds of *bestiarii* and as yet unknown except in African mosaics.[169] So far-reaching now was the influence of the African tradition.

OTHER APPLICATIONS OF MOSAIC

This chapter has concentrated on pavements of mosaic because these have survived in vast numbers throughout the former Roman world; but there were also other applications of mosaic and, although ex-

105. Venus and a triton, *bestiarii*, beasts, doves and a bust of Mercury. Mosaic. From Rudston. 467 × 320 cm. *c.*AD 350 (?). Kingston upon Hull City Museums and Art Galleries.

amples from the four centuries spanned by this chapter are relatively rare, the most important deserve at least some mention.

As early as about the mid-first century BC the vault and four columns in a nymphaeum in the 'Villa of Cicero' at Formiae were systematically decorated with marine shells and chips of marble and pumice;[170] and, at approximately the same time, coloured tesserae of stone and pellets of 'Egyptian blue' (or 'blue frit': opaque glass), forerunners of blue *smalti*, were employed together with shells and pieces of marble in the decoration of a vault in the 'Villa of Horace' near Tivoli and in another in a Republican cryptoporticus on the site of the later Villa of Hadrian at Tivoli itself. The choice of such materials was obviously intended to evoke the character of natural grottoes, such as those of Capri which were similarly decorated in late Augustan or early Tiberian times; and it is said that in Italy they continued to be employed in the decoration of fountains and nymphaea until the fourth century AD.

Glass, in the form of discs, pieces cut from twisted rods,[171] and fragments of vessels, also came increasingly to be employed in the decoration of the walls and vaults of grottoes and nymphaea, and tesserae actually cut from glass appeared in the time of Tiberius (AD 14–37). To this period is assigned the columbarium of Cn. Pomponius Hylas, outside Rome, above the entrance to which is a shell-bordered panel bearing his name and the representation of a tripod between confronted griffins, all executed in tesserae cut from glass.[172] Within, the walls were decorated with tesserae of coloured glass and other materials more characteristic of fountains and grottoes.

By the mid-first century AD the decoration of fountains and nymphaea included panels of mosaic depicting figure-subjects. Examples survive at Anzio[173] and in Nero's Golden House at Rome (64–8);[174] and it may be added that the Golden House has also yielded a few *smalti* of gilt glass, apparently a rarity before the fourth century.

About twenty houses in Pompeii preserve remains of mural mosaic, some having more than one example, and the instances from Pompeii and Herculaneum together number approximately forty. 'Mural mosaic decorated niches, fountains, nymphaea, well-heads, columns, vaults, lararia, pediments, walls, and sometimes formed panels equivalent to paintings.' All appear datable to 62–79.[175] The contemporary reference of the elder Pliny (*NH*, XXXVI. 64) to 'glazed vaults' (*camerae vitreae*) may be recalled. The exceptional degree of preservation and the elaborate decoration of certain Pompeian fountains in particular offer especially interesting evidence for the application of mosaic to vertical and curved surfaces in this period. These shrine-like structures combine the materials characteristic of the decoration of the earlier grottoes with a much more extensive use of mosaic, now of colourful *smalti*; and the decoration regularly includes figured motifs and panels, the latter generally depicting a marine subject, with a background of 'Egyptian blue' in preference to translucent blue glass. Non-representational and architectural motifs in endless variety extend to the flanking columns or pilasters and the architrave and pediment above.

More striking than any of these, however, are the two Neronian mural mosaics of *smalti* associated with a fountain in the atrium of the House of Neptune and Amphitrite at Herculaneum. One of these decorates an apsidal alcove with semidome and a rectangular niche on either side.[176] Naturalistic vines rise from three-dimensionally rendered *canthari* in shell-bordered panels flanking the niches and above both niches is a panel depicting a hound pursuing a stag under a beribboned swag on which perches a peacock. Part of another tier of decoration survives above. The second mosaic, edged with shells, comprises a panel depicting Neptune and Amphitrite under a canopy in the form of a finely shaded scallop-shell in a representation of an *aedicula* with a roof of a coloured *imbrices* supported by two pilasters (Plate 14).[177] In its dimensions (*c.*1.8 × 1.5 m [6 × 5 ft.]), frontality of the figures and their plain yellow background, and in its generally hieratic character, this mosaic foreshadows early Christian and Byzantine mural mosaics portraying saints against a golden background.

Both the figured and the non-representational repertory of early mural mosaics clearly derive from mural paintings. For example, a Pompeian panel (in the House of Apollo) depicting Achilles on Skyros illustrates a popular subject represented in two surviving Pompeian paintings,[178] and the Three Graces are the subject of another mural mosaic from either Pompeii or Herculaneum[179] and of no fewer than four Pompeian paintings,[180] while a shell-edged apsidal niche from a fountain of *c.*100 at Baiae[181] depicts a shrubbery with birds behind a low wall which recalls the paintings – though a century and a half earlier – in the 'Garden Room' of Livia's Villa at Prima Porta (Chapter 4).

Demand for the application of mosaic to the internal walls and vaults of buildings, especially baths, undoubtedly increased during the second and third centuries. Remains of a decorative mosaic including *smalti*, of *c.*130, still survive on the soffit of an arch and in the semidome beyond in the Baths of the Seven Sages at Ostia.[182] Much better preserved and obviously imitating painting is a niche with semidome of *c.*200 from the Palazzo Imperiale at Ostia in which Silvanus is depicted with a hound between two trees against a background of deep blue *smalti*.[183] Later, *c.*250–75, the vault of a tomb under St Peter's in Rome was decorated in mosaic of *smalti* with a representation of the Sun-god in his chariot as a symbol of Christ triumphant (the Ascension?) against a background of gilded tesserae, framed by a pattern of vines in green and surrounded by other subjects which are overtly Christian.[184] Later still, between *c.*300 and 320, the domed vestibule of Diocletian's villa at Salonae (Yugoslavia) and vaults in the Baths of Diocletian and the dome of the so-called Temple of Minerva Medica in Rome were all successively decorated with mosaic.[185] The well-preserved and important mosaics of *c.*326–37 of the vaults of the mausoleum of Constantine's daughter (Santa Costanza) in Rome have already been mentioned. The designs of a number of fourth-century pavements of mosaic, especially in Britain, appear to imitate the decoration of domes.[186]

Certain western provinces have also yielded remains of mural mosaic incorporating shells, but these appear to date only from the second and earlier third century and all perhaps come from rooms in baths. The most northerly examples known are from Trier and its vicinity, including the Barbarathermen;[187] others are recorded from Switzerland[188] and one in Spain, the most westerly, has come to light at Italica.[189] Among those from Switzerland, and also in fragments from France,[190] shells of snails were employed instead of marine shells.

There is no reason to conclude, however, that all mural mosaics of baths, fountains and nymphaea necessarily incorporated shells. Fountains and nymphaea and – as elsewhere in the Roman world – the bottoms of pools at Antioch were decorated with mosaic, but there is no mention of the employment of shells here;[191] and the same can be said of the remains of mural and vault-mosaics in baths at Lepcis Magna (Tripolitania). The mosaic in a semidome in the small Hunting Baths there, which may date from as early as c.200, depicted Dionysiac, Nilotic and marine subjects; it has been described as 'one of the most varied and extensive pre-Christian figured vault-mosaics which have yet been discovered anywhere in the Roman world'.[192]

Imitations of mosaic in mural paintings are known from several large villas in Britain[193] and a few sites have yielded actual fragments of mural mosaic; but generally speaking the evidence for mural and vault-mosaics in the provinces remains, doubtless deceptively, scarce.

In contrast, the ubiquity and inexpensiveness of *opus tessellatum* in paving and other forms of surfacing are amply demonstrated by its employment in mausolea both as pavements and as facing for *loculi*. Pre-Christian examples abound, notably at Ostia and in Rome,[194] and a decorative pavement laid over burials in *loculi* in a mausoleum is recorded even in Britain (near Great Tew, Oxfordshire),[195] while figured or otherwise decorative mosaic, portraying the deceased or incorporating an epitaph, or both, covered or encased innumerable Christian burials. The latter have been found in Spain, Sicily, the Adriatic, the eastern Mediterranean and, especially, North Africa;[196] and one of the interesting aspects of these is that they reveal the desire and ability of many humble people to commission a mosaic, albeit small, to mark the last resting-place of their loved ones. In North Africa the series of Christian funerary mosaics runs from the first half of the fourth century, through the Vandal period, and into Byzantine times.

OTHER FORMS OF DECORATIVE SURFACING

In conclusion, two other forms of decorative surfacing may be briefly noted.

The simpler consists of concrete-like paving, either black ('cocciopesto' or 'cocciopisto': lime mortar with an aggregate of crushed pozzolana) or red (*opus signinum*: lime mortar with an aggregate of crushed brick), in which white tesserae are set singly and equidistantly in rows or in lines forming simple geometric patterns (e.g. meanders, trellis-patterns, etc.), or – in the period of Style II painting (see

Chapter 4) – as rows of equidistant crosslets of five tesserae, generally with a central tessera of black. Such pavements are characteristic of the last century of the Republic in Italy,[197] and elsewhere can be regarded as indicating Italian presence or influence.[198] In the first century BC they began to be imitated in the earliest mosaics of the Italian black-and-white tradition, and in the first century AD to give way to mosaics *sensu stricto,* though their construction continued in Italy into the second century AD;[199] and remains of one of *c.*100 – with a pattern of crosslets – have recently been found even in Britain.[200]

The other form consists of juxtaposed shapes of differently coloured marbles sawn from thin slabs: hence its name, *opus sectile,* 'sawn work'.[201] Pavements of *opus sectile* were introduced into Italy from the Hellenistic East in the mid-second century BC and during the Empire were commonly laid in public buildings throughout the Roman world. Internal walls in these buildings were also frequently faced with sheets of marble, but in the form of relatively large rectangular panels. A particularly notable example of this application of marble is the panelling preserved below the lower cornice in Hadrian's Pantheon (*c.*AD 126; see Chapter 2).[202] It seems, however, that it was not until the late Empire that entire rooms with pavements of *opus sectile* and walls faced with marble became fashionable in well-to-do private houses;[203] and here the best examples, dating from the end of the third to the mid-fourth century, are in the House of Cupid and Psyche at Ostia.[204]

There is evidence for mural decoration in *opus sectile* as early as the period of Claudius (AD 41–54; Pliny, *NH,* XXXV. 2) and Nero (AD 54–68), and the practice of modifying the colours by application of heat may date from the time of Nero.[205] Pieces of figured *opus sectile* have been recovered from Nero's Domus Transitoria (54–64).[206] A striking later example, showing indications of having been heated, is the head of the Sun-god from the Mithraeum under Santa Prisca in Rome;[207] but the most important and impressive remains of figured mural *opus sectile* are the panels from the Basilica of Junius Bassus in Rome (*c.*AD 330–50) which depict wild beasts attacking weaker animals,[208] Hylas and the nymphs,[209] and a consul – presumably Bassus himself, consul in 331 – in a *biga,* accompanied by four horsemen in the colours of the factions of the circus (Plate 35).[210] In addition to coloured marbles these panels employ opaque glass,[211] the raw material of the mosaicists' *smalti,* and the effect is that of un-modelled painting.[212]

Finally, a building of the late fourth century at Ostia has yielded almost in entirety its internal decoration, figured, naturalistic and geometric, again of *opus sectile* and opaque glass; and the figures include a bust of a bearded and nimbed Christ.[213] Both here and in the panels from the Basilica of Junius Bassus there are indications of Egyptian origin; and it is almost certain that Egypt was the source of the panels of vitreous *opus sectile* intended for the decoration of a building at Kenchreai, the eastern port of Corinth, which were submerged – still in their crates – probably in AD 375.[214]

The Luxury Arts: Decorative Metalwork, Engraved Gems and Jewellery

MARTIN HENIG

The objects discussed in this chapter are exceedingly diverse. What most of them have in common is that they would have been treasured by their wealthy owners and at the same time been subject to the hearty disapproval of moralists (including the elder Pliny), for whom the notion of luxury was an affront to the ancestral virtue of customary morality – the *mos maiorum*.

Unlike most architecture and sculpture, which glorified the achievements of the patron, ruler or State, and to a far greater degree than painting and mosaic (which were intended to be seen by a group – perhaps the house-owner and his friends or a religious congregation), gems and silver objects were generally intended for personal use. This private quality is emphasized by the literary sources in numerous anecdotes: for instance, a certain ex-consul gave 70,000 sesterces for a fluorspar cup and became so fond of it that he would gnaw its rim (Pliny, *NH*, XXXVII. 18); the great Republican general C. Marius was seduced from his peasant simplicity by the lure of silver, and drank from wine-cups ornamented with Bacchic scenes in imitation of the god Liber (*NH*, XXXIII. 150). Pliny is perhaps hinting that Marius behaved like a Hellenistic monarch; his readers may have recalled that Ptolemy II Philadelphos staged an elaborate pageant at Alexandria in 276 BC to honour the god Dionysos, whose companion he claimed to be. Julius Caesar, a passionate collector of gems (Suetonius, *Div. Iulius*, XLVII), wore a signet-ring engraved with Venus Genetrix, supposed ancestor of his family (Dio Cassius, XLIII. 43). Nero valued two cups of crystal so much that, during the revolt in Rome that overthrew him, he broke these treasures to punish his thankless age (Pliny, *NH*, XXXVII. 29).

Silver and gems were collected with avidity, and it is certain that in antiquity they would have been regarded as more central to the history of art than they have appeared to most modern commentators – though not to the great artists of the Renaissance, for example, Benvenuto Cellini, who was a skilled silversmith. Very high prices were paid for good specimens, especially when they were the work of well-known craftsmen, and the fact that such precious objects were hoarded has ensured that we can still enjoy works of art owned by the élite of the Roman world, in something like their original condition. Although no doubt some luxury objects were made by artists without any specific patron in mind but in the hope of catching the eye of a would-be purchaser, others are clearly special commissions never intended for the open market. Indeed sometimes the subjects depicted

on figured pieces are very revealing about personal taste: they range
from portrayals of the Emperor and his family, equated with gods and
heroes, to erotic scenes hinting at salacious gossip in society and even in
Court circles (for instance, a cup showing two pairs of Julio-Claudian
princes engaged in homosexual acts reminds us of the scandals re-
ported by the biographer Suetonius).[1] Other cups display pastoral
scenes, proclaiming a delight in the countryside, or fish and game.[2]
Even if bought from a silversmith's shop they imply discrimination on
the part of the customer. Silver and gems are in a real sense the visual
counterpart of Latin poetry, whether like Statius they adulate the
ruler, or explore with Ovid the art of love, or express enjoyment of the
natural world with Horace.

The relationship between the various luxury crafts was close, and
there is some evidence (for instance at Pompeii and Rome) that gem-
cutters and gold and silversmiths lived in the same quarter of town.[3]
Moreover, there are strong links with other crafts – silver vessels and
figurines are obviously very similar to bronze ones; bronze objects may
be inlaid with silver; fine pottery often imitates silverware (p. 179).
With regard to the 'major arts', it should be noted that the great
Pasiteles was (like Cellini) a silversmith as well as a sculptor (Cicero,
De Divinatione, I. 36; Pliny, *NH*, XXXIII. 156) and that some Imperial
statues were made of precious metal (e.g. Suetonius, *Domitian*, XIII. 2).

In the late Republic and early Empire, strong artistic cross-currents
meant that the shape and the character of the decoration of a sardonyx
chalice such as the 'Cup of the Ptolemies', silver *canthari* from Hildes-
heim and Steevenswert, Arretine pots, and marble garden-urns like
the Medici and Warwick vases obeyed a common Hellenistic aes-
thetic. Only later in the Empire was there a change; silverware
retained its purity of design, but the other luxury crafts were largely
displaced by a variety of objects fashioned in a wide range of styles,
some of them rather ostentatious – cut-glass vessels, ivories, large items
of gold jewellery and even illustrated books (*codices*). Despite this,
precious possessions never ceased to reveal a taste for elegance and
splendour, which is in marked contrast to the usual image of Roman
art as massive, brutal and derivative.

SILVER PLATE: LATE REPUBLIC AND EARLY EMPIRE

Silver and gold came to Rome in quantity as a result of her military
and diplomatic triumphs in the East (e.g. Livy, XXXIV. lii. 4–5; Pliny,
NH, XXXIII. 148–50). Indeed, the richly ornamented bowl from
Cività Castellana in South Italy is decorated with acanthus ornament
in the exuberant Hellenistic style of Pergamum and probably arrived
in Italy after Attalos III bequeathed that state to Rome – and 'the city
learned not just to admire foreign opulence but indeed to love it'
(Pliny, *loc. cit.*).[4] We should not therefore be surprised that plate was
amongst the prizes looted by the rapacious governor of Sicily, C.
Verres, who even established his own workshop to set gold cups and
bowls with looted *emblemata* (Cicero, *Verr.*, II. iv. 54). Such centrepieces
are to be found in the rich treasures of Hildesheim (possibly the

personal property of Quinctilius Varus, who perished in an ambush in Germany in AD 9). One shows a figure of Athena seated on a rock, another the infant Hercules strangling serpents, and others busts of Atys and Cybele. Similar *emblemata* ornament bowls from the great hoard concealed in the villa at Boscoreale in Campania, later in the first century AD, a marvellously regal bust personifying the province of Africa being pre-eminent.[5] The vessels were enriched with gilding applied by creating an amalgam of gold and mercury, and vaporizing the latter. Pliny mentions a bowl by Pytheas with an *emblema* showing Odysseus and Diomedes stealing the *Palladium* from Troy (*NH*, XXXIII. 156) which sold for the colossal sum of 10,000 denarii, although it weighed only two ounces. Such a scene is shown on the neck of a silver jug from Berthouville in Gaul and as an *emblema* on a bronze *patera* from Tienen-Avendoren in Belgium, both dating to the first century AD. (The scene was also popular on gems, and surviving examples include one by Augustus' gem-cutter Dioskourides; Ill. 121).

Thus the acquisition of high-quality plate was clearly a prestigious undertaking, but the collector had to be careful not to lay himself open to ridicule. Petronius' fictional parvenu millionaire, Trimalchio, valued his collection of silver by its weight, misunderstood the subject-matter of its ornament, and affected to discard a vessel that accidentally fell to the floor in the course of a banquet as though it was expendable pottery (Petronius, *Satyricon*, 31, 52 and 34). Even if he were not guilty of such lapses in taste, an owner ought to be aware that it was not always appropriate to display all his silver – for instance if he were a general energetically fighting the enemies of the Empire. Pliny (*NH*, XXXIII. 143) mentions Pompeius Paulinus, governor of Lower Germany in AD 56, 'the son of a knight of Rome at Arles and descended on his father's side from a tribe that went about clad in skins', who took '12,000 pounds weight of silver plate with him when on service with an army confronted by tribes of the greatest ferocity'. The Hildesheim Treasure was thus not the only great service of plate to be taken on campaign. However, most collectors were only able to afford a simple *ministerium* of cups and dishes sufficient for themselves, and for their family and friends. But even they must often have revelled in the luxury of possession, and silver plate was depicted in fresco on walls (for example in the Tomb of C. Vestorius Priscus, Pompeii) and in mosaic on floors (p. 120), as well as on precious objects like the sardonyx 'Cup of the Ptolemies'.

From the late Republic, typical finds are the simple but shapely vessels from Arcisate in North Italy, consisting of a wine-strainer with a geometric device pricked out over it, a ladle with a long handle terminating in a swan's head, a bowl and a jug. There were no cups, but examples of these may be seen in a treasure from Tivoli and amongst the finds from Celtic chieftains' graves at Welwyn in Britain.[6] These simple vessels were made by beating out the metal over a stake ('raising'), modest decoration being added *en repoussé* or by engraving, sometimes augmented by gilding. Most early plate has two 'skins', an outer one, which carries the decoration and an inner one, the liner.

Many Hellenistic-Republican cups (and other vessels like the great *crater* from the Hildesheim Treasure) carry rich vegetal ornament such as garlands or acanthus foliage (which we have already seen on a second-century cup from Città Castellana and which goes back at least to the early fourth century, see for instance a splendid gold casket (*larnax*) from a royal Macedonian tomb at Vergina).[7] Other vessels are embellished in addition (or alternatively) with pictorial scenes in neo-classical style: Vergil's 'beechwood cups' – a literary pastoral alternative to metal – were 'made by the inspired Alcimedon' (*Eclogue* III. 35–47). One of these showed Conon with another astronomer, and was further decorated with ivy and vine ornament. The other depicted Orpheus 'charming the trees' and was adorned with acanthus leaves.

It is fitting to mention these imaginary vessels for in reality many of the cups reflect the literary culture of the *triclinium*, the cultivated dinner-table conversation of their owners and the formal readings of the classics that took place on these occasions. Thus it is not in the least surprising that much late Republican and early Imperial silverware brings Greek drama to mind. An example in the British Museum is a cup depicting Pylades with Orestes and Iphigenia, and their half-brother Chryses, priest of Apollo at Sminthe, about to slay the pursuing Thoas, king of the Tauri (Ill. 107). The composition is presumed to follow the action of Sophocles' play *Chryses* (now, alas, lost) or another play on the same theme.[8] Similarly, the tall *calathus* from Wardt-Lüttingen in Germany, showing Jason, Glauke and Medea's gift-bearing children, recalls the *Medea* of Euripides. In accordance with classical dramatic convention, neither cup shows violent episodes in their respective legends. As in a play these take place 'off-stage'.[9] Two cups from a chieftain's grave at Hoby in Denmark carry mythological scenes: one shows Philoctetes, a Greek hero of the Trojan War, rescued by Odysseus and Neoptolemos from pain and exile on Lemnos (where he had been abandoned on account of his festering snake-bite) so that he could use the powerful 'arrows of Herakles' in the conquest of Troy (Ill. 106). The other depicts Achilles listening to the entreaties of Priam, a Homeric subject also reproduced on Arretine ware (p. 179). This is probably a mythological version of the submission scene on one of the Boscoreale cups cited below, in accordance with Augustus' claim to be the new Achilles. It is, however, possible that the head of Achilles is based on a portrait of Tiberius, who followed the tradition of his predecessor's propaganda very closely.[10] We may find more generalized allegory in the decoration of a flagon from Pompeii (*c.*AD 20–50), showing lapiths subduing centaurs; this type also occurs on pottery, and is a good example of the Roman admiration for Athenian art. The subject was carved on the Parthenon metopes in the fifth century BC, with the same probable meaning – the victory of civilization over barbarism.[11]

Direct political allusion is much rarer on surviving silver than, for instance, on gems, but there are two magnificent cups in the Boscoreale Treasure, one of which shows Augustus as master and pacifier of the world and receiving the submission of barbarians (Ill. 108) and the other the triumph of his successor, Tiberius.[12] In a more allegorical

106. (*Top, left*) *scyphus* with relief figure scene showing Odysseus with Philoctetes. From a grave at Hoby, Denmark. Silver gilt. Height 10.9 cm. End of 1st century BC. Copenhagen, National Museum.

107. (*Top, right*) *cantharus* with figure scene in relief showing Pylades, Iphigenia and Orestes. Silver gilt. Height 9.8 cm. 1st century BC. London, British Museum.

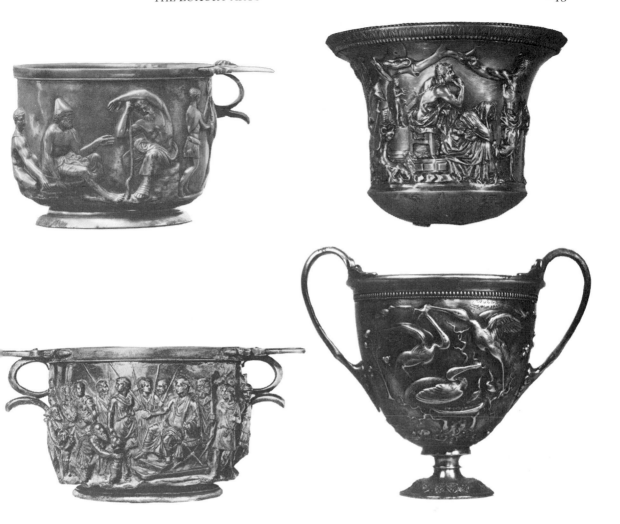

108. (*Bottom, left*) *scyphus* with relief figure scene showing barbarians submitting to Augustus. From Boscoreale. Silver. Height 10 cm. Early 1st century AD. Paris, Rothschild Collection.

109. (*Bottom, right*) *cantharus* with cranes in relief. From Boscoreale. Silver gilt. Height 13.2 cm. 1st century BC–1st century AD. Paris, Musée du Louvre.

vein, a picture-dish from Aquileia represents a Roman prince (identifications range from Mark Antony to Claudius) as the young god Triptolemos, standing before Demeter. Zeus is shown above and the earth-goddess, Ge, below. Greek names are entirely appropriate because this dish is ornamented in the Alexandrian tradition of the sardonyx vessel known as the Tazza Farnese, which dates from Ptolemaic times.[13]

Another aspect of early Roman toreutic is an interest in nature, which may reflect influences from Ptolemaic Egypt, but certainly was prominent in Italian taste. The rustic scenes on a pair of *scyphi* from the House of the Menander at Pompeii, and various cups from the House of the Menander, the Boscoreale villa (Ill. 109) and elsewhere showing cranes in a landscape setting (found also on Arretine vessels, p. 183, and amber pyxides, p. 162) are typical.[14] However, the most obvious subject for drinking-cups was the god of wine, Bacchus, or masks of Bacchus and his followers. Those from the Hildesheim Treasure, which may have belonged to Varus (see above), and the *cantharus* from the Meuse at Steevenswert are splendid examples of such pieces.[15]

LATER ROMAN SILVER PLATE

Towards the end of the first and in the second century, working methods became coarser, and casting and chasing (cutting) were employed for ornament. Pliny records the change as a very sudden one (*NH*, XXXIII. 157) and we do indeed find cast and chased silver vessels at about his time, for instance, a *calathus* from Hermopolis in Egypt, with its exterior covered with a luxuriant vine, a figure of Bacchus, and

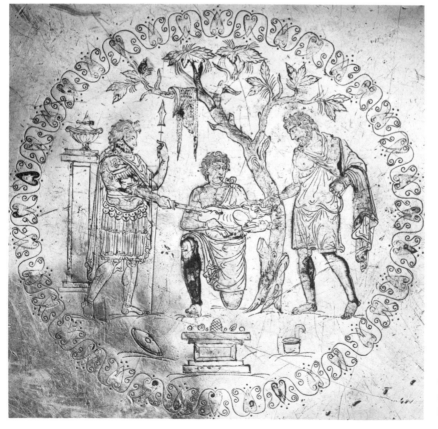

110. (*Above*) detail of relief on the flange of a circular silver *lanx*, engraved and gilded, from Stráže, Slovakia. Width 2.5 cm. Early 2nd century AD. Piešťány Museum.

111. Central *emblema* from the Stráže *lanx*, showing oath-taking scene. Diameter 11.9 cm.

112. Central *emblema* from a shallow bowl (*phiale*). Relief scene of Mercury in a rural sanctuary. From a temple at Berthouville, France. Silver: dedication in gold letters. Diameter of *emblema* 9.6 cm. 2nd century AD. Paris, Cabinet des Médailles.

Cupids gathering grapes.[16] A very attractive large plate (*lanx*), probably dating from the early second century, was found at Stráže in Slovakia, beyond the imperial frontier. It has a central engraved *emblema* enriched with gold foil, showing an oath-taking scene (Ill. 111), while around the rim are chased sacro-idyllic scenes, interspersed with men fighting. One poignant episode shows the execution of two nude youths, perhaps the sons of the elder Brutus (Ill. 110). Technically, the Stráže lanx recalls the large plate from Bizerta in North Africa, which has a central *emblema* of Apollo and Marsyas (inlaid with gold and electrum) and chased Bacchic scenes around the rim.[17] Much of the temple plate from Berthouville in France may date from the second century. The little shrine was evidently patronized by members of the wealthy Gallo-Roman gentry, who not only dedicated household plate, for example two antique (first-century) jugs covered with episodes from the Trojan War, but also commissioned new pieces showing Mercury, who was worshipped at this shrine. The best of these plates has a central *emblema* depicting the god in his rustic sanctuary with sacred column, tree and cult animals (Ill.112). A surrounding legend in gold letters reads 'Deo Merc(urio) Iul(ia) Sibylla d(e) s(uo) d(ono) d(at) – Julia Sibylla gives this to the god Mercury out of her own resources.[18]

One type of vessel often found at sanctuary sites (but also used domestically) is the *patera* or *trulla*. A simple example with acanthus ornament and gilded inscription to the mother-goddesses was found at Backworth in North Britain. There is nothing specifically to link the Chatuzange-le-Goubet treasure with a temple, but while one of the *paterae* is decorated with leafy scrolls, the other shows a religious scene. At the bottom of the handle a woman stands before an altar making an offering; above is a shrine, and the goddess or personi-

fication *Felicitas* is shown, holding caduceus and cornucopia and leaning against a column (Ill. 113). This is reminiscent of a handle from the Capheaton treasure in North Britain showing Minerva presiding over a temple and sacred spring. Indeed simple *paterae* in silver, enamelled bronze, and pewter have been found at the spring of Sulis Minerva at Bath.[19]

The third century was marked in Gaul by insecurity and the deposition of hoards like those of Berthouville, Chatuzange, Chaource and Graincourt-lès-Havrincourt. It is not easy to decide which vessels are more or less contemporary with the deposition of the treasures, but the simple engraved and niello (silver sulphide) designs, rosettes and swastikas seem to be new features, and foreshadow the much more elaborate geometric ornament of the fourth century. Late Imperial examples are seen, for instance, on the treasures of Mildenhall and Kaiseraugst, as well as on plates of the Romano-British silver substitute, pewter, including an especially fine example in the Ashmolean Museum from Appleford, Berkshire.[20] The silver *situla* from Chaource (Ill. 114) and flanged bowl from Graincourt-lès-Havrincourt are decorated with formal friezes of acanthus within heavy beaded borders; these features, again, seem to be typical of third-century ornament.[21] The bucket is of a shape characteristic of the western provinces; as we shall see, bronze pails were probably made in Germany (p. 151). It is possible that the fine third-century mirror from Wroxeter (Ill. 115), with its double-loop handle and vegetal wreathed surround, was also made in the lower Rhine–Mosel region, where such elaborate mirrors are shown in sculpture.[22]

Much more silver plate may be ascribed to the fourth century; it is diverse in its subject-matter, and pagan themes predominate. The continuing custom of aristocratic patronage cushioned the silversmith

113. (*Above, left*) two *paterae* with relief decoration on handles. (*Left*) personification of *Felicitas* and sacro-idyllic scene. Silver. (*Right*) acanthus, vine and ivy ornament. Silver-gilt. From Chatuzange, France. Diameters respectively 12.5 and 13.4 cm. 2nd century AD. London, British Museum.

114. (*Above, right*) *situla* with gilded acanthus frieze in relief. From Chaource, France. Silver. Height 17 cm. 3rd century AD. London, British Museum.

against economic change. Even if the Mildenhall Treasure belonged to Constantius II's Christian general, Lupicinus (as Kenneth Painter believes), the great Neptune dish with its dancing, swaying, thoroughly orgiastic Dionysiac revelry (Ill. 116) and the smaller Bacchic platters are still fully within the pagan, Graeco-Roman artistic tradition. The Corbridge lanx, convincingly dated a few years later to the reign of Julian, shows the deities associated with the Greek island of Delos, visited by Julian in AD 363: Apollo and his companions, Artemis, Leto and Asteria Ortygia, are rendered in a precise but rather stilted manner; the elaborate and fussy engraving of their garments confirms the Late-Antique date.[23] Perhaps the best piece of fourth-century silver is the octagonal Achilles dish (Plate 20) from Kaiseraugst by Augst, in Switzerland. The Treasure perhaps belonged to a leading follower of the usurper Magnentius, who is thought to have had strong pagan support. Its central *emblema* shows Achilles discovered in woman's clothes on Skyros and surrounding scenes display the hero's birth and education – a veritable pagan *biblia pauperum*, as much a rallying cry for the old 'hellenistic' style of art (which indeed survives on silverware into the early Byzantine Empire) as for the Old Religion.[24]

Signatures on Silver Plate. The question of where silver plate was made is a complex one, for not only is it portable, but artists themselves moved around in search of patronage. While a great many vessels – indeed, probably the majority – have been found in the western provinces,

115. Mirror decorated on the back with wreath of leaves and flowers in relief; applied loop handle in form of a Hercules knot. From Wroxeter. Silver. Diameter 29.4 cm. 3rd century AD. Shrewsbury, Rowley's House Museum.

116. *Lanx* with relief decoration and subsidiary engraving, showing head of Oceanus, marine *thiasos* and *thiasos*. From Mildenhall, Suffolk. Silver. Diameter 60.5 cm. 4th century AD. London, British Museum.

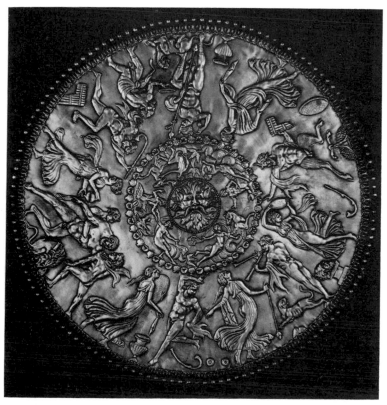

much of the best work will have been made in eastern workshops. Certainly, signatures are generally those of Greeks like Cheirisophos, who signs one of the Hoby cups in Greek and the other in Roman letters; or Pausylypos of Thessalonika, who signed the Achilles dish. However, M. Domitius Polygnos, who signed a mirror, and Sabinus, who signed a *scyphus* (in Greek letters), both from Boscoreale, have in the one case Roman citizenship and in the other at least a Roman name. In the Gallic treasures of the third century there is much to suggest an established industry, and there must have been workshops wherever there was a suitable clientele.

GOLD AND SILVER STATUARY

Gold hardly figures as a medium for plate, though there is a fine lamp with two nozzles from Pompeii and a plain gold amphora recovered from the sea off Cnidus in Asia Minor.[25] Both gold and silver were, however, employed for little statuettes and portrait-busts. Although we hear of large-scale sculpture in precious metals (much of it probably gilt bronze), our surviving evidence is small-scale, like the gold bust of Antoninus Pius from Avenches (Switzerland) or the silver bust from the Marengo Treasure (North Italy) of Lucius Verus (Ill. 117). They were probably, like cameos and miniature sculpture in precious stones or even cheaper works in bronze or glass, gifts to friends and supporters of the Imperial house.[26] However, there are private portraits in precious metals, and a silver bust from Vaison perhaps shows the owner of the house (The House of the Silver Bust). His representation as a clean-shaven individual with somewhat rugged features had Republican precedents, but this 'veristic' style was revived in the portraiture of the late first century. (The bust probably dates from around the time of Trajan.)[27]

Figures of deities were frequently made in precious metals. Most of them were dedicated in public shrines, or else acquired for private devotion. A smith who made such objects was that Demetrius who 'made silver shrines for Diana' at Ephesus (probably representations of 'Ephesian Artemis' in little *aediculae*), and stirred up a riot against St Paul (Acts 19:23–39). Trimalchio kept silver statuettes of the household deities in his *lararium* (Petronius, *Satyricon*, 29). A group of figurines, cast in fine style, was found in a vineyard at Mâcon in France together with a large number of coins, the latest of the time of Gallienus. They included a figure of Jupiter standing with the she-goat Amaltheia, who suckled him on Mount Ida in Crete; a seated Jupiter; and a most elaborate image of a *tutela* (city goddess) pouring a libation over an altar and holding a double cornucopia surmounted by busts of Apollo and Diana; above her head is a bar to which busts of the gods representing the days of the week are affixed. There were also four figurines of Mercury. The fine, regular modelling suggests a fully Roman workshop. More provincial, probably Gaulish in origin, are the two statuettes of Mercury found with the Berthouville temple treasure.[28] Some silver figures did have a secular use: pepper-castors (*piperatoria*) were sometimes made in the form of human figures and

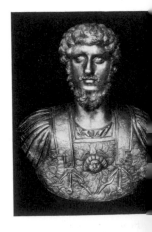

117. Bust of Lucius Verus. From Marengo, Italy. Silver. Height 55.3 cm. 2nd century AD. Turin, Museo di Antichità.

one depicting a small boy clutching a dog came from a treasure buried at Nikolayevo, Bulgaria; another in the form of an aged dwarf was recovered at Chaourse in France. Both may date from the early third century.[29]

Statuettes of bronze are discussed in Chapter 3, but we may here mention that some were inlaid with silver, like the *lar* from Avenches and a similar figurine (probably from Italy) in the Ashmolean (Ill. 82); and a statuette of Nero from Coddenham, Suffolk, where silver and niello have been used to great effect, especially on the cuirass.[30] Gilding was also widely employed: it covers, for example, a figure of the youthful Hercules, an early third-century work found near Birdoswald on Hadrian's Wall.[31] Such elaboration shows us that bronzesmithing was itself, on occasion, a luxury craft and that the best works in that medium were valued almost as much as those in a more precious metal.

METALWORK APPLIQUÉS TO FURNITURE

Figures in very high relief were, as we have seen, employed as *emblemata* on plate. Similar motifs and even free-standing statuettes were sometimes used as embellishments to furniture. The mid-fourth-century Esquiline Treasure provides splendid examples in silver gilt, personifying the great cities of Rome, Constantinople, Alexandria and Antioch.[32] Silver *fulcra*, from the heads and footboards of couches, are known, the best being from the Marengo Treasure. It is set with a

118. (*Right*) Tripod with bacchante busts and panther protome. From Bavai, France. Bronze with applied silver embellishment. Height 80 cm. Early 3rd century AD. Musée de Douai.

119. (*Far right*) Fulcrum ornamented in relief. From a tomb near Amiternum, Italy. Bronze with silver inlay. Length 40.5 cm. 1st century BC–1st century AD. Rome, Museo dei Conservatori.

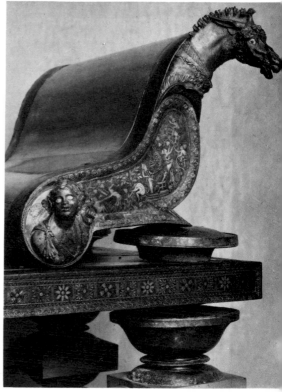

panel depicting a nymph reclining on a luxuriant and fanciful scroll of
acanthus ornament, and a roundel showing a satyr bust in high relief.
Other *fulcra* were made of bronze and enriched with silver inlay
(*intarsia*). A splendid example from Amiternum (Ill. 119) is inlaid with
a busy scene of the vine harvest, and both the high-relief satyr head
emblema at the base and the freely modelled mule's head which forms
the upper finial, have silver eyes (see Pliny, *NH*, XXXIII. 144 on the use
of silver in furniture).[33]

Tripods of solid silver do exist, including a very fine example from
the Hildesheim Treasure, but some tripods cast in bronze, for instance
two found at Bavai in Northern France (Ill. 118) and Augst in
Switzerland, are even more elaborate. They have terminals above, in
the form of Bacchante-heads, and the legs are sometimes embellished
with panther-protomes, a device also found on three-legged tables and
miniature stands. Traces of silver enrichment remain, for instance
covering the little relief *canthari* depicted on the legs.[34] The imagery is
Bacchic, as befits objects used to hold vessels for the mixing of wine
with water at feasts. Such a vessel – but an unusually elaborate one,
designed to rest on a small stand – comes from Pompeii. It was made in
the great bronze-manufacturing centre of Capua in the late first
century BC, and stamped by Cornelias Chelidonis. Ornament consists
of masks at the point of junction with the handles, and an acanthus
frieze below, enriched with silver.[35]

BRONZE VESSELS

Likewise used at the feast but also for pouring libations to the gods was
the *patera*. Silver examples have been mentioned above, but many of
those in bronze are also splendidly ornamental. A *patera* from Bos-
coreale in the British Museum (Ill. 120) has a central *emblema* depict-
ing Scylla striking and killing the companions of Odysseus.[36] Her tail
and the eyes of her dog-heads and her human victims are enlivened
with silver. The *patera* dates from the early Imperial period, as does one
from a barrow at Tienen-Avendoren in Belgium, with an *emblema*
showing Diomedes seizing the *Palladium* and climbing over an altar
wreathed in silver.[37] Pytheas' *emblema* in the base of a silver bowl is
mentioned above (p. 141). Another early Imperial *patera* from a
Belgian tumulus (Bois-et-Borsu) has a powerful centrepiece of a charg-
ing bull, a device that goes back to the classical age of Greece and is
found, for instance, on coins of Thurium in South Italy.[38] A *patera* with
more abstract ornament, vine-branches in niello, and relief-work
showing dolphins, winged sea-monsters and a shell, comes from
Prickwillow near Ely. It is stamped by a certain Bodvogenus, who
must have been a Gaul or a Briton.[39]

Some bronze jugs also carry figural scenes, especially on the handles
and at the junction of handle and body. Despite the restriction of space
compared with the *emblema* of a *patera*, the devices are frequently
fascinating vignettes. One found in the Saône near Chalon is or-
namented with masks on the narrow handle, but an expansion below
shows the full scene of Perseus, victorious over Medusa, holding the

120. *Patera* with ram's-
head handle. Central
emblema shows Scylla
destroying the
companions of Odysseus.
Bronze with silver inlay.
Diameter 27.3 cm.
1st century AD. London,
British Museum.

severed head of his adversary and turning his own away from her stony gaze.[40] Another jug, from Carlisle in England, displays sacrificial scenes and, below, the same solemn Roman oath-taking episode shown on the Stráže lanx, with the difference that here it is in very high relief.[41]

A different aspect of Roman culture is presented by a little bronze *situla* with relief ornament (an idyllic scene, with tree, herdsman and flocks) recalling the world of Vergil's Pastoral. It was found in a tomb at Hautot-l'Auvray near Doudeville in Northern France.[42] This vessel may well have been made in Italy, but other buckets with narrow friezes running round the rim, showing hunting scenes or animal fights in the arena, were almost certainly manufactured in the Rhineland.[43] These 'Hemmoor buckets', which date from the second and third centuries, are related in form to the silver bucket with acanthus ornament from the Chaource treasure, which has also been assigned to Western Europe.

In the north-western provinces decoration of bronze work was also carried out by means of coloured glass fluxes. A group of enamelled vessels, which were probably made in Britain, include the cup from Rudge in Wiltshire and a *patera* from Amiens. They bear stylized representations of Hadrian's Wall and are best regarded as tourist souvenirs.[44] The technique, which was originally developed in the pre-Roman Iron Age, continued through Roman times and reached its greatest achievement in the Celtic areas of the British Isles, after the Roman period.

MILITARY METALWORK

Soldiers were an important element in the population, especially in frontier provinces of both East and West. Parade armour, generally of bronze but often gilded or silvered to appear precious, demonstrates the importance of ceremony and luxury even in the army. Pliny is an excellent source, recording that 'our soldiers' sword-hilts are made of chased silver ... their scabbards jingle with little silver chains and their belts with silver tabs' (*NH*, XXXIII. 152).

The sword-scabbards are especially interesting; a group dating from Augustan times includes one from the Thames at Fulham (probably lost in the invasion of AD 43) with embossed decoration of the Roman wolf and twins at the hilt and, below, acanthus, reminiscent of that on the great Hildesheim *crater*.[45] Another sword-scabbard, from Mainz, almost certainly celebrates Tiberius' victory over the Vindelici in 15 BC. On the plate by the hilt he is shown announcing his victory to Augustus in a dignified scene closely related to similar representations of general and Emperor on the Gemma Augustea and the Grand Camée de France; below is a portrait of Augustus, an eagle in a legionary *sacellum* and an Amazon with a double axe representing the defeated tribe.[46] The relation of military metalwork such as this to *emblemata* on silver plate is shown especially by *phalerae* of silver on a bronze core worn by an officer serving at Lauersfort in the Northern Rhineland in the first century AD. Two of them are roundels depicting children wreathed in vine-leaves – a Bacchic theme taken up by other

roundels showing a silenus, a maenad and a satyr. Yet others depict
Medusa heads, Jupiter Ammon and a double sphinx. Such ornament
is in the spirit of the luxurious excess attacked by Pliny. On duty, the
officer wears silver *phalerae*; off duty, he glories in the possession of
show-plate like the Hildesheim Hercules dish (see above). Links with
gem devices are emphasized by relief roundels from military belts
(*cingula*): examples from Campania (where they were probably made)
show the Spartan hero Othryades announcing his victory over the
Argives at the battle of Thyreatis in 550 BC by inscribing a shield with
his life-blood, and the dispute of Poseidon and Athena for the territory
of Athens.[47]

Most items of parade armour were used in cavalry exercises, the
hippika gymnasia, which took the form of stylized battles between
Greeks and Amazons. Military bronze-workers were skilled enough to
beat out helmets which entirely encased the soldier's face and head; his
rough visage was transformed by a face-mask into the perpetual
beauty of the Greek *ephebe* (as, for instance, with the Ribchester
helmet) or the proud and savage form of the barbarian (these are
rarer, but there are good Amazon-type helmets from Straubing in
Bavaria. On some, the backs of the helmets are also worked naturalis-
tically to represent hair, but others bear symbolical images: represen-
tations of battles allude to the dangers of violent death; gods and
goddesses bring protection to the wearer; heads of Medusa turn away
the Evil Eye; Cupids may symbolize the human soul and where they
ride on sea-creatures they are travelling across the ocean to a life of
bliss in the Blessed Isles. Horse-armour is similarly elaborate and
carries the same wide range of themes. A *chamfron* from Straubing, for
example, is ornamented with figures of the gods Mars and Castor and
Pollux (the Dioscuri) and the goddess Minerva, all of whom were
especially diligent in the care of the Roman army, as well as a triton
and a Medusa.[48]

ENGRAVED GEMS

The carving of precious stones in Roman times was rather more than a
mere adjunct to the manufacture of jewellery, for at least until
Antonine times, the signet was often a personal badge or device
recalling the pride of family tradition, or beliefs firmly held by the
possessor. One did not depict the portrait of an ancestor, or a philo-
sopher or god by chance.[49] Grave and sober senators who would
have eschewed all jewellery as effeminate, nevertheless wore engraved
seal-stones. Indeed, at a time when cursive writing was not highly
developed, the intaglio gem stamped into wax or clay was the only
effective form of signature.

Gems were engraved using only the simplest of tools, a drill with
changeable heads (consisting either of tiny lap-wheels of varying
shape or a diamond point) and a bow wrapped around the drill-shaft,
drawn backwards and forwards to make it rotate. The metal of the
drill-head was in many instances relatively soft compared with the
gemstone, and the cutting power was provided by an abrasive such as

corundum from Naxos (Naxian stone). There is no evidence that lenses or other optical aids were employed by ancient gemworkers.

Republican Origins. Rome was the inheritor of two traditions. One of them, the Italian, is above all characterized by the same archaisms and mannered handling of the drill as are seen in the cutting of some Republican coin dies (Chapter 7, p. 168). In particular, we may note how, on some stones, areas are blocked out with broad cuts of the lap-wheel and detail is added with pellets, simply bored with the drill. Although the subject-matter of intaglios cut in this way is frequently of interest, the artistic significance of these stones is limited. The materials used, mainly cornelian and onyx, were easily available and traditional in Italy. Other intaglios were engraved in a thorough-going Hellenistic manner, bearing witness to Rome's long contact with the Greek-speaking world. Such gems are executed with flowing lines produced with a fine lap-wheel.[50] There is some evidence that this tradition existed at Rome even in the middle Republic (*c.* third century BC), when a few Etruscan-type gems (i.e. still in the traditional scarab-beetle form) bear classical devices like a head of Minerva of unknown provenance.[51] The mixture of traditions demonstrates, as eloquently as the Ficoroni *cista* (Ill. 13; Chapter 1) and similar metalwork, that early Rome could be at the same time an entrepôt between two different worlds and a centre of excellence in the van of artistic innovation.

Augustan Gems. By the first century BC gems were cut in a wide range of stones – sard, cornelian and onyx as well as the rarer amethyst, garnet, aquamarine and sapphire imported from as far away as India. The leading gem-cutters in the service of the Romans were Greeks who displayed a skill and assurance rivalling that of the contemporary silversmiths;[52] the pride they took in their craft is demonstrated by the fact that many gems are signed (in Greek of course). The greatest of the Augustan period engravers was Dioskourides, maker of the Emperor's signet, whose skill is recorded by Pliny (*NH*, XXXIII. 8), Suetonius (*Div. Aug.*, 50) and Dio Cassius (LI. 3, 6–7). Not only are some of his signed works extant, but also several cut by his sons; this is not only an instructive analogy with the silversmith, sculptor and theoretician Pasiteles, one of whose offspring was also an artist (as a signed statue attests), but also shows how ancient crafts tended to be passed on from father to son. Dioskourides' own surviving seals are a fascinating subject in themselves, for although the Augustus portrait does not survive (even if its character may be reflected in other gems and coins showing the *princeps*), we do have one depicting Alexander the Great in the guise of Achilles, which perhaps recalls an earlier seal used by Augustus showing Alexander. Also extant is a restrained and beautiful gem showing Mercury, which reminds us that Horace (*Odes* I ii. 41–4) compared Augustus to 'the winged son of gentle Maia' who brings prosperity to mankind. Best of all is the intaglio showing Diomedes carrying off the *Palladium* from Troy (Ill. 121), a theme attempted by other artists of the time – Gnaios and Felix on gems, and, as we have seen, Pytheas on a silver cup.[53]

121. (*Far left*) cornelian intaglio, signed by Dioskourides, showing Diomedes holding the *Palladium* and climbing over the altar of Apollo at Troy. 1.9 × 1.75 cm. Second half of 1st century BC. Chatsworth, Collection of the Duke of Devonshire.

122. Cornelian intaglio, signed by Hyllos, showing a lion. From Salamis, Cyprus. 2.2 × 1.7 cm. Second half of 1st century BC. Nicosia, Archaeological Museum.

Amongst the artists whose names are known to us from their surviving productions are Solon, Aulos and Hyllos. Their individual work is distinctive and allows us to attribute unsigned gemstones to their workshops. Solon's Medusa, cut on a chalcedony and found on the Caelian hill in Rome, is a splendid baroque production; the wild hair, infested with serpent-forms, carries with it a reminiscence of the giants on the Altar of Zeus at Pergamum, though a more obvious source lies in the coin portraits of Mithridates VI of Pontus. The restless flowing drapery on an intaglio depicting the goddess Flora is surely also by him.[54] Aulos' gems often show cupids who live in a gentle, artificial world of perpetual childhood. The charm of a rock-crystal intaglio showing a cupid holding an enormous cornucopia, or a hyacinthus with a cupid and a butterfly is reflected in a gem unsigned, but very probably from his hand, depicting Venus with two children.[55] Hyllos, son of Dioskourides, produced a fine cameo showing the head of a young satyr and an intaglio with a youthful Bacchus. This work reflects an even finer gem (not signed) cut with an elderly, tipsy satyr. Hyllos may not have spent his entire working life in the West; at any rate, an intaglio from Salamis in Cyprus, showing a fierce and realistic lion, bears his name (Ill. 122).[56] Many other gems of the period are hard to assign to particular artists, but are nevertheless works of high quality, like the Nereid on a sea-horse on an aquamarine from the Petescia treasure, or a bust of Bacchus on a cornelian (in the Vienna collection).[57]

As is the case of silver at this time (p. 142), many of these gems obliquely celebrate the *Pax Augusta*, but sometimes political allusion is more specific, and indeed more 'State gems' have survived than examples of plate showing either the Emperor and his family or personifications representing them. Even when Octavian had become sole ruler of the Roman Empire after his victory over Antony (and Cleopatra) at Actium in 31 BC, and more especially after 27 BC, when he assumed the name of Augustus and supposedly restored the Republic, Rome was, constitutionally, opposed to monarchy. The ruler was first citizen (*princeps*), not a king; his power lay in his *auctoritas*, not in his royal birth, and public monuments such as the Ara Pacis reflected this decent reticence.

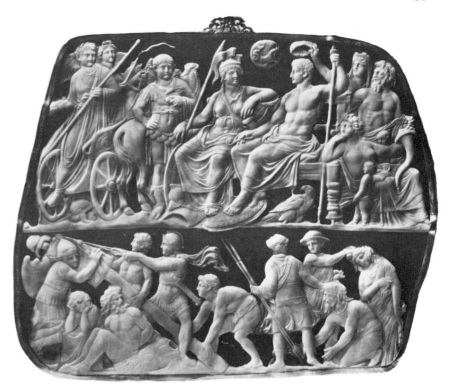

123. Sardonyx cameo, the Gemma Augustea, showing Augustus, Roma and various images of imperial power and victory. 22.3 × 18.7 cm. Early 1st century AD. Vienna, Kunsthistorisches Museum.

Public art was inhibited, but the gem-cutter who in all probability had been trained (or his father before him) in an Eastern court, and who now worked for the Emperor and his friends (*amici*) in a private capacity, was under no such restraint. Thus a cameo shows the young Octavian as a sea-god victorious at Actium, riding the newly pacified seas on the back of a Capricorn (his lucky birth-sign), and a magnificent blue sapphire (Plate 18) depicts Venus as ancestor of the Julian house, giving refreshment to an eagle from a cup (symbolizing imperial power).[58] These scenes had a Republican precedent in devices sometimes shown on coins: for instance the Ulysses struck for the moneyer C. Mamilius Limetanus (Ill. 138c) and the Venus Genetrix on the coinage of the dictator Julius Caesar; in both instances familial descent is advertised, in the one case from a hero, in the other from a goddess, and they are both clearly reflected in gem types.[59]

Augustan dynastic propaganda, however, went much further than this, reaching its apogee in the great cameos cut in State workshops. The largest and best of these are the Gemma Augustea (in Vienna, Ill. 123) and the Grand Camée de France (in Paris). For real precedents, we have to turn to the art of the Ptolemaic monarchy, defeated by Rome at Actium, for instance the moulded figures of Arsinoë II and Berenike II as *Tyche* on the shoulders of jugs (third century BC), a relief in Parian marble (in the British Museum) showing Ptolemy IV and his wife Arsinoë III as the World and Time crowning Homer and recalling their foundation of the *Homereion* in the late third century BC, and a sardonyx cup, the Tazza Farnese in Naples, glorifying Cleopatra I as Isis (second century BC).[60]

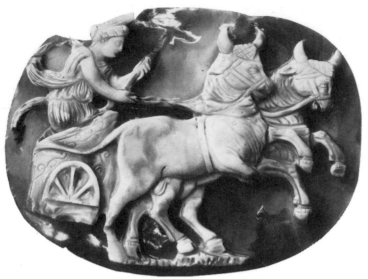

124. Sardonyx cameo showing Julia Domna as Luna (Dea Syria?) in a chariot drawn by bulls. 13.6 × 10.2 cm. Early 3rd century AD. London, British Museum.

On the Gemma Augustea, which was perhaps carved in AD 12, Augustus is crowned by the World and sits next to the goddess Roma; his very proximity hints at quasi-divine power and indeed the eagle at his feet suggests that he is a kind of earthly Jupiter. He greets a returning general, his heir Tiberius – a meeting which is also recorded on the sword of Tiberius from Mainz (p. 151). In a lower register, we see soldiers erecting trophies, as well as conquered barbarians, their locks as shaggy as those of the giants on the Altar of Zeus at Pergamum.[61] The same themes are present on the Grand Camée de France, although there has been considerable disagreement as to the identity of the figures. The central seated emperor is probably Tiberius, for Augustus is already dead, or rather translated to the heavens as *Divus Augustus*, and with other deceased members of the Imperial family he looks down on the world of mortals below. A flying figure in Asiatic costume is perhaps the genius of Rome presented in the form of the Trojan ancestor of the Romans, Aeneas. In front of Tiberius stands a general, probably Germanicus, and a small boy – presumably Germanicus' son Caligula (if the gem dates from AD 17). Once again, the representation of conquest is emphasized by captives shown below.[62]

Later Imperial Glyptics. The tradition of State Cameos was maintained throughout the Empire, though such gems are rare, and it is clear (although the reasons for it are not) that from the middle of the first century there was a marked decline in technical virtuosity. The most ambitious of the later State Cameos are perhaps those of Septimius Severus' reign, especially the one in the British Museum (Ill. 124) depicting Julia Domna in the character of the goddess Luna, here perhaps equated with Dea Syria, standing in a chariot drawn by two bulls (once in the collection of Rubens), or the representation of Julia Domna as Victory, in Kassel.[63] Like the 'Augustan' Gemma Augustea and Grand Camée, they make clever use of the layered structure of the sardonyx on which they are carved, but the cutting is decidedly coarse.

A much later cameo in The Hague depicts Constantine holding
Jupiter's thunderbolt, accompanied by Fausta, Helena and Crispus in
a chariot pulled by centaurs. It is a remarkable achievement which is
not emulated on hard stones, but presages Late Antique virtuosity in
the carving of ivories.[64]

Portraiture was always valued by the Romans, for a man's face
reproduced as a statue, painted, or engraved on a gem, allowed his
influence to be disseminated amongst his contemporaries and de-
scendants. It is not surprising that Augustus employed Dioskourides to
create his gem-portrait or that gem-portraits were cut for rulers and
their families throughout Roman history. There is a strong similarity
to obverse types on coinage, and the cutting of coin-dies and signets
was clearly closely related; indeed, it is likely that on occasion the same
hand was responsible for both. There is here only space to refer to a few
of the more interesting portrait gems: a sardonyx cameo in Windsor
that once belonged to Charles I, showing the Emperor Claudius; an
aquamarine intaglio in Paris cut by Euodos, depicting Titus' daughter
Julia; a cornelian from Carnuntum (now in Vienna), showing the
philosophic Antoninus Pius; a red jasper from Castlesteads in Britain,
presenting Septimius Severus in the persona of Sarapis and his sons
Caracalla and Geta as the Dioscuri; and the highly revealing amethyst
in the British Museum engraved with Constantius II gazing straight
ahead – the same icon-like mask described by Ammianus Marcellinus
(see Chapter 12, p. 242).[65] The change from Principate to Dominate is
thus encapsulated in gemstones of the highest level of craftsmanship.

125. Green chalcedony
(plasma) intaglio
showing Marsyas with his
tibiae. From Chichester.
1.7 × 1.3 cm. Early
1st century AD.
Chichester, District
Museum.

Below this level, gem-cutting barely lasted as a significant activity
into the days of the third-century anarchy. At first, the influence of the
Hellenistic style of the Court workshop was strong. Small intaglios
were engraved on translucent stones – amethysts, garnets, green chal-
cedonies, and, above all, cornelians and sards being preferred. Good
examples are the scenes of rustic sacrifice, reflecting the religious
renewal championed by Augustan propaganda, or the little green
plasma from Chichester (Ill. 125) depicting Marsyas, related to and
perhaps derived from a coin-type of the late first century BC.[66] Many
other intaglios show animals, symbols of prosperity, and deities.

126. Red jasper intaglio
depicting the god
Silvanus-Cocidius. From
South Shields. 2 × 1.5
cm. Late 2nd century
AD. Newcastle
University, Museum of
Antiquities.

Alongside the cut stones are pastes moulded in coloured glass and
intended for a popular market, both in the late Republic and in the
early Empire. Gaudy and even attractive as these glass gems must have
been on the vendor's tray, they tend to produce rather blurred impres-
sions, and can no more be regarded as original works of art than can
plaster casts.[67]

In the later first century and in the second century, there were
workshops even in outlying provinces of the Empire, as well as in old
centres such as Aquileia and Rome. Amongst these were Romula
(Bucarest) in Romania and a site in Northern Britain, probably
Carlisle. Red jasper, cornelian and nicolo (onyx with deep-blue upper
surface) were favoured, and as the workmanship on a gem from South
Shields from the North British workshop demonstrates (Ill. 126), the
engraver was now more interested in texture and pattern than in linear
form.[68] We find a less inventive approach to subject-matter and may

suspect that outside the Court workshops, gems were increasingly being regarded as embellishments to jewellery. Beautiful gems were still sought and much prized, but they were less likely to be carved for setting in rings.

JEWELLERY

Cultivated taste in the late Republic and the early Empire was very simple. Men wore no jewellery after childhood, when traditional Etruscan-style *bullae* were used as protective amulets. The signet-gem, discussed above, was secured in a simple hoop of iron, silver or gold, the last implying possession of aristocratic (senatorial or equestrian) status. Official dress, the toga, was also remarkably uniform, so marks of distinction were fine and subtle: connoisseurs competed in the quality of their signet-stones rather than in more visible luxuries. Attempts to regulate the amount of jewellery a woman might own were largely (but not entirely) abandoned with the repeal of the Lex Oppia in 195 BC (Livy, XXXIV. 2–4), although aristocratic custom continued to avoid excess. Late Republican and early Imperial jewellery followed Hellenistic precedent, and Italy scarcely contributed anything new. The Petescia treasure of the early first century AD must have belonged to a close associate of the Imperial family, for two of the rings are set with cameos depicting Augustus and Livia, and another contains a very beautiful aquamarine showing a Nereid (p. 154). However, the rings themselves are simple; a serpent arm-ring and two serpent bracelets, which were both ornamental and amuletic, allow the display of simple gold surfaces.[69] Even half a century later the cache in the House of the Menander, so notable for the rich embellishment of its plate, still contains simple signet rings and a pair of serpent bracelets. The showiest object is a childhood *bulla*.[70]

Outside the strictly Roman social circle, the flamboyant Greeks of the East might wear ornamental bracelets embellished with filigree, and a similar exuberance appealed to certain sections of provincial society. There is, in fact, a remarkable correspondence between a bracelet from Alexandria and a pair of bracelets from Rhayader in Wales, save that the latter are set with tiny panels of beaded-wire, with enamel infilling in Celtic style (Ill. 127).[71] Brooches in the Celtic regions included the so-called trumpet fibulae, which seem to have developed in Britain during the early first century BC, using modified vegetal ornament from Augustan silverwork as decoration. A very fine example in silver gilt was found recently at Carmarthen. A brooch of fan-tail form in gilt bronze from Aesica (Great Chesters) is even more accomplished in its ornament of confronted scrolls; while enamelled brooches, including the aptly named 'dragonesque brooches', also began to be made in the first century.[72]

Such tastes could only affect the development of Roman jewellery from below. It is fascinating to read Petronius' description in the *Satyricon* of the jewellery worn by Trimalchio (*Sat.* 32): his gold ring studded with iron stars and his gold and ivory bracelets; or the description of the objects belonging to Trimalchio's wife, Fortunata:

127. (*Above*) a pair of gold bracelets (incomplete) ornamented with beaded wire. End plates filled with green and blue enamel. From Rhayader, Wales. Lengths respectively 9.8 cm. and 9 cm. Second half of 1st century AD. London, British Museum.

128. Gold necklace with peltate links set with large amethysts in gold-band surrounds and small plasmas in box-settings. Length 40 cm. Early 3rd century AD. London, British Museum.

her bracelets, anklets and gold hair-net – in all, six and a half pounds weight of jewellery (*Sat.* 67). Social mobility characterized by the rise of this freedman class, and the induction of provincials into the Imperial service, together with the normal pressures of a capitalist society, created the conditions for a rapid growth in luxury amongst the middle ranks of society, which was bitterly resented by a ruling class powerless to prevent it in spite of sumptuary edicts promulgated from time to time. Petronius, as Nero's arbiter of elegance, exposed the vulgarity of Trimalchio's taste and the elder Pliny fulminates against the moral corruption which gold, silver, gems and perfumes brought in their wake, but the Empire was becoming a commonwealth of different peoples and the cause of austerity was hardly likely to find many champions.

The personal ornaments of the Middle Empire are characterized by their jewelled splendour. The continuing availability of gems from the East – cornelians, amethysts, emeralds and other stones – meant that long rows of them could be worn on necklaces and bracelets, either as beads or set into gold box-settings (Ill. 128). A large treasure of the late second or early third century from Lyons contains both types; and similar jewellery was evidently admired throughout the third century and into the fourth century, as the jewellery from the Beaurains (Arras) treasure (Plate 22) and the painting of a lady of the Imperial House with a jewel-box from Constantine's palace at Trier (Ill. 90)

show (see Chapter 4).[73] Amongst new styles of ornament, one of the most significant is open-work (pus interrasile) which allowed large surface areas of gold to be used, while the gaps actually enhanced its decorative effect. It appears on a group of rings with flat or facetted hoops which date from the second century and includes examples from Italy, Bulgaria, Holland, Belgium and Britain. A fine example found near Bedford (Ill. 129) inscribed EUSEBIO VITA ('Life to Eusebius') was clearly a love-token, but it is not certain where it and other examples of the class were made although some bear Greek inscriptions, which is suggestive of an origin in the eastern portion of the Empire. *Opus interrasile* was used to ornament the splayed shoulders of the typical third-century ring type as on an example from Tarsus (Ill. 130), while later on, bracelets, buckles and brooches were sometimes embellished with flat open-work or else with linear designs reflecting this luxury style.

129. Gold ring in *opus interrasile* inscribed EUSEBIO VITA. From Bedford. Diameter 1.98 cm. 2nd century AD. London, British Museum.

Late Roman goldwork tends to be heavier and is certainly more ornate than earlier work. Thus we find wide bracelets, necklaces with enlarged central pendants, and brooches in which the spring-plate has developed into a heavy cross-bar – the cross-bow brooch worn by all classes of Late Roman society apart from the Imperial House, which used oval or circular jewelled brooches at all times. Although simple cross-bow brooches are merely utilitarian safety-pins, the best are showy pieces of ornament, presented on behalf of Emperors to generals and other important subjects, and they are frequently inscribed. They take the place in large measure of the engraved gems with the Imperial portrait that were bestowed as gifts in the early principate. Men wore not only brooches but also belts, jewelled or set with gold plates, and buckles. A buckle recently discovered at Thetford in Britain depicts a satyr in relief (Plate 21). It was found with a treasure of gold jewellery and silver spoons that seems to have been associated with a provincial cult of the god Faunus. The satyr would have been a suitable emblem for a devotee of this rustic cult. However, the culmination of the development of Roman jewellery design is to be seen in the very notable fifth-century Algerian hoard from Ténès, with its fine, large cross-bow brooches and *opus interrasile* bracelets and belt-plates. To the classicist it may appear to be abstract, even un-Roman, but its stylistic character was, after all, moulded by the evolving society and social needs of the Empire, and not, like early Roman jewellery, in the Hellenistic or barbarian world at its frontiers.[74]

130. Gold ring with projecting shoulders ornamented in *opus interrasile* and set with an uncut nicolo. From Tarsus, Syria. Diameter 4.5 cm. 3rd century AD. London, British Museum.

MINIATURE SCULPTURE IN SEMI-PRECIOUS STONE, GLASS AND OTHER MATERIALS

As an alternative to precious metal large nodules of precious stone were sometimes hollowed out to serve as drinking-vessels, and carved in cameo. For example, a sardonyx vase known as the 'Cup of the Ptolemies' (once in the treasury of the Abbey of St Denis but since the French Revolution in the Cabinet des Médailles, Paris) is ornamented with masks similar to those found on the Steevenswert *cantharus* (Ill. 131). It also depicts sideboards laden with plate and is thus very

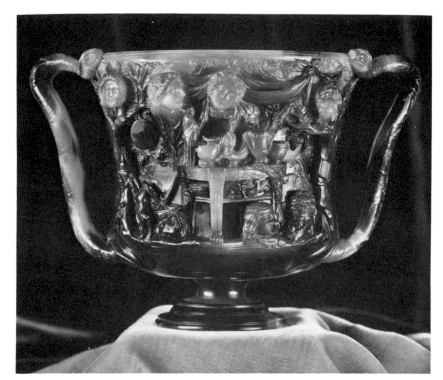

131. Sardonyx cup, cameo-carved with bacchic masks and a sideboard laden with plate. Height 8.4 cm. Middle of 1st century BC. Paris, Cabinet des Médailles.

useful extrinsic evidence for luxury craftsmanship. The technique is linked to that of the shallow sardonyx cup of Ptolemaic date, the Tazza Farnese, but the Cup of the Ptolemies was probably carved in early Imperial times. Two cameo-cut *amphorae* – the Portland Vase and the Pompeian Blue Vase – are of about the same date but they are made of bi-coloured glass and consequently discussed in Chapter 9. Other figured vessels with relief ornament in the Alexandrian tradition were carved in the Roman period down to the fourth century. The body of the agate vase once in Rubens' collection (now in Baltimore) is encrusted with vine-leaves and there are Pan heads on the handles; it has technical analogies with glass *diatreta* of the time, especially the Lycurgus Cup (Plate 28) in the British Museum.[75] According to Pliny, the most valued vessels were of *murrina* (fluorspar) (*NH*, XXXVII. 18–22), of which there is a good example in the British Museum. The texture, colour and physical warmth of these vases are admittedly intrinsic rather than artistic qualities, but there is something in the taste for them which anticipates the more abstract aesthetic of the late Empire.[76]

Gems were also cut as free-standing portraits and figurines, although surviving examples of small-scale sculpture in precious stones are rare. They include a notable head of one of Caligula's sisters in green chalcedony (Ill. 132), charming busts of Antonine children in chalcedony (in Paris and Dumbarton Oaks), and an extraordinary little bust of Julian also in chalcedony (in Leningrad), with Antonine beard and enormous fourth-century eyes.[77] Pliny (*NH*, XXXVII. 118) mentions a statuette of jasper showing Nero wearing a breastplate probably something like the bronze statuette from Coddenham, Suffolk mentioned above (see also Chapter 10, Ill. 184 for a moulded-

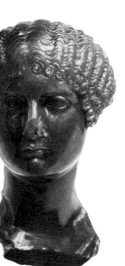

132. Green plasma bust portraying a sister of the Emperor Caligula. Height 9 cm. AD 37–41. London, British Museum.

glass head of Augustus). Precious stones were also used for non-figural carvings, for example animals. A rock-crystal lizard was found in a grave at Noirment, Belgium, and there are a number of rock-crystal cicadas, including one from Pompeii.[78]

Amber and jet, unlike other gemstones, are organic in origin. The former is a fossil resin brought down from the Baltic to Aquileia by Roman traders, and there carved into small vessels and boxes, figurines, pendants, rings and other objects. The trade evidently flourished from the time of Augustus (objects made from it occur in the Petescia treasure) until the end of the second century. Pliny says that a small figurine of amber was more expensive than a number of slaves, and proceeds to castigate the use of the material as an unjustifiable luxury (*NH*, XXXVII. 42–50). Some objects of amber were skilfully carved, but as the material tends to be rather friable, the degree of precision obtained in detailed working is less than in agate or a harder stone.

Amber was used, as mentioned above, for small vessels: typical are a *calix* from Heerlen in The Netherlands, ornamented with a vine, and ointment-pots showing cupids harvesting grapes (British Museum) and exercising in the *palaestra* (Ashmolean Museum, Oxford); while a little jar from Aquileia depicts storks in a marshland landscape, a theme also found on both silver plate and Arretine pottery.[79] A large piece of amber in Cologne is carved in the shape of a mussel shell; three cupids in a boat are depicted inside it, and the convex outer side has a sea-monster and a smaller shell. Other shells of this type are known, including one from a burial at Noirment engraved with a Capricorn and another in the Ashmolean showing a dolphin and a fish.[80]

Figures in amber carved in the round are especially impressive. They include little figurines of actors wearing mantles from Pompeii, a Victory on a knife-handle from Cologne, and another knife-handle, from Nijmegen, in the shape of a sleeping hound. Without doubt one of the most delicate and attractive carvings in the round is the figurine of Bacchus with attendant satyr, excavated from a tomb at Esch in North Brabant (Ill. 133).[81] It may have stood in a household shrine.

Amongst smaller objects are many rings carved in relief on the bezel with hounds, or female heads. One found in Carlisle depicts a head of the goddess Minerva. Such objects were highly suitable as presents, for many were evidently lucky motifs expressly opposed to evil forces, hostile chance, and the darkness of death. A leaf carved in amber from Aquileia is inscribed An(num) N(ovum) f(austum) f(elicem), showing it to have been given away as a New Year gift.[82]

A probable attraction of amber was its 'magical' electrostatic properties, which it shares with jet. A form of fossilized wood, jet outcrops near Whitby in Yorkshire, and was probably worked in the nearby *colonia* of York during the third and fourth centuries. It may or may not be a coincidence that it seems to have been discovered after the collapse of the amber trade, when amber was becoming very rare.[83] A jet bracelet from Presles, Belgium, is carved with a medallion flanked by lions. The medallion depicts an Imperial bust which may show Caracalla (or a later ruler).[84] Most portraits though are of private

133. (*Opposite, left*) amber figurine of Bacchus accompanied by a panther and a satyr. From Esch, Netherlands. Height 10 cm. First quarter of 3rd century AD. 's-Hertogenbosch, Central Noord Brabants Museum.

134. (*Opposite, right*) leaf of an ivory diptych commemorating a marriage alliance between members of the Nicomachi and Symmachi families. A priestess is shown offering sacrifices at an altar. 29.9 × 12.4 cm. End of 4th century AD. London, Victoria and Albert Museum.

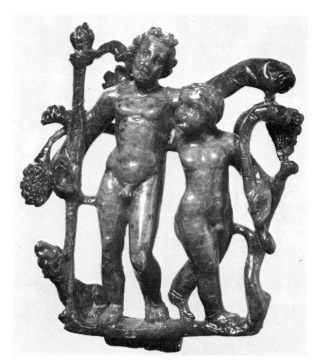

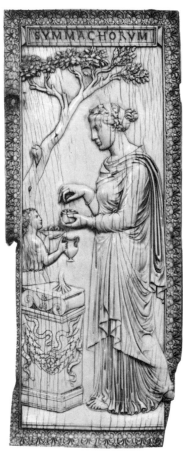

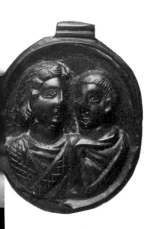

135. Jet pendant with
bust of husband and
wife. From York. 5.7 ×
4.8 cm. End of
3rd century AD. York,
Yorkshire Museum.

citizens – family groups, or husband and wife alone – and were carved
as ornamental pendants (Ill. 135). Examples have been found in both
Britain and the Rhineland. Other pendants depict Medusa heads with
vigorous, staring eyes; the baroque intensity of the usual Graeco-
Roman gorgon is combined with provincial stylization, evident on an
example from Strood, Kent, in which the head is swivelled into a
profile view.[85] Free-standing carvings in jet include a seated male
figure resting his right hand on his chin, found far to the East at
Aquincum (Budapest), and various animals, bears, lions and a hare.[86]
Although these are sometimes said to be toys, it is as well to remember
that jet, like amber, was a suitable material for amulets against hostile,
unseen powers.

Bone and ivory were worked widely throughout Roman times,
although the art does not achieve a major importance until Late
Antiquity, when flat plates of ivory were carved for diptychs at the
behest of great nobles to commemorate important events, marriages
and consulates (Ill. 134). Nevertheless, we find ivory being used earlier
as an inlay on furniture (see Catullus 64, 45) although bone was more
common. Very fine bone-carving is to be seen on a couch from Italy, its
legs mounted with winged Venus-type figures and small cupids in high
relief, and on the corners of the frame are flat plates of bone carved as

136. Reconstructed end
of couch with elaborate
bone inlay. Probably
from East-Central Italy.
Height 84 cm. End of
1st century BC-early
1st century AD. Cambridge,
Fitzwilliam Museum.

Apollo Kitharoidos. Busts of Cupid and vegetal ornament embellish
the *fulcra* (Ill. 136). Many bone plaques from Egypt show Diony-
sos (Bacchus) and his companions; others depict Aphrodite (Venus).
Epic themes, such as Hippolytos and Phaedra, Neoptolemos and
Priam and the Death of Kassandra, are also found.[87] Bone and ivory
can be cut fairly easily with a knife or flat chisel, and it is not surprising
to find a vast number of small ornaments and implements being carved
for women to use – small boxes (certainly cheaper than amber) and
hair pins, the best cut in the shape of female heads wearing the
elaborate coiffures these pins were themselves designed to support,
while others show a hand clutching an egg or a pomegranate (both
potent symbols of eternal life), or pinching an ear, symbolizing re-
membrance.[88]

Although not, strictly speaking, a luxury art, wood-carving is a somewhat similar medium, but wood seldom survives except under exceptional conditions. It was almost certainly more important in antiquity than surviving remains suggest. Figures of men, animals and centaurs on wooden sarcophagi from Kerch have a certain primitive charm, as do figurines of deities and animals from waterlogged deposits in North Western Europe, for instance from the source of the Seine and from Winchester.[89] Wooden beams from the early Byzantine monastery on Mount Sinai, carved with Nilotic scenes, hint at earlier prototypes, while the fourth- or fifth-century doors of Sant' Ambrogio, Milan and Santa Sabina in Rome, carved with biblical scenes, are fully within the traditions of contemporary art, especially the ivory diptychs.[90]

Finally, luxury was to be found in the form of rich hangings and coverlets. Catullus mentions a couch ornamented with ivory (see above) and covered with a purple cloth embroidered with episodes from the life of Theseus (Catullus 64, 47 ff). Hangings mainly of wool and linen have been recovered from Egypt. Designs include brightly coloured fish swimming on a greenish ground, from the city of Antinoopolis, and a hare voraciously devouring grapes, on a panel from the Fayûm. Wall paintings and mosaics (Chapters 4 and 5) tell us something of what we have lost here.[91]

It is significant that in the late first-century Book of Revelation, Rome, described as 'Babylon the Great, Mother of Harlots and Abominations of the Earth' (17:5), is conceived as a woman 'arrayed in purple and scarlet colour, and decked with gold and precious stones and pearls, having a golden cup in her hand' (17:4). Rome (Babylon) will fall, and with it her trade. No one will buy 'The merchandise of gold, and silver, and precious stones, and of pearls, and fine linen, and purple, and silk, and scarlet, and all thyine wood and all manner vessels of ivory, and all manner vessels of most precious wood, and of brass, and iron, and marble' (18:12). If these passages tell us something of how the Roman Empire was viewed by dissenting subjects, they had no influence on the taste and lifestyle of the many Late Roman Christians, who presumably read them. The luxury arts were regarded as highly at the Court of Justinian (Ill. 209) as they had been at the Court of Augustus, or indeed, before him, at the Courts of the magnificent Ptolemies. Gold, silver and gems seem to have a basic attraction to civilized man (and were indeed cherished just as much in the ancient societies of the New World as they were in the Old World). The dazzling beauty and inventiveness of the Roman achievement, at which this chapter can do no more than hint, totally belies the philistine reputation that has been popularly ascribed to ancient Rome. Inheriting the Greek traditions, Roman craftsmen continued to innovate, and their work never ceases to astonish us by its delicacy of form.

Coins and Medals

RICHARD REECE

INTRODUCTION

Coins and medallions form the only detailed dated sequence of
Roman art that exists. These official artistic products must also be the
basis for almost all research on Roman imperial portraiture since coins
are the only works on which the ruler is regularly named. It might be
possible to challenge the first claim with the series of historical reliefs,
but even prolonged search will not provide a securely dated relief for
each decade of the early centuries of our era, whereas coins can
provide hundreds of portraits and scenes dated to individual years.[1] As
for imperial portraiture, the supremacy of coinage cannot be chal-
lenged: most sculptural portraiture is attached to an imperial name
simply because it resembles a coin portrait, either immediately or at
one step removed.

The largest works of numismatic art – and often the most carefully
produced – are known as medallions. This may seem an over simple
definition in view of the arguments that have taken place over the
distinction between a medallion and an ordinary coin. But it remains
reasonable to define as a medallion any coin-like product in gold,
silver, or bronze, that will not fit into the normal sequence of coinage.
This definition obviously changes as our understanding of the coinage
develops, so that the basic and valuable work of Gnecchi classifies
more pieces as medallions than do later works.[2] Toynbee's definitions
are more severe, and Tocci's catalogue of the Vatican collection
follows suit.[3] Thus, for example, Gnecchi rated the large, often bril-
liantly struck radiate bronzes of Trajan Decius (Ill. 143c) as medal-
lions, whereas today they are assumed to be regular double sestertii – a
normal part of the contemporary currency. Earlier in the Empire
Gaius (Caligula) struck a small series of bronze coins of a very high
artistic standard (Ill. 143l) which lack the usual mark of senatorial
approval SC (*Senatus Consulto* – by decree of the Senate): hence al-
though they can be regarded by size and weight as perfectly normal
sestertii, they are sometimes classified as medallions.

The point is important because it affects the deductions that may be
drawn from these issues. If medallions are defined as 'abnormal' coins,
then their production is subject to special constraints and the artistic
standards employed may in consequence be centralized or conserva-
tive, hieratic, cultic, or aristocratic. Medallions cannot, by definition,
be quoted as indicators of the contemporary artistic milieu. They may
be looked upon as examples of what could be achieved at the time,
given special circumstances, but the regular, low-value coinage gives a
far better guide to artistic fashion.

REPUBLICAN COINAGE

The early coinage of the Republic, c.300 BC, was closely related to the Greek coinage of South Italy and followed those issues in weight standards and in actual types depicted, as well as in a general Hellenistic style (Ill. 137b). With the establishment of regular coinage at Rome a more solid, less flowing, style of representation developed (Ill. 137c) which might well be called Italic.[4] The two styles continue side by side in the coinage of Rome until the second century AD, by which time a stylistic compromise had been reached.

In the middle period of Republican coinage, that is from the establishment of the silver denarius just before the year 211 BC until the rise of the Imperatores after 60 BC, a whole series of issues, planned by a three-man committee, the *tresviri monetales*, displays a wide artistic variation, from strongly atticizing heads and delicately drawn figures (Ill. 138c) to stumpy figures packed into crowded scenes – a subject quite unsuitable for the circular silver flan of the standard denarius (Ill. 138b). These contrasting styles often appear in succeeding years or even in different issues of the same year. With the work of Michael Crawford we now have not only a statement of the sequence in which Republican coins were issued, but also the evidence from the coin-hoards on which the relevant dates are based.[5] However, it is not until the later first century BC that coins may be given absolute dates; in the second century BC, a series of issues may be assigned for instance to the years around 120 BC, implying likely dates of 122 to 118 BC.

By the middle of the second century BC the moneyers had freed themselves from the invariable use of traditional types – the Dioscuri, the head of Roma, Victory in a *biga*, or Jupiter in a *quadriga* – and began to exercise a wide choice of what was to be depicted. Where types can be interpreted they are often surprisingly personal; they refer to the moneyers themselves rather than to current social or political events, crises, or victories. Thus a moneyer might choose a design to illustrate a particular point of factual family history of which he was proud (Ill. 138a) or even a mythical aspect of his origins (Ill. 138c).[6] In some cases the type chosen may be no more than a play on a name (Ill. 138d). Portraits are rare, and are restricted to family ancestors. The style is usually more realistic than stylized or hellenizing.

Many of the differences in style and artistic standard that we see today on Republican coinage must be due to the variation in training and ability of the die-cutters. A good example can be seen at the time of the Social War (90 BC) when abnormally large issues by the moneyer L. Piso Frugi seem to have strained the resources of the official die-cutters at the mint, and this seems to have resulted in the employment of less skilled engravers, who cut some most unpleasing busts of Apollo. This is most definitely not a failure of style, attributable to a particular decade, or a low point in numismatic art, for as soon as the war had come to an end and the volume of coinage returned to normal, the standard of die-cutting reverted to its normal level.

Although it remains true that Republican coinage cannot be divided into stylistic or chronological units, and therefore cannot be

137. (a) Head of Mars. Silver didrachm of Metapontum (South Italy). 4th–3rd century BC. (b) Head of Mars. Silver didrachm of Rome. 3rd century BC. (c) Head of Janus. Silver quadrigatus of Rome. Late 3rd century BC. (d) Jupiter in chariot. Silver quadrigatus of Rome. 3rd century BC (all at twice actual size).

dated by style, there is one technical aspect of die-cutting which is much more noticeable in the middle of the first century BC than at any other time. Although the drill had always been used in die-cutting – even the joints of the horses' legs in the *quadrigatus* issues of the late third century BC make this clear – its use only becomes patently obvious in the issues around 50 BC (Ill. 138d). At the height of this fashion the legends are formed from pellets (produced on the die with a drill) joined up with shallow grooves, and the figures are picked out as a series of little globules (a style paralleled in gem-cutting, see Chapter 6, page 153). This trait continues into the coinage of Augustus, perhaps especially in issues which are known to come from the East such as the cistophori (three denarius pieces) from Asia Minor,[7] but it is rare in coinage struck at Rome after Augustus.

a

So far attention has been fixed on the small module of the silver coinage; during the Republic this is a fair comment on both variety and achievement of artistic production, for the bronze coinage changed very little after its weight and denominations were stabilized at the time of the introduction of the silver denarius (*c*.213 BC). The earliest bronze consisted of large slabs of cast metal with only rough designs on a rectangular flan (*aes signatum*). Round cast bronze coins remained rough in style and production in the mid-third century BC (*aes rude* and *aes grave*) and gradually dropped in weight from the original basic unit in which an *As* weighed one libra (pound) of bronze to a token *As* weighing only one uncia (ounce = $\frac{1}{12}$th libra). Subdivisions of the *As* ranged down to a semi-uncia ($\frac{1}{24}$th of an *As*), but on all bronze coins after 213 BC the reverse type, the prow of a ship, was invariable (Pliny, *NH*, XXXIII. 42–5). The heads of various deities were proper to certain denominations throughout the Republican coinage.

b

The legends on Republican coinage seldom play much part in the design except for the locative **ROMA** at the base of the reverse, which is common to all the earlier issues after 260 BC through into the second century. As few Republican types before 60 BC were political or topical the legend was usually confined to the name of the moneyer responsible for the issue, and this, following Greek and Hellenistic practice, was placed at any convenient point on the coin. Legends may be in straight lines, ignoring the circular outline, vertical, or horizontal, and may even continue from obverse to reverse (or vice versa). There is no tradition of legends running clockwise or anti-clockwise, nor of reading from the edge of the coin or the centre, but in the early years of the Empire variation was severely limited, and by the end of the first century AD all coins have legends following the line of the flan, starting from the bottom left, and running clockwise round the coin.

c

d

138a–d. Roman republican denarii (all at twice actual size). Silver. (a) Commemorative column of the moneyer T. Minucius Augurinus. *c*.138 BC. (b) Voting scene. P. Licinius Nerva. *c*.110 BC. (c) Ulysses and Argus. C. Mamilius Limetanus. *c*.82 BC. (d) Head of Pan. C. Vibius Pansa. *c*.48 BC.

THE ROMAN EMPIRE: IMPERIAL PORTRAITURE

Portrayal of living politicians and rulers came late to the Roman coinage. Representation of the supreme ruler was well established in the Hellenistic world by the beginning of the third century BC, but this was invariably associated with kingship and divine rule, and hence unacceptable to Rome. This attitude was changed dramatically in 46

139a–c. Roman republican denarii (all at twice actual size). Silver. (a) Portrait of Pompey the Great c.38 BC. (b) Portrait of Julius Caesar c.44 BC. (c) Portrait of Mark Antony c.40 BC.

BC, when the recently murdered Pompey appeared on the coinage issued by his followers. Caesar quickly followed suit, with the 'approval' of the Senate, and thus became the first living man to appear on the coinage at Rome (Ill. 139b). The first triumvirate continued this practice, as did their successors, so that Augustus was following a well established precedent when he struck his imperatorial portrait series in silver and gold.

The portraits of Pompey, Caesar and Antony are immediately recognizable and not particularly flattering and it is tempting to use of them the word 'realistic'. Logically this word can never be used of any Roman coin portrait, for we have no independent check on the correspondence between the man and the portrait. The best that can be said of these imperatorial portraits is that the portrayal of each man is remarkably consistent, so that the tuft of hair above Pompey's forehead is as immediately recognizable as the boxer's nose of Antony (Ills. 139a, c).

Octavian followed in this 'veristic' tradition, appearing first as a youth with incipient beard; the political transformation of Octavian into Augustus was accompanied by the visual transformation of the pleasant, if undistinguished youth into the ideal Hellenistic ruler.[8] The portraiture of Augustus therefore abandons the Republican or Imperatorial precedent in two main ways: the features portrayed do not depend for identification on an obvious personal characteristic, and hence, in the severely classical sense, on an imperfection; the sequence of portraits of the one man do not follow simple human laws of ageing – in fact they almost do the reverse.

Pompey, Caesar and Antony were all men of Rome and well-known politicians. Much of their coinage was struck either in Rome or their own particular power base at the time, and the transmission of a true likeness was therefore never a problem. Augustus was well known in Rome, but coins were struck for him in Greece, Gaul, Asia Minor, Spain, North Africa, Syria and Egypt, and the variation in portraiture over the provinces is considerable. The fine study by Sutherland of the large silver cistophori produced in Asia Minor shows the variation in portraiture that is possible over only a few years, and perhaps at mints in three neighbouring cities.[9]

In general we do not know how coin portraiture under the Empire was either initiated or distributed. An oft-quoted passage of Lactantius (writing about 320) speaks of the sending of 'imagines' from a newly proclaimed emperor to the centre of power (*De Mort. Pers.*, XXV. 1), and it seems likely that every provincial governor would have been assisted in power by the 'imago' – or, in the Greek East, the 'ikon' – of the emperor sent to him soon after the beginning of a new reign.[10] Certainly a failure in communication can sometimes be seen on the coinage, as in the year AD 69 when contenders for the throne were in distant parts of the Empire, and coining for the new emperor began in Rome before either he or his portrait had arrived in the City. Thus the early coinage of Vespasian looks very much like a slightly modified version of his predecessor Vitellius, and only later in the reign does Vespasian's inimitable cragginess become established. Failure of com-

munication is not the only reason for continuity of portraiture from reign to reign. The adoption by Trajan of his wife's relative Hadrian gave time for a completely individual portraiture of the new emperor, yet the earliest coin portraits of Hadrian demonstrate a remarkable continuity of physiognomy which must be more pious or political than physical (Ill. 141 a, b). After only one or two years Hadrian's characteristic features assert themselves, and his portraiture develops quite independently.

The changing portraiture of any given emperor is a matter of organization specific to his reign, rather than something which follows a general pattern. Imperial reigns seldom lasted more than twenty years so there was obviously not the scope for change given in nineteenth-century Britain to Queen Victoria, whose progression from an 'early' portrait, through the 'jubilee' bust, to the 'old' head with its widow's weeds is well known. The portraiture of most emperors did develop – often markedly – but this is not always a clear chronological indicator since early portraits were often re-used on coins struck later in the reign. One of the clearest sequences is that of Septimius Severus, in which the early simple portrait gives way around AD 208 to what is known as the Sarapis portrait in which the Emperor is portrayed as the god Sarapis.[11] The detailed story is more complex, but in general it is safe to say that the simple portrait belongs early in the reign and the Sarapis portrait, later. Marcus Aurelius, adopted by Antoninus Pius early in his reign (c.138), was portrayed for the unusually long span of forty-two years. Here there is the major division between the young clean-shaven or lightly bearded curly-headed Caesar and the heavily bearded mature ruler. This sequence again is simple and irreversible, but such clarity of design and purpose is perhaps the exception rather than the rule.

One of the most remarkable series of portraits is that of Nero; since the person depicted changes from pleasant youth to gross and vicious middle age – the absolute antithesis of idealization – it seems fair to claim that the coin portraiture closely follows the changing imperial visage. Nero first appears on the later coinage of Claudius (c.AD 50) as a pleasantly alert adolescent. His own early coinage (Ill. 140a) from 54 to 58 shows him as a rather plump and serious twenty-year-old. After this he slowly changes until by about 64 coins depict a fiercely scowling, heavily jowled autocrat with an elaborately curled fringe on his forehead (Ill. 140c). It must be remembered that this is an exceptional opportunity to study, through physiognomy, the decline of a personality.

The historical development of coin portraiture from Augustus to Constantine is clear, but its exposition poses a major problem in that the period covered by this book is only a part of a continous development. Thus the early portraiture of the Empire may fairly be classed with the art of Republican coinage, while the portraiture of Constantine must be seen as a temporary arrest in an otherwise steady transition from the representational portrait of the mid-third century to the presentation of the imperial idea or status late in the fourth century. Whatever may have been happening in the

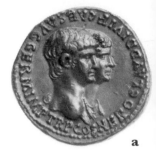

a

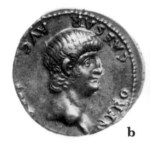

b

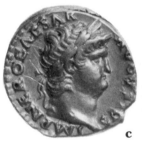

c

140a–c. Portraits of Nero (all at twice actual size). Gold and silver. (a) At the age of about 18, with Agrippina his mother. (b) As a young man aged about 23. (c) At the age of about 30.

other arts (see Chapter 12), the easiest division that can be forced into the sequence of the Roman coinage is the cessation of Imperial coin production in the West in about 480, with the resulting 'Byzantinization' of coin portraiture in the East leading to the ubiquitous full-face hieratic portraits of the sixth century.

It has already been suggested that Augustus broke dramatically with Republican tradition by abandoning the realism of the late Republican-Imperatorial portraiture employed by Caesar, Pompey and Antony for an ideal image worthy of a successor of Alexander. This significant and decisive change happened because of the personality of one man, and must have been facilitated by the striking of coins in widely spread parts of the Empire, each already with its own artistic tradition. But it is important to note that the 'Eastern' coinage of Augustus, as well as his 'Spanish' and 'Greek' Coinage, are the issues of an Imperator (general), on progress through his provinces, minting gold and silver to pay his troops. This was a legitimate Republican form; the Imperator had this authority (which had indeed been used before). At Rome the image of Republican survival allowed a myth by which the Senate struck coins in a normal Italic tradition, far less influenced by the Hellenistic excesses of the East. After Augustus most of the coins in the West were minted in Rome and Lyons and these issues continued to be minted in the Italic tradition, allowing from time to time a breath of Hellenistic, or even Attic, inspiration. At the same time the mints of the East went very much their own way, mostly sinking to a level of no more than local competence. Thus to describe the coinage of the Greek-speaking eastern areas of the Empire may seem summary and cavalier. If the 'local competence' of die-cutting were in any way related to the sculpture and architectural ornament of, say, the cities of Asia Minor in the Antonine prosperity, then coins should rank as major objects for study. Strangely this is not the case; the local, city and provincial coinages of Greece, Egypt, Asia Minor and the Levant seldom, if ever, reach the standards of portraiture or design found in Rome, and, when the standards do compare favourably, as in Cyprus in the reign of Trajan or at Antioch in the reign of Philip, numismatists always assume that dies of such high quality originated in Rome. Nevertheless, this Eastern coinage is varied, interesting, and has, to date, been sadly neglected. There exists no overall survey, no guide or general description, not even a checklist of the mints that struck for each emperor. The Alexandrian coinage is well known and has several works devoted to it, but there is no detailed study of the mint of Antioch in Roman Syria so that reference must be made to the British Museum Catalogue.[12] One work remains in which the coins of the East are given their proper place alongside the coins of the West: the Catalogue of the Ashmolean Museum devoted to the coins of Augustus; for one emperor at least the standards of die-cutting and presentation of East and West can be easily compared.[13] In theory, any *colonia* or *municipium*, or other chartered city, or even a province, might strike coins in the name of the reigning emperor. In the West such practice was forcibly discouraged and, by the time of the Flavian emperors, Rome exerted a virtual monopoly. In the East only

some cities produced coins and few could equal the continuous and
substantial production of Alexandria or Antioch.

Portraiture of the Greek East rarely reaches a high standard of
realism, judged, that is, by the coinage of Rome, where exact por-
traiture could best be expected. It could be suggested that it was the
East which produced realistic portraits while Rome simply mass pro-
duced a stylized form. Unfortunately, not only do the coins of the East
produce portraits which differ from the portraits of Rome, they
produce portraits which differ widely among themselves. To a student
conversant with the standard Imperial portraiture these coins will
probably be identifiable, but often there can be room for doubt and
uncertainty.

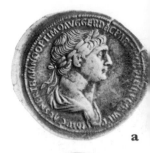

a

b

Augustus' successors, Tiberius and Caligula, did not follow in the
expansive Hellenizing tradition of the first emperor and their portraits
are not particularly remarkable or distinctive. Coins of Claudius, as
might be expected from that emperor's historical leanings – he wrote a
history of the Etruscans – are even more firmly rooted in 'Republican'
traditions in their severity of portraiture, as well as in their restrained
reverse types. Nero's extensive and constantly changing portraits must
argue a personal involvement with the coinage as a means of self-
advertisement and it is under his rule that a stable fusion of Hellenistic
and Italic elements both of portraiture and design seems to have been
established. The Flavian dynasty continued to follow this precedent.
In the second century, under Hadrian, more Attic influence is perhaps
visible, but Antoninus Pius returns to a more Italic realism. It was left
to Commodus to push to an extreme the symbolic connection between
the emperor and a divine protector.

c

141a–c. Portraits on
sestertii (all at actual
size). Bronze. (a) Late
portrait of Trajan
c.AD 112. (b) Early portrait
of Hadrian c.AD 122. (c)
Late portrait of Hadrian
c.AD 134.

Coin portraits in the third century display a remarkable range of
types and styles. The use by Severus of a bust in the style of Sarapis
seems almost moderate after the excesses of Commodus whose con-
viction that he was the re-incarnation of Hercules led to a flamboyant
series of portraits showing him wearing the lion-skin head-dress. This
religious vocabulary was abandoned in the very simple and realistic
style of Severus Alexander. With the soldier successors of Alexander,
Maximinus and Philip the Arab, the simplicity of their portraits
extends almost to brutalism in the close-cropped hair, stubbly beards,
and anxiously furrowed foreheads (Ill. 142a–d). Such portraits have
often been claimed as symptomatic of a time of crisis and the heavy
load of imperial responsibility, but Ramsay MacMullen has quite
rightly pointed out that this is no more than a numismatic resurgence
of a realism well known in the late Republic which maintains a steady
influence on portraiture under the Empire.[14] What is interesting here
is the revival rather than the creation of a style. It must however be
noted that Gordian III, whose reign falls between that of Maximinus
and Philip, followed a Hellenistic model, as did Gallienus, whose reign
fell between that of the ill-fated Trajan Decius (249–51) and the
victorious but short-lived Claudius Gothicus (268–70) (Ill. 142a–d).

The portraiture of Gallienus belongs to a world which is serene,
reflective and apparently secure (Ill. 142c); this is none other than the
robust optimism of the court philosopher Plotinus captured on coins.

142a–d. Third-century portraits (all at twice actual size). Base silver. (a) Gordian III *c*.AD 225. (b) Philip I *c*.AD 246. (c) Gallienus *c*.AD 265. (d) Claudius II *c*.AD 269.

The only flaw in this coinage is the quality of the metal, which presents an unpleasing appearance, and the lettering, which is so undisciplined as to be illegible to the uninitiated: die-engraving, portraiture, and artistic invention of types are all at a high level at the court of this hard-pressed prince.

The portraits and styles of Maximinus, then Gordian, followed by Philip, Gallienus and Claudius, represent remarkable changes which took place in the short period of forty years. In this period inscriptions of any sort are rare, official reliefs are missing, and the chronology, and inscribed representations on the coins are the only documents available for study.

Before outlining the transition from classical coin portraiture to the Late Antique imperial image (or from representation to presentation) special mention must be made of the north-western provinces of the Empire which, twice in the second half of the third century followed a political course distinct from that of Rome and struck their own coins. The most important emperors of the 'Gallic' Empire (AD 259–74) were Postumus, Victorinus and Tetricus; the two rulers of the 'British' Empire (AD 286–96) were Carausius and Allectus. They employed a remarkably pure Roman style which is in very sharp contrast to the eastern elements of stylization which were now creeping into official art in Rome. The die-cutting of the Gallic emperors and especially their portraiture must be reckoned one of the most remarkable and successful compromises between Italic realism and Hellenistic idealism. The coin portrait of Postumus is an excellent example (Ill. 143a). The man would be immediately identifiable to his subjects; this is achieved not by the intricate depiction of every wrinkle and scar, but by the selection of features thought suitable for the ideal ruler. This inevitably leads to a certain subjectivity in interpretation. The qualities of approachability and humour are suggested by the smiling and rounded face: expansiveness and munificence may be read into the flowing hair and curling beard. Some of the reverses of coins of Postumus, with their astonishing almost abstract stylization, give full licence to such unorthodox imagery (Ill. 143b). The use by Carausius of both portraiture and new types follows the Roman pattern with superb intelligence and novelty, but is unfortunately of only marginal concern to the Empire as a whole, which, by now, was set on another course. The Gallic Empire demonstrates through its coins the conservative and 'Roman' nature of the more peripheral western provinces, and this, in turn, highlights the very strong element of eastern stylization in the late third-century Imperial portraits on coins from more central regions of the Empire.

The most abrupt change in numismatic art comes about the year 294, the occasion of Diocletian's all-embracing reform by which the mints throughout the Empire were welded into one system, with one policy and one purpose. The mints of the Greek-speaking East had flourished under Severus early in the third century, and reached a peak of activity in the decade 215–25. From then onwards the third century was a period of decline for Greek mints except perhaps Alexandria, whose tetradrachms were prolific, and the short-lived

issues of some of the new eastern *coloniae*. Diocletian rationalized the mint system in 294 and all coins were henceforward struck to identical designs and with the same Latin legends (whether in Antioch or London), with only the mint-mark proclaiming their origin. Portraits, however, did differ according to the region in which they were produced.

Portraiture on Diocletian's coinage up to 294 followed the trend of the 270s and 280s; it is both stylized and formal (Ill. 143d). A comparison with portraits of Postumus will show how the central Empire was sacrificing individuality in physiognomy for a simplified image. This is the first stage by which the imperial status or idea (*topos* in Greek) replaced the individual man in a unique body (*persona* in Latin); as the centre of gravity of the Empire was already shifting towards the East, it seems highly appropriate to replace an outworn Latin concept by a Greek one. In 294 Diocletian changed the style of coin portraiture even more dramatically. An almost uniform version of the imperial head, already employed in the East became universal (Ill. 143f). But this was as much a political move as an artistic one, for the four rulers (tetrarchs) were subsumed in almost identical portraits. The Idea of the Emperor claimed the subject's devotion, rather than Diocletian, Maximian, Galerius, or Constantius as individuals, and an almost single image was promoted – almost single, because the hooked nose of Constantius, or the broken nasal bridge of Maximian are still apparent through the uniformity of the universal portrait.

By 320 there had been a reaction. Constantine broke with the tetrarchic tradition and emphasized his individuality through his search for a suitable portrait, a quest carried on more intensively in the western mints (Ill. 143g–j) than in the East, where the co-emperor Licinius continued to use the formal portrayal. Constantine was a brilliant erratic individual but his experiments died with him, and his sons, who reigned till after 350, sank their individuality in a version of eastern stylization only slightly humanized.

REVERSE TYPES ON IMPERIAL COINS

A general rule which seems to govern the appreciation of Roman coinage suggests that 'big is better'. The peak of Roman numismatic art is therefore held to fall in the middle of the first century AD from the sestertii of Caligula (37–41) to those of Domitian (81–96). In the middle of this golden age the sestertii of Nero reached a peak of excellence that it is difficult to fault. Silver and gold were of course produced and were, moreover, well designed, but it is in the large flan of the yellow-bronze sestertii, which would have come fresh from the mint in almost golden splendour, that connoisseurs delight. The decline in size and weight of the sestertii between 180 and 260 coincides with a change in artistic standards, and the elimination of the sestertius as a coin in the middle of the third century coincides, in popular thought, with the end of the artistic excellence.

Certainly the large flan gave the designer better scope to show his virtuosity than smaller coins. Moreover, at much the same time die-

143. (a) Postumus. Base silver. Portrait *c.*AD 265 (× 2). (b) Postumus. Sestertius of bronze. Stylized design of Victory (x 1). (c) Trajan Decius. Double sestertius of bronze. Portrait. *c.*AD 250 (× 1).

(d–f) Portraits of Diocletian (all at twice actual size). (d) From a western mint. *c.*AD 286. (e) From an eastern mint. *c.*AD 290. (f) From a western mint after the coinage reform of AD 294.

(g–j) Portraits of Constantine the Great (all at twice actual size). Gold. (g,h) In full regalia with *nimbus. c.*AD 318. (i) Mystical portrait looking heavenward. From Constantinople. *c.*AD328. (j) Standard late portrait in the West. *c.*AD 333.

(k–m) Sestertii of Caius (Caligula) (all at actual size). Bronze. (k) The sisters of Caligula as the three Graces. (l) The speech to the legions. (m) A scene of sacrifice.

cutting was developing rapidly. Republican die-cutters had confined their inspiration to the small flan of the denarius. This did not inhibit the production of graceful, well-proportioned, classicizing designs (Ill. 138c), but stimulated little more than designs with single figures, cut in a manner very much allied to intagli (see Chapter 6). No attention was paid to composition on the large flans of bronze coins until the very end of the Republic. At first the design of the new sestertii under Augustus and Tiberius was timid and unadventurous, then, suddenly, under Gaius, three sestertii were produced of astonishing novelty and brilliant execution (Ill. 143k–m). The motif of the three Graces seems to be a slightly stolid compromise between the claims of the round flan, the three figures, and the square legend; and consequently this is the least successful of the three. The *adlocutio* (address of the Emperor to his troops) takes a presumably well-established representation of a highly formal event and adapts the Emperor, his speech, and his listening troops, seemingly without effort to the circular flan. Emphases are excellent, telling details are picked out and fussy details are dropped, and all in a diameter of 36 millimetres and a depth of field of two millimetres. Whereas the *adlocutio* is formal and official, the scene of sacrifice is free from these constraints. The design is more intricate and less obviously planned, with a richness of detail in low relief, as an impressionistic rendering in a new art form it must rank very highly.

The sestertii of Nero are of high enough quality for analysis one by one, but in this brief compass only a few can be selected for comment. The portraiture is arresting both in design and in technical excellence of die-cutting. The reverses range dramatically from the experimental – even the inept – to the compelling (Ill. 144a–c). The reverse containing only the figure of Roma is a simple design well engraved and brilliantly struck. The temple of Janus, on the other hand, is a propaganda type in which an almost square architectural design is directly surrounded by a circular inscription; the result is informative but unpleasing. The reverse which gives a bird's-eye view of the harbour at Ostia, with the surrounding colonnades, the ships, the mole and a statue included, is experimental – a design never attempted before, and at least on the Imperial coinage struck at Rome, never attempted again. As an exercise in design it is bold and pleasing, but Russell

a

b

c

144(a–c) Sestertii of Nero (all at actual size). Bronze. (a) Roma: the personification of the City. (b) The temple of Janus with its doors closed. (c) A bird's-eye view of the port of Ostia.

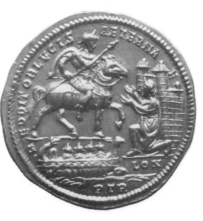

145. The Arras Medallion (twice actual size). Obverse: portrait of Constantius Chlorus. Reverse: the emperor approaching the gates of London. Gold. Minted at Trier in AD 296–7. Arras, Musée Municipal.

146(a–d) Imperial coins from the Greek East (all actual size). Bronze. (a) Portrait of Trajan minted in Cyprus. (b) Portrait of Trajan minted at Alexandria. (c) The Labours of Hercules from Alexandria. (d) The temple of Aphrodite at Paphos, minted in Cyprus.

Meiggs has shown it to be inaccurate in factual detail.[15] Nero's *adlocutio* reverse adds nothing to that of Caligula; unfortunately this judgement is basic to much of numismatic art. Once a scene has been portrayed, whether it has a prototype in painting or sculpture or not, there is little latitude for later engravers.

Trajan used coins for advertising his building policy and his provision of public works, especially aqueducts and roads; Hadrian, by his travels and their commemoration, launched a whole series in which the provinces were depicted in standardized form, a series used by Professor Jocelyn Toynbee to great effect in her study of Hadrianic art.[16] The coins of Antoninus Pius and Marcus Aurelius when considered in artistic detail contain little of compelling interest for the student of art or design; they leave an overriding impression that their themes have been portrayed before – and, sometimes, better. The golden age of tranquillity thus emerges through the coinage as an era of stagnation, although such a judgement can only be made in comparison with on the one hand the frantic change of coin-types in the first century, or on the other the deep-seated changes in portraiture in the third.

After the virtual disappearance of sestertii, the smaller flans of gold, base silver and small bronze gave far less scope for the die-cutters; artistic interest shifts at this date to the medallions struck in gold, silver and bronze. The design of the later medallions follows very closely the rules established for Late Antique official art in general (see Chapter 12). It is easy to be dazzled by the glitter of large, well-struck lumps of gold, and art historians should perhaps be limited to the study of black and white photographs, where the stylization of a scene cannot be softened by the quality of the metal. Whereas the second century enshrined and continued earlier depictions of types and events, the later medallions refined and rarefied well-known scenes until they became the bare bones of a symbolic dialogue. A scene such as an *adventus* (State Arrival) was depicted because it was an *adventus*, not because it formed a harmonious composition. Thus in the arrival of Constantius Chlorus at the gates of Londinium (Ill. 145), artistic inspiration was subsidiary to the important message proclaimed.

The reverse types of Greek Imperial coins are better discussed geographically than chronologically, for the details of changing styles which have been described at Rome can rarely be seen at any of the eastern mints. The reverse types of Egyptian coins – struck at Alexandria – show a strong native-Egyptian influence. This may seem natural but it needs to be considered against the fact that coinage was a Greek invention transplanted to Egypt by the dynasty of Ptolemy, which scarcely showed a single design of Egyptian origin until Roman times. This avoidance of Egyptian monuments (and mythology) gradually broke down during the first century AD so that by the reign of Trajan the depiction of the gods, temples, and even rituals (e.g. the canopic jars for the burial of entrails) of Ancient Egypt had become standard practice. The subjects of the coin types were now often Egyptian, but the style remained totally Hellenistic.

In the confusingly variegated coinage of the eastern cities, one

aspect that is apparent is local pride and self-advertisement. On the architectural side this has been brought together in a book on the cities and their coins and monuments.[17] This is at once a difficult and a useful subject: difficult because of the unusual and sometimes erratic conventions of perspective by which the die-cutters 'opened up' a temple complex to be seen at one glance in a bird's-eye view; useful because we have here a gallery of contemporary elevations of some of the most renowned shrines of Antiquity which otherwise remain to us only as foundations. The same aid can be given by these coins to students of sculpture – for cities were often proud of their most famous statues – and even of myth (Ill. 146d).[18]

It would be wrong, however, to leave the impression that the coinage of the Greek East abounds in exotic designs. These there are, and they are interesting, exciting, and occasionally of good artistic standard. But the general level of die-cutting is not high. Even though there is some evidence for centralized production of dies, several cities combining in the enterprise, these centres seldom give evidence of being in the mainstream of an art or a craft, and neither expertise nor high standards evolve. The contrast with the skills of the schools of sculptors has already been mentioned, and the coins are a valuable corrective as an independent source of information on local artistic standards.

As far as later coin types in bronze, silver and gold are concerned (Ill. 147a–c), two factors already mentioned are of special importance. The message which any type was intended to communicate determined the way in which the die was designed or cut, and Diocletian's great mint-reform meant that a centrally determined slogan was cut thousands of times in many places, for use throughout the Empire. This precluded any appeal to the aesthetic standards of the early Empire; it also precluded technical excellence since mass-production was the order of the day. Excellence in design must be measured not by traditional criteria, and not by proportion and gesture, nor yet by realistic representation, but by the success of the encoding of a message by an official, and the decoding of the message by anyone who saw it.

Silver coins of the Tetrarchs sometimes carried a very simple message – the numeral XCVI. Those who received the coins were no doubt very happy to receive this message, for it spelled out the end of a century of metallic uncertainty, and told them that the coin was one ninety-sixth of a pound of pure silver. On gold, very simple religious information might be given by, for instance, the image of Jupiter in traditional pose, or, later, Sol Invictus, the all-conquering sun. On bronze a strong military bias is often apparent, sometimes explicit both in design (e.g. two soldiers) and legend (e.g. GLORIA EXERCITVS). These designs have seldom been judged to be works of art. By earlier standards the judgement is correct, but the old Graeco-Roman aesthetic was no longer employed. It is intriguing that, while litterati in the later Empire were trying to resuscitate the Classical corpse, the designers, die-cutters, and users of later Roman coinage realized that they lived in a New World in which the old standards no longer applied.

a

b

c

147(a–c) Reverses in the late Empire (all at twice actual size). (a) Silver (XCVI signifies 96 coins to the pound of silver). *c*.AD 300. (b) Gold. Mars Victor. *c*.AD 305. (c) Bronze. Two soldiers. *c*.AD 333.

Pottery

ANTHONY KING

Roman pottery was, for the most part, of a utilitarian character, little emphasis being placed on decoration not connected with the function of the vessel. There was also, however, a certain amount of expensive, well-executed display or table-ware, often highly decorated, that can easily take its place amongst metal or glass counterparts. This chapter will concentrate on such vessels, since they were artistically the most important group of pottery product and served as the standard against which other classes of pottery were produced.

The decorative styles of Roman pottery were very varied, ranging from the purely Greek naturalism of the figures on Arretine bowls to the Celtic curvilinear abstractions on some provincial coarse wares. As far as table vessels are concerned, probably the most important source of influence was the repertoire of designs available on metal vessels, for pottery was often a substitute, and tended to imitate them. In general, direct copying was not practised, although it is possible that some of the negative impressions in clay of figures and other decoration found at Arezzo may have come from metal vessels (see Chapter 6). One of the scenes on the Hoby cups, showing King Priam and Achilles, is copied on Arretine ware.[1]

Glassware was also an influence on pot-making, but more as a rival form of container than as an artistic quarry. However, it was not until the third century AD that pottery started to be widely replaced by glass, particularly for drinking vessels. This competition contributed to the general decline in quality and artistic achievement of pottery in the late Roman period.

TECHNIQUES OF MANUFACTURE

Nearly all fine Roman pottery was made on a fast wheel, although some pieces, such as trays and plaques, were made by pressing clay into frames or moulds. The mould was also used in conjunction with the wheel to make the decorated form of the most ubiquitous high-quality pottery in the early Empire, red-gloss ware.[2] The first stage in the manufacture of this particular type was the making of small clay (or possibly wood) models of the individual elements of the design, either by copying directly from another metal or pottery vessel or by modelling a new figure. These individual punches or *poinçons* were then used to impress a design into the negative mould for the outer surface of the pot, the overall arrangement being unique to that particular mould and sometimes incorporating as many as thirty different *poinçon* types (Ill. 148). The design was often completed by freehand stylus work in

148. Arretine mould made by Pantagathus, the slave of Rasinius. Diameter 16.4 cm. Late 1st century BC. New York, Metropolitan Museum of Art, Rogers Fund, 1919.

the mould. The completed and fired mould was mounted on the wheel in order to produce the vessels, which were thrown into it. To finish the vessel, it was removed from the mould when it was dry and had shrunk enough to avoid damage; it was then mounted on the wheel again, and rims, feet and handles were luted on. Naturally, the number of stages involved in the manufacture of moulded vessels meant that they always remained a luxury product, despite the potential for mass-production offered by the moulds.

Relief-moulded designs formed the most important single group in the Roman repertoire, at least in the early Empire. However, a method of direct application of designs was also used that produced more fluid versions of relief-moulded styles by trailing slip on finished pots (the barbotine technique). Other methods included *appliqués* placed on the body of the vessel (Ill. 149), pinching and finger-impressing the clay surface, stamping, incising and rouletting.

In addition to having some form of decoration, usually in relief, nearly all fineware vessels had a surface finish of some sort, generally a slip, gloss or glaze. Slips were prepared from a suspension of clay particles in water, and were often a different colour from the parent vessel. Their advantage was that they made the surface of the pot harder, and they could be used to give a more pleasing appearance if the ordinary clay was unattractive in colour. A gloss is very similar to a slip, but is lustrous and usually harder, because a finer clay suspension is used (Plate 23). Sometimes slips included minerals such as mica to achieve a sparkling effect, and occasionally metallic washes were used, usually to pass off the vessel as superficially made of gold or silver.[3] Glazes were less often used; they were usually lead-based and applied after a first firing, but sometimes they were put on at the leather-hard stage (Plate 24). The colours that resulted were brown, green or yellow. A much greater variety of colour was achieved in the East, where glazed quartz frit ware (or faience) was made in blue, black, red, green, purple, yellow and white. This pottery was not made of

149. Colour-coated urn with *appliqués* of gladiators, and other decoration *en barbotine*. Made at Colchester. Height 21.6 cm. Late 2nd or early 3rd century AD. Colchester, Colchester and Essex Museum.

clay, but of powdered quartz sand fused in the kiln by the admixture of natron as a flux. True alkaline glazes in green and blue are only found on the eastern fringes of the Empire, and are largely derived from Parthian potting traditions.

Painting was also a fairly common form of decoration (Ill. 150), but it was no longer of the same standard as the highly accomplished products of the Greek vase-painters. The paint, usually a thin, slip-like mixture, was applied with a brush before firing. A semi-transparent effect was sometimes achieved if the paint was sufficiently thin – especially if dark paint was used against a light background. Application onto a slip was less satisfactory than directly onto the fabric of the vessel, since the paint was often not very durable and had a tendency to flake off the smooth surface. This problem also affected barbotine decoration.

The finish of Roman pottery was achieved in the kiln, for it was during firing that the surfaces attained their final colour and texture. Sophisticated kiln types and firing cycles were used, for the most part derived from Greek and Hellenistic practices; close control during firing, by means of opening and closing the flues, or damping down and re-stoking the fires, ensured that the desired colour and finish were usually achieved.

POTTERY OF THE REPUBLICAN PERIOD

In the Republican period the initiative in ceramic art came from the Hellenistic world. The predominant tradition on fineware vessels in Magna Graecia and Etruria – that of red-figure decoration on black-gloss – was dying out by the early third century BC, although these areas continued to exert a powerful influence on Italian pottery. It is in these areas that subsequent developments arose, deriving their inspiration from, on the one hand, the black-gloss surface finishes, and on the other, decorative details taken from relief-moulded metal vessels.

Late Hellenistic wares that influenced the early Roman potters include those made at Canusium in Apulia, where *askoi* with relief and free-standing mythological figures were produced from the fourth century up to *c.*100 BC. Other wares in Apulia, Campania and Etruria were internally black-glossed with details such as ovolos in relief. That these potting traditions were taken up by the Romans is exemplified by the emergence of Cales ware in Campania, probably made between *c.*250 and the first century BC. These pots were black-glossed and relief-moulded, often in the form of *paterae* in imitation of metal prototypes. The potters (e.g. the Gabinii) signed in the moulds, and distinctive designs were produced, sometimes of figured decoration, such as scenes from the Odyssey, but usually predominantly geometric.

Eastern influence on pottery was reinforced by the importation of 'Megarian' bowls, which were made in Athens, Delos and other centres from the mid- to late third century BC. These were hemispherical drinking bowls with moulded relief decoration and a black, grey or red gloss. The repertoire of designs was wide, consisting of crowded figured compositions of deities, mythological scenes (the 'Homeric' vases), masks, *erotes*, genre scenes, or stylized vegetable and geometric decoration.[4] The bowls were also made in Italy from the early second century (Italo-Megarian bowls), probably until the growing popularity of Arretine ware in the late first century caused production to cease. A mid-second century workshop is known at Tivoli, and one of the best known potters, C. Popilius, operated from

150. (*Above, left*) Painted and colour-coated beaker with painted inscription 'Accipe et utere felix'. Made at Trier. Height 24 cm. Late 2nd or early 3rd century AD. Trier, Rheinisches Landesmuseum.

151. (*Above, right*) Italo-Megarian bowl with medallions of Mars (similar to coins of the late 2nd to early 1st century BC); signed by Popilius. From Vulci. Vatican, Museo Gregoriano Profano.

Umbria or South Etruria (Ill. 151). In general the Italian bowls were very similar to their Aegean counterparts, although they were not usually glossed. There is no doubt that, despite the small numbers both of Megarian and Cales bowls, their design and technique had a strong influence on the subsequent emergence of Arretine ware.

ARRETINE POTTERY

The pottery conventionally known as Arretine ware, from the town of Arretium (Arezzo) in Etruria, where the principal kilns were located,[5] was the highest achievement of the Roman potter. The date of its first emergence is not clear, but it would seem that only undecorated plates and bowls were made initially, possibly from the mid-first century BC.[6] The early styles of the plain ware are similar to local black-gloss vessels, and do not have a high-quality finish, but it is likely that manufacture of the characteristic highly glossed relief wares was set up later by potters from the East, as red-gloss ware had been made in the Hellenistic world from the mid-second century (Pergamum being an important production centre), and was becoming fashionable in Italy by the early first century. Greek or eastern names are known from the stamps placed in the moulds for decorated vessels, and it is likely that these were the slaves or freedmen working for Roman proprietors, whose names are also found on the bowls. Some of the proprietors themselves may have been Greek.

From *c*.30 BC to the middle of the first century AD, the Arretine potters made relief-moulded decorated bowls (Plate 26) whose most striking characteristic is the deliberate and strong influence of earlier Greek models. The *crater* and *cantharus* forms were reintroduced, and some bowls have inscriptions referring to the characters depicted, as on Greek vases. Many figures are reminiscent of fifth- and fourth-century Hellenistic and neo-Attic sculpture and decorative art, but there is also a group with a purer Hellenistic inspiration. The ornament, usually of naturalistic leaves, flowers and tendrils, is in the same general style as other Augustan decorative art (Ill. 148). Arretine ware was probably produced as a less expensive alternative to metal vessels when demand for such luxuries was burgeoning after the civil wars.

The best-known Arretine pottery comes from the workshop (*officina*) of M. Perennius Tigranus, which was based in Arezzo itself. Under Perennius worked various freedmen or slaves, of whom the principal was Bargathes. Perennius himself and Bargathes were probably the most inventive and influential of the Arretine potters, and together with others, notably Rasinius and Cn. Ateius, produced a decorative repertoire that included *kalathiskos* dancers, Seasons or Muses in procession, erotic, feasting and vine-harvesting scenes (usually arranged in opposing pairs or in narrative sequence), and dancing, chariot and battle scenes in narrative sequence. The general effect of the designs is of a carefully-executed but formal naturalism, which sometimes fails to give life to even the most vivid of subjects. Some of the bowls showing Hellenistic influence are more static, with *bucrania*, masks and garlands dividing panels with figured decoration. Some bowls, par-

ticularly examples from the time of Tiberius or later, have stylized plant ornament without figures.

Cn. Ateius was responsible for setting up production in various places outside Arezzo, principally Pisa and Lyons, but further kiln-centres may yet be found. His moves were partly in response to the large military market in Gaul and Germany, and it is fairly certain that the Lyons workshop supplied most of the Arretine ware found in the Rhineland. Probably as a result of this output, and of the Aco beakers and Sarius cups produced in Lyons and in the Po Valley (see below, p. 187), two major Gaulish pottery industries, at Lezoux in the Auvergne and La Graufesenque in Hérault, started to imitate the Arretine forms in a simplified manner, and to experiment with the red-gloss technique.

PROVINCIAL RED-GLOSS WARE

The La Graufesenque kiln-centre and, to a lesser extent, that at nearby Montans, were able to secure control of the fine pottery market by the mid-first century AD (Plate 23). They produced highly-finished relief-moulded red-gloss ware and plain red-gloss plates, cups and bowls.[7] During the period c. AD 50–80, La Graufesenque and the other South Gaulish officinae produced the most successful pottery, in commercial, though not in artistic, terms, known from the ancient world. Distribution extended to virtually every corner of the Empire, and, to a significant degree, beyond as well. The decorated bowls must have been amongst the most ubiquitous reminders of Roman taste in the newly conquered provinces and neighbouring regions.

Early La Graufesenque bowls were of a similar standard, both artistically and technically, to those in the Arretine tradition. However, the subject-matter was different, consisting of continuous scrolls of tendrils, leaves and flowers, or geometric ornaments such as gadroons and rouletting. The decorated areas also became more crowded in appearance. The shapes of the bowls changed, the typical decorated vessels being carinated, or straight-sided, drinking bowls without pronounced feet (Ill. 152). These styles established the South Gaulish wares as a distinctive product, and from the time of Claudius to the end of the first century, they formed the dominant pottery fashion in the provinces and in the important military market. Towards the end of the first century, scenes with figures or running animals amidst panelled decoration became common, on the initiative of such potters as Germanus. The horror vacui of the earlier styles continued, but the well-spaced and well-composed scenes of the earlier period were abandoned. The hemispherical bowl with a foot-ring was the common decorated form.

In Italy itself, and to a lesser extent in the East, local red-gloss wares continued, derived in large part from Arretine and 'Aco/Sarius' styles. Even in these areas, however, South Gaulish bowls made inroads into the pottery market; at Pompeii, an unopened case of decorated bowls was found amongst the ashes covering one of the houses.[8] The local kilns, especially in Italy, tended to produce comparatively poorly decorated bowls for distribution in their immediate regions, and their

152. Red-gloss bowl
made at La
Graufesenque. From
Sandy, Bedfordshire.
Height 12.1 cm.
Claudian. London,
British Museum.

production was concentrated on plain plates, cups and bowls that
imitated metal prototypes.

Central and East Gaulish wares took the place of South Gaulish in
the northern provinces from the early second century, and the African
Red Slip industry started to replace South Gaulish pottery in the
Mediterranean basin. The Gaulish kilns continued with the decorative
designs of the first century in a modified form. In Central Gaul,
Lezoux had started production in Tiberian times but was initially
eclipsed by La Graufesenque. However, by taking over and adding to
the styles developed in South Gaul at the end of the first century, and
through technical superiority, Lezoux and nearby Les-Martres-de-
Veyre came to dominate the market for mass-produced fine table-
ware. New potters such as Libertus and Butrio added to the range of
figure types, and mythological and hunting scenes became popular,
particularly on the bowls produced by later potters such as Cinnamus
and Paternus.

The Central Gaulish styles were also adopted by potters in East
Gaul and Germany. Much copying of motifs took place, generally by
poaching designs directly from the bowls of another potter (*sur-
moulage*). As a consequence many later designs are not particularly
original, and from the late second century a general decline in the
standard of reproduction of the bowls set in. Figures and field decora-
tion became poor caricatures of their prototypes. At some time in the
early third century, decorated red-gloss wares went out of production
in these areas, probably as a result of disruption of the distribution
facilities during barbarian raids and civil wars. The subsequent pot-
tery styles mark a distinct change of fashion (see below).

Other provinces also produced red-gloss ware. Spain had several
kilns in operation from the late first century, whose styles tended to be
a distinctive derivation from those of South Gaul, although unlike the
latter, figured decoration does not form a major part of their tradition.
This pottery was virtually confined to the local market, as were the
red-gloss products of other kilns, such as those at Colchester, Bern and
Aquincum.

Another centre of production, in modern Tunisia, became much more than locally significant from the late second century. The pottery, known as African Red Slip ware,[9] consisted of a large variety of plates and dishes ultimately derived from metal prototypes and usually without decoration. Some, however, had moulded or *appliqué* human and animal figures, and stylized vegetation placed around the rim or in the body. This type of decoration appears in the late second century and consciously imitates contemporary silver-ware. The subjects depicted consist either of *venatio* and similar scenes on pear-shaped jugs, or isolated fish and plant *appliqués* on the rims of plates.

The African workshops became the dominant suppliers of fine pottery to the Mediterranean basin by the end of the second century, and large-scale production continued to the seventh century, albeit in styles and forms that were markedly conservative. Decoration in the late fourth to fifth century was predominantly in the form of rouletting or *appliqués*; the latter generally few in number on each vessel, but forming some coherent scene (Ill. 153). Animals, fish, *venationes*, mythological (e.g. Leda and the swan, the Hercules cycle), religious (e.g. Mithras), and biblical (e.g. Adam and Eve, Abraham sacrificing Isaac) scenes are the most frequently occurring motifs. The style is low-relief and rather formal, with many similarities to contemporary silver-ware, such as in the stippling of hair and fur.[10] Geometric stamped decoration, usually of rosettes and leaves, is also common.

EASTERN RELIEF WARES

In the East, the red-gloss tradition held sway throughout the Imperial period, the kilns at Çandarli near Pergamum being the main supplier. Most of the products were plain, for the potters do not appear to have attempted to compete with the decorated vessels coming from Italy

153. (*Above, left*) African Red Slip ware plate. Said to be from Aquileia. Diameter 15 cm. 4th century AD. Vienna, Kunsthistorisches Museum.

154. (*Above, right*) Cnidian relief ware *oinophoros*, 2nd or 3rd century AD. Height 24.5 cm. London, British Museum.

and the West. There were, however, relief-moulded vessels in other fabrics that were distributed widely in the Aegean and eastern Mediterranean areas. Corinthian bowls, copying metal vessels and decorated with a variety of hunting, battle, ritual and mythological scenes, were made in the third century. Cnidian *oinophoroi*, jugs and head-vases, made in plaster moulds from clay prototypes, were made from the late first to the third centuries (Ill. 154). The decoration probably derived from terracottas and metalwork, with depictions of maenads and satyrs, Dionysos and similar mythological scenes being common. These vessels were widely imitated, principally at Pergamum, Athens, and in North Africa, where the potter Navigius signed late third and early fourth century *oinophoroi* decorated with hunting scenes, Bacchanalia and deities reminiscent of similar scenes on metal vessels. The Navigius vessels form part of an expansion of African Red Slip ware distribution into the East at this time, and thereafter this pottery, and its local rivals, Phocaean and Egyptian red-slip wares, provide the bulk of the fine pottery in the area.

COLOUR-COATED AND PAINTED POTTERY

Strictly speaking, all the red-gloss and red-slip wares mentioned above come within the definition of colour-coated ware, but it is usual to ascribe only the other categories of slipped wares to this class. As the name implies, they are distinguished by a slip coating that is usually a different colour from the core fabric. The colour is sometimes very thin, allowing any relief or incised decoration to be picked out by the running and pooling of the slip.

Colour-coats first appear in Italy *c*.75 BC on vessels which are otherwise identical to previous types, known as 'thin-walled' ware. Like many other fine table-wares, these are imitative of metal vessels, and generally take the form of drinking-cups. As with the red-gloss wares, 'Megarian' bowls were a powerful influence, leading to the production in the Augustan period of relief-moulded beakers and cups with colour-coats. The best-known of these are the Aco beakers and Sarius cups, named after the potters commonly associated with them. The decoration is simple on the Aco series, and is usually in the form of closely and regularly spaced leaves or goemetric ornament, resulting in the illusion of scales on the side of the bowl. There is also figured decoration, in a simplified and less well-crafted imitation of contemporary Arretine styles and subject-matter. In the first century AD, brown colour-coated wares formed a complement to the more widely available South Gaulish red-gloss pottery. Cups were the usual product, being made in Italy, Spain, Gaul and the Rhineland from the period of Augustus to the end of the century. The Italian and Spanish examples were often decorated with leaves, ferns, or other plant-derived motifs executed *en barbotine*, but Lyons and Central Gaulish cups were more usually covered with a plastic rendering of scales or other, generally amorphous, shapes. Only in South Gaul were moulds used, to produce the more complicated decoration associated with the red-gloss bowls.

155. Drawing of painted bowls from the Nabatean pottery at Oboda, Israel. Diameter of bowl at bottom left 22.8 cm., others 18 cm. Augustan.

All of the first-century types went out of fashion by the end of the century, to be replaced in the northern provinces by brown and black colour-coated beakers produced in Central Gaul, the Rhineland and eastern Britain.[11] These were often highly decorated with animals and plants *en barbotine*. Dogs chasing deer and similar energetic hunting scenes predominated, partly as a result of the fluidity of the technique. Sometimes human figures were present, either produced in the same way or as *appliqués* (Ill. 149). The decoration was usually in the same colour as the body of the vessel, but the finer examples have white and yellow barbotine to enchance the details. Occasionally more complicated figured decoration in polychrome was used, for instance on Trier colour-coated ware (Ill. 150). The busts on the Trier vessels were painted, not slip-trailed, and the careful but rather static appearance of the figures contrasts strongly with the field decoration *en barbotine*. These types of colour-coated ware were contemporary with the later phase of red-gloss ware production in Central Gaul and Germany.

 Painted pottery formed a much less important part of Roman ceramic production, except in certain areas. One such was on the fringes of the Empire in Nabataea, where a vigorous style of painted ware flowered and died between the late first century BC and the late first century AD. Shallow bowls were decorated with leaves and flowers

arranged symmetrically around the centre (Ill. 155). Brushing was the method of application, and the potters were able to produce many delicate and finely executed designs. Painting was also common elsewhere in the Near East and Africa, for instance on Nubian and later 'Coptic' pottery. The only western painted pottery of any sophistication was the early Gallo-Roman painted ware of Central Gaul, which was strongly Celtic in inspiration and continued into the early first century AD, when it was submerged by the introduction of redgloss wares. Painting was also a common method of decoration for the late Roman pottery of the northern provinces (see below).

GLAZED WARE

Pottery coated with a coloured glaze was of eastern origin, and appears to have been connected with the development of glass-working in Egypt and Syria. In general, the decoration of glazed wares followed that of contemporary red-gloss and colour-coated styles, and the pottery was often made in the same workshops. Eastern glazed cups in Roman styles appear in the first century BC (Plate 24),[12] and moulds and kiln debris are known from Tarsus, Notion near Ephesus and Çandarli. The styles consisted of simple scale patterns and leaf and flower wreaths; the forms such as the *scyphus* imitating metalwork. In the West, small cups, *unguentaria* and flasks were lead-glazed in green. yellow or brown over relief-moulded or plastic decoration, usually plant-derived or geometric. Italy (e.g. Aco wares) and Central Gaul were the main early production centres. Many others followed in the late first century AD, only to fade out soon after as a result of fashion changes during the Trajanic-Hadrianic period. Sometimes the underlying decoration was executed in different-coloured slips (usually applied *en barbotine*), resulting in a bi- or polychrome effect after glazing. There are good examples of this technique from a probable kiln-centre in South Russia, whose figured subject-matter tended to concentrate on the grotesque and the satirical.[13]

Lead-glazed wares were the usual type of glazed pottery in much of the Empire. In Egypt, however, faience-derived quartz frit ware was also made in the Hellenistic and early Roman periods. Flagons, *amphorae*, plates and other sometimes quite large vessels were produced at Memphis and other centres for the eastern Mediterranean market. The ability to create an astonishing range of colours allowed the potters to produce moulded designs with details enhanced with different colours. In addition, polychrome designs were produced by means of surface washes, which contributed ultimately to the development of Islamic *maiolica* in Egypt. The most sophisticated products of these potters were realistically modelled portrait heads of deities and rulers.

POTTERY IN THE LATE EMPIRE

The third century marks a period of widespread change in the styles of pottery produced in the western and northern parts of the Roman

world. Fashion changes had previously contributed to the alteration and demise of pottery styles, principally in the early Augustan, Claudian and Trajanic periods, but it is not until the upheavals of the period after Severus Alexander that large-scale changes were made. Away from the Mediterranean lands, the red-gloss tradition virtually disappears, continuing in a less well-executed form only at kilns in the Argonne and in Oxfordshire. Decoration also changes – figured and relief-moulded designs disappear, as do the figured versions of *en barbotine* colour-coated wares. Painting is revived, generally in the form of geometric or leaf- and feather-derived motifs, such as those on New Forest vessels (Ill. 156). Light colour-washes, sometimes with the appearance of being applied with a sponge, were also used as a form of decoration. In the Argonne, rouletted impressed decoration in the form of narrow, highly detailed lattice-work bands was common. Forms were also different in this period, but the changes are less clear-cut than in the other aspects of ceramic design. The trend away from using metal prototypes, first seen in the second century and possibly earlier, was intensified; new forms were more autochthonous, owing no particular inspiration to vessels made in other materials.

156. Colour-coated bottle from the New Forest potteries. Height 12.7 cm. 4th century AD. London, British Museum.

A different influence on pottery styles resulted from the spread of glass-working. Glass cups, bowls and plates started to oust pottery as the usual form of fine table-ware. This led to the disappearance of the more expensive and highly decorated ceramic products, which now gave way to cheaper and more easily manufactured designs. Fine and coarse pottery tended to come together in style and technique, and it was often the case that finewares were made in the same, fairly regionalized, kiln-centres as the kitchen and storage wares. Regionalization of styles and decoration was another important development of the late Empire after the *koine* of the red-gloss tradition ended. In some areas, such as the Rhineland and Pannonia, glazed pottery was revived to compete with glassware, usually without much embellishment.[14]

In the Mediterranean basin and the East, change was less evident, but the same trends can be picked out in certain areas. For instance, although the red-gloss tradition continued, relief-moulded and figured decoration on African Red Slip ware became very rare in the course of the third century, and was only revived in the later fourth and fifth centuries in a different form (see above). The fine and coarse wares from the African kilns also tended to become more homogeneous in technique and style.

The demise of Roman pottery styles does not lend itself to easy generalization, as local conditions were an important factor in determining the survival of potting traditions. In many areas any continuity was lost in the upheavals of the migrations, but exceptionally a centre like Cologne was able to preserve the heritage of Roman ceramics in the succeeding centuries. In the East, decline was more gradual, and the red-slipped wares only succumbed finally with the Arab conquests and the subsequent introduction of glazed ware. Even so, the traditions of the former lingered on in Nubia and Ethiopia.[15]

Terracotta Revetments, Figurines and Lamps

DONALD BAILEY

TERRACOTTA REVETMENTS AND FIGURINES

Fired clay is a most useful and versatile substance and was used extensively for many of the decorative material aspects of Roman culture, in addition to its employment functionally for more mundane items, such as pots, bricks and tiles. Following Etruscan models, religious buildings, for many centuries from the sixth century BC, used, in their roofing, timber faced with terracotta revetments. This could be of an extremely elaborate nature, highly decorated with patterns and figures in relief, and richly hued with fired-on coloured details. The revetments and the large elaborate antefixes, required in quantity on such a building, were mould-made, but pedimental and acroterial figures were probably hand-modelled, as were other free-standing figures, such as cult-statues. For example, the cult-statue in the Temple of Jupiter on the Capitoline hill was, at the end of the monarchy, reported to have been made by Vulca, an Etruscan sculptor from Veii (Pliny, *NH*, XXXV. 157), who also produced chariot-groups for the pediments. The Apollo of Veii is a well-known example of the work of such a sculptor. Although foreign artists continued to be employed in Republican times (two Greeks, Damophilus and Gorgasus, decorated the Temple of Ceres in the early fifth century BC — *NH*, XXXV. 154), the production of mould-made architectural terracottas (see Ill. 157), a comparatively simple process, should not have been beyond the capabilities of native Roman craftsmen, although large, complex figures in the round would have presented greater difficulties. There is some evidence, however, that craftsmen from Veii produced some of the terracotta revetments found in Rome.[1] After the late Archaic period, for many centuries, external terracotta architectural decoration in Rome, although of high quality, is found only in small quantities, but this is probably an accident of survival and the consequence of radical urban renewal, as many buildings with splendid and elaborate terracotta fittings continued to be erected in Etruscan cities until at least the second century BC, and it may be expected that this also happened in Rome.

During the first century BC and the first century AD, terracotta was widely used by the Romans in Italy for architectural purposes other than the extensive cladding of timber public buildings. Water-spouts round the *compluvia* of houses at Herculaneum and Pompeii were often modelled in the forms of animals. Antefixes decorated with relief patterns finished the roof-edges of large buildings. The example shown

here (Ill. 158) presumably commemorated the victory of Augustus at the battle of Actium: a series of these would be a propaganda exercise of a multiple kind: examples have been found at Rome and at Ostia. Interiors as well as exteriors were furnished with the decorative panels known as Campana reliefs, from the nineteenth-century collection of the Marchese G. Campana, which was particularly rich in these objects. Campana reliefs often depict religious and mythological scenes, for instance the Labours of Hercules (Ill. 159).[2] Although used less in Italy after the early Empire, architectural terracottas such as antefixes were made in the provinces, particularly by the army, as far away as York in Britain and in Pannonia.

During the Republic the use of terracotta was not confined to buildings. There was prolific production, both in Etruscan and Latin areas of Italy, of fired-clay votive offerings (the Greek areas of south-

ern Italy had always had, from the early sixth century onwards, a tradition for producing terracotta votive figures). Romans and Romanized Etruscans manufactured terracotta figures of deities in vast quantities for dedication at the many local shrines, and also portrait heads, both naturalistic and idealistic, mass-produced to vow to the gods, and for burial in tombs. Votives also included dedications at healing shrines, such as that at Ponte di Nona, and that of Minerva Medica in Rome. Many of these portray with some accuracy parts of the body, torsos, hands, feet, ears, eyes, genitals, breasts, for example, and internal organs, such as wombs. These pleas for supernatural healing add a poignant dimension to our knowledge of Roman life during the last four centuries BC.

There is little doubt that the majority of Roman terracotta figures were produced for votive use, dedicated at temples or in household shrines, but some were obviously toys (horses on wheels from Gaul, Moesia and Athens) and others may have been ornaments and souvenirs (gladiators, actors and victorious charioteers). Nearly all Roman terracottas were made in moulds, as were their Greek predecessors. The general picture of terracotta production in the Roman Empire is far from clear. The evidence relies almost wholly upon early unscientific finds and illicit excavations, often with no proveniences and certainly undatable, and on the few places where major well-conducted excavations have been made and the terracottas published. Future work may possibly bring to light examples of Roman terracottas from areas not well represented at present.

160. Group of Isis, Harpocrates and Anubis, made in Campania. Terracotta. Height 17.5 cm. 1st century AD. London, British Museum.

In Italy itself, very few terracotta figures seem to have been produced after the Flavian–Trajanic period. Apulia and especially Campania appear to have been the main areas of manufacture in the first century AD, with figures of gods and goddesses predominating, although representations of actors, figures from the mimes, and gladiators are also known. The long coroplastic tradition of Tarentum in Apulia extended to the beginning of the first century AD, but apparently no later. Campania was the main production area. The great Egyptian goddess Isis was very popular in Campanian cities, and the group from Avella (Ill. 160), showing her with her son Harpocrates and the jackal-headed Anubis, is a good example of the type of terracotta manufactured by the coroplasts of Campania. Some Campanian terracottas may have been exported to Spain and the Balearic Islands, where close copies in local fabrics are known. Although Sicily had an active terracotta industry from late in the seventh century, there is little evidence to indicate that it continued long after the Roman occupation of the island.

Athens, once a prolific producer of terracotta figures, became something of a cultural desert after the destruction of the Kerameikos by Sulla in 86 BC, and it was not until the end of the second century AD that terracottas again began to be made in any quantity. Figures of gods, mother-goddesses in profusion, dramatic representations and animals bulked large in the repertoires of Athenian coroplasts. Many of these terracottas were of fine quality and workmanship, and remained so for much of the third century AD, although the Herulian

sack of AD 267 did not help matters. A sturdy formalism (Ill. 161) had developed by the fourth century, and there was continuity of production until perhaps the early fifth century AD; there were few other places in the Roman Empire that made terracotta figures as late as this. There is some evidence for terracotta production at Corinth during the Roman Imperial period, but information is lacking for much of the Greek mainland. In North Greece and Corfu terracotta manufacture was a dying craft in the first century BC, but some figures were still being made in the first century AD.

In western Asia Minor, the ruin and bankruptcy of many of the Greek cities, caused by the harsh fiscal measures of grasping Roman governors in late Republican times, is reflected in the running-down or even cessation of a number of hitherto prolific terracotta production centres. Cnidus, Halicarnassus, Priene, Troy, Ephesus, and many more were affected in this way. Ephesus still produced figures of the Ephesian Artemis in the first century AD, presumably because of a demand by tourists for souvenirs. Cnidus recovered strongly in the Flavian period and exported vases and relief-decorated vessels, often of a highly ribald character, over much of the Mediterranean world; Lucian, in the second century AD, found no little amusement in the 'wanton' products of the Cnidian potters when describing a visit to that city in his *Amores* IX. (If he had lived a century later he would not have found such things, as the industry was virtually defunct by the mid-third century.) But terracotta figures, unlike relief wares, were not plentiful in Roman Cnidus. Two cities of western Asia Minor in which the production of fine terracotta figures did not cease after the coming of Roman administration were Myrina and Smyrna. Myrina made superb terracottas throughout the Hellenistic period, both Tanagra types and those of the subsequent late Hellenistic tradition: figures of goddesses and youths, *erotes* and children. The great majority of the thousands of surviving Myrina terracottas came from tombs, excavated mostly without record in the 1870s and 1880s. Many of the figures are signed and the names of a great number of makers are known. The graceful Aphrodite from the workshop of Menophilos (Ill. 162) probably dates to the early first century AD. An earthquake in AD 106 seems to have brought terracotta production at Myrina to an end. At Smyrna there was a lively manufacture of distinctive terracottas during the first century BC and the first century AD. Most of the surviving examples came from illicit excavations in the nineteenth century, and, more often than not, only the heads of figures were preserved by the dealers concerned. A large proportion are grotesques or are caricatures, and one can only assume that they were for ornamental use. However, beautifully modelled heads of gods and goddesses also abound, some of them based upon famous sculptures, and these may well have been made for votive use.

Tarsus, in Cilicia, had a terracotta industry that is well documented. Scientific excavations by Bryn Mawr College both before and after World War II, and adequate publication, both by the excavators and by the Louvre, have brought order to the thousands of Tarsus terracottas found during the mid-nineteenth century.

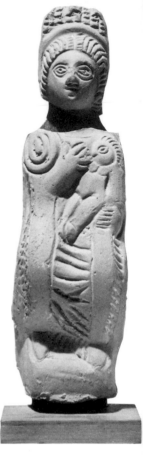

161. Mother-goddess from Athens. Terracotta. Height 16.8 cm. 4th century AD. Athens, Agora Museum.

162. Aphrodite from Myrina. Terracotta. Height 27.5 cm. Early 1st century AD. London, British Museum.

Terracotta figures were manufactured there from Hellenistic times until the third century AD. A large proportion of the figures, which include many *erotes*, wear wreaths round their heads, and these wreaths together with the hard, smooth fabric, often whitish-buff in colour, are very distinctive of Tarsus.

During the last two decades many terracottas of naïve workmanship, but competently made and often large and elaborate, from an unknown source in Asia Minor, have appeared. Their normally complete state indicates that they have come from tombs. The extraordinary Aphrodite combing her hair (Ill. 163) is a fine example which appears to date to the second half of the second century AD. The narrow-breasted, wide-hipped shape of such a terracotta is very much like that of some of the Gaulish pipeclay Venus figures from the other end of the Empire, which are totally different from the earlier Greek ideal exemplified in some of the Myrina statuettes. It is a shape which anticipates representations of women in Late Antiquity and early medieval times.

In the Levant, terracotta figures of a very high quality indeed were made at Jerash during the early second century AD; these include representations of Aphrodite, Apollo, Hermes, Athena, and Eros, together with animal figures. Strangely, some of the female figures are completely bald: presumably wigs were made for these in organic materials.[3]

A huge coroplastic industry developed in Egypt under the Ptolemies and continued without break at least to the fourth century AD; indeed the Christian Copts of Egypt made terracotta praying figures (*orantes*) as late as the sixth and seventh centuries AD. Alexandria, the Delta and the Fayûm were the main centres of production during Hellenistic and Roman times, Alexandria producing its finer work during the early Ptolemaic period. In addition to representations of gods and goddesses of the classical pantheon, many Egyptian deities were depicted; Isis, Sarapis and particularly Harpocrates, the gods of the Ptolemaic state religion, are found in huge numbers, together with the dwarf-god Bes and the obese Baubo, while Pharaonic gods were also made, the final flowering of three millennia of such representations. The phallic god Min, the resurrection god Osiris, and the falcon-headed Horus in Roman armour were all produced during Roman times. The variety of terracotta figures made in Egypt probably far exceeds that of figures made elsewhere. Votive offerings of gods, models of shrines and fertility figures of quite evident virility were produced. Animal representations were manufactured in large numbers. Again many of these were probably votives, but some were toys and others appear to be ornaments, for example the pleasing lap-dogs of many sizes that are reminiscent of the Staffordshire dogs of the nineteenth century. Nile mud, of which most of the Egyptian terracottas were made, does not have a very attractive appearance when fired, and many of the figures were subsequently painted in white, pink, black, blue and yellow colours. The two figures of Aphrodite-Isis of Plate 17 are completely overpainted in this way. Terracotta figures from elsewhere may also have been painted, but the fugitive colours survive better in the dry conditions of Egypt. Such is the continuity of production in Egypt, with no stylistic break between the terracottas made under the later Ptolemies and those produced during the Roman Imperial period, that in many cases it is not possible to decide either on a chronological sequence, or on the date to which a particular piece may be assigned. This situation may change when well-conducted excavations of Classical-period sites take place, and are published, but one cannot be too hopeful as the confusions caused by residuality in the densely populated sites of Egypt are difficult to disentangle.

Moving westwards along the Mediterranean shore of Africa, Cyrenaica and Tripolitania seem to have been singularly lacking in terracotta production during the Roman Empire, although in Greek and Hellenistic times many figures of deities and of Tanagra-type women and young men were made. Some plaster figures, often large and of some complexity, have survived, and these seem to date from the first and second centuries AD.[4] In Africa Proconsularis, terracotta production by the Punic inhabitants, based upon Greek and

163. Aphrodite from Asia Minor. Terracotta. Height 59 cm. Late 2nd century AD. Oxford, Ashmolean Museum.

164. Pan riding a panther, from Carthage. Terracotta. Height 13.6 cm. 1st–2nd century AD. London, British Museum.

Hellenistic models, had died out with the destruction of Carthage in 146 BC. Carthage was colonized under Julius Caesar and Augustus, and thenceforth developed into one of the largest and richest cities of the Roman Empire. There was therefore no continuity or tradition of terracotta manufacture there, but very attractive figures of gods, animals, musicians and actors, as well as human busts and other objects began to be made during the first century AD, continuing into the second century (Ill. 164). In the third and early fourth century, plastically modelled vases, often in the shape of human heads, were produced in Central Tunisia in the type of pottery known as African Red Slip ware, the workshop of one Navigius (Chapter 8) being particularly prolific of these. Head-lagynoi, carinated jugs with modelled mouths, copied from Cnidian examples, were also made in this material.5 In Spain, also, attractive figures of deities were produced during the Roman period.

In the north-west provinces of the Roman Empire, Celtic lands with no tradition at all for the making of terracotta figures, workshops with a very large-scale production were set up during the first half of the second century, notably in Central Gaul, in the Allier Valley, and, rather later, c. AD 150–200, in Eastern Gaul, on the banks of the Rhine and the Mosel. The white, iron-free clay (now known as pipeclay) was the preferred raw material of these centres. Owing very little to the Lysippan suppleness of much of the Mediterranean Hellenistic and Roman tradition of figural representation, the upright formalism of the Gaulish pipeclay figures is very distinctive. The Allier Valley figures have a softer, rounder appearance than those of the Rhineland. The variety of production is immense, particularly in the Central Gaulish workshops: figures of Venus (sometimes in elaborate shrines), Mercury, male Celtic deities, and mother-goddesses (often seated in a basket-chair) abound, as do grotesques and busts of children and women. Animals are plentiful, both as toys and votives, especially horses, cocks and doves; small vases were also made, often in the shape

of hares and monkeys, and these are sometimes coated in a green vitreous glaze. There appears also to be an Egyptian religious element: a very large number of jackals, sacred to Anubis and recognizable from their characteristic seated pose (but despite this usually described as dogs), have been found, as have representations of the god Thoth in baboon form, rather amusingly seated in a basket-chair. The Rhineland terracottas are rich in standing and enthroned goddesses: Fortuna (including an extraordinary seated example, showing the goddess leaning forward with one leg crossed over the other, and flanked by two horns of plenty), Minerva, Nehallenia (a local Gallo-Roman deity), Cybele, the Matres, and others, often represented in several different ways. Signatures are found on many of these Gaulish terracottas or on their moulds: both Celtic and Latin names, such as NATTI, PESTIKA, PISTILLVS, PRISCVS and SACRILLOS from the Allier Valley, STRAMBVS from Trier, and FABRICIVS, VINDEX and the prolific SERVANDVS from Cologne. It is interesting that the Allier Valley terracottas are amongst the few groups which were exported to any extent, most examples made at other centres being for a strictly local market. Figures, particularly of Venus and of mother-goddesses, were exported to both Britain and the Rhineland (where they may have initiated the Rhineland industry); some travelled as far east as Pannonia. This trade was no doubt largely due to the inclusion of terracottas in consignments of Central Gaulish pottery sent to these areas during the second century AD (see Chapter 8, p. 185). Illustration 165 shows a Central Gaulish Venus and an Eastern Gaulish Cybele, both found in Cologne.

In the third century AD, and continuing into the fourth, Trier was also a production centre for terracotta relief plaques and bowls, many of them carrying depictions of Orpheus, Narcissus, Mercury, or Mithras. Similar plaques, some with erotic scenes, were made further east, in Pannonia, particularly at Aquincum.[6] A prolific terracotta industry grew up during the third and fourth centuries AD in Moesia, the easternmost part of the Roman Empire in Europe.[7] These terracottas, normally mould-made, but with some hand-modelled examples, from workshops at Hotnitsa, Pavlikeni, and the very large centre at Boutovo, were on the whole very crude objects, but at this date few Roman terracottas were being made anywhere, and those that were, at Athens, for example, and in Egypt, were not very much better than these products of a remote province.

Thus, during the Roman Imperial period, some Roman provinces, but by no means all, produced terracotta figures in large quantities. This production often continued a tradition from Greek and Hellenistic times of terracotta manufacture and use, for example in South Italy, Greece, certain areas of Asia Minor, and Egypt. However, there is little excavated evidence for the manufacture of terracottas during this time in other areas which were also prolific in Greek times: Sicily, Cyrenaica, Crete, Cyprus and certain areas of Asia Minor. Except in a few places, terracotta manufacture in Mediterranean lands died out gradually, but not uniformly, during the last century BC and the early first century AD. The gradual re-

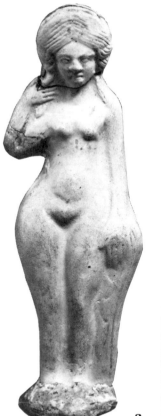

165. Central Gaulish Venus (a) and East Gaulish Cybele (b). Terracotta. Height 14.2 and 17 cm. 2nd century AD. London, British Museum and Cologne, Römisch-Germanisches Museum.

a b

duction of the cost of bronze figurines (Chapter 3, p. 96) was probably the main factor in the demise of the terracotta industry. But places outside the Mediterranean ambit began to make terracotta figures after coming into the sphere of Roman control: Central Gaul, the Rhineland, Pannonia and Moesia; as did Spain and also Africa Proconsularis during its Roman economic expansion.

TERRACOTTA LAMPS

Lighting is a necessity of civilization: it was as essential for the Romans as it is for us. The oil-lamp of antiquity was simple: a chamber to hold the fuel (normally olive oil) and a nozzle to hold a wick. Such a lamp produced only a small amount of light, which could be increased only by adding to its number of wicks, or by using more than one lamp. Most terracotta lamps have only one wick, but 'multi-nozzlers' were made in many areas. These were no doubt expensive to buy and costly to use: a lamp with twelve wicks uses twelve times as much oil as a lamp with one (but gives off twelve times as much light). Throughout the Empire and during its long life, lamps in materials other than fired clay were manufactured in large numbers. Gold (see Chapter 6) and silver lamps are known, but bronze lamps must have been made in vast quantities; however, the melting-pot has claimed most of them. In

later antiquity, glass float-wick lamps, suspended in bronze lamp-holders, were plentiful. Many metal lamps have utilitarian shapes, which very seldom correspond to the forms of terracotta lamps. A large variety of exotic bronze lamps have survived which are of plastically-modelled shapes, human figures and heads, animals and birds, and terracotta versions of these exist.

It is often possible to determine with some accuracy the manu-facturing sources of terracotta lamps, but this is seldom so in the case of bronze examples. No real lines of development are discernible in the shapes of bronze lamps, whereas these may be seen with many terra-cotta lamps. Dating is a problem not yet resolved. The largest quantity of dated examples are those found in the Vesuvian disaster-towns of AD 79.[8] Most of these are probably of Italian manufacture, and lamps of the same forms were no doubt made for many decades after this destruction date. After the second century, few bronze lamps have been recognized until they appear in some quantity in the eastern Mediterranean in late Roman times, in the fifth to seventh centuries AD, often decorated with crosses, or with gryphons' heads, or in the form of doves and dolphins. The latter are especially prevalent, to-gether with their extremely elaborate stands, in the X-group ceme-teries of Ballana and Qostol in Nubia.[9]

Most surviving Roman lamps are of terracotta and, unlike terra-cotta figurines, the production and use of which was largely a local affair, many groups of lamps were exported widely throughout the Empire.[10] Lamps in Rome itself are first found in some quantity in the Esquiline cemetery. These lamps of the third and second centuries BC are, like most lamps made elsewhere in Italy at this time, wheel-made and covered with a black glaze. Some of them may be local, but many of them are imports from Greece, particularly from Athens.[11] During the first century BC, mainly in the last years of the Republic and in early Augustan times, mould-made *Warzenlampen* were produced, nor-mally with the red slip made fashionable by the Pergamene pottery factories and the workshops of Arezzo. These blunt-nozzled lamps with raised-point decoration, sidelugs, and applied handles, based on Hellenistic shapes from the eastern Mediterranean, were made in Italy and exported in large numbers to Spain, North Africa, Gaul and Germany, where they were occasionally copied.

Italian lampmakers of the early Empire were innovators, devising several shapes of lamp which remained in production, with local variations, in many parts of the Empire for centuries. Volute-lamps were the earliest of these, introduced in Augustan times. These are distinguished by two curved ornaments flanking the nozzle; the nozzle itself had either an angled or a rounded termination (Ill. 166). Unlike earlier lamps, the wide, dished top of volute-lamps gave ample space for a huge variety of relief scenes. Both forms remained in production well into the second century in Italy, and Italian examples were exported throughout the Empire and occasionally beyond the fron-tiers. Local factories began to copy them as soon as they arrived, in Gaul, Germany and Britain (often in army establishments), in Asia Minor, Cyprus, Egypt and at Petra in Jordan. In many areas, how-

a b

166. Italian volute-
lamps: (a) goat and vine;
(b) Icarus flying.
Terracotta. Length 10.3
and 13.8 cm. 1st century
AD. London, British
Museum.

ever, imported lamps were plentiful exotica, and local workshops did
not begin to copy imports to any extent until the second century AD, by
which time the volute-lamp had fallen out of fashion: Africa Procon-
sularis and Cyrenaica are cases in point, as also is the Greek mainland.

The most common shape of lamp which these belated provincial
ateliers produced was based upon another Italian model, probably
devised in the decade AD 40–50. It has a circular oil-chamber, a
narrow, rounded shoulder, and a short, rounded nozzle. An Italian
example of early date (Ill. 167) shows the shape that was copied
closely in the East and in military establishments along the north-
western *limes*. Originally made without a handle, it soon acquired one,
and the shape became ubiquitous in central and southern Italy. The
earlier examples were as highly decorated as the contemporary volute-
lamps, but the scenes became much simpler in the second century AD,
although some late Antonine/early Severan makers working in Rome
produced very elaborately decorated lamps. This shape died out in
Italy in the post-Severan period, during the first half of the third
century AD, and was succeeded, in those troubled and uncreative
times, by a globular version decorated with rows of raised points. This
in turn was replaced, in the late fourth century, by local copies of a
distinctive elongated lamp from Tunisia.

At the end of the first century AD, a developed and simplified form of
the earlier circular-bodied, short-nozzled lamp, often signed with the
tria nomina, was exported in vast numbers from Italy to Africa Procon-
sularis and to Cyrenaica, in both cases initiating large-scale local
production; the shape was more closely copied in the former than in
the latter area. This form of lamp also became very popular in the
Greek East, but far fewer Italian imports have been found in Greece,
Asia Minor, South Russia, Cyprus, Egypt and the Levant than along

167. Italian lamp with
elephant and rider.
Terracotta. Length 11.7
cm. Second half of
1st century AD. London,
British Museum.

168. Athenian lamp with Leda and the Swan. Terracotta. Length 17.5 cm. First half of 3rd century AD. Athens, Agora Museum.

169. (*Below*) African Red Slip ware lamp with a monogrammed cross (reversed), and representation of coins of Theodosius II on the shoulders. Terracotta. Length 14.5 cm. 2nd quarter of 5th century AD. Aquileia, Museo Archeologico.

170. (*Below*) Ephesian lamp decorated with a cross. Terracotta. Length 10.6 cm. 5th-6th century AD. London, British Museum.

the North African coast, and the influence which brought about this Empire-wide popular shape is less apparent.

In all these southern and eastern provinces, variations and developments of the basic Italian shape were produced for a very long time indeed, in many cases to the end of the fourth century and into the fifth. Corinth and Athens, from the end of the second century until the middle of the third, produced probably the finest Roman lamps made anywhere in the Empire, often with beautifully modelled scenes (Ill. 168). In Africa (renamed Byzacena), at the end of the fourth century, African Red Slip ware lamps replaced the buff ware lamps which, after a period of very fine workmanship in Antonine–Severan times, had become stereotyped and dull. The new red lamps based ultimately on their buff predecessors, developed an elongated, channelled nozzle which quite transformed their appearance. They were exported very widely indeed, to almost every part of the Empire (though none has been found in an archaeological excavation in Britain). They were made for about a century and a half, from the last quarter of the fourth century AD, and throughout the Vandal occupation, to die out in the period of depression following the re-occupation of Africa by the Byzantine forces of Justinian. The shape (Ill. 169 represents the developed form) was copied in many areas which imported the lamps, including Italy (particularly Rome), Greece and Asia Minor.

Also in Asia Minor, principally at Ephesus, another elongated but distinctive development of the basic circular-bodied lamp was devised (Ill. 170). It has a much more carinated body-shape than has the African Red Slip ware lamp, although it eventually borrows the nozzle-channel from the latter. It seems to start during the fifth century AD, and dies out in the seventh century. It was much exported in the Greek East, and was copied closely in many places, particularly in Greece and in Egypt. A distinctive eastern Danubian version is also known, with cross-shaped or animal-headed handles.

Egypt pursued its own course. Although, primarily in the Delta, very close copies of imported Italian volute-lamps and circular-bodied, short-nozzled lamps were made (the latter remaining in use until the fourth century AD), from late in the second century until probably the fifth century, the so-called Frog-lamp was manufactured in vast numbers, mainly in Middle and Upper Egypt. Many of these have a frog or toad on their upper surface, well-modelled at first, but increasingly debased to become barely recognizable on late examples. Other simple designs are found on these lamps, including rosettes and ears of corn. The Egyptians also reintroduced at the same time a shape resembling that of Hellenistic lamps of two or three centuries earlier, with a carinated body and long, splayed nozzle; the body was now kidney-shaped, however, rather than circular. Oval lamps bearing the names of saints and bishops were sold at shrines in Upper Egypt during the sixth and seventh centuries.

Distinctive lamps were also made in the Levant. While at Petra, before its conquest by Trajan, close copies of imported Italian volute-lamps were made by the Nabataean potters, and, later, circular bodied, short-nozzled lamps ultimately based upon similar Italian lamps were produced in Syria, in Judaea the local lampmakers preferred their own designs, from the simple wheel-made 'Herodian' lamp and its mould-made successors, to the oval lamps of the fifth–sixth centuries, with their raised linear patterns; the oval shape, becoming more sharply carinated and acquiring a stub-handle, was to remain standard, both in the Levant and in Egypt, for many centuries after the Arab conquests.

In Italy, a North Italian lampmaker, perhaps one Strobilus, invented a shape of lamp, the *Firmalampe* (Ill. 171), which became the standard form made and used in the northern provinces of the Empire. It was exported also to other parts, and occasionally copied, but it never ousted the circular-bodied, short-nozzled lamp preferred in Mediterranean lands. The first Italian examples, in a brick-red clay, were produced in very early Flavian times, about AD 70 (but there is controversy about this, and earlier dates are preferred by some scholars). It is a simple, practical lamp; the example with the open nozzle-channel was devised some two decades after that with the closed channel, and both versions continued to be made contemporaneously. The majority are undecorated, but simple masks, mainly theatrical, occasionally of Cupid or Jupiter-Ammon, are found on some. Italian examples were exported to the Provinces of Britannia, Gallia, Germania, Raetia, Noricum, Pannonia, Dacia and Moesia. In all

a

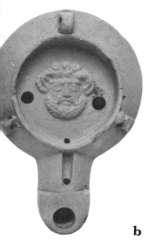

b

171a, b. North Italian *Firmalampen*, showing (a) a dramatic mask and (b) a head of Jupiter Ammon. Terracotta. Length 10.2 and 11.3 cm. Last third of 1st century to first quarter of 2nd century AD. London, British Museum.

these places they were copied by local lampmakers. It has been argued that many of these workshops were branches of the Italian establishments whose names are frequently found on their products,[12] but it seems more probable that most provincial *Firmalampen* were made at ateliers which pirated not only the shape but also the names of the original Italian lampmakers, using the process of surmoulage: imported lamps were used as archetypes from which moulds were taken. Be that as it may, and we will never know the full story, the *Firmalampe* dominated the lamp market in the northern provinces from late Flavian times at least until the third century AD, and into the fourth century in some places. Only in Dacia and nearby areas of Pannonia were other shapes produced in any quantity during this period. *Firmalampen* died out with the break-up of Empire and the consequent lack of imported oil.

The lamps of Italy in the first century AD were of a very high quality and many of the decorations found on lamps produced elsewhere stem ultimately from the figure-types adorning them: the same scenes often appear on examples made at each end of the Empire. Representations of gods and goddesses are common, including minor deities such as Fortuna and Victoria, in addition to the Olympian gods; Cupid is particularly prevalent. Scenes from myth and legend abound: the exploits of Hercules and depictions of Homeric and Vergilian themes were popular. Many lamps show the different types of gladiators, both singly or engaged in combat. The circus as well as the amphitheatre is well illustrated, not only by two and four-horsed chariots, but by scenes showing the structures of the circus, and by representations of winning charioteers and victorious racehorses. Erotic scenes of lovers and of dwarf entertainers appear on a sizeable proportion of figured lamps. A very large number depict animals of many species, mythological, wild and domesticated: mammals, birds, fish and crustacea are found. Decorative patterns are plentiful, particularly rosettes and wreaths. All these devices were designed to attract the customer by making the product more pleasing to the eye.

The Italian figure-types were copied in many lampmaking centres, but several areas were almost equally inventive in the centuries following the first century AD. The beautifully modelled scenes on Corinthian and Athenian lamps (Ill. 168) had great variety, sometimes depicting famous sculptures now lost and otherwise known only from descriptions in literature, from gems and coins, or from Roman copies. In Egypt, the locally produced lamps show Egyptian deities, Sarapis, Isis, Harpocrates, and also renderings peculiar to that country of Greek myth and legend. During the fifth century AD, African Red Slip ware lamps from Tunisia bear distinctive decorations. The Sacred Monogram, the Monogrammed Cross, and the Cross, are shown in many forms, but even more interesting are scenes from the Old and New Testaments: Jonah and the sea-monster, the Hebrews in the fiery furnace, Daniel in the lions' den, the Spies with the grapes of Eshcol, Christ trampling the Serpent, and many more. The scenes found on terracotta lamps are a most useful source of information about life, religious thought and practice, and the art of the period.

Glass

JENNIFER PRICE

INTRODUCTION

Glass served a wide variety of purposes in Roman times and exerted a greater influence on daily life than at any other period before the Renaissance. It was most commonly used for the production of vessels; some of these were of such luxury as to compete with precious metals for table and toilet wares, but most were more modest household objects or containers for the storage and transport of perishable commodities. Glass was also widely used for windows and for interior decoration in the form of ceiling and wall mosaics and elaborate inlaid panels for walls and furniture. In addition, imitations of gemstones (see Chapter 6) and items of personal adornment such as hairpins, necklaces, ear-rings and finger rings, were often made of glass, and its occasional use for mirrors as well as for statuettes, gaming-pieces and other small objects, is also attested. More unusual functions are also recorded in ancient literature, and these include the use of globular vessels filled with water to concentrate the sun's rays and kindle fire, or to magnify small writing, as well as a suggestion that powdered colourless glass was effective as a tooth-powder, and for other medicinal purposes. Roman authors frequently made reference to glass and these accounts are most valuable for estimating the significance of the material in everyday life, as they fill out the information available from sources such as epigraphy, contemporary illustrations, and the vessels and fragments which survive.

EARLY HISTORY OF GLASS IN THE CLASSICAL WORLD

Glass, in common with most other materials in use in the Roman world, had been in production from very early times, and glass vessels were first made more than fifteen hundred years before the Roman Empire was established. Most of these were very small polychrome core-made[1] vessels with narrow necks, which in the classical Greek and Hellenistic world often imitated stone and pottery forms such as the *alabastron, amphoriscus, aryballos, hydria* and *oinochoe*, and were probably used as perfume and unguent containers. They were brightly coloured, nearly opaque, and have been found in many burials throughout the Mediterranean region.

Larger open vessels, closely imitating contemporary metal bowls and plates, were produced in Mesopotamia from the eighth century BC onwards. They were cast and ground and were made both in colourless and in coloured monochrome glass. At first, this glassware reached the

Mediterranean region only infrequently, and its exotic and luxurious status in fifth-century Greece is indicated by a reference to Athenian ambassadors at the Persian court who drank from goblets of glass and gold (Aristophanes, *Acharnians*, 74).

From the end of the fourth century BC onwards, translucent glass-wares became more common in the eastern Mediterranean area and in burials in southern Italy. The first appearance of polychrome mosaic vessels also dates from this time, and a wide variety of floral, lace, strip and other mosaic patterns were produced in the Hellenistic period, as well as sandwich-gold glass.[2]

During the late Hellenistic period glass was used to a greater extent than at any previous time, both for tablewares and for small perfume containers, and it is probable that vessels were being produced at Alexandria and several eastern Mediterranean centres. None the less, glass seems to have been regarded at this time as a minor luxury material, produced by complex, time-consuming and expensive methods in a limited range of forms which were also available in stone and metal, as well as in pottery. There is very little evidence in contemporary literature that glass had yet made a substantial impact in everyday life, and most early Greek allusions to the material emphasize either its strangeness or its transparency and brightness.

It is obvious from surviving Latin literature that glass was similarly unimportant in Republican Rome. Both core-made and cast vessels were known in many parts of Italy from the eighth or seventh century BC onwards, and some types of small unguent bottles were probably produced in Etruria, yet the common Latin word for glass, *vitrum*, is not recorded before the middle of the first century BC.

THE INVENTION OF GLASS-BLOWING

During the middle and later first century BC glass ceased to be merely a rare luxury product and came into very general use in the Roman world. This change was brought about by the discovery of blowing as a method of forming glass vessels, surely the most significant technological innovation made in glass production in antiquity. Unfortunately, no surviving literary account throws any light on the discovery of glass-blowing, so the exact date and place of this event remain uncertain; early examples of blown glasses have been found in the region of Syria and Palestine. A rubbish deposit dating from around 50 BC, which contained glass-blowing debris, was found in Jerusalem in 1970, and this indicates that a glass-blowing workshop was already established there.[3] It is certain that blown glass vessels, and probably glass-blowing as well, reached Italy soon after this time, and Strabo's account of the discoveries at Rome relating to the production of glass, and of glass drinking-cups purchased 'for a copper coin' (*Geography*, XVI. ii.25), which certainly refers to the manufacture of inexpensive glass vessels, may perhaps indicate that blown glass was being made in Rome in the late first century BC. From the time of this discovery onwards, glass-blowers were able to make thin-walled transparent vessels in a vast range of sizes and shapes, many of which had not been attainable by the earlier methods of manufacture; they were

also able to make them with great speed and so, presumably, at a comparatively low cost. The effect of this revolution in production was to make glass more readily accessible to virtually all levels of society, and the huge increase in demand resulted in glass vessels becoming items of common use.

The increase in production is evident from the large quantities of glass fragments regularly found on archaeological sites dating from the Augustan period onwards, and the new interest in the material is also reflected in literary accounts of this period. The earliest allusions to glass in Latin literature occur in Lucretius (*De Rerum Natura*, IV. 145, written before about 55 BC) and in Cicero (*Pro Rabirio Postumo*, XIV. 40, delivered in 54 BC), and for more than a century afterwards glass was frequently mentioned in literature, especially in the poetry of the Augustan and later periods. Although these references rarely contain any very specific information it is apparent that glass had become an object regularly encountered in daily life, and was accepted as a standard of comparison for qualities such as brilliance, transparency, fragility and, when broken, sharpness.

As glass vessels and glass production spread throughout the Roman world, the great popularity of blown forms appears to have created new markets for other glassware and may have had the effect of stimulating the production of cast glass. Several forms of cast table-wares either make their first appearance or develop from earlier forms *after* the invention of glass blowing. During the later first century BC and early first century AD, both techniques were regularly used for vessel glass. The cast and ground tablewares, usually produced in forms with very close counterparts in fine stone, metals and pottery, must always have been regarded as expensive and luxurious pos-sessions. By contrast, blown glass, with its variety of new forms for drinking cups and other tablewares, vessels for display or for the preservation, storage and transport of foodstuffs, liquids and cos-metics, was surely viewed as extremely costly and luxurious in some instances, and as inexpensive and functional in others. Glassmaking was always regarded as a skilled craft rather than as an art in the ancient world, and although Seneca could marvel at the glass-blower 'who by his breath alone fashions glass into numerous shapes, which could scarcely be accomplished by the most skilful hand' (*Epistulae Morales*, XC. 31), it seems probable that many of the finest vessels were admired for the colour and quality of the glass, for their similarity to other luxury materials, or for the intricacy of their decoration, rather than for the beauty of their forms.

CAST TABLEWARES IN THE EARLY ROMAN EMPIRE

Cast glass vessels were made during the later first century BC and first century AD but are found only rarely after this time. They continued the traditions of manufacture originally established in Mesopotamia and carried on at Hellenistic glass-making centres in the eastern Mediterranean world, though many of the forms produced were new. Most of the Roman Imperial cast glass vessels were drinking cups or bowls, but plates, jugs and other forms of tableware were also made,

and toilet vessels such as *alabastra*, *pyxides* and unguent bottles also occur. Until the middle of the first century AD Roman cast vessels were produced in polychrome and brightly coloured opaque and translucent monochrome glass, but after this time colourless glass dominated the production of these fine tablewares.

Most polychrome glass relied for its decorative effect on the arrangement of prefabricated component parts into mosaic patterns, and a wide variety of designs was achieved by several methods. Care was usually taken to arrange the design to its best effect on the surface most often visible, so bowls and other open forms such as plates generally exhibit a superior inside surface, while the reverse is the case on closed forms such as the jar, unguent bottle and *pyxis*. The five main categories of polychrome mosaic designs found in the Roman world are: floral mosaic (*millefiore*), which contained composite rods with flower and roundel designs; strip mosaic, which was arranged in geometric patterns from strips of different-coloured glass and tesserae (Plate 25); lace mosaic (*reticella*), where trails containing twisted threads of coloured glass were coiled like raffia-matting to form the vessel; gold-band glass, which consisted of large segments of coloured glass and included pieces with gold leaf sandwiched between two layers of colourless glass; mottled and marbled glass, where the ground contained chips or streaks of glass in contrasting colours. Many of these vessels were produced in colours and designs intended to imitate rarer and more expensive materials such as agate, sardonyx and fluorspar, from which the *vasa murrina*, celebrated by late Republican and early Imperial writers, are thought to have been made (see Chapter 6). Other colour combinations have close counterparts among pottery vessels as well as fine stone; perhaps the most notable examples of this similarity are the small bowls and plates made from opaque orange glass with fine dark-red streaks which were sometimes made in the later first century BC and early first century AD. These vessels bear a very close resemblance to the marbled samian ware vessels of the early first century AD (see Chapter 8), and it seems possible that both were intended to imitate coloured marble.

The places of manufacture of polychrome cast glass have been the subject of much debate. The passage in Strabo (*Geography*, XVI. ii. 25) '... I heard in Alexandria from the glass workers that there was a kind of glass sand without which it was not possible to produce expensive polychrome vessels ...', establishes that city as a place where high-quality polychrome glass, very probably cast, was made in the late first century BC, but the distribution of finds suggests that other centres, in Syria and Italy, also produced this glass.

Cast vessels made from brightly coloured translucent glass, and from opaque glass, in white, brown (which appears black), and various shades of blue, red and green, enjoyed a certain popularity in the early years of the Roman Empire, and a range of substantially undecorated cups, plates, bowls and trays was produced. Most of these may be related to silver and other metal prototypes, and are frequently encountered among the undecorated forms of Samian pottery.

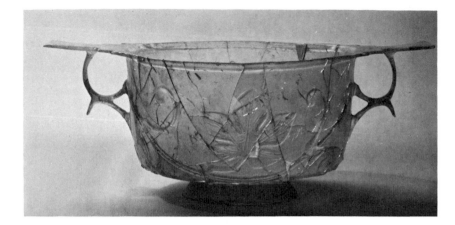

172. Cast colourless glass *scyphus* with vine stems, leaves and bunches of grapes carved in relief. From a 3rd-century burial in Cologne. Height 8 cm. Cologne, Römisch-Germanisches Museum.

Cast colourless tablewares make their first appearance in the Roman world during the third quarter of the first century AD, though they had previously been produced by Hellenistic and earlier glass-makers. Pliny provided some clear indications of the regard in which good colourless glass was held in the later first century when he wrote that 'the most highly valued glass is colourless and transparent, resembling rock-crystal as closely as possible' (*NH*, XXXVI. 198), and that 'glassware has now come to resemble rock-crystal in a remarkable manner and the value of the former has increased without diminishing that of the latter' (*NH*, XXXVII. 29). This expensive glassware was presumably made in limited quantities in order to preserve its value, and it seems probable that Pliny was referring to cast, rather than blown, colourless vessels. Another of Pliny's stories (*NH*, XXXVI. 195) records the discovery of a technique of glass-making during Nero's reign which resulted in two quite small cups of the kind known as *petroti* being sold for 6,000 sesterces. This may also relate to colourless cast glass, if *petrotos* means 'like stone', but this word is obscure and has sometimes been read as *pterotos*, or 'winged'.

Colourless cast drinking vessels were made quite frequently, and one of the forms often encountered was the *scyphus*, with elaborate carved horizontal handles (Ill. 172). These cups are closely comparable with silver and other metal examples, as well as rock-crystal vessels. Another cast form sometimes produced in colourless glass was the *trulla*, a shallow bowl with one elongated horizontal handle. Many of the cast cups are undecorated except for the carving on the handle supports, but relief-cut decoration, in the shape of vine scrolls, laurel wreaths, and closely-set waved grooves, occurs on some examples and on the *trullae*, and a pale-greenish cup from a Flavian grave at Siphnos bears a fine wheel-engraved design showing a hippocamp and a griffin ridden by cupids.[4]

Shallow cast colourless circular and oval bowls and plates were also made in the late first and early second centuries AD (Ill. 173). Some of these have 'egg and dart' cutting on the overhang at the edge of the rim and facet-cut designs on the underside of the rim, and on the body and base, and a few have elaborately carved horizontal handles. The

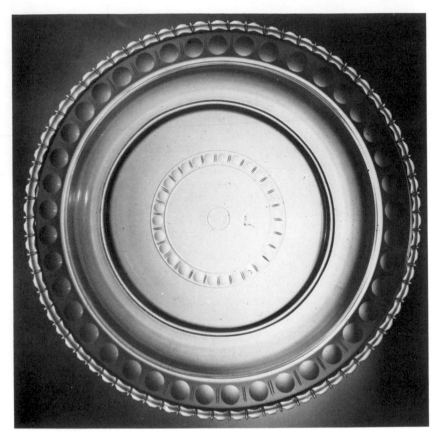

173. Cast colourless glass plate with 'egg and dart' and facet-cut decoration. From the Cave of the Letters, Nahal Hever, Judaean Desert, Israel. Diameter 33.8 cm. Late 1st or early 2nd century AD. Jerusalem, Israel Museum.

forms of these vessels, and the decoration on the rim edge, strongly suggest that they were copies of Roman silver tableware.

Glass seems to have been widely appreciated as a material for luxury drinking vessels during the early Empire, on account of its lack of smell and taste, as well as for its aesthetic qualities. Trimalchio states that he prefers glass vessels (to Corinthian bronze) as they do not smell, and also says that if only they were not so fragile he would prefer them to gold (Petronius, *Satyricon*, L. 7), and Pliny made a rather similar observation when he wrote that although glass drinking vessels had ousted gold and silver, they could not bear heat unless cold liquid was poured in first (*NH*, XXXVI. 199). However, the very wealthy did not favour glass tablewares consistently, and glass vessels were apparently quite unfashionable during some parts of the third century AD though they enjoyed Imperial support at other periods. According to the late fourth-century *Historia Augusta*, the Emperor Gallienus (AD 253–68) always drank from gold cups, and despised glass because he said nothing was more common (*S.H.A.* – Trebellius Pollio, *Gall. Duo*, XVII. 5), and a third-century Christian Apocryphal account mentions a woman 'who was called Chryse because all her vessels were of gold; she had never used a vessel of silver or glass' (*Actus Petri cum Simone*, XXX). On the other hand, the Emperor Tacitus (AD 275–6) was recorded as being 'greatly pleased by the diversity and elaborate workmanship of glass cups' (*S.H.A.* – Flavius Vopiscus, *Tac.*, XI. 3).

MOULD-BLOWN VESSEL GLASS

The realization that vessels could be formed by blowing glass into decorated moulds permitted the production of glass vessels with shapes and designs similar to those of cast glass vessels, and thus simplified the accurate reproduction of many forms and patterns used on contemporary relief-decorated metal tablewares. Most glass forms produced by mould-blowing were table vessels, such as drinking cups, jugs and amphoras, though some small unguent bottles and *pyxides* were also made. Many were carelessly produced and were clearly very cheap imitations of expensive objects, but there were also some exceptionally fine mould-blown vessels, which occasionally carried the names of their makers.

The most outstanding vessels are signed by Ennion, who appears to have worked in Syria, probably at Sidon, and in northern Italy, during the early to mid-first century AD (Ill. 174). He produced a variety of tablewares decorated with gadroons and arcades, bands of network and honeycomb, ivy and vine sprays, and other vegetal motifs, as well as a hexagonal bottle form with symbols based on the objects carried in Dionysiac revels. Many of these design elements, which were admirably produced in low relief, are found on Hellenistic as well as on early Imperial metalwork and pottery, and it may be that they were copied

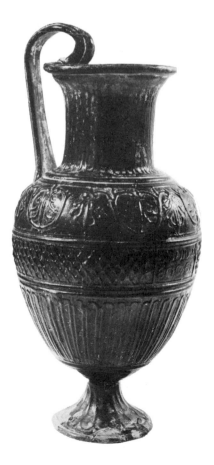

174. Dark blue glass jug, signed by Ennion, with mould-blown designs on the neck, body and foot. Height 22 cm. Early to mid–1st century AD. Tel Aviv, Haaretz Museum.

from plaster or clay casts taken from the original vessels and re-arranged to make new moulds.[5] The successful production of these fine decorated vessels probably depended at least as much on the quality of the design and on the shape of the moulds as on the skill of the glass-blowers, and it seems probable that Ennion, Aristeas and the other men whose names are found on mould-blown tablewares would have been responsible for making the moulds as well as for blowing the glass into them.

Among the groups of early mould-blown drinking cups which carried designs in high relief there are some tall beakers with mytholo-gical scenes. These must have derived from metal prototypes, al-though exactly similar vessels have not survived, and similar designs are also known among relief-decorated Arretine forms. Almond-knobbed beakers (Ill. 175), which are decorated with rows of moulded almond-shaped bosses arranged in *quincunx* on the body, also appear to imitate embossed metal vessels, and may, in addition, be seen as inexpensive versions of relief-cut glass tablewares. Decorative bosses apparently enjoyed considerable popularity among first-century tablewares, as they are also seen on a dark-blue glass beaker blown into a silver case with eight rows of openings, which was found in Italy, perhaps at Brindisi;[6] similar almond-shaped bosses have been noted on various forms of samian drinking cups made in Spain.

BLOWN TABLEWARES

The blown vessels of the Roman world differ from the cast and mould-blown vessels in that their forms are not generally comparable with stone, metal and pottery equivalents. Glass was the only material used in antiquity which could be both shaped by inflation and mani-pulated while hot, and the exploitation of these qualities developed forms and decorative effects which were appropriate to glass rather than to any other substance. Most of the blown glass in common use was of an everyday, utilitarian character, and was generally undec-orated, although it was often quite carefully made and shaped (Ill. 176). However, there was also a considerable quantity of much better quality tableware, decorated by a variety of methods, some of which were undertaken while the glass was hot, and others which required the glass to have been fully cooled.

Methods of Decoration. Decoration involving the application of blobs and trails of glass, or the pinching and manipulation of the vessel, or the expansion of designs by inflation, was produced by the glass-makers (*vitriarii*) when the vessel was made, whereas painting and gilding need not have been executed in the same place or by the same craftsmen; in fact the glass-cutters (*diatretarii*) were always considered to have a quite separate identity from the glass-makers.

The decorative effects achieved by applying blobs and trails were popular throughout the period of the Roman Empire. In the early first century AD, opaque white and coloured blobs and streaks were often applied to the walls of brightly coloured jugs, bowls and drinking cups,

175. Mould-blown amber glass beaker with almond-shaped bosses in high relief. From Syria. Height 20.8 cm. Later 1st century AD. London, British Museum.

176. (*Above, left*) blown bluish-green glass cinerary urn and lid with high curved handles. From Place des Carmes, Nîmes. Height about 30 cm. 1st century AD. Nîmes, Archaeological Museum.

177. (*Above, right*) blown amber glass jug with opaque white marvered blobs. From one of the Aegean Islands. Height 23.8 cm. Early to mid-1st century AD. London, British Museum.

and either marvered flush with the surface, thus creating a splashed or streaked effect (Ill. 177), or left projecting from the vessel. Much of this glass was made in northern Italy, probably near Aquileia, but it was distributed widely in the Roman world. The colourless ovoid-bodied flask from Hauxton, Cambridgeshire (Ill. 178), which was made in the late second or early third century AD, has five pairs of vertical ribs nipped together in the middle and pinched out at the base to form a symmetrical network pattern on the body. This form of decoration was never very common, though it occurs on some footed drinking cups from the later first to the third century AD. By contrast, coloured trails bent into complex serpentiform designs were widely used to decorate glass vessels from the later second century AD onwards. It is probable that the decoration developed in the eastern Mediterranean, but was soon brought to the western provinces, perhaps by itinerant glass-makers, and was then made in large quantities at Cologne and other Rhineland centres.

The colourless flask from Cologne (Plate 27) was made with a flattened body in order to provide two broad surfaces, and these are covered with a stylized leaf-and-garland design produced from very fine opaque white, blue, red and gilded glass trails. The rim, neck, handles, sides of the body, stem and foot have also been decorated with trails, some of which have been pinched to provide a corrugated outline to the vessel. The design and decoration of this vessel must surely be admired as a virtuoso performance by a master craftsman of the third century AD, although its formal aesthetic appeal is perhaps rather limited.

The tall drinking cup from Janglinster, Luxembourg, is also decorated with coloured trails (Ill. 179). This vessel dates from the fourth century AD and has the wide, tubular base ring, the high base, and the roughly finished rim which are commonly found on drinking vessels at

178. Blown colourless flask with trailed and pinched decoration on the neck and body. From Hauxton Mill, Cambridgeshire. Height 22.8 cm. Late 2nd or early 3rd century AD. Cambridge, Museum of Archaeology and Anthropology.

this time. The design consists of a horizontal band of zigzag trails below the rim and four carefully arranged and symmetrical scored serpentine trails extending from the zigzag band to the edge of the foot. This is one of the latest examples of snake-trailed glass.

Comparatively few painted vessels have survived, though they were probably produced in small numbers at several periods in Roman times. A group of hemispherical drinking cups and other tablewares with painted scenes are known from the mid-first century AD. Several of these, including a cup from Locarno and an *amphoriscus* from Kerch, have brightly coloured designs showing birds within twisted ivy and vine scrolls, and the decoration is rather reminiscent of the patterns on some of the cylindrical mould-blown cups signed by Ennion, and on contemporary decorated samian ware.

Another group of drinking cups, made in colourless glass and painted with wild beast hunts and circus scenes, have been found in later second and third century contexts at sites in the lower Rhineland and Britain, as well as in burials beyond the Imperial frontiers, at Himlingøje, Nordrup, Thorslunde, Varpelev and elsewhere in Denmark and north Germany (Plate 19). Much of the painted tableware found in the Roman world is thought to have been produced in Egypt, and a variety of vessels with Egyptian scenes have been found as far away as Begram, in Afghanistan.[7] Two tall dark-blue cylindrical cups dating from the third century AD, which have recently been found in the Meroitic necropolis at Sedeinga, in Sudanese Nubia, are both painted and gilded and show scenes of worship of the Egyptian god, Osiris, together with an inscription in Greek characters reading 'Drink, and you may live'.[8]

Designs in gold leaf were occasionally sandwiched between two layers of colourless glass during the Hellenistic period, but this decorative technique did not become common until the third and fourth centuries AD, when gilded and coloured medallions, as well as designs cut from gold leaf or formed by folding gold trails, were sandwiched between two layers of colourless glass. The gilded and coloured medallions appear to have been made for funerary purposes, and many have been found in the catacombs at Rome and elsewhere, while the gold leaf and gold trail designs were often set into the bases of drinking cups and bowls. The *fondi d'oro* frequently depict Jewish and Christian symbols (Ill. 180) and Biblical subjects; some show pagan deities, portraits of individuals or family groups, animals and inscriptions. It is probable that many of these designs were produced at glasshouses in Italy and in the Rhineland in the late Roman Empire.

Wheel-cutting as a method of decoration was in widespread use at all times in the Roman world, and ranged in complexity from the bands of horizontal cut or abraded lines which are frequently found on even

179. Blown pale olive-green beaker with brown and dark-green trails. From Junglinster, Luxembourg. Height 20.3 cm. 4th century AD. Luxembourg, Museum of History and Art.

180. Roundel, from base of colourless glass cup or bowl, with design in gold leaf showing a shepherd and three sheep. Diameter 9.8 cm. 4th century AD. Corning, N.Y., Corning Museum of Glass.

181. Blown dark-blue and opaque white glass amphora (the 'Portland vase') with figured scenes cameo-cut in relief, probably showing the marriage of Peleus and Thetis. From Rome. Present height 24.5 cm. Late 1st century BC/early 1st century AD. London, British Museum.

the simplest drinking cups, to the complex gem-cutting and engraving techniques which were employed on tablewares such as the Portland vase and the Lycurgus cup.

The Portland vase (Ill. 181) is a blown amphora (it has lost its pointed base) made from dark-blue and opaque white cased glass. The opaque white outside surface has been partly cut away to reveal the dark-blue ground colour, and the remaining opaque white areas have been cameo-cut in relief to produce two very detailed figured scenes which may represent the marriage of Peleus and Thetis.[9] The precise date of the production of this masterpiece is not known: artistically it belongs to the reign of Augustus (27 BC – AD 14). It has probably been polished since its discovery in Rome at the end of the sixteenth century, but there is no doubt that it was originally decorated by a *diatretarius* of very great skill, using the techniques normally associated with fine gem-cutting. It is perhaps one of the most impressive glass vessels to survive from the ancient world. One other, more complete, cameo-cut bichrome Roman glass amphora is known: found at Pompeii, it depicts scenes of grape harvesting and was probably made during the second quarter of the first century AD.

During the first and second centuries AD, much of the wheel-cut decoration found on both cast and blown glass vessels consisted of deep facets or lines, but greater variety was achieved in the later Roman period. Abrasion, which relied for its decorative effect on the contrast between the dullness of the areas worked and the general brightness of the vessel, was often used for thin-walled glassware, such as the flasks

with scenes of Baiae and Puteoli in the Bay of Naples, which were manufactured in the third or fourth century AD.[10] The wheel-abraded decoration on the pale-greenish Populonia flask (Ill. 182) shows named buildings and structures in the harbour at Baiae.

Many late Roman cups and bowls have figured scenes which were produced either by fine linear cutting and abrasion, or by various kinds of facet-cutting. The truncated conical cup from Cologne (Ill. 183) has three linear and facet-cut Biblical scenes depicting Adam and Eve and the serpent, Moses striking the rock, and Christ raising Lazarus. Similarly shaped cups with the same use of line and facet-cutting, but depicting different scenes, are known in the north-west provinces, and it seems that these vessels were made and decorated in the lower Rhineland, perhaps at Cologne, during the fourth century AD; vessels with figured linear and facet-cut scenes were also produced in the eastern provinces at this time.

The late Roman vessels with the most spectacular wheel-cut decoration must surely be the *diatreta*, or cage-cups, which were made by cutting away a thick blown blank to produce almost free-standing figures or a network of interlocking rings which were joined to the body by the small columns or bridges of glass not cut away. This work required great skill and patience (engraving or gem-cutting tools were used), and must have taken a very long time to complete. Since these vessels were manufactured during the fourth century AD they cannot have been the subjects of the disputes between the *diatretarii* and *vitriarii* of Aquileia about the responsibility for vessels which broke while being cut, for these disputes took place early in the third century

182. Blown pale-green flask with abraded decoration showing the harbour at Baiae. From Populonia, near Florence. Height 18.4 cm. 3rd or early 4th century AD. Corning, N.Y., Corning Museum of Glass.

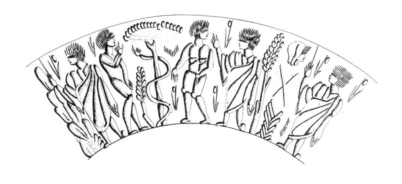

183. Linear and facet-cut biblical scenes on a blown colourless cup from Cologne. Height 12.8 cm. 4th century AD. London, British Museum.

cms.
ins.

AD (Ulpian, *Digest*, IX. ii. 27, 29); but a perfect blank must have been essential to a skilled cutter if he was to stand a reasonable chance of completing a cage-cup successfully.

The Lycurgus cup is probably the best-known of the cage-cups (Plate 28). It tells the story of the death of Lycurgus, and shows him entangled in a vine, together with Pan, Dionysos and his panther, a satyr throwing a rock, and the nymph Ambrosia.[11] Parts of the design have been cut away to produce open-work attached by small bridges, but the bodies of the four figures have also been hollowed away from the inside so that light can pass through the cup more evenly. The colour of the glass is very unusual: an opaque pea-green on the surface, changing to wine-coloured in transmitted light. A similar colour change, from pea-green to translucent amber, occurs in the cage-cup from Termancia, in Spain,[12] but not in any other example. These vessels may perhaps be similar to the kind called *calices allassontes* mentioned in a letter from Hadrian to Saturnius (*S.H.A.* – Flavius Vopiscus, *Saturn.*, VIII. 10).

Although not a vessel, the small head of Augustus (Ill. 184) will complete this survey of cut and carved glass. This is 47 mm. (2 in.) in height and may have come from a small gold statuette. The head was constructed in two colours, with the opaque turquoise exterior overlying a core of dark glass, and was formed in a mould before the final details were produced by grinding and polishing. The figure appears to show Augustus in old age, and has damaged ears, perhaps suggesting that his head was veiled, like the statue of Augustus from the Via Labicana in Rome.[13] It may be compared with other heads of emperors and empresses carved in precious stones (see Chapter 6).

GLASS WALL DECORATION

The use of glass tesserae and *opus sectile* in the decoration of the walls and ceilings of Roman buildings has already been noted in Chapter 5. The first recorded use of glass on walls occurred in 58 BC (Pliny, *NH*, XXXVI. 114), though ceiling mosaics were apparently not developed until the early first century AD (after the completion of the Baths of Agrippa *c.*20 BC: Pliny, *NH*, XXXVI. 189). Glass continued to be used in both public and private buildings throughout the period of the Roman Empire, though the surviving literary accounts suggest that it was always rather a luxurious form of interior decoration and available only to the very wealthy.

Two very small fragments of complex mosaic inlay featuring human heads are known from the Roman villa, Els Munts, at Altafulla, near Tarragona in Spain (Ill. 185). The maximum dimensions of the fragments are 25 × 19 mm. (1 × $\frac{3}{4}$ in.) and 20 × 18 mm. ($\frac{3}{4}$ × $\frac{5}{8}$ in.), and the details of the designs were produced by arranging canes of 'black', amber, opaque pale-green and opaque pale-pink glass in the opaque white background. The heads were found with a wide variety of polychrome mosaic and brightly coloured monochrome strips and shaped fragments, and presumably come from the *opus sectile* panels that decorated the walls of the villa in the fourth century AD.

184. Opaque turquoise glass sculpted head of the Emperor Augustus. Height 4.7 cm. Early 1st century AD. Cologne, Römisch-Germanisches Museum.

More than one hundred glass *opus sectile* panels, representing over 150 square metres (180 square yards) of decorated wall-surface, were found recently, still packed in crates, in a building in the harbour area of Kenchreai, near Corinth, which was destroyed by an earthquake and tidal wave, probably in AD 365.[14] Many of the design elements in these panels are similar to the pieces found at Els Munts, though there are no polychrome mosaic human heads.[15]

GLASS VESSELS IN ROMAN ART

Several wall-paintings containing representations of colourless or pale bluish-green bowls, cups and jars are known from Pompeii, Herculaneum and the villa at Oplontis, as well as from other sites in the bay of Naples and in Rome.[16] The vessels are usually shown filled with coloured or colourless liquids, or fruit, and it seems that the transparency of the glass caused them to be chosen for illustration. The large, bluish-green bowl, shaped rather like a metal *crater*, which occurs in the House of Julia Felix still-life (Plate 5), contains a variety of different fruits, and demonstrates the truth of Seneca's statement that 'apples appear much larger to those looking at them through a glass' (*Naturales Quaestiones*, I. iii. 9).

Glass vessels have sometimes been identified in the designs of floor mosaics, and square and cylindrical bottles are shown on a considerable number of first- and second-century funerary monuments, especially in the Rhineland. The tombstones demonstrate that inexpensive household vessels became part of the ordinary family life of the Roman world, though it is probable that most of the glass vessels discussed in this chapter remained as luxury goods and were available only to comparatively few people.

185. Two fragments of glass mosaic inlay from an *opus sectile* wall decoration. From the Roman villa at Els Munts, near Tarragona. 2.5 × 1.9 cm. 4th century AD. Tarragona, Museo Arqueologico Provincial.

CHAPTER ELEVEN

Epigraphy

ROBERT IRELAND

'I ADDED EGYPT TO THE EMPIRE OF THE ROMAN PEOPLE ...' 'CABBAGE, BEST QUALITY, FIVE FOR FOUR DENARII: SECOND QUALITY, TEN FOR FOUR DENARII ...' 'MARCUS AGRIPPA, SON OF LUCIUS, IN HIS THIRD CONSULATE, BUILT THIS ...' 'SECUNDUS IS A PERVERT ...' 'OH "FLY", MY LITTLE BITCH, HOW SAD THAT YOU DIED ...' 'HER PARENTS NAMED HER CLAUDIA. SHE LOVED HER HUSBAND WITH ALL HER HEART. SHE KEPT THE HOUSE, SHE SPUN WOOL. ENOUGH! GO!'

An inscription is a means of perpetuating information in writing: words cry out from the stone for a memory amongst mankind. '*Passer-by, this silent marble asks you to stay and read: I wished you to know.*' Language becomes visible, shapes convey meaning; executed with authority, character, subtlety and discipline, lettering becomes a work of art. The words may be set down on any surface in any medium; but an inscription, in its best-understood sense, is a class of textual record characterized by being incised on stone, and it is upon the artistic aspects of inscriptions so defined that this short chapter will concentrate.[1]

TEXT AND LAYOUT

On a stone from Palermo in Sicily (Ill. 186), presumably once placed outside his workshop, an inscriptional artist advertises bilingually, for the benefit of potential clients both Greek and Roman, 'INSCRIPTIONS LAID OUT AND CUT HERE FOR RELIGIOUS BUILDINGS AND PUBLIC WORKS.'[2] He handles his lettering better than he handles the two languages, but his choice of words neatly specifies for us the two central stages in the production of a formal inscription: the application of text to the stone and its cutting. One preliminary and one final stage will also be involved in the process: the composition of the text and the colouring of the incised letters.

186. An inscriptional artist's advertisement. Height of lettering *c*.2.4 and 1.2 cm. Early 1st century AD (?). Palermo, Museo Archeologico Nazionale.

Text newly composed for an inscription could be supplied to the cutter's shop on wax tablet or papyrus, usually in the cursive script appropriate to these surfaces and their writing-instruments. Corruptions caused by the misreading of cursive copy sometimes show up in the finished work; as, for instance, when TNVMPE is cut for TRIVMPE in the last line of the famous Arval Hymn.[3] Conventional texts could be extracted from collections of ready-made formulae: verses identical save for the names of the deceased (which often fail to scan) re-appear in metrical epitaphs from different parts of the Empire, and one artist made the careless but revealing error of copying his pattern-text unmodified on to the stone: HIC IACET CORPVS PVERI NOMINANDI – that is, roughly, 'HERE LIES THE BODY OF (a boy: put the name in)'.[4]

The text of the humbler sort of inscriptions might now be traced directly on to the prepared writing-field, with running modifications to fit it to the available space and the designer's taste. The draft of more formal productions will pass to an inscriptional calligrapher, who considers the meaning and purpose of the text and adjusts it to the planned area of writing by determining the style and size to be adopted for the capital lettering, its lineation and the vertical co-ordination of the lines, and any abbreviation of words or ligaturing of letters that may be necessary to bring the inscription within limits. He may choose to place interpuncts between words, using leaf-shaped stops, perhaps, for decorative emphasis; and he will draw bars above numerals. In the late Republic and early Empire he may place *apices*, shaped like our acute accent, above some or all of the long vowels: a long I coalesces with an *apex* to form a tall letter reaching above its neighbours. With the help of these *apices* the inscription could be correctly read – as all ancient texts were intended to be read – aloud. The calligrapher will probably prepare a draft of his design, and it is possible that on a papyrus sheet from Oxyrhynchus in Egypt (Ill. 187)

187. Papyrus with a draft design (?) for a dedicatory inscription by a detachment of Legion Five (the Macedonian) to Diocletian and Maximian. From Oxyrhynchus (infra-red photograph). Height of lettering *c*.3.7 cm. *c*.AD 295. Egypt Exploration Society.

we possess a unique example of 'epigraphic copy', written with a reed pen in 'rustic capitals' by a very accomplished artist.[5] One inscriptional calligrapher is known to us by name: Furius Dionysius Filocalus, the great writing-master who lettered and signed two inscriptions commissioned by Pope Damasus in the late fourth century.[6]

By now the writing-field will have been marked out and smoothed down on the stone; a small tablet can be worked on in the cutter's shop, a public inscription will be put on the monument *in situ*. Upper, lower, and often medial guide-lines (occasionally found incised by the cutter) are marked on the stone in an erasable medium: chalk or charcoal drawn against a straight edge would serve for short rulings, while longer lines would call for a ruddle-cord, coated in dry pigment and snapped against the surface. The inscriptional calligrapher then transfers his copy to the stone; the nature and handling of the writing-instrument that he chooses will profoundly affect the appearance of the resulting lapidary script.

MEDIUM AND LINE

It is probable that early Republican inscriptions were set out on the stone with chalk or charcoal, a method of tracing letters which was no doubt employed for the lowest grade of Imperial productions. These inflexible writing-media begin to mark immediately on touching a surface, and do not need to be edged into or out of their stroke. They yield an even thickness of line in all directions of travel, and the resulting letters are well suited to an unsophisticated cutting tech-

188. Republican capitals. Epitaph of Lucius Cornelius Scipio Barbatus, consul 298 BC, censor 280 BC (?). Rome, Vatican Museum.

nique. Not that they are invariably unimpressive: their very roughness becomes eloquent when, in the epitaph of Lucius Cornelius Scipio Barbatus (Ill. 188), the crude, uneven capitals, ripped out of the granite with a coarse cutting-edge, combine in magnificent unity of effect with the text they transmit, proud, simple phrases cast into the primitive Saturnian metre, commemorating the conquests and the piety of the dead Republican.[7]

But with the development of penmanship and brushwork in the hands of Roman artists there gradually evolved, from the simple geometrical combinations of unshaded line of the earliest capitals, a system of bookhands and lapidary scripts that display the characteristics of letters executed in a fluid medium with pen or brush: serifs and weighting. Serifs are short terminal cross-strokes, integral (at least in origin) with the approach to or departure from a main component of a letter's structure. Top serifs start the flow of fluid as the writing-instrument flexes into the body of its stroke, and bottom serifs allow it to be lifted from the writing-surface without leaving behind an unsightly blot. Their purpose is thus essentially practical, although a decorative treatment of serifs as separate entities becomes apparent in some lapidary and book scripts. The weighting of a letter is the graduation of and contrast between the broad and narrow areas of its component strokes: it is a function of the width, suppleness and capacity of the writing-instrument, the pressures exerted on it during its trace, and the angle at which it is held with respect to the horizontal axis of the writing. Letters executed with a pen, held close to the tip at a fairly constant angle, tend to a uniformity of thickness within straight strokes and a fixed ratio of contrast between traces made by the face of the nib and those made by its side; the smooth travel and responsiveness of a flexible square-ended brush, loaded with paint and held some way down the handle, encourage constant changes of angle and pressure, reducing the harshness of contrasts by subtle modulation of the width of the trace during its progress. Ideally, the resulting letter-forms will have a kinetic quality that rescues the written lines from static rigidity.

MONUMENTALIS AND ACTUARIA

The weighting and serifing of the component strokes, their number, the sequence, direction and speed of their execution, and the chosen module – that is to say, the relationship between a letter's height and

its width – determine the appearance of the finished shape. Developed lapidary writing has been divided into two main styles, (*scriptura*) *monumentalis*, monumental script, and (*scriptura*) *actuaria*, 'record' or 'transaction' script, the latter so called because considered chiefly characteristic of public and private official written transactions (*acta*); the terminology is far from satisfactory, but a completely new classification of epigraphic hands cannot be attempted here. The two styles of lettering are differentiated by their structure, weighting, serifing and module. Comparison of Illustrations 191 and 193 will bring out these differences very clearly. The classic *scriptura monumentalis* is slowly and expansively modelled; its wider letters approximate to a square or a short horizontal rectangle, consuming space; serifs broaden gradually into or emerge smoothly from the main limbs; the carefully-judged weighting produces satisfying proportions of width in the strokes, the ratio between the widest thicks and the narrowest thins being about two to one. Curves are shaded to incline gently upwards from the horizontal, and diagonals and verticals are narrowed at their centre. The developed *actuaria* impresses immediately by the tall rectangular module of its letters. This is essentially a compressed, reconstructed and generally less formal version of the monumental capital, adapted for speed of writing and economy of space, with the overtly calligraphic quality which comes naturally to a fast-travelling brush. The trace is splayed towards the end of straight strokes, but the angle of the square-ended brush to the axis of writing changes relatively little, producing clear contrasts between side- and face-strokes. The vertical emphasis of the letters is helped by their strongly diagonal weighting. A pronounced upward edge-in and edge-out of the angled brush gives T a swung cross-bar and an upswung foot-serif not executed integrally with the vertical – a serif which can also be found on verticals in P and R and on the diagonals of V. The broad down-strokes of M may curve to the right, pulled by the speed of the brush, and, to compress the letter, its narrow up-strokes may meet the down-strokes some way down their length. A, too, may have a short, dropped left limb and an out-curved right diagonal; the brush-angle may tempt its cross-bar to slant up to the right, and the rapidity of the writing may lead to the cross-bar's being omitted altogether. The construction of many letters is simplified and speeded. The top serifs of B, D, P and R mark the attack not of the down-drawn vertical stroke, as they do in *monumentalis*, but of the up-struck curve. In monumental E, F, and L the top left and lower rights serifs (or, in the case of L, the turn into the horizontal) are integral with the vertical; in *actuaria* the forms simplify to a vertical with serifed cross-bars swung across it, the horizontal stroke of L swinging down in later examples of the style.

CUTTING AND COLOURING

With the writing of the letters on the stone the process known as *ordinatio* is complete, and the sculptor's task begins. Where soft stone was used, and contrast between the breadth of strokes was not sought, a rounded metal gouge could be used under the mallet to attack the

surface; harder stone, and the variable breadth of cut required for the weighted strokes of brush-lettering, demanded a straight-edged chisel. Chisel incision began, perhaps – if modern practice is any guide – with a preliminary groove, cut centrally along each stroke, which was gradually worked out longitudinally and transversely to the edges of the written trace, and down to the depth appropriate to the stroke's breadth; terminations of the brush-lines were perhaps struck sharply downwards and in from their tip to the main channel. In developed lapidary capitals the walls of the cut slant in to form a V-shaped groove whose root, centred on its upper width, lies deeper in broad than in narrow areas of the letter, rising fairly steeply to the surface at stroke-end. The channel, even at its broadest, is quite shallow, since the purpose of the cutting is not to enhance the legibility of the text by a contrast between shadow-filled grooves and brightly-lit surface: instead, the cut is made to protect the paint which, in all but the cheapest and least public inscriptions, was applied to the letters after incision to re-create their original written quality. The paint was usually a scarlet or vermilion, mercuric sulphide or red oxide of lead; we sometimes hear of letters being gilded.[8] Besides restoring character and visibility to the lettering, the painting allowed the correction of errors in the cut. Strokes wrongly added by the sculptor could be left uncoloured, and missing or badly-engraved strokes could be supplied or improved with the brush.

The inscriptional process is now complete. Any subsequent modification of the finished product may include the addition of text, or, conversely, the chiselling-out of the names and titles of Imperial personages or public figures or legions, condemned, after disgrace or dishonour, to official oblivion, the notorious *damnatio memoriae*.[9]

STYLE AND DEVELOPMENT

The arts of calligrapher and sculptor, and their combination in the brush-written, chisel-cut inscription, developed swiftly under the Empire. The Caesarian *monumentalis* of Illustration 189 displays an emergent technique, a striving for regularity realized imperfectly and without fluidity and assurance.[10] Individual letters are inconsistently sized: their similar module broadens E and F and narrows R; O is compass-drawn; cross-bars slant; some letters are precariously balanced on their axes; and the *apex* over the long V of IVLIO is transformed into an ill-advised extension of a serif. The cutting is uncertain, and the asymmetrical lines of text incline up to the right. A mid-first century *monumentalis* from Pompeii, however (Ill. 190), represents the first great period of Roman inscriptional lettering.[11] Modules are well calculated for all four sizes of writing; spacing is careful, and the lines compose well, though AE(DEM) and (TE)RRAE in the second line are set too wide: a slightly more distant letter-spacing throughout the line would have brought it to length without this breakdown in coherence. The weighting is delicately graduated, the centering exact, the cutting firm and clean; the overall effect is of a remarkable clarity and precision of line. This very precision may

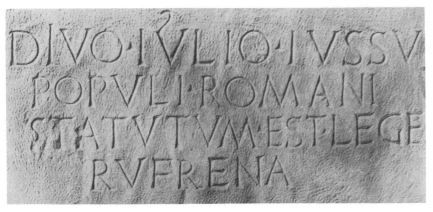

189. Caesarian capitals. Dedication of a statue to the deified Julius. Height of lettering *c*.3.5 cm. *c*.44 BC (squeeze). Rome, Vatican Museum.

190. 1st-century *scriptura monumentalis*. Inscription recording the restoration of the temple of Isis at Pompeii by Numerius Popidius Celsinus. Height of lettering *c*.14–4 cm. AD 62–79. Naples, Museo Archeologico Nazionale.

amount to a fault in first-century *monumentalis*: the contrast and cut of strokes may become over-sharp, and contours may tend to appear too geometrical and abstract, constructed with ruler and compass rather than written with a free hand.

The inscription on the pedestal of Trajan's Column in Rome (Ill. 191) is generally agreed to represent an absolute standard, the perfection of Roman monumental lettering.[12] Splendidly proportioned and superbly modelled, authoritative and deliberate, the great capitals – their average height is some 10.3 cm. (4 in.) – retain both flexibility and subtlety: no two instances of the same letter are quite

191. Early 2nd-century *monumentalis*. Inscription on the pedestal of Trajan's Column in the Forum Romanum (cast). Height of lettering *c*.12–10.3 cm. AD 113.

192. Painted *scriptura actuaria*. Election notices on a wall of the house of Aulus Trebius Valens in Pompeii. Height of largest lettering *c.* 60 cm. Before 24–25 August AD 79 (largely destroyed in 1943).

identical, and diagonals apparently straight are in fact segments of extremely shallow curves. The excellent co-ordination of the lettering, achieved by finely-judged manipulation of the spacing and the inter-play of the serifed limbs, ensures a homogeneous horizontal texture, and the vertical rhythm of the straight strokes is pointed by the tall form of long I. The calligrapher was well served by his sculptor, who contrived a perfect relationship between depth of cut and weighting of stroke, and was especially successful in managing stroke-junctions and transitions to the serifs. The finished composition has an incomparable majesty, purity, and strength; it also has repose, but a repose instinct with the inner life of dynamically conceived and executed shapes.

The difficult art of *scriptura monumentalis*, perfected under the Julio-Claudian emperors and finding its most magnificent expression under Trajan and Hadrian, was not long preserved in its early splendour; handsome *actuariae*, however, were consistently achieved over a rather longer period. The expertly written large letters of a painted election notice from Pompeii (Ill. 192) offer a fine specimen of a formal early *actuaria* set out at enormous size (they are nearly 60 cm. [$23\frac{5}{8}$ in.] high).[13] The S, A and R of SATRI have a monumental construction, contour, and weighting, but the compression of letters to a tall re-ctangular module, the horizontals of E and T upswung across the verticals, and the unequal-limbed A at the extreme right of the plate, are typical of the *actuaria* style. Beneath the large capitals appear lines of much smaller *actuaria* painted with a short, hard brush held with its face almost at right angles to the line of writing. The horizontals here are broad, the verticals narrow; top and bottom serifs swing decorat-ively across the verticals in a separate stroke. So written, *actuaria* may strongly resemble the 'rustic capital' bookhand (Ills. 1 and 187), and indeed there seems to have been some considerable interaction be-tween the book script and the lapidary style. The calligraphic vitality and economy of *actuaria*, its characteristic letter-forms, and something of the fluency and rhythm of the brushwork, survive the careless cutting of the *acta* of the Arval Brothers for AD 91 (Ill. 193).[14]

A hand occasionally seen in inscriptions that is clearly linked with a pen script is the epigraphic uncial (Ill. 194).[15] The bookhand, deve-loped perhaps in North Africa in the first century AD, is a rounded

193. Incised *actuaria*.
Proceedings of the Arval
Brothers in AD 91
(squeeze). Height of
lettering *c*.2 and 1 cm.
Rome, Museo Pio-
Clementino.

194. (*Below*) Epigraphic
uncial. Epitaph of an
unknown man
(Caeselius? Caeselianus?),
a farmer
and local magistrate.
Maktar, Numidia.
3rd century AD (?). Paris,
Musée du Louvre.

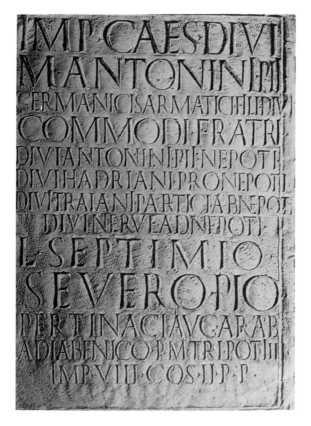

195. (*Above*) Late 2nd-century *monumentalis*. A dedication to Septimius Severus (squeeze). Height of lettering *c.* 7–4 cm. AD 196. Rome, Cortile of the Lateran.

196. (*Above, right*) Early 3rd-century formal *actuaria*. Inscription in honour of Quintus Pompeius Falco, *quaestor kandidatus* (etc.) under Caracalla or Elagabalus (squeeze). Height of lettering *c.*7.5–4.5 cm. AD 212–17 or 218–22. Rome, Museo Nazionale.

capital written with a broad pen whose nib is held with its face nearly parallel to the horizontal axis of writing. Some inscriptional calligraphers – unpractised, it may be, in the approved lapidary hands – employed the style on stone, to which (as lettering devised for execution with a hard pen on a yielding surface) it is badly adapted.

CHANGE AND DECAY

Already by the end of the second century, flexibility and power had begun to drain from *scriptura monumentalis*. The *pax romana*, sympathetic to the elegance of *actuaria*, rarely produced a monumental capital of real distinction. Proportions of module and stroke, as Illustration 195 shows, tend to be less well established;[16] a vertical shading may be introduced in curves; a change of attack at the top of strokes gives serifs on both sides of the heads of A, M and N; the short vertical and horizontal of G fuse into a curl. Spacing and centering tend to insecurity, and the sculptor may reduce serifs to curved hair-lines. Decorative emphasis of the constructional elements of *actuaria* can lead to a highly calligraphic effect. The distinction between the two leading styles of lettering becomes increasingly blurred; a hybrid hand (not unexampled earlier) asserts itself, an *actuaria* formalized by the introduction of some monumental weightings and forms. The age of Septimius Severus, however, saw *scriptura monumentalis* cut with great skill and confidence in the flourishing cities of that emperor's homeland, and later Antonine formal *actuaria* (Ill. 196) can have a flowing

197. Late 3rd-century *actuaria*. Inscription commemorating repairs to the bank of the Tiber by Manius Acilius Balbus Sabinus, Commissioner of Sewers (etc.) under Diocletian and Maximian (squeeze). Height of lettering *c*.7–5.5 cm. AD 284–305. Vatican Museums.

beauty.[17] But with the anarchy of the third century, lapidary lettering, with the rarest exceptions, simply disintegrated. The *ordinatio* of public texts becomes unskilful, their spelling less instructed; artists working on inadequately sized writing-surfaces tend to employ increasingly frequent and grotesque combinations of letters in ligature. A true *monumentalis*, even of a degenerate type, is rarely seen; the Diocletianic *actuaria* of Illustration 197 – the lapidary terms, perhaps, into which the contemporaneous rustic pen-capitals of Illustration 187 might have been translated – tells its own ugly story.[18] Inscriptions of the

198. 4th-century *monumentalis*. Inscription dedicated to Valens, from a pedestal of an arch at the approach to the Valentinian Bridge across the Tiber. Height of lettering *c*.7–3.5 cm. AD 365–75. Rome, Museo Nazionale.

199. 4th-century *monumentalis* and *actuaria*. Dedication of an altar to the Great Mother and Attis by Lucius Ragonius Venustus. Height of lettering *c*.3–2.5 cm. AD 390. Rome, Capitoline Museum.

Dominate do not freeze, as the other plastic arts do, into a static, formal hierarchy of organization reflecting the new, regularized order of state; fine lettering fell, with literature, into neglect in an age which had little time for either.

The renascence of literary culture in the fourth century, however, temporarily checked the decline of lapidary techniques and prompted the partial revival of inscriptional art at a time when civilization clung to its inheritance from the past as a defence against the uncertainty of the future. A tall, rather anaemic *monumentalis* was sometimes attempted (Ill. 198), Severan rather than Trajanic in serifing, weighting and modules;[19] letters whose final form seems to be determined more by the chisel than by the brush. Vertically emphasized and mechanical in cut, these cold, rigid shapes are decadent in their self-contemplating formality. More typical of the fourth century, perhaps, are the types of hand shown conveniently together in a text dedicating an altar to the All-Powerful Gods (Ill. 199).[20] Here, the first two lines carry a courageous attempt at a squared *monumentalis* into which, at UENVSTVS, a rounded V typical of unicals and some rustics in-

trudes: the script then settles into a coarse mixed *actuaria* incorporating monumental M and N and the rusticizing U. The cutting is poor throughout, and obscures any weighting that the calligrapher may have built into his strokes.

Skill and taste had long been failing; in the latest period of Roman antiquity their decline into extinction accelerated. The early fifth century drew and cut unsteady, debilitated, compressed monumental capitals, their strokes often wretchedly co-ordinated; *actuaria* drops out of sight, to be replaced in informal inscriptions by broken monumental letters diversified with bookhand forms, such as d, h and t, and the Byzantine A with a V-shaped cross-bar. The summing-up of past knowledge and its transmission to posterity – a feature of literary work of the period – did not extend to a revival of good inscriptional practice. The art of the public inscription was lost with the Empire; and with the angular, irregular script of a sixth-century epitaph (Ill. 200)[21] – its letters unweighted, mostly unserifed, wilfully contrasted in size, and often clearly influenced by bookhand forms – Roman inscriptional lettering reaches ultimate degradation, as the pen-scripts are reaching perfection, on the edge of the approaching darkness.

200. 6th-century lapidary script. Epitaph of Maxima, buried 23 June AD 525. Height of lettering *c.*5–1.2 cm. Rome, Museo Nazionale.

INSCRIPTIONS AND CIVILIZATION

The text of inscriptions tells us who the Romans were and what they achieved: the lettering tells us what they were and how they achieved it. The crude vigour of Republican capitals, and the breakdown of fine writing and cutting in the late period, are witnesses of their times as eloquent as the unsurpassed lapidary technique of the early Empire. It is not surprising that the Romans cultivated the art of the inscription. The conquering temper burns to leave behind a record of itself for all time: inscriptional artists were sent out with the legions. The ordered majesty of the Latin tongue – the language of authority – is ideally suited to the terse, forceful directness of monumental statement. Roman writers themselves were aware of the lapidary possibilities of their language: the literary epitaph was an accepted verse-form, the elegists worked funerary and dedicatory half-lines and couplets into their poems, and Tacitus' characterizations of famous men have the concision and finality of phrases chiselled into a tombstone. Dignity of utterance, and the grandeur and confidence of an Imperial civilization, find their classic expression in the perfection of *scriptura monumentalis*, where the organized strength of the brushwork is given stability and permanence by the cut. Above all, the inscription is an intensely practical art-form; it has an evident utility and purpose to which the Roman mind responded. It is very characteristic that the noble lettering on the pedestal of Trajan's Column should commemorate earth-moving operations in the Forum. The inscription is a fact of Roman civilization; and at its best, its masters raised it to the level of the highest and most exacting art.

Art in Late Antiquity

RICHARD REECE

Rebirth is meaningless without death: revival presupposes disuse. This, in simple terms, is the major problem to be considered in any study of Roman art after the third century. But it would be pointless to confine a study of Late Antique art within such narrow limits. In the first place a renaissance is a metaphor drawn from living bodies; this may be an interesting idea, even a good working model, but its use is bound to lead to trouble, for it presupposes a life-span, finite but renewable, which develops inexorably from birth to maturity. There is no reason at all why art and architecture should share the constraints of biological life. An art style need not die; it changes rather than develops; and it usually co-exists with other styles and intermingles in a way totally foreign to biology. Change, revival, and co-existence seem therefore to be better ideas for examination than the death of classical art or the fifth-century renaissance.

The best documented changes may be seen in official sculpture and especially in official portraiture where there is a clear change in direction from representation of individuals to symbolic types.[1] The extremes may be seen by comparing two state reliefs, Trajan's Column (Ill. 59) and the panel from the base of the obelisk of Theodosius (Ill. 201). In the former the scene is portrayed realistically; all the participants appear to be people identifiable by their physical attributes. The court of Theodosius, on the other hand, is shown without background, though we may understand the Emperor and his entourage to be in their box at the circus; the individuals here are no more than symbols whose size, decoration, and disposition range from the biggest and most important figure, Theodosius himself, through the less important (but still Imperial) members of his family, shown centrally, at a smaller scale, to the courtiers (outer centre but still facing frontally), and, finally, in rows and columns abreast, to the populace.

The progress from the one style to the other can be documented through the arches of Trajan at Beneventum, of Septimius Severus at Rome and Lepcis Magna, of Galerius at Thessalonika, and of Constantine at Rome. The most instructive comparison is between the two nearly contemporary arches of Septimius Severus, for the Lepcis arch is already more hieratic (formal) than the relatively traditional arch at Rome, which retains elements of early naturalism. This is one example which helps to demonstrate that Late Roman art first emerges in the provinces, particularly in the South and East, before establishing itself at the centre, a tendency well documented in coin portraiture during the third century. Many of the changes can be seen in one monument – the Arch of Constantine – for its composite nature

201. The court at the games. Base of the obelisk of Theodosius in the hippodrome, Constantinople. Marble, height 240 cm. *c.*AD 390.

provides instant comparison from Trajan, through Hadrian and Marcus Aurelius to Constantine himself.

The convention obeyed in many scenes on Trajan's Column is openly breached on the base of the column of Antoninus Pius (see Chapter 3), where the apotheosis – a non-material event – is shown in fully material terms. This is no sudden innovation, for many personifications, for example Roma, had appeared in official reliefs throughout the early Empire. Rather it is a change of emphasis in the public art of the Empire whereby, since human forms become symbols, the distinction between the material and the non-material is eroded. The way is therefore open for the depiction on sarcophagi of the Imperial Christ with Apostles as senators at his court, not because this was ever a historical scene, but because these symbols and decorations in themselves express a whole range of ideas and parallels. The scenes depicted on the official arches gradually lose their settings as sculptors concentrate more and more on what the figures are, and what they are doing. As the setting drop away, so the dimension of depth lapses, in the same way that the protagonists in a play who have just acted on a full stage may play a scene on the front of the stage before a shallow curtain so that the plot may go forward while the scene is changed.

Another feature is the sculptor's arrangement of figures in a manner which resembles the photographic technique of the modern news-cameraman. The sacrifice scene of Marcus Aurelius is still crowded

a

and realistic, with the chance of mistaking the participants and part of the scene quite naturally obscured (Ill. 61). On the Arch of Galerius, the depiction of a sacrifice has been codified and arranged. The sculptor composes his scene much like a modern press photographer. He re-arranges the figures huddled round the altar, ignores unimportant people, removes to the fringes of the group anyone who might dominate the composition, and places the protagonists in the centre, in an order that will instantly be understood by the viewer, even without a caption.

b

Among official portraits coins must be considered first since they form the only complete series of portrait heads from Constantine to Justinian.[2] Here a general progression can be seen after the eclectic age of Constantine has passed. The sons of Constantine are almost indistinguishable (Ill. 202a, b): the individual is hidden under the insignia of his office – the great mantle, the jewelled diadem, the circular gold and jewelled brooch with pendants. The tendency continues so that Arcadius and Honorius cannot be distinguished by their images alone; they are simply brother-Emperors (Ill. 202c, d). Just as Constantine had reacted against the uniform portraiture of the Tetrarchy, so two fourth-century rebels may be distinguished from their coin portraits. The portrait of Magnentius (a Gallic usurper in the years 350–3) is remarkable at that date for the bare head and the general avoidance of the diadem (Ill. 203a). The distinguishing feature of Julian, last of the male line of the family of Constantine, who ruled as Augustus from 361 to 363, is his Athenian philosopher's beard, a pagan symbol not seen since the conversion of Constantine and the death of Licinius in 324 (Ill. 203b). These exceptions deserve to be noted, but they made no impression whatever on late Imperial portraiture in general.

c

In the fifth and sixth century even portraits gradually lose any element of individuality so that around 500 the uniform portrait bust is no more than an imperial symbol, in profile on bronze coins, but full-face on gold. Although the shape, size, and design of the coinage changes radically in 498 under Anastasius, it was left to Justinian around 530 to standardize the typical Byzantine full-face portrait on the very large copper coins (*folles*) struck in the middle of his reign (Ill. 203c). Wherever commentators may choose to draw a line between Late Roman and Byzantine art, the numismatic evidence makes a division abundantly clear about the year 500.

d

Imperial portraits in stone, marble, and bronze can be readily identified as such in the later Empire from the insignia of office so important to the depiction. The most obvious characteristic is the diadem, the form of which changes between 330 and 480; but recognition of individual portraits is impossible. A good example is the marble head in Istanbul which is often identified as a portrait of Arcadius on the grounds that it is a well sculpted head, not over-stylized, with a diadem type of *c*.350 to 450.[3] The prince is young, and the sculpture was found in an eastern province of the Empire. The generally life-like portrayal favours a date earlier in this period rather than later, and the first young emperor to reign from Constantinople

202a–d. Coin portraits. Gold (all at twice actual size). (a) Constans. *c*.AD 346. (b) Constantius II. *c*.AD 356. (c) Arcadius. *c*.AD 398, (d) Honorius, *c*.AD 400.

a

b

c

203a–c. Coin portraits.
Bronze (all actual size).
(a) Magnentius, bare
headed. *c*.AD 351.
(b) Julian, bearded.
c.AD 363. (c) Justinian,
full face. *c*.AD 550.

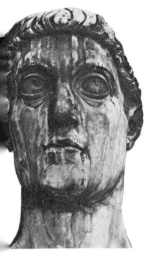

204 The Emperor
Constantine. Fragment
of a colossal statue.
Marble. Height 260 cm.
c.AD 315. Rome,
Palazzo dei
Conservatori.

was Arcadius. But there is nothing in this reasoning which prevents another commentator suggesting an eastern portrait of the young Gratian, or a humanizing portrait of Valentinian III or Theodosius II. A general description reading 'head of young emperor *c*.350 to 450, found in Asia Minor' seems adequate. Another example of portraiture which is even less well dated is the large bronze statue now in Barletta.[4] Here, attributions have ranged from Valens (364–78) to Marcian (450–7), and it is only a constant repetition of the latter name, rather than logical argument, which has persuaded scholars to date the statue to the middle of the fifth century.

Two heads without diadems demand inclusion among great works of art. The first is in stone, well over life-size (Ill. 204), and is usually said to be Constantine the Great; the second is in bronze, smaller, but still over life-size, and this is usually described as Constantius II. Whatever the exact date of these heads, they are much more individual than the typical tetrarchic portrait, and less stylized than portraits of the fifth century. They belong to a transition in portraiture and their excellence springs from a fusion of two ideals. No one who sees these heads before him can warm to the personalities depicted as he can to a Hadrian or a Postumus; indeed their deliberate remoteness from the spectator can send a shiver down the spine of even the most insensitive onlooker. A human being may have posed for these 'portraits', but only a very general likeness has been produced and the remarkably able sculptor has imbued it with an aura of divinity. Modern writers have tended to dwell on the mesmeric power of the eyes, but this is to misunderstand these images. Each head belonged to a more than life-size statue so that to overawe or inspire the observer the eyes should look down; they do not, they are inclined very slightly upwards so that they gaze out just above the spectator's head, taking him into slight account. These heads, sculpted in the second quarter of the fourth century, demonstrate a moment of equilibrium between the portrayal of the human and the presentation of the encompassing idea. Late portraits have left the human behind and seem to eschew any direct emotional communication as a result. The portraits of the fifth century and beyond were intimately bound up with a whole social hierarchy and system; without this they can only convey an impression of detachment. Whereas a portrait of Postumus or even of the stern and autocratic Constantine appears to communicate directly with the viewer, those of Honorius or Arcadius seem to be masks encased in imperial trappings. To a contemporary these trappings would communicate an implacable, often hard and demanding power; for us they have lost their magic and signify no more than a particularly lavish form of court dress.

One of the most important categories of carving apart from the imperial reliefs and portraits is that of the sarcophagi which were produced from the second until the seventh century without interruption. The problem that they immediately pose is one of date, for very few are securely dated by inscriptions or incontrovertible associations. I shall select only two late Roman examples for comment. The great porphyry sarcophagus in the Vatican Museum (Ill. 205) is usually

205. Porphyry
sarcophagus, perhaps of
Helena, the mother of
Constantine. Height 242 cm
c.AD 330. Rome,
Vatican Museum.

associated with the Augusta Helena, mother of Constantine the Great.
The use of imperial porphyry suggests an imperial tenant for the
sarcophagus, but the scenes of battle portraying victorious horsemen
and barbarians in defeat would be surprising for even so redoubtable a
woman as Helena. In the absence of any direct evidence it is perhaps
best to regard it as a product of the imperial prophyry quarries in
Egypt finished for a late Imperial burial. All the details except one
militate against an affinity with known Constantinian products and a
brief mention of these points may be the best way of bringing out some
of the problems in understanding the art of the period. The first
comparison must be with the one clear and unequivocally
Constantinian monument in Rome – the Arch. Unfortunately the two
monuments are at opposite extremes of the artistic scale, for the Arch
contains Constantinian reliefs which are severe and Italic in their
squat regimentalization, while the sarcophagus is almost Hellenistic in
its lively presentation of human and animal forms. There is perhaps
only one characteristic which marks out the sarcophagus as later than
the column of Marcus Aurelius and that is the total loss, not only of
any background for the scenes, but of ground levels when several

scenes occur one above the other in the same panel. This apart, it would be tempting to compare the scenes of the sarcophagus with those on the column of Marcus Aurelius or the *decursio* scene from the base of the column of Antoninus Pius, with the implication that they should not be too far different in date.

It is perhaps worth emphasizing that this discussion has the object of exploring the very varied artistic themes and influences which were effective in the third and fourth centuries rather than of re-dating major works of art. Monuments only need 're-dating' if they are obstructing a predetermined pattern, in which Roman art moves at a uniform and contemporaneous rate through a series of changes, whatever the subject, the medium, or the commission, from the humanism of late Antonine times to the hieratic stylization which is held to be typical of the art of Byzantium. Since it is fairly easy to disprove such regular progress there is no need for rigid rules, and exceptions can therefore be accepted.

To return to the porphyry sarcophagus, it may be thought a point of difficulty that there are no Christian motifs to decorate the supposed tomb of a Christian empress. This raises the whole question of the derivation and development of early Christian art. There is probably more sense in objecting to the scenes on the sarcophagus as unsuitable for a woman than as unsuitable for a Christian. Attitudes to Christian art often overemphasize the division between pagan and Christian, and hence between two art styles. The historical sources give no support to a theory of irreconcilable conflict between opposing ideologies. Indeed, when we have detailed evidence of relationships within and between families there is usually a strong suggestion of toleration. In the catacombs of the Via Latina a small group of families seems to have clubbed together to select an exclusive burial system.[5] This comprises two main passages which open out from time to time into *cubicula* painted in an intelligible and highly competent manner. The visitors obviously found no doctrinal difficulty in passing through a pagan burial chamber, decorated with medusa heads or figures of Ceres and Persephone, to hold the obsequies of a Christian in a room frescoed with the raising of Lazarus or the crossing of the Red Sea. Indeed it was even acceptable to use pagan imagery to decorate a Christian tomb. The peacock has a fully documented iconography as the bird of Juno; by extension, as the emperor is related to Jupiter, so the empress is related to Juno, and therefore in scenes of apotheosis it was the peacock that was depicted as carrying the dead empress aloft. The peacock was therefore already associated with death and immortality; it appears in some of the earliest Christian art, presumably with the same implications.[6] Putti and *erotes* have a long history in ornamental scenes; a good example in the house of the Vettii at Pompeii shows them in a number of pursuits. Even with their relationship to Venus and the other gods of the classical pantheon, Bishop Theodore of Aquileia found nothing surprising in his mosaicists, early in the fourth century, making them the shipmates of Jonah, symbols of the Apostles, fishers of men, and the drawers-in of the miraculous draught of fishes (Ill. 96). In exactly the same way the marine mosaic, typically

laid in a bath-house, was a highly suitable context in which to set the
story of Jonah and the fishing putti.

This summary has examined most of the points usually brought to
bear on dating the sarcophagus thought to be that of Helena. Taken
together, they provide no conclusive arguments either for accepting
the attribution and the date 329, or for rejecting the one, the other, or
both. During the reign of Constantine artistic styles were in a ferment,
so there need be nothing to prevent the acceptance of the sarcophagus
as a realistic work of $c.330$ and the reliefs of the Arch of Constantine as
highly stylized official works of $c.315$; since uniformity is not to be
expected at this period, we may take them as examples of stylistic
variety. One point which would probably not be contested, either
historically or stylistically, is that they were both created before the
middle of the fourth century, for after that date art had largely
abandoned the eclecticism of the reign of Constantine.

It is cheering to turn to Junius Bassus, a known historical figure, who
died in 359. His sarcophagus, which has always been in the Vatican,
bears his name with the inscription VIII KAL SEPT [25 August]
EVSEBIO ET YPATIO COSS (when Eusebius and Hypatius were
consuls – that is, the year 359).[7] The sculpture ignores practically all
the rules obeyed by official reliefs. Some figures are portrayed front-
ally, but certainly not all, and they are not shown in a thoroughly Late
Antique manner; the scenes are three-dimensional and have depth and
background, an interesting contrast to the porphyry sarcophagus;
drapery hangs on recognizable human forms rather than being
arranged in predetermined folds; heads are varied, portraying
recognizably different people.

While sarcophagi are normally large enough and heavy enough to
stay in the places to which they were delivered by the workshops which
sold them, ivories are, by contrast, so portable as to lead commentators
to despair.[8] Provenance can rarely, if ever, be assumed; date is in only
a few cases beyond argument. While there is a category of ivory
carving whose Roman (fourth- to sixth-century) origin is rarely dis-
puted, and another well known Carolingian group, there is a whole
corpus of material whose date may be given by various writers as
between 300 and 1000 with little hope of reconciliation or certainty.
Consular diptychs – by which aristocrats might announce their con-
sulships to friends (or that is the common explanation) – are in-
valuable for forming a chronological sequence at least when the consul
in question is specified. Unfortunately one of the best portraits, usually
identified as Stilicho, self-styled regent for Honorius in Italy and the
West, is unsigned. (His wife Serena and son Eucherius appear on the
companion leaf.)[9] A diptych bearing on one leaf the name of the
Nicomachi and on the other the Symmachi, both of them depicting a
goddess at an altar, may celebrate a marriage alliance between these
two families who had great influence in Rome between 350 and 450.[10]
It is generally assigned a date of near to 395, and cited as an example of
a remarkable revival of Greek forms and fashion. Influence from the
diptych is seen in other ivories, but rarely in other forms of carving.
Yet this single example is sometimes cited as evidence of a classical

Plate 17. Large figures of Aphrodite-Isis from Egypt. Terracotta. Height 64 cm.
1st century BC–1st century AD. London, British Museum.

Plate 18. Blue sapphire cameo showing Venus nourishing the eagle of imperial power. 3.5 × 3 cm. End of 1st century BC. Cambridge, Fitzwilliam Museum.

Plate 19. Three blown colourless painted cups with wild-beast scenes, showing leopards, a bull and a bear. From Nordrup and Himlingøje, Denmark. Height of cup below right 8.4 cm. 3rd century AD. Copenhagen, Danish National Museum.

Plate 20. Octagonal *lanx*, with relief frieze around flange showing the birth and
education of Achilles. Central *emblema* depicts Diomedes and Odysseus' discovery
of the young Achilles (dressed as a girl) at the court of King Lykomedes. From
Kaiseraugst, Switzerland. Silver. Diameter 53 cm. 4th century AD. Augst,
Römermuseum.

Plate 21. Gold buckle ornamented with a satyr in relief on the plate and a pair of
horse-heads on the loop. From Thetford, Norfolk. Length 5 cm. 4th century AD.
London, British Museum.

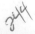

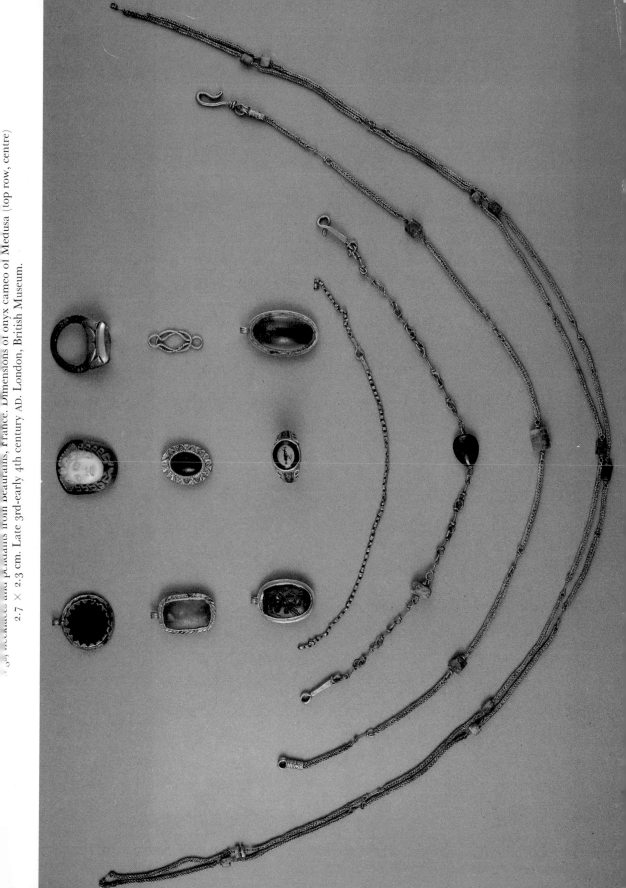

necklaces and pendants from Beaurains, France. Dimensions of onyx cameo of Medusa (top row, centre)
2.7 × 2.3 cm. Late 3rd–early 4th century AD. London, British Museum.

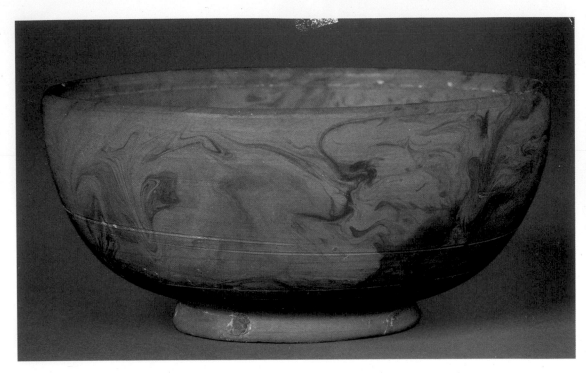

Plate 23. Red-gloss bowl with marbled glass, made by Castus of La Graufesenque. From Bordighera. Diameter 10.9 cm. Neronian. London, British Museum.

Plate 24. Lead-glazed cup from Asia Minor. Diameter 8.3 cm. 1st century BC or 1st century AD. London, British Museum.

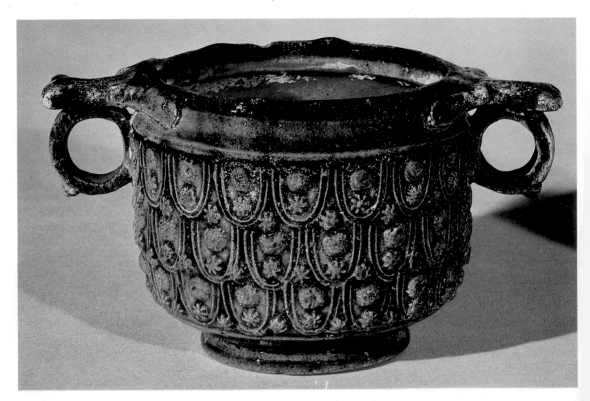

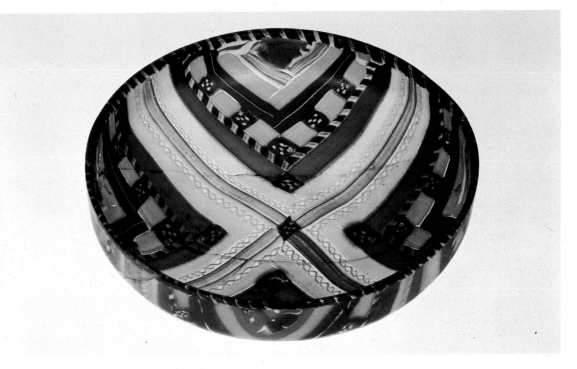

Plate 25. Cast polychrome strip mosaic bowl. From Hellange, Luxembourg. Diameter 14.5 cm. 1st century AD. Luxembourg, Museum of History and Art.

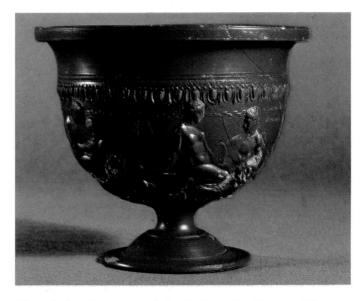

Plate 26. Arretine *crater* made by M. Perennius Tigranus. Diameter 17 cm. Late 1st century BC. Oxford, Ashmolean Museum.

247

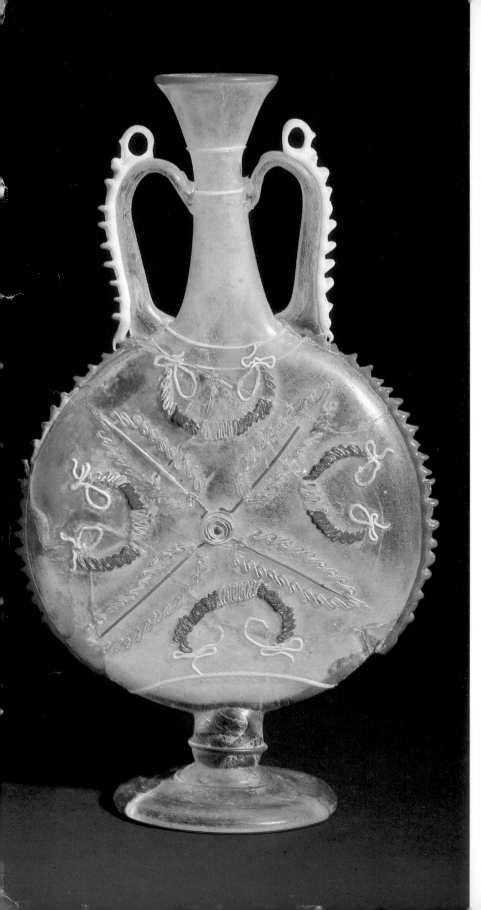

Plate 27. Blown colourless two-handled flask with fine polychrome trailed decoration. From Cologne. Height 27.5 cm. 3rd century AD. Cologne, Römisch-Germanisches Museum.

(*Right*) Plate 28. Blown opaque green (translucent wine-red in transmitted light) cup with openwork figured decoration showing Lycurgus caught in a vine. Height 16.5 cm. Early 4th century AD. London, British Museum.

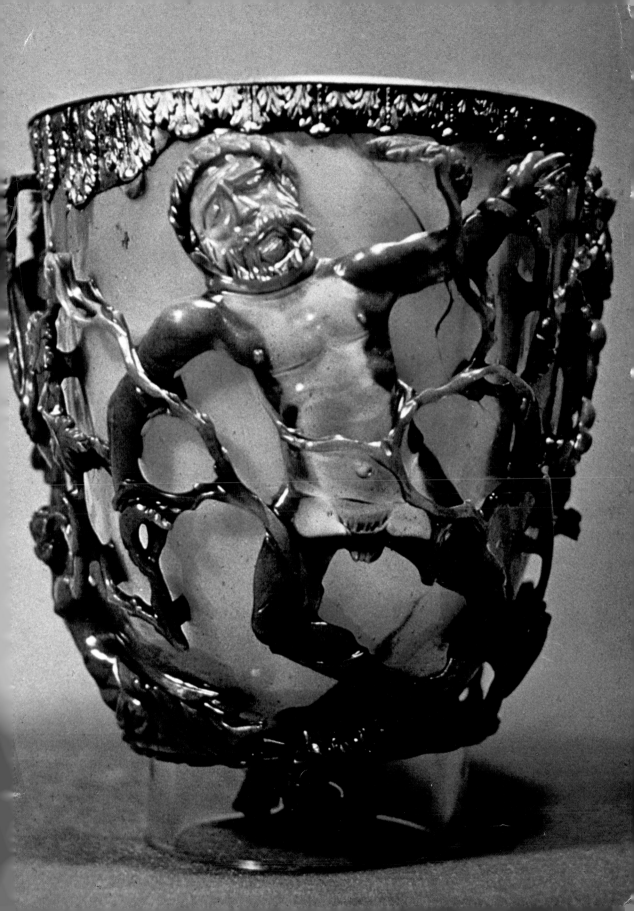

Plate 29. Casa Celimontana (under the Basilica of St John and St Paul, Rome). Fresco. 2nd century AD or later.

Plate 30. Vault of the Tomb of the Pancratii, Rome. Fresco and stucco. AD 150.

(*Above*) Plate 31. The offering of Abel and Melchisedek. Mosaic from the north side of the presbytery of the church of San Vitale, Ravenna. *c*.AD 550.

Plate 32. The offering of Abel and Melchisedek. Mosaic from the north side of the apse of the church of Sant'Apollinare in Classe, near Ravenna. *c*.AD 670.

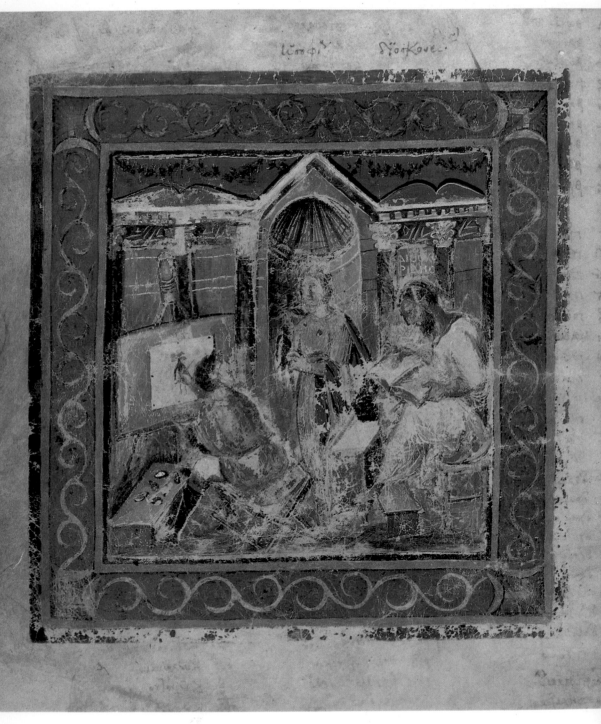

Plate 33. The artist at work. Full-page illustration from the *De Materia Medica*, written by Dioscorides. Copied and illuminated for the Princess Juliana Anicia in Constantinople. *c.*AD 510. Vienna, Nationalbibliothek.

(*Right*) Plate 34. Full-page illustration of the Crucifixion and Resurrection from the Gospels written and illuminated by the scribe Rabbula in Mesopotamia. Dated AD 586. Florence, Biblioteca Laurenziana.

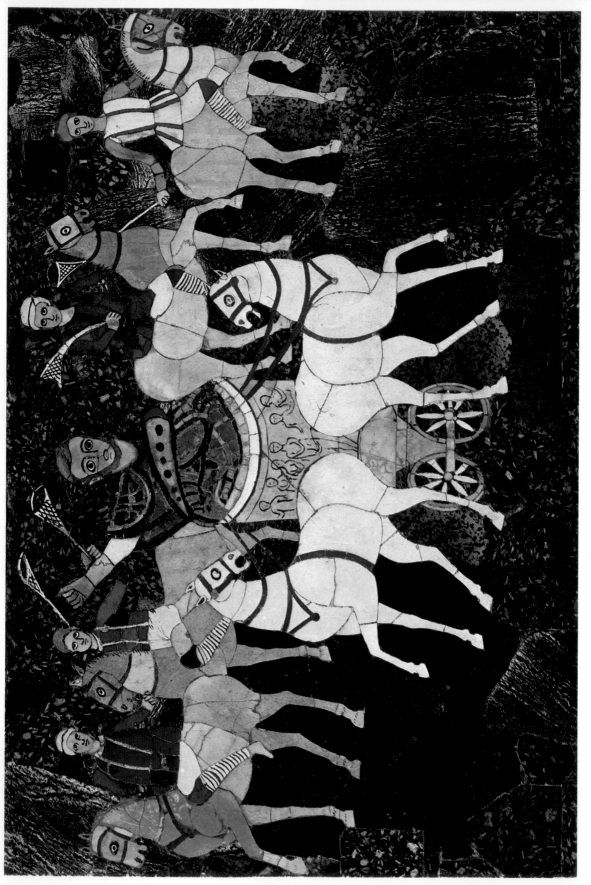

Plate 25. A consul in a chariot and horsemen in racing colours. Mural *opus sectile* of marble and opaque glass.

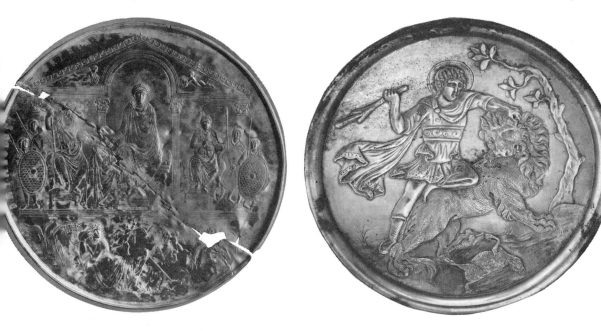

206. The Madrid Missorium. A large silver dish showing the court of Theodosius I. Found near Mérida, Spain. Diameter 74 cm. c.AD 388. Madrid, Academia de la Historia.

207. David and the Lion. Silver plate from the Cyprus treasure. Diameter 14 cm. c.AD 620. New York, Metropolitan Museum of Art.

revival at the end of the fourth century.

We have seen that some forms of art resist any attempt to mark out a straight course of development. Late Roman silver-ware is also resistant to close dating.[11] The great Oceanus dish from the treasure from Mildenhall in Suffolk is usually dated to the middle of the fourth century (Ill. 116). The dish, nearly 30 inches across, now in Madrid, sent out by the Emperor Theodosius I on his tenth anniversary (387–8) could not be much more securely dated in the later part of the fourth century (Ill. 206). The plate showing David and the Lion, from the Cyprus treasure and now in New York (Ill. 207), belongs to a group firmly assigned by silver control marks to the reign of the Emperor Heraclius (610–43). Of these three pieces one is an official gift and obeys the rules of official portraiture and composition, showing an imperial scene almost without a third dimension of depth, with frontally posed figures and little anatomical detail discernible through drapery. A geometrical and inflexible symmetry is observed, and features on the faces are minimal. The Mildenhall and Cyprus plates belong to a different world, an art of naturalistic movement in which draperies swirl in the air or cling to the bodies of well-drawn figures with recognizable musculature. Balance rather than rigid symmetry is sought, and the humans depicted are endowed with individuality. Here, as elsewhere, it is fair to say that no honest description of Late Roman silver work can show a simple unidirectional change from naturalism to stylization.

The Missorium of Theodosius in Madrid stands out as official art outside the general run of silver engraving, and its distinguishing characteristics are the very ones which we know belong to the style of the Late Roman Court. Any event in which the emperor took part was carefully choreographed theatre. The scene on the missorium is symmetrical to the point of rigidity, but so, almost certainly, was the scene

when it was acted out in the flesh. Theodosius looks straight ahead, we may imagine at the assembled crowds, rather than bending in a human manner to present a commission (codicil) to the kneeling official with a few kind words. We are reminded that what impressed the historian Ammianus Marcellinus when he saw Constantius II enter Rome in 356 was the fact that throughout the whole procession he stared straight ahead, just like a statue, looking neither to right nor left: 'nor was he ever seen to spit, or to wipe or rub his face or nose, or move his hands about.' (Amm. Marc., XVI. 10). No greater commendation could be given; the Emperor had behaved impeccably – like his statue. It is a little hard to pass adverse comment on the official court silversmith whose work is so true not only to the actual event, but even to the spirit of it.

Our knowledge of Late Roman architecture is astonishingly unbalanced; many late Roman churches survive, and our knowledge of their changing fashions in building and decoration is excellent. But apart from the palaces of the fourth century (Trier, Split, Thessalonika), our ignorance of secular building is so great as to be a blind spot.[12] The churches are mainly either basilican (long rectangles) or centrally planned. The former developed out of the secular basilica, while the most obvious origin for the central plans – whether circles, squares, polygons, or crosses – was the pagan mausoleum. Constantine's orders to his architects in Rome to build him churches over the shrines of St Peter, St Paul, and St Lawrence must have puzzled them: what, apart from an upper room of the house of a member of the congregation, suitable for the breaking of bread, was a church? 'A place', the answer may have been given, 'in which large numbers of worshippers and pilgrims may gather.' Armed with this information, the State architects could have found no better model than the basilica built by Maxentius in Rome, which they had only just remodelled for Constantine so as to emphasize the western apse on the long axis rather than the usual centre of attention, a cult statue in the northern apse opposite the main south door. But attached to the basilica, built for the crowds, the relics of the three saints demanded a cult centre for rites at the tomb. Hence in the case of St Peter's on the Vatican hill, and St Paul's outside the walls, an extra building was placed across the west end of the basilica instead of the normal apse. This idea of a dual building was not much used again until it was revived and extended in the Carolingian period: for the Late Roman period the simple basilica was the norm.

Constantine's building, perhaps under the direction of his mother Helena, extended to the Holy Land, and at the Holy Sepulchre in Jerusalem the shrine, or martyrium, over the holy spot followed the central plan; here again a basilica was built nearby for the crowds. The central plans in Ravenna included the baptisteries and the mausoleum built by Galla Placidia, with the church of San Vitale as the last major representative. In Constantinople there was Constantine's church of the Holy Apostles and then in the sixth century SS Sergius and Bacchus leading to Justinian's great church of the Holy Wisdom (Hagia Sophia). The two architects of the last, Anthemios and

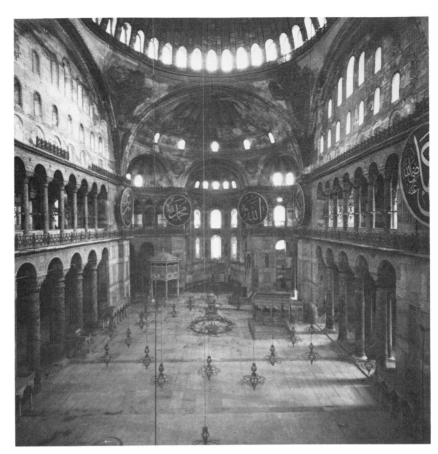

208. The interior of Justinian's church of the Holy Wisdom (Hagia Sophia), Constantinople, looking east. Dedicated AD 537.

Isidorus were mathematicians, and the wonder of their building is not the stone exterior, nor its interior decoration, which now consists of dulled marble veneer and yellow whitewash, but the fact that it stands, and has stood, against considerable odds, for nearly a millennium and a half. The casual tourist will absorb little of the wonder, for he will see an exterior of massed volumes, and an interior which seems to be an elongated rectangle with an apse at the east end. The visitor who sits and thinks under the great dome has to ask himself where the thrust of that second dome (for the earlier, flatter dome had a very short life) is earthed. He will note the great semi-domes to east and west, which elongate the central square to an apparent rectangle, and the massive external buttresses to north and south. The thrust of the main semi-domes is led to earth by smaller semi-domes, and the buttresses viewed from inside seem no more than very solid piers (Ill. 208). The magnificence demanded by the presence of the court is there – though sadly muted in its modern role as a whitewashed museum – and this will impress the accidental visitor, but the greatness of the building is a matter of thought in which the structure only becomes obvious and necessary as one follows, however unsurely, the same stages of problem and solution as the original architects.

But this church is a final solution; it formed the prototype for many Ottoman mosques, but it developed no further. Another extreme

central plan is that of the initial form of Santo Stefano Rotondo in Rome, which Krautheimer has recently suggested belongs to the family of pavilions and garden retreats of the late mansions and palaces of Rome in the fourth and fifth centuries.[13] This only serves to underline our ignorance of secular architecture.

Painting and mosaic seem to owe less to their antecedents than the forms of art so far considered. Late Roman art is epitomized, for many, by the mosaics of Ravenna.[14] Commentators who wish to avoid overvaluation of the mosaics in Ravenna point to accidents of survival. They say that Ravenna was one of many such cities in Italy, unique only in that its churches escaped later changes of artistic fashion through the inaccessibility of the city, on the sandy delta of the river Po; this is hardly true. First of all Ravenna was the Imperial capital in the West from soon after 400, when Honorius correctly identified the marshes of the area as a safe refuge, until the papacy had subsumed all that remained of Byzantine power into the Papal States. The busy, forward-looking provincial capital of today is no more than the thriving heir of the capital city of the medieval Marche.

Because the mausolea, baptisteries, chapels and churches of Ravenna comprise a connected series from about 430 to 680, the mosaics which decorate them form a skeleton framework of Late Roman wall and vault mosaic into which individual works outside Ravenna may be fitted. The essence of the appeal of these mosaics is colour and attack, the absolute antithesis of the cerebral satisfaction afforded by the mathematical solutions to the problems posed by the dome of Hagia Sophia. Early Roman mosaics belonged to the floor. Already in Hadrian's villa they were migrating onto the walls and perhaps even to some vaults in light airy patterns set in very small tesserae. In Ravenna they belong to walls and vaults alone.

The exterior of the mausoleum built by Galla Placidia in Ravenna is unassuming brick; the floor laid with grey and white marble flagstones; the marble sarcophagi are huge, simple Roman forms; only the mosaics of the vaults launch out into a new world. Once the eyes of the visitor have accepted the twilight, the brilliant colours sparkle at him from the inky blue background (Plate 15). The tesserae are glass, broken to catch and reflect every stray beam of light, and set on an uneven pitch to increase the variety of reflection. In this mausoleum, whether or not the sarcophagi are those of Galla Placidia's step-brother Honorius and her husband Constantius III, the visitor may sit in the silence and dimness and share with complete directness the feelings of that remarkable woman, daughter, sister, wife, and mother to different emperors who had nevertheless been married off to a Goth, Athaulf, brother of Alaric, sacker of Rome. There is no other building completed before the twelfth century where so perfect and complete a testimony remains.

The mosaic of the triumphal arch of Santa Maria Maggiore in Rome shares the blue background with the Galla Placidia mausoleum, but it is remote, many feet from the ground. The small panels below the windows of the same church are hard to appreciate amidst the sharp light and gilded sparkle of baroque decoration around them.[15]

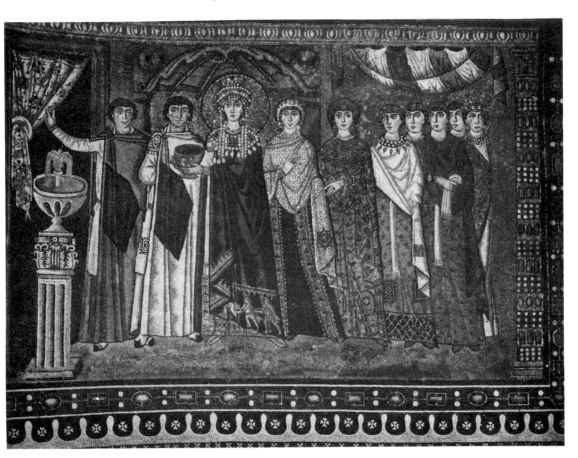

209. Theodora and her court. Mosaic in the apse of the church of San Vitale, Ravenna. *c*.AD 550.

The Orthodox and Arian baptisteries at Ravenna show a change, by about 475 to 500, to a golden ground on which to portray a procession of Apostles, and this change was to be permanent. In the church of Sant'Apollinare Nuovo, built under the Arian and Gothic king Theoderic, much of the decoration was replaced after the arrival of the orthodox Justinian. What remains from the time of Theoderic is of bold design and good colour, but the Justinianic addition of processions of saints is much weaker and rather repetitive. A complete change may be seen in San Vitale, a building started late in the reign of Theoderic (*c*.520) and completed under full Byzantine approval, as is shown by the full complement of now fashionable Proconnesian marble capitals direct from the Sea of Marmora, and the court portraits of the Emperor Justinian and his wife Theodora (Ill. 209).

Judged as examples of official portraiture, these apse mosaics are superb, for they combine the formal design and luxurious use of colour proper to the period with the presentation of a set of portraits that are surprisingly individual. But there is a contrast between the Emperor and Empress and their immediate associates on the one hand and the general entourage of courtiers and soldiers, who are depicted as stock characters, on the other. All the figures are shown frontally, but there is an element of depth in the composition, so that there is an illusion of at least two rows of courtiers. These mosaics are perhaps the latest in

the building and show direct Constantinopolitan influence. The symbols of the evangelists on the great arch are less rigidly organized, and include one of the most friendly lions to survive from antiquity. The scenes on either side of the altar – Abraham and Isaac, Cain and Abel, the three angels, and the offering of Melchisedek – seem to grow from a firmly Italian, Roman, root with little influence of stylization from the East. But the colour is disappointing compared with the Galla Placidia mausoleum; the greens are weaker, the reds less bright, and the blues less deep. The impoverishment of colour can be seen, taken several steps further, when the court scene and the sacrifice scenes are copied during a reconstruction at the church of Sant'Apollinare in Classe which must date to c.680 (Plate 31). The weaker colours of San Vitale are garishly strengthened at Sant'Apollinare in Classe to give acid greens and oranges, and plummy purples. Portraiture and the composition of the court panel are far below the standard achieved by Justinian's workmen.

The art of the catacombs is vital to our understanding of the origins and development of Christian iconography, but it shows few masterpieces of painting. It is a fully acceptable development of Roman interior decoration, perhaps taking up Trimalchio's point (*Satyricon*, 71) that it is wasteful to decorate your house while you are alive, while economizing on your surroundings for eternity. Although some of the best schemes of decoration come from Rome – such as those in the newly discovered catacomb on the Via Latina – the Christian sepulchral art of the provinces – for example the underground tombs at Pécs (Hungary) – is of equally high standard both in design and in execution.[16]

Finally, we need to take account of the art of manuscript illumination. It is generally assumed that book illumination has a long history before the year 400, but there is no direct evidence to support such an assumption. All illuminated manuscripts that survive today date from after the year 350: there may have been earlier examples, but none survives.[17] Once again colour is the vital factor. Just as the mosaic vault of the mausoleum of Galla Placidia ends a long tradition of sparse scenes and vignettes on a white ground, and plunges into a riot of colour on every surface, so the occasional line-drawing in a manuscript broadens out to become a framed miniature, every inch in colour. The two earliest manuscripts are both of Vergil; the Vatican Vergil an assured series of illustrations in carefully measured Late Antique fashion; the Roman Vergil a much brasher use of bright primary colours and simple direct drawing (Ill. 1). Earlier criticism made the difference one of date, more recent suggestions seem to be reaching a consensus on a date between c.400 and c.500, giving the assured work to Rome, and the 'younger' work to the north-west provinces.[18]

These two works are closely followed by the Ambrosian Iliad and the Quedlinburg Itala fragment, the latter a single page surviving from an illuminated Book of Kings. The fifth century therefore has a spread of examples. Early in the sixth century a manuscript of Dioscorides' *De Materia Medica*, written and illuminated, presumably,

in Constantinople, shows us the illuminator at work (Plate 33). With a mandrake root before him to copy, a set of pigment jars, and vellum stretched on his drawing-board with thumb tacks, the artist himself is depicted. The late fifth and early sixth centuries have left us a series of luxury manuscripts written and illuminated on purple vellum. By this stage the artist, who had previously had to confine his work to the occasional frame on the roll between long stretches of text, has taken over whole pages to depict single scenes, or a series of episodes one above the other as in the earlier sculptured historical reliefs. The trial of Jesus from the Rossano Gospels shows the full scene carefully spread out in a circular form as if in bird's-eye view; illustrations to accompany the story of Joseph in the Vienna Genesis proceed in registers, at times three to the page. Complete survival and the immediate impact of boldly used colour on vivacious drawing make a manuscript such as the Vienna Genesis communicate directly with an onlooker in a way that earlier Roman art can rarely match. We are here not at the end of the classical tradition, but at the beginning of a new art.

Inevitably, given the conservative nature of the Byzantine capital, these final changes happened in the provinces, or even beyond the frontiers of the Greek Empire. In the Middle East in the year 568 the scribe Rabbula depicted the feasts of Easter, Pentecost and the Ascension in brilliantly vivid colours, both soft and striking, with a deftness of touch and delicate suggestion that almost lifts the impression of the page (Plate 34). But still the use of colour was tied to depiction and representation, while the vaults of the mausoleum of Galla Placidia had moved by 430 to almost pure pattern (Plate 15). Merovingian manuscripts edged away by piecemeal decoration of letters, but it was left to the scriptoria of Northumbria to start from classical models, imitate them passably as in the Codex Amiatinus and then speed on, perhaps in the lifetime of one great artist, around the year 700, to fuse colour and pattern into the pure decoration of the Carpet Page.[19]

Throughout our survey of Late Roman art, and its change into the art of the early Middle Ages, the centre of gravity or excellence of each form has moved progressively later. Thus mosaics came to their peak after sarcophagi and court portraiture. Late Roman painting divides into two branches which seem to flourish at different times, for the wall painting of the catacombs is a product especially of the fourth century and is a direct development from classical wall painting of the earlier centuries, while the illumination of luxurious manuscripts only gathers strength by about 400 and reaches a peak in the sixth century.

What had happened? Around AD 150 the civilized world, that is the provinces of the Roman Empire, was united in an art which centred on the depiction of man as he was, or perhaps mildly idealized. There were fashions and there were local variations, but this general statement holds. It is perhaps no accident that the best-known emperor of the period was a Stoic philosopher, a humanist with belief in the effectiveness of 'The Good Man'. Inscriptions on the exteriors of buildings from Spain in the West to Greece and Asia Minor in the East show that they were erected to glorify the benevolent patron; not all

were functional: seldom have there been such non-utilitarian monu-
ments as the columns of Trajan and Marcus Aurelius. But then
buildings began to turn inside out – attention in the great imperial
baths was focused on internal function, and the exterior form was no
longer planned to delight the spectator. A building aimed to satisfy the
practical needs of the user, rather than act as an ornament to please the
eye of the passer-by. The human element became submerged during
the third century; living man, as man alone, seemed to lose his power
and the strength seems to belong to the office rather than to the holder
of it. Simultaneously, the religion of the emperor – to make no wider
assertions – changes from belief in man and his own destiny to an
authoritarian Christianity in which an emperor can be almost as
unworthy a vessel of God as the meanest of his subjects. Theodosius the
Great learned this lesson the hard way from his court bishop Ambrose
of Milan.

Sinful humanity could achieve nothing by its own efforts. Certain
offices were sanctified – *sacra* – and as such were powerful, but to point
out the humanity of the holder of an office was to point out his
weakness; to depict him as Office Personified was to emphasize
strength. A few individuals – Constantine, Justinian – were brave, or
conceited, enough to emphasize their individuality, others simply
went through the motions inside their shell of office. This is a reas-
onable commentary on official art, the demise of the depiction of the
individual, and the move from explicit humanism and humanity to
symbolic Christianity.

But how to explain the really arresting developments of Late
Roman art – colour and pattern in mosaics and manuscripts? What
accounts for the change in less than a hundred years from the tasteful
white background of one light airy imperial burial place (the vault
mosaic of the church of Santa Costanza in Rome), to the dense chorus
of colour in the tiny dark space over the coffins in the mausoleum of
Galla Placidia? One clue has already been mentioned, the virtual
disappearance of monumental art and the construction of buildings
for those who owned and used them rather than as public amenities or
monuments. What is left to us from the later Empire, apart from the
many churches, are intimate works of art produced for the delight of a
patron rather than public productions, art produced for an important
person, but then restricted to that person or a very small gathering.
Certainly those works have an impact on the individual – one person in
a mausoleum, one person looking at a manuscript – in a way quite
different from the Parthenon, the Pantheon or the mosaics of Santa
Maria Maggiore. For the moment it can remain only a hint worthy of
further thought: no fifth-century thinker would see anything wrong in
ending on a note of mystery.

Abbreviations

AE	*L'Année Épigraphique*
AJA	*American Journal of Archaeology*
Ant. J.	*Antiquaries Journal*
AntAf	*Antiquités Africaines*
ANRW	*Aufstieg und Niedergang der römischen Welt* (ed. H. Temporini and W. Haase, Berlin and New York, 1973–)
Arch. Ael.	*Archaeologia Aeliana*
Arch. J.	*Archaeological Journal*
Atti III	R. Farioli Campanati (ed.), *Atti del III Colloquio Internazionale sul Mosaico Antico* (Ravenna, forthcoming).
BABesch	*Bulletin van de Vereeniging tot Bevordering der Kennis van de Antieke Beschaving te's-Gravenhage*
BAR	*British Archaeological Reports. British Series*
BAR Int. Ser.	*British Archaeological Reports. International Series*
BJ	*Bonner Jahrbücher*
Blake I	M. E. Blake, 'The pavements of the Roman buildings of the Republic and early Empire', *MAAR*, VIII, 1930, 7–159.
Blake II	M. E. Blake, 'Roman mosaics of the second century in Italy', *MAAR*, XIII, 1936, 67–124.
Blake III	M. E. Blake, 'Mosaics of the late Empire in Rome and vicinity', *MAAR*, XVI, 1940, 31–120.
BMQ	*British Museum Quarterly*
BSA	*Annual of the British School at Athens*
CIL	*Corpus Inscriptionum Latinarum* (Berlin, 1863–)
CLE	*Carmina Latina Epigraphica* (ed. F. Buecheler and E. Lommatzsch: part II of *Anthologia Latina*, ed. F. Buecheler – A. Riese – E. Lommatzsch, Leipzig, 1895–1926, reprinted Amsterdam, 1972).
De Arch.	Vitruvius, *De Architectura*
DOP	*Dumbarton Oaks Papers*
Dunbabin	K. M. D. Dunbabin, *The Mosaics of Roman North Africa* (Oxford, 1978).
Ep.	Pliny the Younger, *Epistulae*
ILCV	*Inscriptiones latinae christianae veteres* (ed. E. Diehl, Berlin, 1925–67)
Jahr RGZM	*Jahrbuch des Römisch-Germanischen Zentralmuseums, Mainz*
JDAI	*Jahrbuch des Deutschen Archäologischen Instituts*
JHS	*The Journal of Hellenic Studies*
JRS	*The Journal of Roman Studies*
Levi	D. Levi, *Antioch Mosaic Pavements* (Princeton, London, The Hague, 1947).
MAAR	*Memoirs of the American Academy in Rome*
MGR I	G. Picard and H. Stern (eds.), *La Mosaïque Gréco-Romaine* I, Éditions du Centre National de la Recherche Scientifique (Paris, 1965).
MGR II	H. Stern and M. Leglay (eds.), *La Mosaïque Gréco-Romaine* II, Éditions A. and J. Picard and Centre National de la Recherche Scientifique (Paris, 1975).
Mon. Piot	*Monuments et Mémoires, Fondation Piot*
NH	Pliny the Elder, *Naturalis Historia*
PBSR	*Papers of the British School at Rome*
P. Oxy.	*The Oxyrhynchus Papyri* (ed. B. P. Grenfell, A. S. H. Hunt and others. Egyptian Exploration Fund, London 1898).
Proc. Brit. Acad.	*Proceedings of the British Academy*
Rev. Arch.	*Revue Archéologique*
RIB	*The Roman Inscriptions of Britain. I. Inscriptions on Stone* (ed. R. G. Collingwood and R. P. Wright, Oxford, 1965).
Röm. Mitt.	*Mitteilungen des deutschen archäologischen Instituts. Römische Abteilung*
S.H.A.	*Scriptores Historiae Augustae*

Vessel Forms

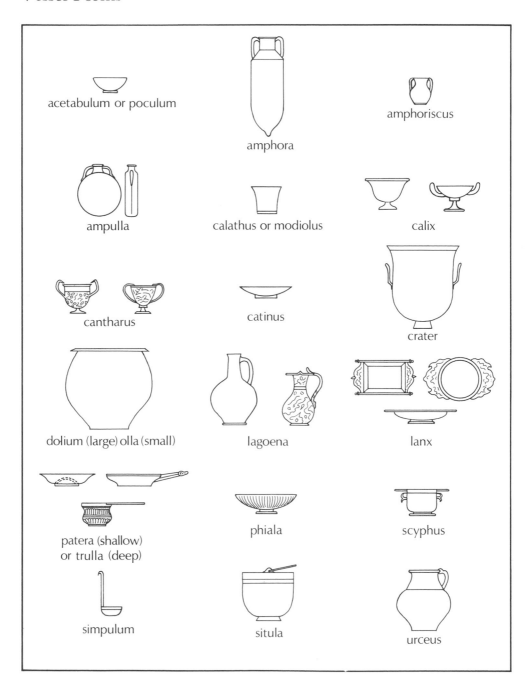

acetabulum or poculum

amphora

amphoriscus

ampulla

calathus or modiolus

calix

cantharus

catinus

crater

dolium (large) olla (small)

lagoena

lanx

patera (shallow)
or trulla (deep)

phiala

scyphus

simpulum

situla

urceus

Glossary

Aedicula(e): a small shrine (*aedes*), frequently in the form of a pair of columns surmounted by a pediment (q.v.) framing a niche for a statue.

Agora: the public square or market-place of a Greek city, corresponding to the Latin *forum*.

Albastron (alabastra): a container for perfumes and unguents with a long, narrow, cylindrical body.

Alassontes: glass cups of changeable colour.

Ambulatory: the covered walk surrounding a building or a precinct.

Amphitheatre: a building with seating arranged in tiers around an oval arena. Used for displays of combat involving gladiators or wild animals.

Antefix: vertical ornament masking the joins of the tiles at the edge of a roof, above the eaves.

Apse: a recess in the wall at the end of a building, normally semicircular.

Architrave: horizontal course carried by the columns or piers of a building; the lowest part of the entablature (q.v.).

Arretine ware: a type of red-gloss pottery (q.v.), produced *c.*30 BC – AD 30 at Arezzo, Pisa, Pozzuoli and Lyons.

Ashlar: masonry of rectangular blocks dressed to a vertical face (see *opus quadratum*).

Askos (askoi): literally, a wine-skin; a container for wine resembling a wine-skin (sometimes also made in the form of an animal, e.g. a goose).

Atrium (atria): the reception hall of the traditional type of Roman house (*domus*).

Augustus: originally a title with religious overtones, bestowed on Octavian by the Senate in 27 BC. Used later for an emperor with full executive powers. From the mid-second century there could be more than one Augustus at a time.

Barbotine: a method of decorating pottery by trailing slip over its surface.

Bucranium (bucrania): ox-skull; often included in decorative reliefs in temples and altars as a sacrificial symbol. Also found in funerary contexts.

Caesar: the *cognomen* borne by some members of the Julian *gens* (clan), notably Gaius Julius Caesar. Later adopted by emperors who were junior to the Augusti and had limited powers. The title was often given to the heir apparent, although right of succession was not always implied.

Caldarium (caldaria): the hottest room in a suite of baths.

Camillus (camilli): an acolyte; he had to be free-born, below the age of puberty and to have both parents living.

Carination: on pottery etc., a sharp angle on the side or shoulder.

Caryatid: a column in the form of a female figure.

Cavea: the tiers of seating in a Roman theatre or amphitheatre (q.v.).

Cella: the cult-room within a temple.

Chamfron: the head-piece worn as a frontal by a horse; often in metal to serve as armour.

Cista: a small box or casket.

Colonia(e): a chartered town of Roman citizens, frequently settled by legionary veterans.

Compluvium (compluvia): an open area in the roof of an *atrium* (q.v.) by which the hall was lighted. Rain fell through it, into the water-tank (*impluvium*) beneath.

Cornice: the projecting, uppermost part of an entablature (q.v.).

Coroplast: a maker of terracottas.

Cubiculum (cubicula): the bedroom of a Roman house. Also, a place where the

passages in a catacomb broaden out to form an underground chamber, used either for a religious gathering or for burial.

Diatretarius (diatretarii): a glass-cutter specializing in the production of *diatreta*.

Diatretum (diatreta): cut glass, often used for elaborately cut vessels.

Diptych: two-leaved, hinged ivories bestowed as gifts in Late Antiquity to celebrate marriage alliances and consulates.

Dominate: the late Empire, when the ruler is held to have assumed a monarchic role as *dominus* (Lord).

Emblema(ta): centrepiece of mosaic floor or metal vessel.

Entablature: the horizontal superstructure of a building above the columns and beneath the pediment (or equivalent decoration at the top of a wall), consisting of cornice (q.v.), frieze (q.v.) and architrave (q.v.).

Ephebe: the Greek term for a youth under military age.

Eros (erotes): love personified, a cupid.

Exedra: a semicircular or rectangular recess in a wall or colonnade; originally, to accommodate seating.

Fibula(e): a brooch, generally of 'safety-pin' form, used as a fastening for a garment.

Flan: (numismatic): a thin piece of metal, usually circular, although occasionally square or globular, on which the design from a die may be impressed to form a coin. A flan may either be cast from a mould or cut from a sheet of metal.

Fondo (fondi) d'oro: literally, a gold base; the base of a vessel incorporating a gold foil decoration.

Frieze: the middle part of an entablature (q.v.), often decorated with sculpture in relief.

Frigidarium (frigidaria): the room in a suite of baths containing the cold bath.

Fulcrum (fulcra): the head-rest of a Roman couch.

Gadroon: elongated, straight or S-shaped tongue used in the field ornament of metal and pottery vessels.

Glyptics: the art of gem-cutting; from the Greek *gluptos*, carved.

Hydria(e): a jug with a vertical handle and two handles arranged horizontally at the shoulder.

Hypogeum (hypogea): an underground chamber.

Imbrex (imbrices): a curved roofing tile, laid over the flanges of two adjoining flat tiles (*tegulae*).

Insula(e): literally, an island. One of the rectangular plots defined by the street grid of a town; a block of shops or apartments built on such a plot.

Interpunct: (inscriptions): a stop separating words within a line of lettering.

Kalathiskos: literally, a small basket (Greek); used with reference to the characteristic hats worn by certain female entertainers (*kalathiskos* dancers).

Koine: a common, all-pervading style.

Lar(es): a Roman household god, often shown as a youth wearing a tunic and holding a *rhyton* (drinking-horn) and *patera*.

Ligature: (inscriptions): a combination of the elements of two or more letters into a single written unit.

Limes: the frontiers of the Roman Empire.

Loculus (loculi): a burial niche.

Marver: to roll a glass vessel on a flat surface during manufacture.

Metopes: the carved slabs of a Doric frieze.

Ministerium: a service of silver plate.

Missorium: a silver plate (*lanx*, see diagram) presented by an emperor on a festive occasion.

Modillion: scrolled or rectangular bracket beneath the projecting part of a cornice of the Roman Corinthian Order.

Nymphaeum: a shrine of the nymphs; the term is used more widely to denote any building associated with a fountain, particularly one with elaborate architectural and sculptural decoration.

Oculus: (literally, an 'eye'); a circular opening in the centre of a dome.

Oecus: a richly decorated living-room.

Oinochoe (oinochoai): a jug with a vertical handle and a trefoil rim.

Oinophoros (oinophoroi): flagon, wine jar (= *lagoena*).

Opus: (literally, 'work'); in Roman architectural terminology, a type of wall or floor construction, usually defined by its superficial facing or covering.

Opus caementicium: Roman concrete; rubble aggregate (*caementa*) laid in lime mortar.

Opus incertum: irregular wall-facing of small rubble.

Opus mixtum: wall-facing of reticulate masonry with levelling courses and quoins of brick.

Opus quadratum: squared stone masonry (i.e. ashlar).

Opus reticulatum: wall-facing of small square blocks set diagonally to form a net-like pattern.

Opus sectile: floor- or wall-facing of coloured marbles cut to form geometrical patterns.

Opus signinum: lime mortar with aggregate of crushed brick used as floor covering.

Opus tessellatum: mosaic pavement made with tesserae (small cubes of stone and other material).

Opus testaceum: wall-facing of brick.

Opus vermiculatum: mosaic pavement made of very small tesserae.

Orchestra: the level area of a theatre, in front of the stage and surrounded by the *cavea* (q.v.), normally semicircular in Roman theatres.

Ovolo: a convex moulding, of egg-like form, used in sculptural ornament and also on pottery.

Palaestra: open courtyard for physical exercise, especially that attached to a bath-building.

Pediment: corniced gable above the entablature (q.v.) at the end of a building; usually triangular, but occasionally segmental when used decoratively above an *aedicula* (q.v.).

Peristyle: colonnaded courtyard within a building.

Petit appareil: concrete faced with coursed rubble masonry of small squarish blocks, characteristic of Roman building in Gaul.

Petrotos (or **Ptetrotos**): stone (or winged) cups.

Phalera(e): metal disks worn by soldiers, frequently bestowed on them as decorations.

Podium (podia): high platform with mouldings at top and bottom and steps at one end, carrying a Roman temple.

Poinçon: (pottery): a clay or wood model of a decorative detail, used to impress a design into a negative mould.

Portico: colonnade or porch, usually referring to the covered colonnade or arcade along the side of a building.

Principate: the early Empire, when the emperor was, notionally, just *princeps* (first citizen).

Pyxis (pyxides): small lidded box.

Quincunx: an arrangement of five objects at the corners and centre of a square; design elements arranged so that those in the second row occur between those in the first and third rows.

Red-gloss: a shiny red surface slip used on pottery.

Rouletting: ornamentation applied with a revolving toothed wheel.

Samian ware: common generic name for red-gloss (q.v.) pottery produced in Gaul, Germany and the Mediterranean area between the 1st and 3rd centuries AD. Alternatively known as *terra sigillata* (q.v.).

Scenae frons: decorated façade of the building behind the stage of a theatre.

Smalto (smalti): glass tessera(e).

Squeeze: (inscriptions): an impression of an inscribed surface, usually made by laying dampened paper over the stone and beating it into the lettering with a hard brush.

Stela(e): a standing block or slab; frequently a tombstone.

Tablinum (tablina): a reception room in a Roman house.

Tepidarium (tepidaria): the room of medium heat at the baths.

Terra sigillata: modern generic name for red-gloss (q.v.) pottery produced in Gaul, Germany and the Mediterranean area between the 1st and 3rd centuries AD. Alternatively known as samian ware (q.v.).

Tessella(e): mosaic cubes.

Tessera(e): mosaic cubes.

Thiasos: the companions of Bacchus.

Thyrsus: the staff filleted and tipped with a pine-cone carried by Bacchus or other members of the *thiasos* (q.v.).

Toreutics: the art of the metalworker, especially the chasing and embossing of plate; from the Greek *toreuō* work in relief.

Tria nomina: the three-part name of a Roman citizen, consisting of *praenomen, nomen* and *cognomen*, e.g. Gaius Julius Caesar.

Triclinium (triclinia): the dining-room of a house, set with three banqueting couches. In late Roman houses, the chief reception-room.

Tufa: stone composed of compacted volcanic dust; particularly the stone of central Italy.

Unguentarium (unguentaria): a container for perfumes and unguents.

Venatio (venationes): the hunting of wild beasts, either in the countryside or in the arena. A popular subject for genre scenes in art.

Vitriarius (vitriarii): glassmaker.

Acknowledgements

The publishers wish to thank all private owners, museums, galleries libraries and other institutions for permission to reproduce works in their collections. Particular acknowledgement is made to the following (references are to illustration numbers):

© Agora Excavations, 161, 168

Alinari, 5, 7, 14, 18, 20, 48, 52, 55, 60, 73, 74, 77, 78

Ashmolean Museum, 137–44, 146–7, 202–3

Judith Bannister, 113

Biblioteca Laurenziana, Pl. 34

Bibliothèque Nationale, Paris, 112, 131

Tom Blagg, 31, 32

Reproduced from D. B. Harden *et al., Masterpieces of Glass* (British Museum, London, 1968, no. 99, p. 77), 183.

Reproduced by Courtesy of the Trustees of the British Museum, 2, 12, Pl. 17, Pls. 21–4, Pl. 26, Pl. 28

By courtesy of F. E. Brown and the American Academy in Rome, 4

Caisse Nationale des Monuments Historiques et des Sites, 35, 43, 49

DAI, 8, 11, 13, 28, 33, 46, 50, 56, 58, 59, 62, 68, 80, 98, 99, 205

Fototeca Unione, Rome 15, 16, 17, 22, 23, 29, 63, 69, 25, 36

John Freeman, 34

H. Gabelmann, 44

Giraudon, Pl. 12, Pl. 13, 108

Reproduced from A. E. and J. S. Gordon, *Album of Dated Latin Inscriptions: Rome and the Neighbourhood*, Vols. I–III (Berkeley, Los Angeles, 1958–65), 189, 196–8

Sonia Halliday, Pl. 11, 201

Martin Henig, 40

Istituto Centrale per il Catalogo e la Documentazione, 87, 102

Professor W. F. Jashemski, Pl. 4

Jennifer Johnson, artwork for Vessel Forms, p. 250

A. F. Kersting, Frontispiece

Joan Liversidge, 90

Luxembourg Museum of History and Art, Pl. 25

Barbara Malter, Pl. 30, 51, 61, 66, 67, 75, 199, 200

Mansell Collection, 70, 71, 79, 101

Metropolitan Museum of New York, Pl. 6; Rogers Fund, 148; Gift of J. Pierpont Morgan, 207

Museo Archeologico Nazionale, Naples, 192

National Museet, Copenhagen, Pl. 19

Reproduced from A. Negev, *The Nabatean Potter's Workshop at Oboda* (Rudolf Hablet Verlag, Gmbh, Bonn, 1974), 155 (by permission of the author)

Newcastle University, Museum of Antiquities, 126

Osterreichische Nationalbibliothek, Pl. 33

Reproduced from A. Boethius and J. Ward Perkins, *Etruscan and Early Roman Architecture* (1978) © Penguin Books, 37, 39

Phaidon Archive, Pls. 1–3, 6, 9, 10, Pl. 16, Pl. 20, Pl. 21, 24, Pl. 26, Pl. 28, Pls. 35, 45, 54, 57, 76, 81, 83–6, 88, 94–6, 106, 107, 116, 117, 120–3, 125, 134, 135, 188, 204, 206, 209

Pontificia Commissione di Archeologia Sacra, 89

Josephine Powell, 208

Jennifer Price, 185

Princeton University Art Museum, Pl. 8

Susan Raven, 41

Rheinisches Landesmuseum, Trier, 103

Römisch-Germanisches Museum, Cologne, Pl. 7, Pl. 27

Scala, Pl. 5, Pls. 14–15, Pl. 29, Pls. 31–2

Service de Documentation Photographique, Pl. 10, Pl. 12, 53, 100, 109

Slovenska Akademia vied Archeologicky, Ustav, 110, 111

University of London, Warburg Institute, 149

Vatican Library, 1

Roger Wood, 21, 97

Worcester Art Museum (Mass.), Pl. 9

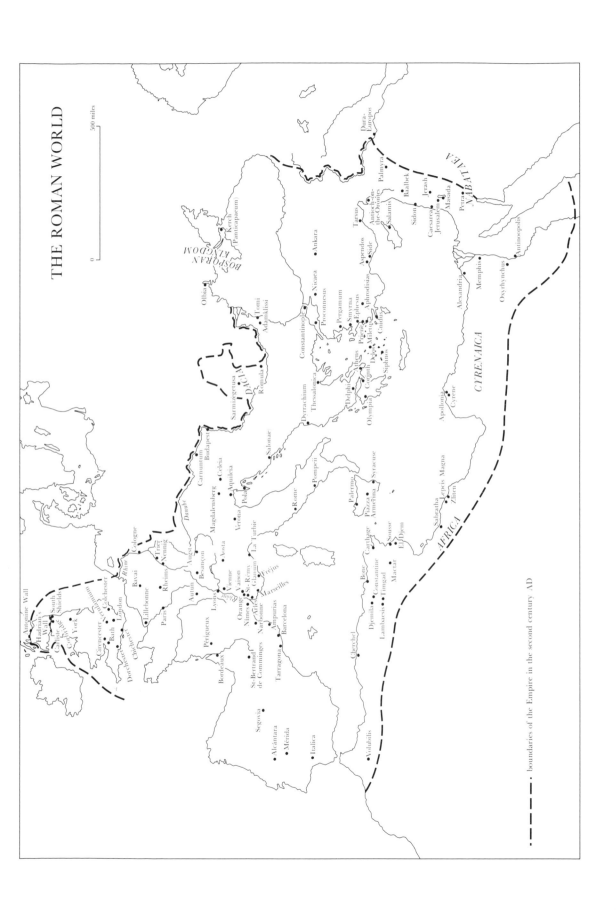

THE ROMAN WORLD

500 miles

0

BOSPORAN KINGDOM

DACIA

NABATAEA

CYRENAICA

AFRICA

Antonine Wall
Hadrian's Wall
Carlisle
South Shields
Corbridge
York
Cirencester Colchester
Bath London
Lullingstone
Dorchester Chichester
Segovia
Alcántara
Mérida
Italica
Bordeaux
Périgueux
St-Bertrand-de-Comminges
Tarragona
Barcelona
Empúrias
Paris
Reims
Bavai
Cologne
Trier
Nennig
Besançon
Autun
Lyons
Vienne
Orange
Nîmes
St-Rémy
Vaison
Glanum
Marseilles
Narbonne
La Turbie
Fréjus
Augst
Aosta
Magdalensberg
Carnuntum
Celeia
Budapest
Aquileia
Verona
Pola
Salonae
Rome
Pompeii
Palermo
Piazza Armerina
Syracuse
Cherchel
Bône
Carthage
Constantine
Djemila
Lambaesis
Timgad
Mactar
Sousse
El Djem
Sabratha
Lepcis Magna
Zliten
Volubilis
Olbia
Panticapaeum
Kerch
Sarmizegetusa
Romula
Tomi
Adamklissi
Constantinople
Dorrachium
Thessalonica
Delphi
Athens
Corinth
Olympia
Delos
Siphnos
Nicaea
Ankara
Proconnesus
Pergamum
Smyrna
Ephesus
Priene
Miletus
Aphrodisias
Cnidus
Tarsus
Aspendos
Side
Antioch-on-the-Orontes
Salamis
Sidon
Baalbek
Jerash
Caesarea
Jerusalem
Masada
Petra
Palmyra
Dura-Europos
Alexandria
Memphis
Oxyrhynchus
Antinoopolis
Apollonia
Cyrene

Rhine
Rhône
Danube

--- --- boundaries of the Empire in the second century AD

Notes

Introduction

Names of deities, mythological characters, etc. are generally given in their Latin forms, but Greek equivalents are employed where, in the opinion of the author, these are more appropriate. In writing about a bilingual and multi-cultural empire total consistency is impossible.

1. F. Haskell and N. Penny, *Taste and the Antique, The Lure of Classical Sculpture, 1500–1900* (New Haven and London, 1981).
2. K. Clark, *The Nude* (London, 1960), 43.
3. G. M. A. Richter, *Ancient Italy* (Ann Arbor, 1955), 105–16.
4. M. Andronikos in M. B. Hatzopoulos and L. D. Loukopoulos, *Philip of Macedon* (London, 1981), 208–11, Pls. 111–13.
5. R. G. Collingwood and J. N. L. Myres, *Roman Britain and the English Settlements* (2nd edn., Oxford, 1937), 249–50.
6. A. Burford, *Craftsmen in Greek and Roman Society* (London, 1972), 184–218 (on the status of artists in antiquity).
7. J. Onians, *Art History*, 3, 1980, 1–24.
8. J. Charbonneaux, *L'art au siècle d'Auguste* (Paris, 1948).
9. J. M. C. Toynbee, *The Hadrianic School. A Chapter in the History of Greek Art* (Cambridge, 1934).
10. G. M. A. Richter, *My Memoirs, Recollections of an Archaeologist's Life* (Rome, 1972, privately printed).

CHAPTER ONE *Early Roman Art*

1. See G. M. A. Richter, *A Handbook of Greek Art* (London, 1969, *passim*). E. Langlotz and M. Hirmer, *The Art of Magna Graecia* (London, 1965); A. G. Woodhead, *The Greeks in the West* (London, 1962), 121–32, 144–55.
2. Early commerce with Greek South Italy: E. La Rocca, *La Parola del Passato*, 32, 1977, 381–97. Recent archaeological work, important for the chronology of archaic art in Rome, is summarized by T. J. Cornell, *Archaeological Reports for 1979–80*, 1980, 71 ff., esp. 83–5.
3. According to the Roman tradition the Etruscans ruled Rome from 616 to 510 BC. But Gjerstad prefers a lower chronology of c.530–450, and Bloch would have Etruscan rule end c.475: see E. Gjerstad, *Early Rome*, I–VI (Lund, 1953–73) and R. Bloch, *The*

Origins of Rome (London, 1960). For a lucid discussion of these controversies see M. Pallottino, 'The origins of Rome', in D. and F. R. Ridgway (eds.), *Italy before the Romans*, (London and New York, 1979), 197–222. Most modern authorities accept the Roman tradition as being closer to the truth.

4. For the various types of column in use in Etruscan Italy, including that of Vitruvius' Tuscan Order (with moulded base, plain shaft, and capital of Doric type) see A. Boëthius, *AJA*, 66, 1962, 249–54.
5. For detailed discussion and a reconstruction of the temple: Gjerstad (n. 3), III, 168 ff.
6. O. J. Brendel, *Etruscan Art* (Harmondsworth, 1978), 238–44, Figs. 165–9.
7. Surveys of archaic architectural terracottas from Rome: A. Andrén, *Architectural Terracottas from Etrusco-Italic Temples* (Lund, 1939–40), 324 ff.; Gjerstad (n. 3), IV, 452–92.
8. Gjerstad (n. 3), III, Fig. 129.
9. Andrén (n. 7), CXIX, 409, Figs. 13–14.
10. The function of this statue is discussed by L. A. Holland, *AJA*, 60, 1956, 243–7.
11. Sacking of Veii: Livy, V. xxii. 3–8; Volsinii: Pliny, *NH*, XXXIV. 34; Syracuse: Livy, XXV. xl. 1–3; Tarentum: Livy, XXVII. xvi. 7; Corinth: Strabo, VIII. vi. 23.
12. For early Roman town-planning: J. B. Ward-Perkins, *Cities of Ancient Greece and Italy* (London, 1974), 27 ff. For Cosa: F. E. Brown, *Cosa I, History and Topography*, MAAR, XX, Rome, 1951; *id.*, *Cosa, The Making of a Roman Town* (Ann Arbor, 1980).
13. For Etruscan engineering skills: J. B. Ward-Perkins in M. Renard (ed.), *Hommages à A. Grenier* (Brussels, 1962), 1636 ff.
14. For a recent discussion of the origin of the basilica: J. J. Coulton, *The Architectural Development of the Greek Stoa* (Oxford, 1976), 180–3.
15. Cossutius: Vitruvius, VII. *praef.* 15. For the building history of the temple: Wycherley, *Greek, Roman and Byzantine Studies*, 5, 1964, 161–79; Abramson, *California Studies in Classical Antiquity*, 7, 1974, 1–25.
16. For a discussion of the First Style at Pompeii, with special reference to the House of the Faun: A. Laidlaw, in B. Andreae and H. Kyrieleis (eds.), *Neue Forschungen in Pompeji* (Recklinghausen, 1975), 39–45. For the Greek antecedents: Bruno, *AJA*, 73, 1969, 305–17.
17. M. H. Crawford, *Roman Republican Coinage* (Cam-

bridge, 1974), 273–5, no. 242.1, Pl. XXXVI.

18. Canopic urns: Brendel (n. 6), 106–9, 129–32; R. D. Gempeler, *Die etruskischen Kanopen* (Einsiedeln, 1974).

19. A. C. Brown, *Ancient Italy before the Romans* (Oxford, 1980), Plate 42.

20. Andrén (n. 7), 350–60, Fig. 34 and Plates 110–12.

21. Brendel (n. 6), 416.

22. D. E. Strong, *Roman Imperial Sculpture* (London, 1961), 88, Fig. 13.

23. H. H. Scullard, *The Etruscan Cities and Rome* (London, 1967), Pl. 46; M. Sprenger and G. Bartoloni, *Die Etrusker* (Munich, 1977), Pl. 226. The painting has been dated to the second half of the fourth century BC.

24. Lucanian paintings: M. Napoli, *Paestum* (Novara, 1970), 60, 62–3; *Enc.*, Suppl. 1970, 'Paestum', 574–6.

25. Brendel (n. 6), Figs. 275–7; T. Dohrn, *Die ficoronische Ciste* (Berlin, 1972).

CHAPTER TWO *Architecture*

1. For annotated text and translation, see P. A. Brunt and J. M. Moore, *Res Gestae Divi Augusti* (Oxford, 1967); and translation in N. Lewis and M. Reinhold, *Roman Civilization, Sourcebook II: The Empire* (New York, 1966), 9–19.

2. D. E. Strong and J. B. Ward-Perkins, *PBSR*, XXVIII, 1960, 7–32.

3. Various recipes for mortar are given by such writers as Pliny, Vitruvius and Faventinus; for comparison of the last two, see H. Plommer, *Vitruvius and Later Roman Building Manuals* (Cambridge, 1973), 18 ff. For detailed studies of Roman construction methods and materials, see Bibliography.

4. The rebuilding is mentioned by Livy, XLI. xxvii. 8. Both the date and the identification of the surviving remains have been disputed: A. Boëthius, *Etruscan and Early Roman Architecture* (Harmondsworth, 1978), 128–9 and 231, note 7, for further references.

5. R. Delbrueck, *Hellenistische Bauten in Latium* (Strasbourg, 1907–12).

6. D. E. Strong and J. B. Ward-Perkins, *PBSR*, XXX, 1962, 1–30, at p. 25.

7. F. W. Shipley, *Agrippa's Building Activities in Rome* (St Louis, 1933).

8. Domus Transitoria: M. Barosso, *Atti del III Congresso nazionale di storia dell'architettura* (Rome, 1941), 75–8; A. Boëthius and J. B. Ward-Perkins, *Etruscan and Roman Architecture* (Harmondsworth, 1970), 212–4. Domus Aurea: A. Boëthius, *The Golden House of Nero* (Ann Arbor, 1960).

9. For arguments against vaulting, see Boëthius and Ward-Perkins (n. 8), 232 and 566, note 14, and J. B. Ward-Perkins, *Roman Architecture* (New York, 1977), 112; for the contrary view: W. L. MacDonald, *The Architecture of the Roman Empire*, I (New Haven and London, 1965), 56–63, and G. Wataghin Cantino, *La Domus Augustana* (Turin, 1966), 66–9.

10. F. Rakob, *Gnomon*, XXXIII, 1961, 243–50. Study of the brickstamps has distinguished two major phases of Hadrianic building: AD 118–25 (including the Maritime Theatre) and 125–33 (including the Piazza d'Oro): H. Bloch, *I bolli laterizi e la storia dell'edilizia romana* (Rome, 1947), 102–17.

11. Bloch (n. 10), 102–17. There is a useful discussion in MacDonald (n. 9) to add to the principal monograph K. de Fine Licht, *The Rotunda in Rome. A Study of Hadrian's Pantheon* (Copenhagen, 1966). Also see W. L. MacDonald, *The Pantheon. Design, Meaning, and Progeny* (London, 1976).

12. Boëthius and Ward-Perkins (n. 9), 257, mistakenly give the number of coffers in each row as forty: corrected in Ward-Perkins (n. 9), 140, in making the point about the rhythmical variation.

13. G. P. Panini's painting of the Pantheon in the State Museum of Art, Copenhagen, shows the interior as it was in about 1749, just before Pope Benedict XIV's alterations. See Licht (n. 11), 107, Fig. 115 (colour).

14. The absence of the detailed study which the Market deserves is mitigated by the perceptive summaries of MacDonald (n. 9), 75–93, and Ward-Perkins (n. 9), 124–33.

15. A. Carandini and S. Settis, *Schiavi e padroni nell'Etruria romana* (Bari, 1979).

16. F. E. Brown, E. H. Richardson and L. Richardson, Jr., *Cosa II, The Temples of the Arx*, MAAR, XXVI, Rome, 1960), 206 ff.

17. Brown, Richardson and Richardson (n. 16), 269 and 296–300; G. Carettoni, *Rendiconti*, 44, 1972, 123–39.

18. For the use of terracotta architectural ornament in the West, see T. F. C. Blagg in A. McWhirr (ed.), *Roman Brick and Tile*, BAR Int. Ser., 68 (Oxford, 1979), 267–84.

19. H. Kammerer-Grothaus, *Röm. Mitt.*, 81, 1974, 131–252; M. Lyttelton and F. Sear, *PBSR*, XLV, 1977, 227–51.

20. G. Lugli, *La tecnica edilizia romana* (Rome, 1957), Pls. cxlvii-cl.

21. R. Gnoli, *Marmora romana* (Rome, 1971). For a bibliography of work on classical marbles, see S. Paton, *PBSR*, XXXIX, 1971, 88–9.

22. B. Cunliffe, *Excavations at Fishbourne 1961–69*, Research Reports 26 and 27 of The Society of Antiquaries of London (Leeds, 1971), ii, 1–35.

23. D. E. Strong, 'The Monument', in B. W. Cunliffe (ed.), *Fifth Report on the Excavations of the Roman Fort at Richborough, Kent*, Research Report 23 of The Society of Antiquaries of London (London, 1968), 40–73.

24. D. E. Strong, *JRS*, LIII, 1963, 73–84.

25. Strong and Ward-Perkins (n. 6), 18–25.

26. Discussed by D. E. Strong, *PBSR*, XXI, 1953. See also, P. H. von Blanckenhagen, *Flavische Architektur und ihre Dekoration* (Berlin, 1940), and C. F. Leon, *Die Bauornamentik des Trajansforums* (Vienna and Cologne, 1971).

27. One pioneering study of provincial architectural

ornament is H. Kähler, *Die Römischen Kapitelle des Rheingebiets* (Berlin, 1939).

28. *ILS* 5317.

29. *CIL* 2. 761.

30. Plommer (n. 3).

31. R. Amy and P. Gros, *La Maison Carrée de Nîmes*, Supplement XXXVIII to *Gallia* (Paris, 1979), 85–108.

32. Strong and Ward-Perkins (n. 2).

33. Boëthius and Ward-Perkins (n. 8), 379–81.

34. Strong (n. 26), 130–8.

35. M. F. Squarciapino, *Sculture del Foro Severiano di Leptis Magna*, Monografie di archeologia libica, 10 (Rome, 1974), 167–70; see also J. B. Ward-Perkins, *JRS*, XXXVIII, 1948, 59–80.

36. J. B. Ward-Perkins, *JRS*, LX, 1970, 1–19; and, for the Romano-British forum, R. G. Goodchild, *Antiquity*, XX, 1946, 70–7.

37. B. Cunliffe, *Roman Bath*, Research Report 24 of The Society of Antiquaries of London, (Oxford, 1969).

38. K. M. Kenyon, *Archaeologia*, LXXXIV, 1934, 247–53.

39. C. Hill, M. Millett and T. Blagg, *The Roman Riverside Wall and Monumental Arch in London*, London and Middlesex Arch. Soc. special paper 3 (London, 1980).

40. Ward-Perkins (n. 36).

41. T. F. C. Blagg, *World Archaeology*, 12.1 1980, 27–42, contrasts civilian and military architecture in Britain.

42. It has been claimed that it was built for the Emperor Maximian, but the mosaics, now datable to 315–40 AD, make this unlikely: A. Carandini, in his forthcoming publication, assembles epigraphic evidence to suggest that the owner might have been the nobleman C. Valerius Proculus.

43. J. M. C. Toynbee, *Death and Burial in the Roman World* (London, 1971), illustrates the great variety of Roman funerary monuments.

CHAPTER THREE *Sculpture*

For bronze figurines embellished with precious metals, gold and silver statuary and miniature sculpture in other materials see Chapter Six.

1. M. A. R. Colledge, *The Art of Palmyra: Studies in Ancient Art and Archaeology* (London, 1976); id., *Parthian Art* (London, 1977).

2. H. Rolland, *Le Mausolée de Glanum*, Supp. XXI to *Gallia* (Paris, 1969); F. S. Kleiner, 'The Glanum Cenotaph Reliefs, Greek or Roman?', *Bonner Jahrbücher*, 180, 1980, 105–25; R. Amy, P. M. Duval, J. Formigé, J. J. Hatt, A. Piganiol, C. Picard, R. G. Picard, *L'arc d'Orange* (Supp. XV to *Gallia*, Paris, 1962).

3. See L. Rossi, *Trajan's Column and the Dacian Wars* (London, 1971); F. B. Florescu, *Monumentul de la Adamklissi* (Bucharest, 1959) and L. Rossi, *Arch. J.*, CXXIX, 1972, 56–67.

4. R. Bianchi Bandinelli, *Rome: The Centre of Power*, *Roman Art to AD 200* (London, 1970), 28–32.

5. G. Zinserling, *Eirene*, 1, 1960, 153–86.

6. H. Kähler, *Der Fries vom Reiterdenkmal des Aemilius Paullus in Delphi* (Berlin, 1965), 17–18.

7. H. Kähler, *Seethiasos und Census. Die Reliefs aus dem Palazzo Santa Croce in Rom* (Berlin, 1966); F. Coarelli, *Dialoghi di Archeologia*, 3, 1969, 1–67.

8. G. Moretti, *Ara Pacis Augustae* (Rome, 1948); J. M. C. Toynbee, *Proceedings of the British Academy*, 39, 1953, 67–95.

9. I. S. Ryberg, *Rites of the State Religion in Roman Art*, *MAAR*, XXII, 1955, 75–80; G. Lippold, *Die Skulpturen des Vaticanischen Museums*, III, 2 (Berlin, 1956), 505–12, Pls. 229–33.

10. F. Magi, *I Rilievi Flavi del Palazzo della Cancelleria* (Rome, 1945); J. M. C. Toynbee, *The Flavian Reliefs from the Palazzo della Cancelleria* (Oxford, 1957); A. M. McCann, *Röm. Mitt.*, 79, 1972, 249–76, attempts a highly controversial re-dating of the reliefs.

11. F. Wickhoff, *Roman Art* (English edition translated by E. Strong; London, 1900).

12. A detailed, comprehensive study of the reliefs is still lacking. Cf. A. Bonanno, *Portraits and Other Heads on Roman Historical Relief up to the Age of Septimius Severus*, BAR Int. Ser., 6 (Oxford, 1976), 62–8; F. Magi, *Röm. Mitt.*, 84, 1977, 331–47.

13. F. J. Hassel, *Der Trajansbogen in Benevent: ein Bauwerk des römischen Senates* (Mainz, 1966): M. Rotili, *L'Arco di Traiano a Benevento* (Rome, 1972).

14. The Column has been published in several monumental editions, see especially C. Cichorius, *Die Reliefs der Trajanssäule* (Berlin, 1896–1900); and K. Lehmann-Hartleben, *Die Trajanssäule* (Berlin and Leipzig, 1926). Later bibliography in L. Rossi, *Trajan's Column and the Dacian Wars* (London, 1971).

15. M. Pallottino, *Bullettino della Commissione Archeologica Comunale di Roma*, 66, 1938, 17–56; W. Gauer has attempted to return to a Domitianic dating in *JDAI*, 88, 1973, 318–50, Figs. 1–13.

16. H. Bulle, *JDAI*, 34, 1919, 144–72; I. Maull, *Jahreshefte des oester. arch. Instituts*, 42, 1955, 53–67.

17. W. Helbig, *Führer durch die öffentlichen Sammlungen klassischer Altertümer in Rom*, II (Tübingen, 1966), 264–5, 569–70, nos. 1447, 1800.

18. L. Vogel, *The Column of Antoninus Pius* (Cambridge, Mass., 1973).

19. There is some disagreement on the date of the relief. C. C. Vermeule, *Roman Imperial Art in Greece and Asia Minor* (Cambridge, Mass., 1968), 95–123, Figs. 33–52, dates it around AD 140. E. Eichler, *Jahreshefte des oester. arch. Instituts*, Beihefte II (1971), 102–35, Figs. 1–33, believes it was made after the Parthian campaigns of AD 161–5.

20. I. S. Ryberg, *Panel Reliefs of Marcus Aurelius* (New York, 1967); G. Becatti, *Archeologia Classica*, 19, 1967, 321–31.

21. C. Caprino, A. M. Colini, G. Gatti, M. Pallottino, P. Romanelli, *La Colonna di Marco Aurelio* (Rome, 1955).

22. R. Bartoccini, *Africa Italiana*, 4, 1931, 32–152; V. M.

Strocka, *Antiquités Africaines*, 6, 1972, 147–72.

23. D. E. L. Haynes and P. E. D. Hirst, *Porta Argentariorum (British School at Rome Supplement)* (London, 1939); M. Pallottino, *L'Arco degli Argentari* (Rome, 1946).

24. The most recent and by far the most comprehensive edition of the Arch and its reliefs is R. Brilliant, *The Arch of Septimius Severus in the Roman Forum*, MAAR, XXIX, 1967.

25. H. P. L'Orange, *Röm. Mitt.*, 53, 1938, 1–34.

26. H. P. Laubscher, *Der Reliefschmuck des Galeriusbogens in Thessaloniki* (Berlin, 1975).

27. H. P. L'Orange and A. Von Gerkan, *Spätantike Bildschmuck des Konstantinsbogen* (Berlin, 1936); A. Giuliano, *Arco di Costantino* (Milan, 1955).

28. A. N. Zadoks-Josephus Jitta, *Ancestral Portraiture in Rome and the Art of the Last Century of the Republic* (Amsterdam, 1932); R. Bianchi Bandinelli, 'Ritratto', *Enc.* VI, 695–738; *id.*, *Rome: the Centre of Power* (London, 1970), 75–93; G. M. A. Richter, *JRS*, XLV, 1955, 39–46; J. D. Breckenridge, *ANRW*, I, 4 (Berlin and New York, 1973), 826–54; R.R.R. Smith, *JRS*, LXXI, 1981, 24–38, has made a strong case for Hellenistic antecedents to the veristic style.

29. H. Kähler, *Die Augustusstatue von Primaporta* (Cologne, 1959).

30. V. H. Poulsen, *Acta Archaeologica*, 17, 1946, 1–48; *id.*, *Claudische Prinzen* (Baden-Baden, 1960); Z. Kiss, *L'iconographie des princes julio-claudiens au temps d'Auguste et de Tibère (Travaux du Centre d'Archéologie Méditerranéenne de l'Académie Polonaise des Sciences)* 17 (Warsaw, 1975).

31. M. Wegner, *Die Flavier. Das römische Herrscherbild*, II, 1 (Berlin, 1966).

32. W. H. Gross, *Bildnisse Trajans*, (Berlin, 1940).

33. On Hadrian's portraiture see M. Wegner, *Hadrian. Das römische Herrscherbild*, II, 3 (Berlin, 1956). For private portraiture in the same period see G. Daltrop, *Die städtromischen männlichen Privatbildnisse trajanischer und hadrianischer Zeit* (Münster, 1958).

34. G. M. A. Richter, *Portraits of the Greeks* (London, 1965), I, 102–14, Figs. 429–43; M. Robertson and A. Frantz, *The Parthenon Frieze* (London, 1975), Plate 16.

35. C. W. Clairmont, *Die Bildnisse des Antinous. Ein Beitrag zur Porträtplastik unter Kaiser Hadrian* (Rome, 1966).

36. M. Wegner, *Die Herrscherbildnisse in Antoninischer Zeit. Das römische Herrscherbild*, II, 4 (Berlin, 1939).

37. A. M. McCann, *The Portraits of Septimius Severus*, MAAR, XXX, 1968; D. Soechting, *Die Porträts des Septimius Severus* (Bonn, 1972).

38. H. B. Wiggers and M. Wegner, *Caracalla bis Balbinus. Das römische Herrscherbild*, III, 1 (Berlin, 1971); B. M. Felletti Maj, *Iconografia imperiale da Severo Alessandro a M. Aurelio Carino (222–285 dC)* (Rome, 1958).

39. Foremost, amongst others, R. Bianchi Bandinelli, 'Ritratto', *Enc.* VI, 729; *id.*, *Rome: The Late Empire, Roman Art AD 200–400* (London, 1971), 1–21, 42.

40. R. Delbrück, *Spätantike Kaiserporträts* (Berlin, 1933); H. P. L'Orange, *Studien zur Geschichte des spätantiken Porträts* (Oslo and Leipzig, 1933); *id.*, *Art Forms and Civic Life in the Late Roman Empire* (Princeton, 1965).

41. Exhibition, Venice 1977, London 1979. See G. Perroco (ed.), *The Horses of San Marco*, Venice (London, 1979).

42. W. Lamb, *Greek, Etruscan and Roman Bronzes* (London, 1929), re-edited, with updated bibliography, with the title *Ancient and Roman Bronzes* (Chicago, 1969); S. Boucher (ed.), *Actes du IV^e Colloque internationale sur les bronzes antiques (17–21 mai 1976)*, Annales de l'Université Jean-Moulin (Lyons, 1977).

43. S. Boucher, *Recherches sur les Bronzes Figurés de Gaule Pré-Romaine et Romaine* (École Française, Rome, 1976).

CHAPTER FOUR *Wall Painting and Stucco*

1. A. Barbet and C. Allag, *Mélanges de l'école française de Rome*, LXXXIV, 1972, 935–1063. D. Strong and D. Brown (eds.), *Roman Crafts* (London, 1976), 223–9.

2. S. Augusti, *I Colori Pompeiani* (Rome, 1967), 15–16.

3. J. M. C. Toynbee, *The Art of the Romans* (London, 1968), 111–12.

4. M. Borda, *La Pittura Romana* (Milan, 1958), 159.

5. A. Mau, *Pompeii, Its Life and Art* (trans. F. W. Kelsey, London, 1899), 41–4, 446–60.

6. G. E. Rizzo, *Le Pitture della Casa dei Grifi* (Rome, 1936).

7. R. Ling, *PBSR*, XL, 1972, 28–9.

8. A. Maiuri, *La Villa dei Misteri* (Rome, 1929); K. Lehmann, *JRS*, LII, 1962, 62–8; Toynbee (n. 3), 110–11; Borda (n. 4) 24–30.

9. P. W. Lehmann, *Roman Wall Paintings from Boscoreale in the Metropolitan Museum of Art* (Cambridge, Mass., 1953).

10. Borda (n. 4), 43–6.

11. D. Strong, *Roman Art* (Harmondsworth, 1976), 51; Borda (n. 4) 46–52; E. Wadsworth, *MAAR*, IV, 1928, Pls. I–IX.

12. Borda (n. 4), 57.

13. *The Villa of Oplontis* (guide-book; Mestre–Venice, 1980), 29–32; cf. O. Elia, *Pittura di Stabia* (Naples, 1957), 47, Pl. XIX (woman cithara player from Stabiae).

14. Borda (n. 4), 59.

15. Toynbee (n. 3), 119–20; G. M. A. Richter, *Perspective in Greek and Roman Art* (London [1970]), 49–55.

16. Toynbee (n. 3), 119–20; W. J. Th. Peters, *Mededelingen van het Netherlands Instituut te Rome*, XXXIX, 1977, 95–128.

17. Borda (n. 4), 80.

18. *Ibid.*, 83.

19. *Ibid.*, 254–6.

20. Maiuri (n. 8) 66–9; M. M. Gabriel, *Masters of Campanian Painting* (New York, 1952).

21. Elia (n. 13), 47, Pl. XIX.

22. *Ibid.*, 14; W. Dorigo, *Late Roman Painting* (London, 1971) 40–6.
23. Borda (n. 4), 67.
24. Strong (n. 11), 69–70, 100; Toynbee (n. 3), 120; Borda (n. 4), 70–5.
25. Toynbee (n. 3) 113–15; Strong (n. 11), 34–5.
26. R. Ling, *JRS*, LXVII, 1977, 1–16; S. Silberberg-Peirce, *Art History*, III, 1980, 241–51.
27. Ling (n. 24), 7.
28. P. H. von Blanckenhagen and C. Alexander, *The Paintings from Boscotrecase* (Heidelberg, 1962).
29. M. M. Gabriel, *Livia's Garden Room at Prima Porta* (New York, 1955).
30. W. F. Jashemski, *The Gardens of Pompeii* (New York, 1979), 74.
31. *Ibid.*, 63.
32. Wadsworth (n. 11), 61, Pl. XVII.
33. *Ibid.*, 69, Pls. XX–XXIV.
34. *Ibid.*, 73, Pls. XXV–XXXV; Borda (n. 4), 102, Pl. opp. p. 96.
35. R. Meiggs, *Roman Ostia* (Oxford, 2nd edn. 1973), 436–46.
36. *Ibid.*, 442; Toynbee (n. 3), 123.
37. In the Palatine Museum, Borda (n. 4), 301; Dorigo (n. 22), Pl. XLVIII.
38. Toynbee (n. 3), 123; Borda (n. 4), 321.
39. Meiggs (n. 35), 443.
40. Borda (n. 4), 319; M. J. Vermaseren, *Mithriaca*, I, *The Mithraeum at S. Maria Capua Vetere* (Leiden, 1971).
41. Borda (n. 4), 299.
42. M.J. Vermaseren and C.C. Van Essen, *The Excavations in the Mithraeum of the Church of Santa Prisca in Rome* (Leiden, 1965), 148–240; Borda (n. 4), 319.
43. J. B. Onians, *Art History*, III, 1980, 1–22.
44. J. M. C. Toynbee and J. Ward-Perkins, *The Shrine of St. Peter and the Vatican Excavations* (London, 1956), 109–17; Sister Charles Murray, *Rebirth and Afterlife*, BAR Int. Ser., 100 (Oxford, 1981), especially 60–3 and Chapter III; M. Gough, *Origins of Christian Art* (London, 1981), Chapter II.
45. J. Goodenough, *Journal of Biblical Literature*, LXXXI, 1962, 113–42.
46. Dorigo (n. 22), 120–2; Borda (n. 4), 316.
47. Borda (n. 4), 132, 134.
48. Meiggs (n. 35), 552.
49. Borda (n. 4), 138.
50. *Ibid.*, 343–6.
51. Dorigo (n. 22), 223.
52. A. Carandini, *Schiavi e Padroni nell'Etruria Romana: La Villa di Sette Finestre dallo Scavo alla Mostra* (Bari, 1979).
53. H. Kenner, in R. Egger, *Carinthia I*, no. 153, 1963, 62; no. 156, 1966, 435 and in H. Vetters and G. Piccottini (eds.), *Magdalensberg-Grabungsbericht, 14, 1973–4* (Klagenfurt, 1980), 143.
54. A. Barbet, *Recueil Général des Peintures Murales de la Gaule, I, Narbonnaise, i, Glanum* (Paris, 1974), 43–64.
55. *Id.*, *Étude sur la décoration des édifices de la Gaule romaine* (Paris, 1973); *id.*, in J. Liversidge (ed.), *Roman Provincial Wall Painting of the Western Empire* BAR Int. Ser. 140 (Oxford, 1982).
56. R. Sanquier and P. Galliou, *Annales de Bretagne*, LXVII, 1970, 180–3; LXXIX, 1972, 170–89. I am indebted to Professor Galliou for this reference.
57. A. Blanchet, *Étude sur la décoration des édifices de Gaule romaine* (Paris, 1913), 49–51, Pl. II.
58. J. Liversidge in J. Munby and M. Henig, *Roman Life and Art in Britain*, BAR 41 (Oxford, 1977), 79–80; *Britain in the Roman Empire* (London, 1968), 94–9; full report in S. S. Frere, *Verulamium* III (London, forthcoming).
59. B. Cunliffe, *Excavations at Fishbourne 1961–1969*, II, *The Finds*, (Leeds, 1971), 57, no. 2, Pl. XIVa.
60. Liversidge in Munby and Henig (n. 58), 80–1, 84–90, 95–6; E. J. Swain and R. J. Ling, *Britannia*, XII, 1981, 167–75.
61. G. W. Meates, *Lullingstone Roman Villa* (London, 1955), 126–53; J. Liversidge in G. W. Meates, *The Roman Villa at Lullingstone*, II (forthcoming).
62. M. Schleirmacher, in J. Liversidge (ed.) *Roman Provincial Wall Painting of the Western Empire* BAR Int. Ser. 140 (Oxford, 1982).
63. Dorigo (n. 22), 198–203; T. K. Kempf, 'Das Haus der heiligen Helena', *Neues Trier. Jahrb.* (Trier, 1978).
64. Dorigo (n. 22), 51–2; S. Aurigemma, *L'Italia in Africa – Tripolitania* I *I Monumenti d'Arte Decorativa*, Part II, *Le Pitture d'Età Romana* (Rome, 1962), 29.
65. Aurigemma (n. 64), 103–11.
66. *Ibid.*, 84–6; Dorigo (n. 22), 208–9.
67. Aurigemma (n. 64), 95–8; Toynbee (n. 2), 121; Borda (n. 4), 349.
68. V. Monneret de Villard, *Archaeologia*, XCV, 1953, 85–105.
69. Toynbee (n. 2), 125–7; Borda (n. 4), 331–2; Strong (n. 11), 131–2.
70. Dorigo (n. 22), 86–100; A. Perkins, *The Art of Dura-Europos* (Oxford, 1973), Chapters III and V; C. Kraeling, *Excavations at Dura-Europos*, VIII, 1, *The Synagogue* (New Haven, 1956), 10. For a shield from Dura decorated with paintings of Amazons, and another showing the Sack of Troy, see M. I. Rostovtzeff, F. E. Brown and C. B. Welles, *The Excavations at Dura-Europos, Preliminary Report of the Seventh and Eighth Seasons of Work* (New Haven, 1939) 326–69; also Borda (n. 4), 356.
71. Toynbee (n. 3), 129.
72. A. F. Shore, *Portrait Painting from Roman Egypt* (London, 1962), 26–8; G. Sokolov, *Antique Art on the Northern Black Sea Coast* (Leningrad, 1974), Ill. p. 110; and Richter, *Perspective in Greek and Roman Art* (London [1970]), 53, Fig. 219; Borda (n. 4), 387.

CHAPTER FIVE *Mosaics*

1. This is the 'direct method'. See, further, P. Fischer, *Mosaic: History and Technique* (New York and Toronto, 1971), 141 ff. On evidence for other methods in antiquity, including prefabrication, see

the references in n. 12; D. S. Neal, Ch. 19 in D. Strong and D. Brown (eds.), *Roman Crafts* (London, 1976).

2. Cf. M. E. Blake, *MAAR*, VIII, 1930 (hereafter cited as Blake I), 128; K. M. D. Dunbabin, *AJA*, 83, 1979, 265–77.

3. K. M. Phillips, *The Art Bulletin*, 42, 1960, 243–62. Cf. W. A. Daszewski in H. Maehler and V. M. Strocka (eds.), *Das Ptolemäische Ägypten* (Mainz, 1978), 123–36.

4. The most important site for mosaics of *c*.100 BC is Delos: Ph. Bruneau, *Les Mosaïques de Délos* (Paris, 1972).

5. For the history, relationship and significance of these subjects see K. Parlasca, *JDAI*, 78, 1963, 256–93. Cf. Blake I (n. 2), 129–31; D. Levi, *Antioch Mosaic Pavements* (Princeton, London, The Hague, 1947), 90–1; J. Charbonneaux, R. Martin and F. Villard, *Hellenistic Art 330–50 BC* (London, 1973), 156–7, Figs. 156, 158; K. M. D. Dunbabin, *The Mosaics of Roman North Africa* (Oxford, 1978), 3–4, nn. 16, 18.

6. For example the 'Alexander mosaic' from Pompeii (5.92 × 3.42 m. [19½ × 11¼ ft.] including borders), a masterpiece of the later second century BC, undoubtedly reproduces a famous Greek painting of *c*.300 BC (lost but mentioned by the elder Pliny, *NH*, XXXV. 110); the two mosaics of *c*.80 BC at Palestrina (Praeneste) also follow Hellenistic paintings. For the 'Alexander mosaic' see B. Andreae, *Das Alexandermosaik* (Bremen, 1959); also Charbonneaux *et al.* (n. 5), 116–18, Figs. 115–16 (colour), 117. For the mosaics of Palestrina see G. Gullini, *I Mosaici di Palestrina* (Rome, 1956); H. Whitehouse, *The Dal Pozzo Copies of the Palestrina Mosaic*, BAR Int. Ser., 12 (Oxford, 1976); also Charbonneaux *et al.*, 176–83, Figs. 182–6 (colour), 181, 188, and Hanfmann (n. 18), Pl. XXVI (colour).

7. Cf. M. E. Blake, *MAAR*, XVI, 1940 (hereafter cited as Blake III), 101–19; J.M.C. Toynbee, *The Art of the Romans* (1965), 180, n. 15.

8. Cf. Blake I (n. 2), 128; Charbonneaux *et al.* (n. 5), 138–42, Figs. 138–40.

9. Blake I (n. 2), 129–31. Parlasca (n. 5), 256–7, 262–6, Figs. 1, 10. Charbonneaux *et al.* (n. 5), 156, Fig. 158 (colour).

10. For one of *c*.200 BC from Egypt, apparently the earliest known, see Charbonneaux *et al.* (n. 5), 159, Fig. 162. For *emblemata* in Italy see Blake I (n. 2), 125–45, III (n. 7), and for those of Pompeii in particular see E. Pernice, *Die Hellenistische Kunst in Pompeii* VI: *Pavimente und Figürliche Mosaiken* (Berlin, 1938), 149 ff.

11. Cf. Blake I (n. 2), 140; Bruneau (n. 4), 100–1; D.E. Johnston in R. Farioli Campanati (ed.), *Atti del III Colloquio Internazionale sul Mosaico Antico* (Ravenna, forthcoming) (hereafter cited as *Atti III*).

12. Cf. Blake III (n. 7), 101–19; K. Parlasca, *Die Römischen Mosaiken in Deutschland* (Berlin, 1959),

135–40; Neal (n. 1), 244–6; Smith, *Atti III* (n. 11). Cf. Levi (n. 5), 630–2.

13. Cf. J. M. C. Toynbee, *Latomus*, 9, 1950, 295–302. See also the list, although not up to date, in *Mosaico e Mosaicisti nell'Antichità* (Istituto della Enciclopedia Italiana, Rome, 1967), compiled from the *Enciclopedia Italiana dell'Arte Antica, Classica, e Orientale* I–VII.

14. Cf. Blake I (n. 2), 127.

15. Cf. *ibid.*, 71–8.

16. R. Stillwell (ed.), *The Princeton Encyclopedia of Classical Sites* (Princeton, 1976): 'Antioch on the Orontes.'

17. The Atrium House: Levi (n. 5), 15–25, 625, Pls. I, II, a, CXLV–CXLVIII. F. Baratte, *Mosaïques Romaines et Paléochrétiennes du Musée du Louvre* (Paris, 1978), no. 43 ('The Judgement of Paris'). It should be noted that while Levi (15–16, 625) and others prefer to assign these mosaics to before AD 115, Baratte considers them to date from AD 115–(?)150, citing in support K. Parlasca, *Gnomon* 26, 1954, 112.

18. G. M. A. Hanfmann, *Roman Art* (New York, 1964), describes the 'Drinking Contest' (commentary on Pl. XXI) as 'one of the most advanced renderings of light and shadow that have come down to us from antiquity'.

19. Baratte (n. 17), 88.

20. Levi (n. 5), 15.

21. House of Polyphemus and Galatea: *ibid.*, 25, 625, Pl. II, b, c.

22. House of Trajan's Aqueduct: *ibid.*, 34, 625, Pl. V, a.

23. R. Hinks, *Catalogue of the Greek, Etruscan, and Roman Paintings and Mosaics in the British Museum* (London, 1933), 56, no. 85, Pl. XXIV.

24. *BJ*, 168, 1968, 5, Fig. 1.

25. *Les Dossiers de l'Archéologie* (Fontaine-les-Dijon, France) 15 (March-April, 1976), 95 (Sidon, Lebanon). X Barral I Altet, *Les Mosaïques Romaines et Médiévales de la Regio Laietana: Barcelona* (Barcelona, 1978), no. 8, Pls. XV–XVIII (Barcelona); on east-Mediterranean influence in this mosaic, *ibid.*, 17.

26. Levi (n. 5), Fig. 28, Pls. XV, b, XXIX, b, c, L, c.

27. *Ibid.*, 32–226.

28. House of the Calendar: *ibid.*, 36–8, 625, Pl. V, b.

29. *Ibid.*, 38–9, Pls. VI, CXLIX, a, CLXXXII, a.

30. House of the Buffet Supper: *ibid.*, 127–9, Pls. XXIII, a, XXIV, CLII, CLIII, a. Although assigned to *c*.193–235 in the Chronological List (Levi, 625) the mosaic sealed pottery of *c*.150–250 (Levi, 129).

31. House of the Drinking Contest: *ibid.*, 156–9, Pls. XXX, CI, b. Again (see n. 30), although assigned to *c*.193–235 the mosaic sealed pottery as late as *c*.250 (Levi, 156).

32. House of Dionysus and Ariadne: *ibid.*, 141–9, Pls. XXVII, a, XXVIII, CI, a, CLIV, CLV, a, CLXXIX. Levi evidently considered this pavement to be earlier than its counterpart in the House of the Drinking Contest (p.625), but at least approximate contem-

poraneity is clearly indicated by their associated geometric patterns: cf. *ibid.*, Pl. CI, a, b. In fact, Levi's otherwise encyclopaedic work is essentially a study of the figured scenes; the geometric repertory still awaits analysis and commentary in its own right, and this might lead to a reappraisal of his chronological sequence.

33. See, at least, the 'three-dimensional' dado with 'projecting' plinths in the remains of the third-century wall-painting in the House of the Consul Attalos at Pergamum: Parlasca (n. 5), 286, Fig. 18.

34. Levi (n. 5), 226–44, Pls. LII–LXI, CLX, CLXI. Baratte (n. 17), no. 45 (with frontispiece in colour illustrating part of the scroll). W. Dorigo, *Late Roman Painting* (London, 1971), colour plates 19, 20 (illustrating Spring and Autumn). It is now known that in addition to the Constantinian coin sealed by this most important pavement there was another, from which the period of the mosaic cannot be earlier than 347: S. D. Campbell, *Atti III* (n. 11).

35. For the gesture of the huntsman in the centre, foreground, see G. Amad, *Le Baiser Rituel: un Geste de Culte Méconnu* (Beirut, 1973).

36. Cf. that framing the *emblema* from Pompeii depicting the doves of Sosus: Parlasca (n. 5), 264–6, Fig. 2.

37. I. Lavin, *DOP*, 17, 1963, 180–286; but cf. Dunbabin (n. 5), 222–33.

38. Cf. Blake I (n. 2), 75, illust. (Teramo); *id.*, *MAAR*, XIII, 1936 (hereafter cited as Blake II), 133–7.

39. Cf. Blake I (n. 2), 127. For an exceptionally late example, of the third or fourth century AD, see Blake III (n. 7), 105, Pl. 22, 2 (Rome). Apart from this the latest appear to be those of *c.*200 AD from Baccano near Rome: G. Becatti *et al.*, *Baccano: Villa Romana* (Mosaici Antichi in Italia, Librería dello Stato, Rome, 1970). Cf. Levi (n. 5), 3, n. 11.

40. See n. 4.

41. Blake I (n. 2), 78–124, II (n. 38), 76–113, 138–71. G. Becatti, *MGR* I, 15–26. M. Donderer, *Atti III* (n. 11).

42. G. Becatti, *Scavi di Ostia* IV: *Mosaici e Pavimenti Marmorei* (Librería dello Stato, Rome, 1961). R. Meiggs, *Roman Ostia* (Oxford, 1960, 2nd edn., 1973), 446–54.

43. Cf. Blake I (n. 2), 127; H. Joyce, *AJA*, 83, 1979, 253–63.

44. Also elsewhere: cf. Blake I (n. 2), 80, 121, 123; Pernice (n. 10), *passim*; J. R. Clarke, *Roman Black-and-White Figural Mosaics* (New York, 1979), 7–18, Figs. 4–16.

45. Becatti (n. 42), nos. 181–7, Pl. CCXXII.

46. *Ibid.*, nos. 219–29, Pl. CCXXIV.

47. *Ibid.*, nos. 237–67, Pl. CCXXV.

48. Cf. Blake II (n. 38), 79–83.

49. Becatti (n. 42), no. 292, p.389, Pls. LXXV–LXXVIII. Clarke (n. 44), Fig. 20.

50. Becatti (n. 42), no. 293, pp. 288–9, Pl. LXXX. Clarke (n. 44), 22, Fig. 19.

51. Becatti (n. 42), no. 268, pp. 289–90, Pls. LXXXIV–LXXXVI. Clarke (n. 44), 23, Fig. 23.

52. Blake I (n. 2), 123–4, Pl. 49. Becatti (n. 42), no. 68, pp. 269–70, Pls. CXXII–CXXIII. Clarke (n. 44), Fig. 21.

53. Cf. Blake I (n. 2), 122–3, pl. 48; but note *id.*, II (n. 38), 138 and n. 2 (erroneously in n. 1), 139–45.

54. Becatti (n. 42), nos. 51, 52, p. 316, Pls. CIX, CXXIX, CXXX, CXXXIII. Clarke (n. 44), 25–6, Figs. 29, 30, 80.

55. Becatti (n. 42), no. 64, pp. 297–300, Pls. XVII, CVII, CVIII. Clarke (n. 44), 24–5, Fig. 27.

56. Blake II (n. 38), 145–6, Pl. 34, 3, 4. Becatti (n. 42), nos. 70, 71, pp. 310–16, Pls. CXXIV–CXXX, CXXXIII–CXXXVI. Clarke (n. 44), 26–9, Figs. 31–3.

57. Cf. Blake II (n. 38), 139–54: 'The Marine Cycle'; Becatti (n. 42), 310–16. The latest examples at Ostia are Becatti (n. 42), no. 320, pp. 342–4, Pls. CLXIV–CLXV (Baths of the Lighthouse, *c.*250), no. 445, Pl. CLXX (*c.*250–300).

58. Cf. Blake I (n. 2), 71–95, II (n. 38), 114–37, 172–84; G. Becatti, *MGR* II, 173–90 and discussion, 190–2.

59. Becatti (n. 42), no. 283, pp. 295–6, Pls. CIII, CIV, CCXII, CCXIII.

60. Blake III (n. 7), 108, Pl. 24, 2. Becatti (n. 42), no. 313, Pl. CIV.

61. Blake II (n. 38), 130. Becatti (n. 42), no. 315, Pl. CII.

62. Becatti *et al.* (n. 39), no. 25, Pls. XIX, XX.

63. Cf. Lavin (n. 37), 244–62; Dunbabin (n. 5), 212–22.

64. G. Brusin, P. L. Zovatto, *Monumenti Paleocristiani di Aquileia e di Grado* (Udine, 1957), 105–11, Figs. 25, 47, 48; R. Bianchi Bandinelli, *Rome: the Late Empire – Roman Art AD 200–400* (London, 1971), Fig. 216 (colour).

65. Becatti (n. 42), no. 217, pp. 360–1, Pls. CXXXIX–CLIII, CCXIV–CCXVI. Lavin (n. 37), Fig. 119.

66. Cf. Lavin (n. 37), 204–44; Bandinelli (n. 64), 223–37. Dunbabin (n. 5), 16–23. *Dossiers de l'Archéologie* (n. 25), 31 (Nov.-Dec., 1978): 'Mosaïque Romaine: l'Age d'Or de l'École d'Afrique.'

67. *Princeton Encyclopedia* (n. 16): 'Zliten.' S. Aurigemma, *I Mosaici di Zliten* (Rome, Milan, 1926). Lavin (n. 37), 206–10, Figs. 18–23. G. Ville, *MGR* I (n. 41), 147–52. Dunbabin (n. 5), 17, 18, 234–7, Figs. 1, 2, 46–9, 95, 96. For *emblemata* in a mosaic at Homs see Lavin (n. 37), 207, Fig. 22.

68. Dunbabin (n. 5), 19, Figs. 3–5. *Dossier 31* (n. 66), 17–18.

69. Dunbabin (n. 5), 19–23. G. Charles-Picard, *Dossier 31* (n. 66), 12–31.

70. Dunbabin (n. 5), 20, 110, 254, Figs. 97–8.

71. *Ibid.*, 179–80, 256, Figs. 178–9.

72. Levi (n. 5), 529–60, Fig. 199. J. Lassus, *MGR* I (n. 41), 175–89, Fig. 8. Dunbabin (n. 5), 21, n. 35.

Dossier 31 (n. 66), 93, 95–6.

73. There seem to be more than is generally conceded: e.g. cf. Hinks (n. 23), 72, nos. 11, 12 (Carthage); Lavin (n. 37), 253, n. 315; M. A. Alexander, M. Ennaïfer, *Corpus des Mosaïques de Tunisie* I: *Utique* (Tunis, 1973), *passim*; C. Dulière *et al.*, *Corpus ... Tunisie* II: *Utique* (Tunis, 1974), *passim*; M. A. Alexander *et al.*, *Corpus ... Tunisie* III: *Utique* (Tunis, 1976), *passim*; Dunbabin (n. 5), 16–17, 18, n. 25, 21, n. 33, 109, n. 5; *Dossier* 31 (n. 66), *passim*; R. Hanoune, *Atti III* (n. 11).

74. G. Picard, *MGR* I (n. 41), 125–32, and discussion, 133–4. S. Gozlan, *Dossier* 31 (n. 66), 68–75.

75. L. Foucher, *La Maison de la Procession Dionysiaque à El Jem* (Paris, 1963), 62–3, 90–6, Pl. XVIII. Dunbabin (n. 5), 260, no. 27 (c) (i). *Dossier* 31 (n. 66), 48–9, 51.

76. M. Wheeler, *Roman Art and Architecture* (London, 1964), Fig. 73. Cf. Blake III (n. 7), 101, n. 139, 116, n. 257.

77. Lavin (n. 37), 230–1, Fig. 75. Dunbabin (n. 5), 51–2, 112–13, Fig. 101. *Dossier* 31 (n. 66), 22–4, 25.

78. P. Romanelli, *MGR* I (n. 41), 275–83.

79. Dunbabin (n. 5), 93–4, n. 18, 113–14, n. 21, 270, no. 13 (c), Fig. 81 (fragment).

80. *Pace* Dunbabin (n. 5), 114.

81. Dunbabin (n. 5), 184, 263, Fig. 183.

82. Bandinelli (n. 64), 233, Fig. 215. Dunbabin (n. 5), 181–2, 269, no. 12 (d), Fig. 182. *Dossier* 31 (n. 66), 47 (colour).

83. Bruneau (n. 4), 242–5 (no. 214), Figs. 182–3.

84. S. Germain, *Les Mosaïques de Timgad* (Paris, 1969), *passim; id.*, *Dossier* 31 (n. 66), 103–7. Cf. Lavin (n. 37), 216–8, Figs. 45–51.

85. Hinks (n. 23), 89, no. 29, Fig. 99, Pl. XXIX. Dunbabin (n. 5), 121, Fig. 110.

86. Dunbabin (n. 5), 38–45.

87. *Ibid.*, 46–64. M. Ennaïfer, *Dossier* 31 (n. 66), 80–92. Bandinelli (n. 64), Figs. 230, 231.

88. Dunbabin (n. 5), 65–108. A. Beschaouch, *Dossier* 31 (n. 66), 32–6. H. Slim, *Dossier* 31, 48–54.

89. Dunbabin (n. 5), 109–23. Bandinelli (n. 64), Fig. 239 (colour).

90. Dunbabin (n. 5), 123–4.

91. *Ibid.*, 125–30. Bandinelli (n. 64), 234, Fig. 217.

92. Dunbabin (n. 5), 124–5. Bandinelli (n. 64), Fig. 214.

93. J. Lassus, *MGR* I (n. 41), 175–89. Dunbabin (n. 5), 154–8. Bandinelli (n. 64), 225–6, Fig. 210.

94. Baratte (n. 17), no. 6. Dunbabin (n. 5), 158, n. 114. *Dossier* 31 (n. 66), 76–8.

95. Foucher (n. 75). Bandinelli (n. 64), 233, Fig. 215. Dunbabin (n. 5), 173–87. L. Foucher, *Dossier* 31 (n. 66), 37–47.

96. Cf. Bandinelli (n. 64), Figs. 219, 220 (colour); Dunbabin (n. 5), *passim*; Beschaouch (n. 88), *passim*; Ennaïfer (n. 87), *passim*.

97. Dunbabin (n. 5), 49, Fig. 22.

98. *Ibid.*, 50, 60. Ennaïfer (n. 87), 81, 86, 87, 88–92.

99. Dunbabin (n. 5), 55, Fig. 29. Bandinelli (n. 64),

228, Fig. 211.

100. Dunbabin (n. 5), 67–9, Figs. 52–3. Beschaouch (n. 88), 32–6.

101. Bandinelli (n. 64), 252, Figs. 234, 235 (both colour), 236; cf. Figs. 237–8. Dunbabin (n. 5), 114–15, Figs. 102–4; cf. Figs. 105, 107, 108. *Dossier* 31 (n. 66), 97.

102. Bandinelli (n. 64), 223–4, Fig. 208 (colour). Dunbabin (n. 5), 62, 119–21, Fig. 109.

103. Bandinelli (n. 64), Fig. 1 (colour). Baratte (n. 17), no. 6. Dunbabin (n. 5), Fig. 154.

104. The following is a selection from the copious literature on this site: G. V. Gentili, *La Villa Erculia di Piazza Armerina: I Mosaici Figurati* (56 colour plates; Rome, 1959); Lavin (n. 37), 244–51; A. Carandini, *Ricerche sullo Stile e la Cronología della Villa di Piazza Armerina* (Studi Miscellanei 7, Rome, 1964); H. Kähler, *Die Villa des Maxentius bei Piazza Armerina* (Berlin, 1973); Dunbabin (n. 5), 196–212, 243–5; Bandinelli (n. 64), 237–48.

105. e.g. interruptions in the pattern of waves, and occasional lines of tesserae running across the direction of the tesserae forming the background of the 'Great Hunt' as in Gentili (n. 104), Pl. XXV (at least four instances, the ship's mast probably disguising another), Kähler (n. 104), Pl. 28; also in the 'Small Hunt', as in F. Abbate, *Roman Art* (London, 1972), Pl. 69 (colour).

106. Gentili (n. 104), Pl. X. Kähler (n. 104), Pl. 44, b.

107. Gentili (n. 104), Pls. XVII, XXI. Lavin (n. 37), 248–9, Fig. 110. For a parallel from Carthage for the sacrificial scene see Dunbabin (n. 5), 57–8, Figs. 36–7. Both scenes illustrate the ritual kiss: see n. 35. For the picnic: Bandinelli (n. 64), 244–5, Fig. 199 (colour).

108. Gentili (n. 104), Pl. XXIII. Kähler (n. 104), Pl. 33. For a small-scale but otherwise not dissimilar representation of this subject in an *emblema* of c.200 from Baccano near Rome see Becatti *et al.* (n. 39), no. 11, Pl. XI (colour). On other mythological scenes see Lavin (n. 37), 249–51, Figs. 111–15.

109. See n. 99.

110. Cf. Dorigo (n. 34), Figs. 93–7.

111. Cf. Lavin (n. 37), 242–55; Dunbabin (n. 5), 16–17, 38.

112. On the geometric mosaics cf. R. C. Scovazzo, *Atti III*.

113. Lavin (n. 37), 255–62, Figs. 121–3, 126, 128. Cf. Dunbabin (n. 5), 212–15, Fig. 204.

114. H. Stern, *DOP*, 12, 1958, 157–218.

115. Lavin (n. 37), 212–14, Figs. 31–3. Dunbabin (n. 5), 253, no. 38 (a). S. Germain, *AntAf*, 14, 1979, 171 ff., no. 4, Figs. 2, 3.

116. See n. 5.

117. General: *MGR* I (n. 41), *MGR* II (n. 58), *Atti III* (n. 11); *Dossier* 15 (n. 25). Austria: H. Kenner, *MGR* I, 85–93. Britain: D. J. Smith, *MGR* I, 95–114, *MGR* II, 269–89, *Atti III* (n. 11); *id.*, in A.L.F. Rivet (ed.), *The Roman Villa in Britain* (London, 1969), 71–125. France: *Recueil des Mosaïques de la Gaule* I–*Belgique*,

fascs. 1–3, II–*Lyonnaise*, fascs. 1–3 (continuing), III–*Narbonnaise*, fasc. 1 (continuing), IV–*Aquitaine*, fasc. 1 (continuing). Germany: Parlasca (n. 12). Greece: E. Waywell, *AJA*, 83, 1979, 293–321. Hungary: A. Kiss, *Roman Mosaics in Hungary* (Budapest, 1973). Portugal: M. Bairraõ Oleiro, *MGR* I, 257–63. Spain: A. Balil, *MGR* I, 29–38, Barral I Altet (n. 25), A. Blanco Freijeiro, *Corpus de Mosaicos Romanos en España*, fasc. 1–*Mérida* (Madrid, 1978), fasc. 2–*Italica* (1) (Madrid, 1978), D. Fernández-Galiano, *Anales de Historia Antigua y Medieval* 20 (Buenos Aires, 1980), 100–50. Switzerland: V. von Gonzenbach, *Die Römischen Mosaiken der Schweiz* (Basel, 1961). Yugoslavia: D. Mano-Zissi, *MGR* I, 287–94.

118. Spain: A. Balil, *MGR* I (n. 41), 29–38, Figs. 1–3 (Ampurias); M. Tarradell, *Arte Romano en España* (Barcelona, 1969), Pl. 170 (colour plate of *emblema* depicting the sacrifice of Iphigenia). Southern Gaul: H. Lavagne, *Recueil* (n. 117) III, fasc. 1 (Paris, 1979), no. 45, Pl. XIII (Orange).

119. Barral I Altet (n. 25), 14–15, Freijeiro (n. 117), fascs. 1, 2, *passim*.

120. J. Lancha, *Mosaïques Géométriques: les Mosaïques de Vienne – Isère* (Rome, 1977), 191–2, Figs. 101–5. Also St Romain-en-Gal, across the Rhône from Vienne.

121. B. Cunliffe, *Excavations at Fishbourne 1961–1969* (Leeds, 1971), I, 163–5, Pls. XLVII–LIII. For the *terminus post quem* see now D. Rudkin, *Mosaic* (Newsletter of the Association for the Study and Preservation of Roman Mosaics), 4 (April, 1981), 8.

122. Kiss (n. 117), no. 10, Fig. 10a.

123. Smith, *MGR* II (n. 58), 269–89.

124. Kiss (n. 117), 67.

125. See n. 117.

126. Freijeiro (n. 117), fasc. 1, 22–3, no. 17, Pls. 28–39, 99–100 (colour).

127. J.-P. Darmon, H. Lavagne, *Recueil* (n. 117) II–*Lyonnaise*, fasc. 3 (Paris, 1977), no. 415, Pls. XI–XXIII.

128. H. Lavagne, *Recueil* (n. 117), III–*Narbonnaise*, fasc. 1 (Paris, 1979), no. 58, Pls. XIX–XXII.

129. H. Stern, *MGR* I (n. 41), 233–41. For an Italian example of the first century with a typically Hellenistic *emblema* and 'three-dimensional' panels see the mosaic of Teramo (n. 38): *id.*, *Recueil* (n. 117), I–*Belgique*, fasc. 2 (Paris, 1960), 12, Pl. B.

130. Parlasca (n. 12), 22–48.

131. *Ibid.*, 35–6, Pls. 36–9.

132. Parlasca (n. 12), 41–3, Pls. 42–7, colour plates A, 2, C.

133. *Ibid.*, 88–9, Pls. 88–91.

134. H. Stern, *Recueil* (n. 117), I–*Belgique*, fasc. 1, no. 38, Pls. XI–XIV. A comparable example is a mosaic of (?) c.200 of Augsburg: Parlasca (n. 12), 101–2, Pl. 97.

135. Parlasca (n. 12), 69, Pl. 61, 1.

136. *Ibid.*, 75–8, Pls. 66–79, 80, 2.

137. *Ibid.*, 80–2, Fig. 10, Pls. 80, 1, 81, 82.

138. For a similar contrast in Pannonia cf. Kiss (n. 117), 66.

139. Parlasca (n. 12), 86–8, Pls. 84, 2, 85, 2, 86, 87.

140. D. J. Smith in A. King and M. Henig (eds.), *The Roman West in the Third Century*, BAR Int. Ser., 109 (Oxford, 1981), 159–65; *ibid.*, *Atti III* (n. 11).

141. Kiss (n. 117), 67.

142. Lavin (n. 37), 264–6. Dunbabin (n. 5), 219–22. Barral I Altet, *Dossier* 15 (n. 25), 62–5; *id.* (n. 25), 17–19. D. Fernández-Galiano, *Atti III* (n. 11).

143. Barral I Altet (n. 25), no. 6, with refs. to the mosaic of Gerona, Pls. VI–XI. M. Tarradell (n. 118), colour plates 2, 5, 174.

144. Freijeiro (n. 117), fasc. 1, no. 65, Pls. 95–8, 107–8 (colour).

145. Lavin (n. 37), 259, with refs., Figs. 124, 125. *Dossier* 15 (n. 25), 64 ('Autumn', colour).

146. Bandinelli (n. 64), 193, 195, Fig. 185. *Dossier* 15 (n. 25), 65 (colour).

147. Freijeiro (n. 117), fasc. 1. no. 43B, Pls. 77–9, 101–4 (colour).

148. *Ibid.*, 21, no. 15, Pls. 26, 27. Bandinelli (n. 64), 193, 195, Fig. 186.

149. C. Balmelle, *Dossier* 15 (n. 25), 70–5; *id.*, *Recueil* (n. 117), IV–*Aquitaine*, fasc. 1 (Paris, 1981).

150. H. Stern, *Gallia*, XIII, 1955, 41–77; *id.*, *Recueil* (n. 117), I–*Belgique*, fasc. 1 (Paris, 1957), no. 77. Lavin (n. 37), 264, Fig. 132. Dunbabin (n. 5), 135, n. 28. *Dossier* 15 (n. 25), cover (colour).

151. Lavin (n. 37), 263, Fig. 130.

152. *Ibid.*, 263–4, Fig. 129. J.-P. Darmon, *La Mosaïque de Lillebonne* (Rouen, 1976); *Actes du Colloque International d'Archéologie* (Rouen, 1978), 235–64; *id.*, *Gallia*, XXXVI, 1978, 65–88.

153. For a tame stag as a decoy in a late mosaic from Carthage: Hinks (n. 23), 144, no. 57a, Pl. XXXII; Dunbabin (n. 5), 59, Pl. 41. An antelope and even ostriches and a tigress are apparently tame decoys in the 'Great Hunt' at Piazza Armerina: Gentili (n. 104), Pls. XXVI, XXVIII.

154. *Princeton Encyclopedia* (n. 16): 'Augusta Treverorum'. E. M. Wightman, *Roman Trier and the Treveri* (London, 1970), 58–68, and 318: 'mosaics'.

155. Parlasca (n. 12), 49–64.

156. *Ibid.*, 60, Pls. 11, 2, 56, 3.

157. *Ibid.*, 61–2, colour plate B, 2, plates 58, 1, 59, 1, 2.

158. *Ibid.*, 56–7, colour plates D, E, plates 54–5. Cf. Wightman (n. 154), 65.

159. Smith, *The Roman Villa in Britain* (n. 117); *id.*, in J. Munby and M. Henig (eds.), *Roman Life and Art in Britain*, BAR 41 (Oxford, 1977), 105–93. Cf. J. M. C. Toynbee, *Art in Roman Britain* (London, 1962), 196–205; *id.*, *Art in Britain under the Romans* (Oxford, 1964), 228–89. A. A. Barrett, *Britannia*, IX, 1978, 307–13. R. Stupperich, *Britannia*, XI, 1980, 289–301. R. Ling, *Mosaic*, 5, 1981 (see n. 121), 16–17.

160. D. J. Smith, *Atti III* (n. 11), Fig. 2.

161. *id.*, *MGR* I (n. 41), 105–11; *id.*, *Hommages à Henri*

Stern (ed. J.-P. Darmon, forthcoming).

162. *id.*, *MGR* I (n. 41), 113–4, Fig. 18; *id.*, *The Roman Villa in Britain* (n. 117), 116, Pl. 3.32; *id.*, *Atti III* (n. 11), Fig. 2.

163. J. M. C. Toynbee, *JRS*, LIV, 1954, frontispiece (colour), 7–14, Pls. I–VII.

164. Smith, *MGR* I (n. 41), 99–105; *id.*, *The Roman Villa in Britain* (n. 117), 109–13; *id.*, *Atti III* (n. 11).

165. Hemsworth (Dorset): Hinks (n. 23), 99, no. 33, Pl. XXX.

166. E. Coker (Somerset): C. R. Smith, *Collectanea Antiqua*, II, 1852, 51–2, Pl. XX. *VCH Somerset*, I, 1906, 329, Fig. 87. On the costumes and their dating: Blake III (n. 7), 117, Pl. 27, 3; cf. Lavin (n. 37), 258, Figs. 122–3; Dunbabin (n. 5), 213, Fig. 204.

167. Smith, *MGR* I (n. 41), 98–9, Fig. 3; *id.*, *The Roman Villa in Britain* (n. 117), 107, Pl. 3.20; *id.*, in I.M. Stead, *Rudston Roman Villa* (Leeds, 1980), 134–6, Pl. XII. Cf. J. Lassus, 'Vénus Marine', *MGR* I, 175–89; Dunbabin (n. 5), 154–8.

168. Dunbabin (n. 5), 73. A bull in a mosaic of Cos has the Greek equivalent of this name: J. M. C. Toynbee, *PBSR*, XVI, 1948, 36.

169. Dunbabin (n. 5), 78–84. *Dossier* 31 (n. 66), 36.

170. F. Sear, 'Wall and vault mosaics', Ch. 18 in *Roman Crafts* (n. 1), 232–3, Figs. 365–6.

171. *Ibid.*, 234–5, Fig. 369.

172. *Ibid.*, 234–5, Fig. 368.

173. *Ibid.*, Fig. 363.

174. *Ibid.*, Fig. 370.

175. D. Joly, *MGR* I (n. 41), 57–71.

176. Sear (n. 170), Pl. X (colour); Toynbee (n. 7), 157, Pl. 85.

177. A. Maiuri, *Ercolano-I Nuovi Scavi: 1927–1958* (Rome, 1958), 393–402, Figs. 332–7; Hanfmann (n. 18), colour plate XX.

178. Museo Nazionale, Naples, nos. 9110, 116085. Charbonneaux *et al.* (n. 5), Figs. 124, 125 (colour).

179. Museo Nazionale, Naples, no. 10004. Fischer (n. 1), Fig. 10.

180. For one see Charbonneaux *et al.* (n. 5), Fig. 154 (colour); Fischer (n. 1) illustrates this and the mosaic for comparison, Figs. 10, 11.

181. In the Fitzwilliam Museum, Cambridge. Sear (n. 170), Fig. 361.

182. Becatti (n. 42), no. 269.

183. *Ibid.*, no. 310, with colour plate.

184. J.M.C. Toynbee, J.B. Ward-Perkins, *The Shrine of St. Peter and the Vatican Excavations* (1956), 73–4 and 117, Pl. 32; Becatti (n. 42), 294; Hanfmann (n. 18), colour plate XIV.

185. For more extensive accounts of Roman mural and vault-mosaics see H. Stern, *Ét. d'Arch. Class.* II, 1959, 101–21; Sear (n. 170); F. B. Sear, *Roman Wall and Vault Mosaics* (Heidelberg, 1977), and the valuable review of the last-named work by M. Donderer, *Gnomon*, 52, 1980, 761–9.

186. Smith 1969 (n. 117), 104, n. 2. Cf. K. S. Painter, *Ant. J.*, LVI, 1976, 49–54; D. J. Smith, in M. Todd (ed.), *Studies in the Romano-British Villa* (Leicester,

1978), 128–37, Figs. 39–44.

187. Parlasca (n. 12), 77 and n. 1, 78.

188. Von Gonzenbach (n. 117), 165–6, 264–5, and 365, s.v. 'Muscheln'.

189. Freijeiro (n. 117), fasc. 2 (1), no. 30.

190. J.-P. Darmon, H. Lavagne (n. 127), nos. 452, 454 (with note on instances of mosaic incorporating shells).

191. Levi (n. 5), 2, nn. 8, 9, with references to Malalas, *Chronogr.* XI, 369, XII, 400, and Libanius, *Or.* XI, 202.

192. J. B. Ward-Perkins, J. M. C. Toynbee, *Archaeologia*, XCIII, 1949, 179–80, 192, Pls. XXXIV (colour), XLI.

193. J. Liversidge, 'The Roman Villa in Britain', in A. L. F. Rivet (ed.), *The Roman Villa in Britain* (London, 1969), 134, Fig. 4.1.

194. See esp. G. Calza, *La Necropoli del Porto di Roma nell'Isola Sacra* (Rome, 1940), 161 ff. For two pagan funerary mosaics from Tunisia see P. Gauckler, *Inventaire des Mosaïques de la Gaule et de l'Afrique Romaine: Afrique Proconsulaire* (1910), nos. 24, 25 (Henchir-Thina), with Plate. For one in *opus vermiculatum* from Salonae (Yugoslavia), assigned to the end of the third century, see D. Mano-Zissi, *MGR* I (n. 41), 290–1, Fig. 13 = Duval (n. 196), 64, Pl. XXV, 2.

195. J. N. Brewer, *The Beauties of England and Wales*, XII, Part II, *Oxfordshire* (London, 1813), 462–4.

196. N. Duval, *MGR* II (n. 58), 63–107, including a note on Christian funerary mosaics outside North Africa. For one in Spain not cited by Duval see A. Garcia y Bellido, *Colonia Aelia Augusta Italica* (Madrid, 1960), 31, Pl. XI.

197. Blake I (n. 2), 25, 27–9, 32, 33–4; Joyce (n. 43)

198. e.g. on Delos: Bruneau (n. 4), 22–3; at Fishbourne: Cunliffe (n. 121), I, 66–9.

199. Becatti (n. 43), 247–79, *passim*.

200. London: *Britannia*, X, 1979, 313, 317.

201. Blake I (n. 2), 35–49. *Mosaico e Mosaicisti nell'Antichità* (n. 13), 36–40 ('Incrostazione'), 40–6 ('Opus Sectile'). *Pace* Blake I (n. 2), 50–67, '*Opus sectile*' is evidently not '*lithostroton*': Bruneau (n. 4), 6, no. 1, 120.

202. Hanfmann (n. 18), Pl. X (colour).

203. Cf. Becatti (n. 43), 355–67.

204. *Ibid.*, nos. 47, 49, Pls. CCX, CCXIX (colour); Hanfmann (n. 18), Pl. XV (colour).

205. *Mosaico e Mosaicisti nell'Antichità* (n. 13), 42–3. For examples of figured *opus sectile* see pp. 43–4.

206. M. L. Morricone Matini, *Mosaici Antichi in Italia: Reg. I–Roma: Reg. X–Palatium* (Rome, 1967), 64, Pl. XXXIII. Fishbourne has yielded geometric fragments only 1–1.5 mm ($c.\frac{1}{32}$ in.) thick, and others only 0.3–0.4 mm. ($c.\frac{1}{100}$ in.) thick suggesting a floral pattern which Cunliffe thinks may have come from furniture: (n. 121), II, 24–37, Pls. VII, X.

207. Bandinelli (n. 64), 93, Fig. 83 (colour).

208. *Ibid.* 96–8, Fig. 90 (colour).

209. *Mosaico e Mosaicisti nell'Antichità* (n. 13), 44, colour plate.

210. Bandinelli (n. 64), 96, Figs. 88, 89 (colour).
211. *Mosaico e Mosaicisti nell'Antichità* (n. 13), 44; Bandinelli (n. 64), 98, Fig. 91 (colour).
212. For an exhaustive study of these panels, with many other examples of vitreous *opus sectile* in Italy, see G. Becatti, *Scavi di Ostia* VI: *Edificio con opus sectile fuori Porta Marina* (Librerìa dello Stato, Rome, 1967), 181–215.
213. *Ibid.* For part of an inhabited scroll from this building, crude but in the tradition of that of the mosaic of Zliten, see Bandinelli (n. 64), 98, Fig. 91 (colour).
214. L. Ibrahim, R. Scranton, R. Brill, *Kenchreai – Eastern Port of Corinth* II: *The Panels of Opus Sectile in Glass* (Leiden, 1976). For one of the panels see Bandinelli (n. 64), Fig. 311 (colour).

CHAPTER SIX *The Luxury Arts*

1. Vermeule, *Antike Kunst*, 6, 1963, 33–40, especially 39.
2. A. Maiuri, *La Casa del Menandro e il suo Tesoro di Argenteria* (Rome, 1933), 265–310, Pls. XVI–XXIV; A. Héron de Villefosse, *Mon. Piot* 5, 1899, 79–83, Pls. XV, XVI; S. Bourgey, *Archéologia*, no. 153, April 1981, p. 64.
3. J. M. C. Toynbee, *Some Notes on Artists in the Roman World*, Collection Latomus, 6 (Brussels, 1951), 51–3; *CIL* 6. 9207 ('aurifex de Sacra Via') and 9434 ('gemmarius de Sacra Via'). Other references to gemmarii in *Enc.*, III, 888–9.
4. D.E. Strong, *Greek and Roman Gold and Silver Plate* (London, 1966), 109 and Pl. 31A. Strong's monograph is a fundamental reference work and most of the plate to which reference is made in the text is also cited there.
5. U. Gehrig, *Hildesheimer Silberfund* (Berlin, 1967), Pls. I and III (colour), 13 and 14; de Villefosse (n. 2), 39–47, Pls. i and ii.
6. A. Oliver, *Silver for the Gods. 800 Years of Greek and Roman Silver* (Toledo Museum of Art, Ohio, 1977); D. E. Strong in I. M. Stead, *Archaeologia*, CI, 1967, 20–3.
7. P. E. Corbett and D. E. Strong, *BMQ* XXIII, 1961, 77–83; A. Oliver, *J. Paul Getty Museum Journal*, 8, 1980, 155–9; Gehrig (n. 5), Pls. 2–5; M. B. Hatzopoulos and L. D. Loukopoulos, *Philip of Macedon* (London, 1981), 213, Pl. 114.
8. Corbett and Strong (n. 7), 68–77.
9. E. Künzl, *BJ* 169, 1969, 321–92.
10. Vermeule (n. 1), 36–8.
11. E. Künzl, *Jahr. RGZM*, 22, 1975, 62–80.
12. de Villefosse, (n. 2), 134–68, Pls. XXXI–XXXVI.
13. Strong (n. 4).
14. Maiuri (n. 2), 347–8, Pl. XLV; de Villefosse (n. 2), 73–9, Pls. XI–XIV.
15. Gehrig (n. 5), Pls. 15, 16, 23–6 and A. Roes and W. Vollgraff, *Mon. Piot*, 46, 39–67.
16. A. Adriani, *Le Gobelet en Argent des Amours Vendangeurs du Musée d'Alexandrie* (Alexandrie, 1939).
17. B. Svoboda, *JRS*, LVIII, 1968, 124–5 and *Neuerworbene Römische Metallgefässe aus Stráže bei Piešťany* (Bratislava, 1972); P. Gauckler, *Mon. Piot* 2, 1895, 77–94.
18. E. Babelon, *Le Trésor d'Argenterie de Berthouville près Bernay (Eure)* (Paris, 1916).
19. H. B. Walters, *Catalogue of the Silver Plate, Greek, Etruscan and Roman in the British Museum* (London, 1921), 46–7, no. 183; 34 nos. 135, 136; and 50–1 no. 192; B. Cunliffe, *Ant. J.*, LX, 1980, 201, Pl. XVIII.
20. F. Baratte, *Antike Kunst*, 21, 1978, 40–5; K. S. Painter, *The Mildenhall Treasure. Roman Silver from East Anglia* (London, 1977), 12–13 and 27, no. 4, Pls. 10–14; D. Brown, *Oxoniensia*, 38, 1973, 193 and Pl. VIIIB.
21. Walters (n. 19), Pl. XXV, nos. 148 and 170; Bourgey, (n. 2), 161–2.
22. G. Lloyd-Morgan, in A. King and M. Henig, *The Roman West in the Third Century*, BAR Int. Ser., 109 (Oxford, 1981), 146 and 151.
23. Painter (n. 20), 26, Pls. 1–8, nos. 1–3; F. Haverfield, *JRS*, IV, 1914, 1–12; and J.M.C. Toynbee, *Art in Roman Britain* (London, 1962), 172, no. 108.
24. K. Weitzmann, *Age of Spirituality. Catalogue of the Exhibition at the Metropolitan Museum of Art* (New York, 1979), 231–4, no. 208.
25. J. Ward-Perkins and A. Claridge, *Pompeii AD 79* (Royal Academy of Arts Exhibition Catalogue 1976), no. 169; F. H. Marshall, *Catalogue of the Jewellery, Greek, Etruscan and Roman in the Departments of Antiquities, British Museum* (London, 1911), 383 and Pl. LXXIII, no. 3168.
26. C. Vermeule, *Greek and Roman Sculpture in Gold and Silver* (Boston, 1974), 36, nos. 102, 103.
27. C. J. Sautel, *Vaison dans l'Antiquité I. Supplément – Travaux et Recherches de 1927 à 1940* (Avignon, 1941), 108, Pl. LXVII.
28. Walters (n. 19), 8–11, Pls. V and VI, nos. 27–35; Babelon (n. 18), 73–6, Pls. I–IV, nos. 1 and 2.
29. I. Venedikov, *Thracian Treasures from Bulgaria* (British Museum, 1976), 85, no. 455 (Ill.); Walters, (n. 19), Pl. XXIII, no. 145.
30. A. Leibundgut, *Die Römischen Bronzen der Schweiz II Avenches* Mainz, 1976), 30–2, Pls. 14–16, no. 15; D. Brown, *Burlington Magazine* CXIII, 1971, 334, Figs. 58 and 59; J.M.C. Toynbee, *Art in Britain under the Romans* (Oxford, 1964), 49, Pl. V.
31. A. S. Murray, *Archaeologia*, LV, 1896, 199–202. On the technique of gilding, see W. A. Oddy, L. Borrelli Vlad and N. D. Meeks in G. Perroco (ed.), *The Horses of San Marco, Venice* (London, 1979), 182–5.
32. Weitzmann (n. 24), 176–7, no. 155. K. J. Shelton, *The Esquiline Treasure* (London, 1981), 86–8, nos. 30–3, Pls. 35–43.
33. Strong (n. 4), 179 and Pl. 53B; G. M. A. Richter, *The Furniture of the Greeks, Etruscans and Romans* (London, 1966), 108, Fig. 548. For similar inlay of silver, base gold and brass on a strigil from Caerleon in Wales, showing the Labours of Hercules see *Ant.*

J., LX, 1980, 333–7.

34. Gehrig (n. 5). Pl. 10; G. Faider Feytmans, *Recueil des Bronzes de Bavai* (Paris, 1957), 114–15, Pls. XLIV, XLV, no. 280; A. Kaufmann-Heinimann, *Die Römischen Bronzen der Schweiz I. Augst* (Mainz, 1977), 120–1, Pls. 119–23, no. 189.

35. E. Pernice, *Die Hellenistische Kunst in Pompeji IV: Gefässe und Geräte aus Bronze* (Berlin and Leipzig, 1925), 22, Pl. IV.

36. H. B. Walters, *Catalogue of the Bronzes, Greek, Roman and Etruscan in the Department of Greek and Roman Antiquities, British Museum* (London, 1899), 162, Pl. XXV, no. 882.

37. G. Faider-Feytmans, *Les Bronzes Romains de Belgique* (Mainz, 1979), 179–80, Pl. 147, no. 368.

38. *Ibid.*, 183, Pl. 154–5, no. 375.

39. Toynbee (n. 30), 321, Pl. LXXV b.

40. S. Tassinari, *La Vaisselle de Bronze Romaine et Provinciale au Musée des Antiquités Nationales* (Paris, 1975), 67, Pl. XXXIII, no. 172.

41. Toynbee (n. 30), 325, Pl. LXXIII b.

42. E. Espérandieu and H. Rolland, *Bronzes Antiques de la Seine-Maritime* (Paris, 1959), 69–70, Pls. XLII–XLIII, no. 139.

43. H. Willers, *Die Römischen Bronzeeimer Von Hemmoor* (Hanover and Leipzig, 1901).

44. J. Heurgon, *Mon. Piot* 46, 1952, 93–115.

45. Toynbee (n. 30), 299–300, Pl. LXIX b.

46. S. Walker and A. Burnett, *Augustus. Handlist of the Exhibition and Supplementary Studies*, British Museum – Occasional Paper 16 (London, 1981), 49–55.

47. A. Greifenhagen, *Staatliche Museen Preussischer Kulturbesitz: Schmuckarbeiten in Edelmetall* (Berlin, 1975), II, 101–2, Pls. 69, and V. A. Maxfield, *The Military Decorations of the Roman Army* (London, 1981), 94 f., Pl. 15; E. Künzl, in S. Boucher (ed.), *Actes du IVᵉ Colloque International sur les bronzes antiques*, Annales de l'Université Jean Moulin (Lyons, 1977), 83–6.

48. H. Russell Robinson, *The Armour of Imperial Rome* (London, 1975); J. Garbsch, *Römische Parade-Rüstungen* (Munich, 1978).

49. See Sister Charles Murray, *Rebirth and Afterlife. A Study of the Transmutation of some Pagan Imagery in Early Christian Funerary Art*, BAR Int. Ser., 100 (Oxford, 1981), 23, on devices worn by Christians (citing Clement of Alexandria, *Paedagogus*, III, 12.1).

50. Neither group is entirely exclusive, note pelleting and thick wheel-cuts on Campanian gems (M. Maaskant-Kleibrink, *Catalogue of the Engraved Gems in the Royal Coin Cabinet, The Hague* (The Hague, 1978), 108 ff.) and Hellenistic influence on Italic gems in the Etruscan tradition (*ibid.* 101 ff.).

51. J. Boardman, *Intaglios and Rings, Greek, Etruscan and Eastern from a Private Collection* (London, 1975), 42 f., no. 143.

52. M. L. Vollenweider, *Die Steinschneidekunst und Ihre Künstler in Spätrepublikanischer und Augusteischer Zeit* (Baden-Baden, 1966).

53. *Ibid.*, 56–64.

54. *Ibid.*, 47–56.

55. *Ibid.*, 40–3; J. Boardman and D. Scarisbrick, *The Ralph Harari Collection of Finger Rings* (London, 1977), 35–6, no. 62; H. Carnegie, *Catalogue of the Collection of Antique Gems formed by James Ninth Earl of Southesk* (London, 1908), 42 and Pl. III, no. C22 (now in Fitzwilliam Museum, Cambridge).

56. Vollenweider (n. 52), 69–73; J. Boardman, *Engraved Gems. The Ionides Collection* (London, 1968), 30 f., no. 31 (now in Fitzwilliam Museum, Cambridge).

57. Greifenhagen (n. 47), I. 79–80, Pl. VII (colour), 6; E. Zwierlein-Diehl, *Die Antiken Gemmen des Kunsthistorischen Museums in Wien I* (Munich, 1973), 147 and Pl. 77, no. 465.

58. Vollenweider (n. 52), 60 and Pl. 61, 1; 81–5, Pls. 1 and 2.

59. M. H. Crawford, *Roman Republican Coinage* (Cambridge, 1974), II, 727–8.

60. D. B. Thompson, *Ptolemaic Oinochoai and Portraits in Faience. Aspects of the Ruler Cult* (Oxford, 1973); C. M. Havelock, *Hellenistic Art* (London, 1971), 200–1, Pl. 170; G. M. A. Richter, *Engraved Gems of the Greeks and the Etruscans* (London, 1968), 151, no. 596.

61. G. M. A. Richter, *Engraved Gems of the Romans* (London, 1971), 104, no. 501.

62. *Ibid.*, 104–5, no. 502 and H. Jucker, *JDAI*, 91, 1976, 211–50 (who reinterprets the cameo and dates it to AD 51, which is unconvincing).

63. H. Möbius, *Rev. Arch.* N.S. 1968, 315–26 and O. Neverov, *Burlington Magazine*, CXXI, 1979, 431, Fig. 40; P. Zazoff, *Antike Gemmen in Staatliche Kunstsammlungen Kassel* (Kassel, 1969), 28 and Pl. 23, Fig. 140.

64. Richter (n. 61), 122–3, no. 600.

65. C. D. E. Fortnum, *Archaeologia*, XLV, 1877, 6–9, Pl 1; Richter (n. 61), 144, no. 676; E. Swoboda, *Carnuntum. Seine Geschichte und Seine Denkmäler* (Graz, 1964), 102, Pl. XXV, 1; A. M. McCann, *MAAR*, XXX, 1968, 183 and Pl. XCIIj; Richter (n. 61), 123–4, no. 605.

66. H. Guiraud, *Annales. L'Université de Toulouse-Le Mirail* N.S.X., 1974, 111–17; M. Henig, *A Corpus of Roman Engraved Gemstones from British Sites*, BAR 8 (Oxford, 2nd edn., 1978), 299–300 and frontispiece, no. app. 108.

67. E. Zwierlein-Diehl, *Die Antiken Gemmen des Kunsthistorischen Museums in Wien II* (Munich, 1979), 7–117, also on wasters from a workshop M. Henig, 'A Cache of Glass Gems dating to the Second Triumvirate', appendix to *The Lewis Collection of Engraved Gemstones in Corpus Christi College, Cambridge*, BAR Int. Ser., 1 (Oxford, 1975), 81–94. See now B. Czurda-Ruth, *Die römischen Gläser vom Magdalensberg* (Klagenfurt, 1979), 174–5 for a recent examination of technique. It seems that the glass was impressed into the mould in a viscous state rather than poured in as a liquid.

68. On workshops, see G. Sena Chiesa, *Gemme del Museo Nazionale di Aquileia* (Padua, 1966), and *Gemme di*

Luni (Rome, 1978), 17–21; Henig, (n. 66), 33–4; M. Gramatopol, *Les pierres gravées du Cabinet numismatique de l'Académie Roumaine*, Collection Latomus 138 (Brussels, 1974), 29–36; For the South Shields gem see Henig (n. 66), 208 and Pl. XXXVI, no. 184.

69. Greifenhagen (n. 47), I, 77–81.

70. Maiuri (n. 2), 378–82, Pl. LXV.

71. B. Pfeiler, *Römischer Goldschmuck des ersten und zweiten Jahrhunderts n. Chr. nach datierten Funden* (Mainz, 1970), 51, Pl. 10.

72. G. C. Boon, *Ant. J.*, LV, 1975, 41–61; D. Charlesworth, *Arch. Ael.* fifth ser. 1, 1973, 226–8; J. M. C. Toynbee, (n. 24), 179, nos. 130, 131, Pls. 154 and 155.

73. On third century jewellery, see M. Henig in King and Henig, (n. 22), 127–43.

74. J. Heurgon, *Le Trésor de Ténès* (Paris, 1958), is an admirable study of the late period of Roman jewellery. A full account of the Thetford treasure by Catherine Johns and Timothy Potter is in preparation.

75. H-P. Bühler, *Antike Gefässe aus Edelsteinen* (Mainz, 1973).

76. A. I. Loewental and D. B. Harden, *JRS*, XXXIX, 1949, 31–7; D. B. Harden, *JRS*, XLIV, 1954, 53.

77. Richter (n. 61), 106, no. 508, and see Walker and Burnett (n. 46), 21, no. 228; G. M. A. Richter, *Catalogue of Greek and Roman Antiquities in the Dumbarton Oaks Collection* (Cambridge, Mass., 1956), 14–15, no. 10, Pl. V; O. Neverov, *Antique Cameos in the Hermitage Collection* (Leningrad, 1971), 95, no. 107.

78. M. E. Mariën, *Belgica Antiqua. L'Empreinte de Rome* (Antwerp, 1980), 268, Fig. 182; Ward-Perkins and Claridge (n. 25), no. 238.

79. H. J. H. Van Buchem, *Numaga*, XXII, 1975, 214, Fig. 8; Mariën (n. 78), 280, Fig. 194; D. E. Strong, *Catalogue of the Carved Amber in the Department of Greek and Roman Antiquities, British Museum* (London, 1966), 92–3, no. 114; D. Brown and M. Henig, in J. Munby and M. Henig, *Roman Life and Art in Britain*, BAR 41 (Oxford, 1977), 28, no. 3, Pls. 2.iii and 2.iv; M. Carina Calvi, *Aquileia Nostra*, XLVIII, 1977, 102, Fig. 8.

80. P. La Baume, in M. Claus, W. Haarnagel, K. Raddatz (eds.), *Studien zur europäischen Vor- und Frühgeschichte* (H. Jankuhn Festschrift, Neumünster, 1968), 108, no. 2, Pl. 9; Mariën, (n. 78), 26, Fig. 178; Brown and Henig (n. 79).

81. R. Siviero, *Gli Ori e le Ambre del Museo Nazionale di Napoli* (Florence, 1954), 134–5, nos. 565 and 568; La Baume (n. 80), 108, no. 1, Pl. 8; Mariën (n. 78), 283, Fig. 197.

82. Carina Calvi, (n. 79), 98, Fig. 5; *Aquileia Nostra*, XLIX, 1978, 191 and Pl. I, 3.

83. Toynbee (n. 30), 363–8.

84. Mariën (n. 78), 338, Fig. 246.

85. W. Hagen, *BJ*, 142, 1937, 127–30, Pls. 30 and 31; Toynbee (n. 23), 184, no. 137, Pl. 149.

86. J. Szilágyi, *Aquincum* (Budapest, 1956), 70 and Pl.

LXII; Toynbee, (n. 23), 183, no. 135, Pl. 156; P. J. Drury, *Ant. J.*, LIII, 1973, 273, no. 2, Pl. LIV b, c; *Britannia*, XI, 1980, 410 and Pl. XXVII.

87. R. V. Nicholls, *Archaeologia*, CVI, 1979, 1–32; L. Marangou, *Benaki Museum, Athens. Bone Carvings from Egypt 1. Graeco-Roman Period* (Tübingen, 1976); see also Toynbee (n. 30), 359 and Pl. LXXXII (for ivory plaques from Caerleon).

88. M. Henig, in Munby and Henig (n. 79), 359 and Pl. 15. VI; P. Arthur, *ibid.*, 367–74 and Pl. 16.1 a.

89. M. Vaulina and A. Wasowicz, *Bois Grecs et Romains de l'Ermitage* (Warsaw, 1974), 101–6, Pls. XCIX–CXI; R. Martin, *Antiquity*, XXXIX, 1965, 247–52, Pls. XLV–LI; *Britannia*, III, 1972, 349 and Pl. XXIV, B.

90. G. H. Forsyth and K. Weitzmann, *The Monastery of Saint Catherine at Mount Sinai. The Church and Fortress of Justinian* (Ann Arbor, c. 1966), Pls. LXVI–LXXIX; W. F. Volbach, *Early Christian Art* (London, 1961), 330–1, nos. 102–5.

91. W. F. Volbach, *Early Decorative Textiles* (Feltham, 1968), especially Pls. 3 and 8. Mr Julian Ward kindly pointed out the Catullus reference to me.

CHAPTER SEVEN *Coins and Medals*

1. A. Bonanno, *Relief portraiture to Septimius Severus*, BAR Int. Ser., 6 (Oxford, 1976).

2. F. Gnecchi, *I medaglioni Romani* (Milan, 1912).

3. J. M. C. Toynbee, *Roman Medallions*, Numismatic Studies V (New York, 1944); L. Michelini Tocci, *I medaglioni Romani e i contorniati del Medagliere Vaticano* (Vatican City, 1965).

4. R. Bianchi Bandinelli, *Rome the Centre of Power* (London, 1970), Chapter 2.

5. M. Crawford, *Roman Republican Coinage* (Cambridge, 1974).

6. e.g. J. M. C. Toynbee in J. Munby and M. Henig (eds.), *Roman Life and Art in Britain*, BAR 41 (Oxford, 1977), 4–7.

7. C. H. V. Sutherland, *The Cistophori of Augustus*, Royal Numismatic Society Special Publication 5 (London, 1970).

8. S. Walker and A. Burnett, *The Image of Augustus* (London, 1981) and the handlist to the exhibition, *Augustus*, British Museum Occasional Paper 16 (London, 1981).

9. see n. 7.

10. C. C. Vermeule, *Roman Imperial Art in Greece and Asia Minor* (Cambridge, Mass., 1968), 200.

11. A. M. McCann, *The Portraits of Septimius Severus 193–211*, *MAAR*, XXX, 1968.

12. J. G. Milne, *Catalogue of Alexandrian Coins in the Ashmolean Museum* (Oxford, 1933); *British Museum Catalogue of Greek Coins* XX *Galatia, Cappadocia, and Syria* (London, 1899). For other Greek Imperial issues see other volumes of this catalogue.

13. C. H. V. Sutherland and C. M. Kraay, *Catalogue of Roman Coins in the Ashmolean Museum* I *Augustus* Oxford, 1975).

14. R. MacMullen, *Roman Government's Response to Crisis AD 235–337* (Yale, 1976), Chapter 1.
15. R. Meiggs, *Roman Ostia* (2nd edn., Oxford, 1973), 54–8 and Pl. XVIII a.
16. J. M. C. Toynbee, *The Hadrianic School* (Cambridge, 1934).
17. M. J. Price and B. L. Trell, *Coins and their Cities: Architecture on the Ancient Coins of Greece, Rome and Palestine* (London, 1977).
18. F. Imhoof-Blumer and P. Gardner, *A Numismatic Commentary on Pausanias* (London, 1887) reprinted from *JHS*, VI–VIII, 1885–7).

CHAPTER EIGHT *Pottery*

The author would like to thank Miss Catherine Johns for her help in the preparation of this chapter.

1. K. Johansen, *Acta Archaeologica* (Copenhagen) 31, 1960, 185–90. See also P. Corbett and D. Strong, *BMQ*, 23, 1961, 83 for a similar link. The common motif of cranes in a marsh, on various silver vessels (see Ill. 109), is also copied onto Arretine ware, although not directly. R. Charleston, *Roman Pottery* (London, 1955), Pl. 5A.
2. Also known as samian ware, *terra sigillata*, or by the region in which it was produced. The probable ancient name is *vasa samia*, see A. King, *Britannia*, XI, 1980, 139–43. For ancient ceramic terminology in general, see J. Hilgers, *Lateinische Gefässnamen* (Düsseldorf, 1969).
3. P. Mingazzini, *Catalogo dei Vasi della Collezione Castellani II* (Rome, 1971), 259 ff.
4. For a silver bowl similar to 'Megarian' leaf-decorated bowls, see D. Strong, *Greek and Roman Gold and Silver Plate* (London, 1966), Pl. 31A.
5. It was also made at Cincelli near Arezzo, Pisa, Pozzuoli and Lyons.
6. C. Goudineau, *Fouilles de l'École Française de Rome à Bolsena IV, La Céramique Arétine Lisse* (Paris, 1968), 317 ff.
7. The usual modern name for this pottery is samian ware in Britain and *terra sigillata* elsewhere.
8. D. Atkinson, *JRS*, IV, 1914, 27–64.
9. Also called Late Roman A and B wares, or *terra sigillata chiara* A, C and D wares.
10. J. Hayes, *Supplement to Late Roman Pottery* (London, 1980), 519–21.
11. The surface finish was often up to black-gloss standards, and is known as *firnis* or *vernis*.
12. F. Waagé dates some of the glazed sherds from Antioch to the early second century BC; *Antioch on the Orontes* IV, i, *Ceramics and Islamic Coins* (Princeton, 1948), 80.
13. Charleston (n. 1), 25.
14. R. Pirling, *Germanische Denkmäler der Völkerwanderungszeit*, Serie B, Band 2 (Berlin, 1966), Farbtafel A, from Krefeld-Gellep.
15. J. Hayes, *Late Roman Pottery* (London, 1972), 424.

CHAPTER NINE *Terracotta*

1. A. Andrén, *Architectural Terracottas from Etrusco-Italic Temples,* (Lund and Leipzig, 1940), 409.
2. A. H. Borbein, *Campanareliefs* (Heidelberg, 1968).
3. J. H. Iliffe in *Quarterly of the Department of Antiquities in Palestine* 11, 1945, 1–26.
4. G. Baroni in *Quaderni di Archeologia della Libia* 11, 1980, 35–74; D. M. Bailey in *BSA*, 67, 1972, 5–7.
5. J. W. Salomonson in *BABesch* 44, 1969, 85–98.
6. B. Kuzsinszky, *Das grosse römische Töpferviertel in Aquincum bei Budapest* (Budapest, 1932).
7. B. Soultov, *Ancient Pottery Centres in Moesia Inferior* (Sofia, 1976).
8. *Delle Antichità di Ercolano* 8 (Naples, 1792), Pls. 19, 23–4, 38–44, 49–51, 55–7, 69–72, 64–70.
9. W. B. Emery and L. P. Kirwan, *The Royal Tombs of Ballana and Qustul* 2 (Cairo, 1938), Pls. 98–102.
10. This view has been questioned recently by W. V. Harris in *JRS*, LXX, 1980, 126–45, but in the present writer's opinion the archaeological evidence for wide-scale exportation is overwhelming, despite economic arguments, which are always contentious.
11. E. Dressel in *Annali dell'Istituto* 52, 1880, 265–342; R. H. Howland, *The Athenian Agora* 4, *Greek Lamps and their Survivals* (Princeton, 1958), 102–3.
12. W. V. Harris in *JRS*, LXX, 1980, 138–42.

CHAPTER TEN *Glass*

1. The techniques of manufacture of pre-Roman and Roman vessels are described in D. B. Harden, *Arch. J.*, CXXV, 1968, 46–72, and CXXVI, 1969, 44–77, and J. Price, in D. Strong and D. Brown, *Roman Crafts* (London, 1976), 110–25.
2. D. B. Harden, *Journal of Glass Studies*, X, 1968, 21–47.
3. N. Avigad, *Israel Exploration Journal*, 22, 1972, 198–200.
4. G. Mackworth-Young, *BSA*, XLIV, 1949, Grave 20, Pl. 33.
5. G. Lehrer, *Ennion — A First Century Glassmaker* (Ramat Aviv, 1979).
6. K. S. Painter, in D. Harden *et al.*, *Masterpieces of Glass* (British Museum, London, 1968), 59, no. 74.
7. O. Kurtz, in J. Hackin, *Nouvelles recherches archéologiques à Bégram* (Paris, 1954), 102–5. P. Hamelin, *Cahiers de Byrsa*, II, 1952, 11–25; *Cahiers de Byrsa*, III, 1953, 121–8; *Cahiers de Byrsa*, IV, 1954, 153–83.
8. J. Leclant, *Journal of Glass Studies*, XV, 1973, 52–68.
9. This has been the subject of some controversy, see B. Ashmole, *JHS*, LXXXVII, 1967, 1–17; D. E. L. Haynes, *JHS*, LXXXVIII, 1968, 58–72, and of course D. E. L. Haynes, *The Portland Vase* (British Museum, London, revised edn., 1975).
10. K. S. Painter, *Journal of Glass Studies*, XVII, 1975, 54–67.
11. D. B. Harden and J. M. C. Toynbee, *Archaeologia,*

XCVII, 1959, 179–212. D. B. Harden, *Journal of Glass Studies*, V, 1963, 9–17.

12. T. E. Haevernick, *Madrider Mitteilungen*, 12, 1971, 202–4.

13. O. Doppelfeld, *Kölner Jahrbuch*, 8, 1956/7, 7–11.

14. See L. Ibrahim *et al.*, *Kenchreai, Eastern Port of Corinth II. Panels of Opus Sectile in Glass* (Leiden, 1976).

15. A very similar, though larger, head is known in the collections of the Corning Museum of Glass; see S. M. Goldstein, *Pre-Roman and Early Roman Glass in the Corning Museum of Glass* (Corning, 1979), no. 789.

16. See D. F. Grose, *Journal of Glass Studies*, XIX, 1977, 27–9.

CHAPTER ELEVEN *Epigraphy*

1. The quotations in these opening paragraphs are taken (in order) from: *res gestae divi Augusti* (*monumentum ancyranum*), column 5 line 24; *edictum Diocletiani de pretiis rerum venalium*, column 6 lines 9–10; *CIL* 6.896 (Pantheon, portico frieze); *CIL* 4.1772 (Pompeii, graffito); *CLE* 1512 lines 4 and 7 (Auch); *CIL* 6.15346 lines 3–4, 7–8 (Rome); and *CLE* 53 lines 1 and 5 (Rome).

2. *CIL* 10.7296.

3. *CIL* 6.2104*a* line 37 (Rome).

4. *AE* 1931 no. 112 (Annaba, Algeria).

5. P.Oxy. 2950.

6. *ILCV* 963 and 1997a (both Rome). Filocalus was also responsible for the calligraphy of the great calendar bearing his name, which survives in a seventeenth-century copy: on this, H. Stern, *Le Calendrier de 354* (Paris, 1953).

7. *CIL* 1^2.7.

8. For example, *RIB* 2059 (Bowness-on-Solway).

9. For example, *RIB* 1279, 1280, 1281 (all High Rochester).

10. *CIL* 1^2.797 = 6.872.

11. *CIL* 10.846.

12. *CIL* 6.960.

13. *CIL* 4.7621–2, 7625–30, 7992.

14. *CIL* 6.2068.

15. *CIL* 8.11824.

16. *CIL* 14.112.

17. *CIL* 14.2803.

18. *CIL* 6.1242+31556.

19. *CIL* 6.31402.

20. *CIL* 6.503.

21. *ILCV* 1469.

CHAPTER TWELVE *Art in Late Antiquity*

1. D. E. Strong, *Roman Art*, integrated edn. (Harmondsworth, 1980), 264.

2. J. P. C. Kent and K. S. Painter, *Wealth of the Roman World AD 300–700* (London, 1977), 159–86; J. P. C. Kent, *Roman Coins* (London, 1978), 48–62 – to Anastasius.

3. W. F. Volbach, *Early Christian Art* (London, 1961), 323, Pls. 56, 57; R. Bianchi Bandinelli, *Rome. The Late Empire* (London, 1971), 359, Fig. 340.

4. Volbach, (n. 3), 325, Pls. 69–71; A. Grabar, *Byzantium from the Death of Theodosius to the Rise of Islam* (London, 1966), 222, Fig. 247.

5. A. Ferrua, *Le pitture della nuova catacomba di Via Latina* (Rome, 1960).

6. J. M. C. Toynbee, *Animals in Roman Life and Art* (London, 1973), 252–3.

7. Volbach, (n. 3), 320, Pls. 41–3.

8. P. Metz, *Elfenbein der Spätantike* (Munich, 1962).

9. *Ibid.*, Figs. 2, 3; Volbach (n. 3), 324, Pls. 62, 63 (Monza Cathedral Treasury).

10. Metz (n. 8), Fig. 1; Volbach (n. 3), 328, Pls. 90, 91 (in the Musée de Cluny, Paris and the Victoria and Albert Museum, London respectively).

11. Kent and Painter (n. 2), 15–115.

12. R. Krautheimer, *Early Christian and Byzantine Architecture* (Harmondsworth, 1965) and *Studies in Early Christian, Medieval and Renaissance Art* (London, 1971).

13. Krautheimer in K. Weitzmann (ed.), *Age of Spirituality: A Symposium* (Metropolitan Museum of Art, New York, 1980), 121–39.

14. G. Bovini, *The Mosaics of Ravenna* (London, 1969).

15. W. Oakeshott, *The Mosaics of Rome from the third to the fourteenth centuries* (London, 1967), 73–89.

16. A. Grabar, *The Beginnings of Christian Art* (London, 1967), 209–35.

17. K. Weitzmann, *Ancient Book Illuminations* (Cambridge, Mass., 1959); *Late Antique and Early Christian Book Illumination* (London, 1977).

18. *Ibid.*, 22 and Pls. 11–14; C. Eggenberger, *Byz. Zeits.* LXX, 1977, 58–90; G. M. A. Hanfmann in Weitzmann (ed.) (n. 13), 79 and 95, n. 27 for suggestion of North Italy; M. Henig in M. W. C. Hassall and R. Ireland (eds.), *De Rebus Bellicis* BAR Int. Ser., 63 (Oxford, 1979), 17–37 gives a rather extreme case for a late fourth-century origin in Britain or Gaul.

19. C. Nordenfalk, *Celtic and Anglo-Saxon Painting: Book Illumination in the British Isles, 600–800* (London, 1977).

Select General Bibliography

The most important are Pliny the Elder's *Natural History* (*NH*); Pausanias' *Description of Greece* and Vitruvius' *On Architecture* (*De Arch.*); Petronius' *Satyricon* is also useful. All are available in both original and translation in the Loeb Classical Library. Vitruvius has also been translated under the title *The Ten Books on Architecture* by M. H. Morgan (Harvard, 1914, reissued by Dover Books, 1960), with copious explanatory diagrams and photographs.

For selected sources see J. J. Pollitt, *The Art of Greece, 1400–31 BC* (Englewood Cliffs, N.J., 1965) and *The Art of Rome c. 753 BC–337 AD* (Englewood Cliffs, N.J., 1966).

General Works on Art
Enciclopedia dell'Arte Antica Classica e Orientale, Instituto dell' Enciclopedia Italiana (Rome, 1958–66; supplement 1973) for specialist articles on a wide range of topics (abbrev. *Enc.*).

B. Andreae, *The Art of Rome* (London, 1978).

R. Bianchi Bandinelli, *Rome, The Centre of Power* (London, 1970).

R. Bianchi Bandinelli, *Rome, The Late Empire* (London, 1971).

R. Brilliant, *Roman Art from the Republic to Constantine* (London, 1974).

G. M. A. Hanfmann, *Roman Art: A Modern Survey of the Art of Imperial Rome* (London, 1964).

D. Strong, *Roman Art* (Harmondsworth, 1976, and integrated edition 1980).

J. M. C. Toynbee, *The Art of the Romans* (London, 1965).

C. C. Vermeule, *Roman Art. Early Republic to Late Empire* (Boston, 1978).

R. E. M. Wheeler, *Roman Art and Architecture* (London, 1964).

Artists and Techniques
A. Burford, *Craftsmen in Greek and Roman Society* (London, 1972).

D. Strong and D. Brown (eds.), *Roman Crafts* (London, 1972).

J. M. C. Toynbee, 'Some Notes on Artists in the Roman World', Collection Latomus, 6, 1951.

Greek Forerunners
(See also Bibliography to Chapter 1)

J. Charbonneaux, R. Martin and F. Villard, *Hellenistic Art 330–50 BC* (London, 1973).

C. M. Havelock, *Hellenistic Art* (London, 1971).

P. Levi, *Atlas of the Greek World* (Oxford, 1980).

J. Onians, *Art and Thought in the Hellenistic Age: The Greek World View 350–50 BC* (London, 1979).

M. Robertson, *A History of Greek Art* (Cambridge, 1975) and *A Shorter History of Greek Art* (Cambridge, 1981).

T. B. L. Webster, *Hellenistic Poetry and Art* (London, 1964).

T. B. L. Webster, *Hellenistic Art* (London, 1967).

Provincial Art
M. Avi-Yonah, *Art in Ancient Palestine. Selected Studies* (Jerusalem, 1981).

M. A. R. Colledge, *The Art of Palmyra* (London, 1976).

M. E. Mariën, *Belgica Antiqua. L'Empreinte de Rome* (Antwerp, 1980).

A. Perkins, *The Art of Dura-Europos* (Oxford, 1973).

J. M. C. Toynbee, *Art in Roman Britain* (London, 1962) and *Art in Britain under the Romans* (Oxford, 1964).

C. C. Vermeule, *Roman Imperial Art in Greece and Asia Minor* (Cambridge, Mass., 1968).

Roman Taste
J. H. D'Arms, *Romans on the Bay of Naples* (Cambridge, Mass., 1970).

P. Grimal, *Les Jardins Romains* (Paris, 1969).

W. F. Jashemski, *The Gardens of Pompeii. Herculaneum and the Villas Destroyed by Vesuvius* (New York, 1979).

G. M. A. Richter, *Ancient Italy. A Study of the Interrelations of its Peoples as shown in their Arts* (Ann Arbor, 1955).

A. F. Stewart, 'To Entertain an Emperor: Sperlonga, Laokoon and Tiberius at the Dinner-Table', *JRS*, LXVII, 1977, 76–90.

D. E. Strong, 'Roman Museums' in D. E. Strong (ed.), *Archaeological Theory and Practice. Essays Presented to W. F. Grimes* (London, 1973), 248–64.

J. M. C. Toynbee, *Animals in Roman Life and Art* (London, 1973).

C. C. Vermeule, *Greek Sculpture and Roman Taste. The Purpose and Setting of Graeco-Roman Art in Italy and the Greek Imperial East* (Ann Arbor, 1977).

Influence
F. Haskell and N. Penny, *Taste and the Antique: the Lure of Classical Sculpture, 1500–1900* (New Haven and London, 1981).

G. Mathew, *Byzantine Aesthetics* (London, 1963).

O. Neverov, 'Gems in the Collection of Rubens', *Burlington Magazine*, CXXI, 1979, 424–32.

W. Oakeshott, *Classical Inspiration in Medieval Art* (London, 1959).

S. Runciman, *Byzantine Style and Civilization* (Harmondsworth, 1975).

D. Talbot Rice, *Art of the Byzantine Era* (London, 1963).

D. Talbot Rice, *The Appreciation of Byzantine Art* (Oxford, 1972).

C. C. Vermeule, *European Art and the Classical Past* (Cambridge, Mass., 1964).

K. Weitzmann, *Classical Heritage in Byzantine and Near Eastern Art* (London, 1981).

Various articles in the *Journal of the Warburg and Courtauld Institutes*, which is largely devoted to the classical tradition in art, especially W. S. Heckscher, 'Relics of Pagan Antiquity in Mediaeval Settings', *Journ. Warburg and Courtauld*, 1, 1937–8, 204–20. H. Wentzel, 'Portraits "à l'Antique" on French Mediaeval Gems and Seals', *Journ. Warburg and Courtauld*, 16, 1953, 342–50.

General Historical Background

J. P. V. D. Balsdon, *Life and Leisure in Ancient Rome* (London, 1969).

D. Bowder (ed.), *Who Was Who in the Roman World* (Oxford, 1980)

T. Cornell and J. Matthews, *Atlas of the Roman World* (Oxford, 1982).

M. Crawford, *The Roman Republic* (Glasgow, 1978).

M. Grant, *The World of Rome* (London, 1960).

M. Grant, *The Climax of Rome* (London, 1968).

N. G. L. Hammond and H. H. Scullard, *The Oxford Classical Dictionary* (2nd edn., Oxford, 1970).

A. H. McDonald, *Republican Rome* (London, 1966).

F. Millar, *The Roman Empire and its Neighbours* (London, 1967; 2nd edn., 1981).

R. M. Ogilvie, *Roman Literature and Society* (Harmondsworth, 1980).

J. Vogt, *The Decline of Rome* (London, 1967).

CHAPTER ONE
Early Roman Art

A. Andrén, *Architectural Terracottas from Etrusco-Italic Temples* (Lund, 1939–40).

M. Blake, *Ancient Roman Construction in Italy from the Prehistoric Period to Augustus* (Washington, 1947).

R. Bloch, *The Origins of Rome* (London, 1960).

A. Boëthius, *Etruscan and Early Roman Architecture* (Harmondsworth, 2nd edn., 1978).

F. Boitani *et al.*, *Etruscan Cities* (London, 1975).

O. J. Brendel, *Etruscan Art* (Harmondsworth, 1978).

A. C. Brown, *Ancient Italy before the Romans* (Ashmolean Museum, Oxford, 1980).

F. Coarelli, *Guida Archeologica di Roma* (Milan, 1974).

B. M. Felletti Maj, *La tradizione italica nell' arte romana* (Rome, 1977).

E. Gjerstad, *Early Rome*, I–VI (Lund, 1953–73).

P. Gros, *Architecture et société à Rome et en Italie centro-méridionale aux deux derniers siècles de la République* (Brussels, 1978).

E. Langlotz and M. Hirmer, *The Art of Magna Graecia* (London, 1965).

M. Pallottino, *Etruscan Painting* (Geneva, 1952).

M. Pallottino, *Civiltà artistica etrusco-italica* (Florence, 1971).

E. H. Richardson, 'The Etruscan origins of Roman sculpture', *MAAR*, XXI, 1953, 75–124.

G. M. A. Richter, *Ancient Italy* (Ann Arbor, 1955).

Roma Medio Repubblicana (exhibition catalogue, Rome, 1973).

H. H. Scullard, *The Etruscan Cities and Rome* (London, 1967).

M. Sprenger and G. Bartoloni, *Die Etrusker; Kunst und Geschichte* (Munich, 1977).

O. Vessberg, *Studien zur Kunstgeschichte der römischen Republik* (Lund and Leipzig, 1941).

In addition, *ANRW*, 1, 4 (Berlin and New York, 1973) contains a number of articles dealing with early Roman art. See in particular O.–W. v. Vacano, 'Vulca, Rom und die Wölfin'; L. Bonfante Warren, 'Roman costumes: a glossary, and some Etruscan derivations'; J. D. Breckenridge, 'The origins of Roman Republican portraiture'; L. Crema, 'L'Architettura romana nell'età della Repubblica'.

CHAPTER TWO
Architecture

General

A. Boëthius, *Etruscan and Early Roman Architecture* (2nd edn., revised by R. Ling and T. Rasmussen, Harmondsworth, 1978).

A. Boëthius and J. B. Ward-Perkins, *Etruscan and Roman Architecture* (Harmondsworth, 1970).

L. Crema, *L'architettura romana*, Enciclopedia Classica, III, vol. 12, 1 (Turin, 1959).

D. R. Dudley, *Urbs Roma* (London, 1967).

W.L. MacDonald, *The Architecture of the Roman Empire, I: an introductory study* (New Haven and London, 1965).

E. Nash, *Pictorial Dictionary of Ancient Rome* (2nd edn., 2 vols., London, 1968).

H. Plommer, *Ancient and Classical Architecture* (Simpson's History of Architectural Development, I), (London, 1956).

D. S. Robertson, *A Handbook of Greek and Roman Architecture* (Cambridge, 1945).

R. E. M. Wheeler, *Roman Art and Architecture* (London, 1964).

J. B. Ward-Perkins, *Roman Architecture* (New York, 1977).

Construction and Design

S. Aurigemma, *Villa Adriana* (Rome, 1962).

M. E. Blake, *Ancient Roman Construction in Italy from the Prehistoric Period to Augustus* (Washington D. C., 1947).

M. E. Blake, *Roman Construction in Italy from Tiberius through the Flavians* (Washington D. C., 1959).

M. E. Blake and D. Taylor Bishop, *Roman Construction in Italy from Nerva through the Antonines* (Philadelphia, 1973).

H. Bloch, *I bolli laterizi e la storià dell'edilizia romana* (Rome, 1947).

A. Boëthius, *The Golden House of Nero* (Ann Arbor, 1960).

G. Calza *et al.*, *Scavi di Ostia*, I (Rome, 1953).

K. de Fine Licht, *The Rotunda in Rome: a Study of Hadrian's Pantheon* (Copenhagen, 1966).

R. Delbrueck, *Hellenistische Bauten in Latium* (2 vols., Strasbourg, 1907, 1912).

F. Fasolo and G. Gullini, *Il Santuario di Fortuna Primigenia a Palestrina* (Rome, 1953).

C. F. Giuliani, 'Volte e Cupola a doppia calotta in età adrianea', *Röm. Mitt.* 82.2, 1975, 329–42.

G. Lugli, *La tecnica edilizia romana con particolare riguardo a Roma e Lazio* (2 vols., Rome, 1957).

W. L. MacDonald, *The Pantheon. Design, Meaning, and Progeny* (London, 1976).

H. Plommer, *Vitruvius and Later Roman Building Manuals* (Cambridge, 1973).

G. Wataghin Cantino, *La Domus Augustana* (Turin, 1966).

Materials and Decoration

A. Andrén, *Architectural Terracottas from Etrusco-Italic Temples* (Lund and Leipzig, 1940).

T. F. C. Blagg, 'The Use of Terracotta for Architectural Ornament in Italy and the Western Provinces', in A. McWhirr, *Roman Brick and Tile*, BAR Int. Ser., 68 (Oxford, 1979), 267–84.

P. H. von Blanckenhagen, *Flavische Architektur und ihre Dekoration* (Berlin, 1940).

A. H. Borbein, *Campanareliefs: typologische und stilkritische Untersuchungen, Röm. Mitt.*, Ergänzungsheft 14 (Heidelberg, 1968).

R. Gnoli, *Marmora Romana* (Rome, 1971).

W.-D. Heilmeyer, *Die Korinthische Normalkapitelle, Röm. Mitt.*, Ergänzungsheft 16 (Heidelberg, 1970).

C. F. Leon, *Die Bauornamentik des Trajansforums und ihre Stellung* (Vienna and Cologne, 1971).

M. B. Lyttelton, *Baroque Architecture in Classical Antiquity* (London, 1974).

D. E. Strong, 'Late Hadrianic Ornament in Rome', *PBSR*, XXI, 1953, 118–51.

D. E. Strong, 'Some Observations on Early Roman Corinthian', *JRS*, LIII, 1963, 73–84.

J. B. Ward-Perkins, 'Tripolitania and the Marble Trade', *JRS*, XLI, 1951, 89–104.

Architects and Architecture

C. Promis, *Gli architetti e l'architettura presso i Romani* (Turin, 1871).

E. Rawson, 'Architecture and Sculpture: the activities of the Cossutii', *PBSR*, XLIII, 1975, 36–47.

D. E. Strong, 'The Administration of Public Building in Rome during the Late Republic and Early Empire', *Bull. Inst. Class. Stud.*, 15, 1968, 97–109.

J. M. C. Toynbee, 'Some Notes on Artists in the Roman World', Collection Latomus, 6, 1951, 9–15.

Vitruvius, *De Architectura*, English translation by M. H. Morgan (Cambridge, 1914).

Types of Building and Provincial Architecture

E. Akurgal, *Ancient Civilizations and Ruins of Turkey* (Istanbul, 1970).

R. Bianchi Bandinelli, E. V. Caffarelli and G. Caputo, *The Buried City. Excavations at Leptis Magna* (London, 1966).

A. García y Bellido, *Arte romano* (2nd edn., Madrid, 1972).

M. Bieber, *The History of the Greek and Roman Theater* (2nd edn., Princeton, 1961).

T. F. C. Blagg, 'Civilian and Military Architecture in the Province of Britain: Aspects of Patronage, Influence and Craft Organisation', *World Archaeology*, 12.1, 1980, 27–42.

A. Giuliano, *La cultura artistica delle province della Grecia in età romana* (Rome, 1965).

A. Grenier, *Manuel d'archéologie gallo-romaine*, III: *L'Architecture* (Paris, 1958) and IV: *Les Monuments des eaux* (Paris, 1960).

J. Hanson, *Roman Theater-Temples* (Princeton, 1959).

D. M. Krencker and W. Zschietzschmann, *Römische Tempel in Syrien* (Berlin, 1938).

A. Lézine, *Architecture romaine d' Afrique* (Tunis [1961]).

A. G. McKay, *Houses, Villas and Palaces in the Roman World* (London, 1975).

J. Percival, *Roman Villas* (London, 1976).

S. Stucchi, *Architettura cirenaica* (Rome, 1975).

K. M. Swoboda, *Römische und romanische Palaste* (Vienna, 1924).

J. B. Ward-Perkins. 'The Roman West and the Parthian East', *Proc. Brit. Acad.*, II, 1965.

J. B. Ward-Perkins, 'From Republic to Empire: Reflections on Early Provincial Architecture in the Roman West', *JRS*, LX, 1970, 1–19.

CHAPTER THREE
Sculpture

Apart from works cited, the great international corpus of sculpture of the Roman World, the *Corpus Signorum Imperii Romani*, started in 1963, the catalogues of Roman sculpture in various European and American museums and collections, and monographs on portraiture of single emperors or dynasties as well as monographs on individual sculptured architectural monuments may be consulted.

General Works on Sculpture

P. E. Arias, *La Scultura Romana* (Messina, 1943).

R. Bianchi Bandinelli, *Storicità dell'Arte Classica* (second edn., Florence. 1950).

G. Bauchhenss and P. Noelke, *Die Jupitersäulen in den Germanischen Provinzen* (Cologne and Bonn, 1981).

M. Bieber, *Ancient Copies. Contributions to the History of Greek and Roman Art* (New York, 1977).

R. Brilliant, *Gesture and Rank in Roman Art* (New Haven, 1963).

E. Espérandieu, *Recueil Général des Bas-Reliefs de la Gaule Romaine*, I (Paris, 1907) – XV (Paris, 1966).

E. Espérandieu, *Recueil Général des Bas-Reliefs, Statues et Bustes de la Germanie Romaine* (Paris and Brussels, 1931).

M. Floriani Scuarciapino, *La Scuola di Afrodisias* (Rome, 1943).

A. Frova, *L'Arte di Roma e del mondo romano* (Turin, 1961).

A. García y Bellido, *Esculturas Romanas de España y Portugal* (Madrid, 1949).

A. W. Lawrence, *Greek and Roman Sculpture* (London, 1972).

H. P. L'Orange, *Art Forms and Civic Life in the Late Roman Empire* (Princeton, 1965).

H. P. L.'Orange, *Studies on the Iconography of Cosmic Kingship in the Ancient World* (Oslo, 1953).

C. Robert *et al.*, *Die antiken Sarkophagreliefs* (Berlin, 1890–1980).

H. Sichtermann and G. Koch, *Griechische Mythen auf römischen Sarkophagen* (Tübingen, 1975).

E. Strong, *Roman Sculpture* (London, 1907).

J. M. C. Toynbee, *The Hadrianic School. A Chapter in the History of Greek Art* (Cambridge, 1934).

C. C. Vermeule, *Roman Imperial Art in Greece and Asia Minor* (Cambridge, Mass., 1968).

C. C. Vermeule, *Greek Sculpture and Roman Taste. The Purpose and Setting of Graeco-Roman Art in Italy and the Greek Imperial East* (Ann Arbor, 1977).

C. C. Vermeule, 'Greek and Roman Sculpture from the Northern Coasts of the Black Sea (chiefly Russia), *Burlington Magazine*, CXIX, 1977, 810–18.

C. C. Vermeule and K. Anderson, 'Greek and Roman Sculpture in the Holy Land', *Burlington Magazine*, CXXIII, 1981, 7–19.

State Reliefs

E. Courbaud, *Le bas-relief romain à représentations historiques* (Paris, 1899).

P. G. Hamberg, *Studies in Roman Imperial Art. The State Relief of the Second Century* (Copenhagen, 1945).

I. S. Ryberg, *Rites of the State Religion in Roman Art*, *MAAR*, XXII, 1955.

D. Strong, *Roman Imperial Sculpture* (London, 1961).

Portraiture

M. Bergmann, *Studien zum römischen Porträt des 3. Jahrhunderts n. Chr.* (Bonn, 1977).

J. J. Bernoulli, *Römische Ikonographie* (Stuttgart, 1882–94).

R. Bianchi Bandinelli, 'Il Ritratto', *Enc.*, VI, 695–738.

A. Bonanno, *Portraits and other Heads on Roman Historical Relief up to the Age of Septimius Severus*, BAR Int. Ser., 6 (Oxford, 1976).

R. Calza, *Iconografia romana imperiale da Carausio a Giuliano (287–363 d.C.)* (Rome, 1972).

L. Goldscheider, *Roman Portraits* (London, 1940).

G. M. A. Hanfmann, *Observations on Roman Portraiture* (Brussels, 1953).

A. Hekler, *Greek and Roman Portraits* (London, 1912, reprinted New York, 1972).

R. P. Hinks, *Greek and Roman Portrait Sculpture* (British Museum, London, 1935; second edition, 1976).

H. P. L'Orange, *Apotheosis in Ancient Portraiture* (Oslo, 1947).

E. Paribeni, *Il Ritratto nell'Arte Antica* (Milan, 1934).

V. Poulsen, *Les portraits romains*, I–II (Copenhagen, 1962–74).

G. M. A. Richter, *Roman Portraits* (Metropolitan Museum New York, 1948).

B. Schweitzer, *Die Bildniskunst der römischen Republik* (Leipzig and Weimar, 1948).

R. R. R. Smith, 'Greeks, Foreigners, and Roman Republican Portraits', *JRS*, LXXI, 1981, 24–38.

J. M. C. Toynbee, *Roman Historical Portraits* (London, 1978).

R. West, *Römische Porträt-Plastik* (Munich, 1933).

Bronzes

S. Boucher, *Recherches sur les Bronzes Figurés de Gaule Pré-Romaine et Romaine* (École Française de Rome, 1976).

Dossiers de l'archéologie, no. 28, May-June 1978 'Les Bronzes de l'Occident Romain'.

E. Espérandieu and H. Rolland, *Bronzes Antiques de la Seine-Maritime*, Supplement XIII to *Gallia* (Paris, 1959).

G. Faider-Feytmans, *Recueil des Bronzes de Bavai*, Supplement VIII to *Gallia* (Paris, 1957).

G. Faider-Feytmans, *Les Bronzes Romains de Belgique* (Mainz, 1979).

R. Fleischer, *Die römischen Bronzen aus Österreich* (Mainz, 1967).

V. Galliazzo, *I bronzi romani del Museo Civico di Treviso* (Rome, 1979).

A. Kaufmann-Heinimann, *Die römischen Bronzen der Schweiz* I *Augst* (Mainz, 1977).

K. Kluge and K. Lehmann-Hartleben, *Die antiken Grossbronzen* II (Berlin and Leipzig, 1927).

W. Lamb, *Ancient Greek and Roman Bronzes* (London, 1929; revised edn. Chicago, 1969).

A. Leibundgut, *Die römischen Bronzen der Schweiz* II *Avenches* (Mainz, 1976).

A. Leibundgut, *Die römischen Bronzen der Schweiz* III *Westschweiz, Bern und Wallis* (Mainz, 1980).

H. Menzel, *Die römischen Bronzen aus Deutschland* I *Speyer* (Mainz, 1960).

H. Menzel, *Die römischen Bronzen aus Deutschland* II *Trier* (Mainz, 1966).

L. Pitts, *Roman Bronze Figurines from the Civitates of the Catuvellauni and Trinovantes*, BAR, 60 (Oxford, 1979).

H. Rolland, *Bronzes Antiques de Haute Provence*, Supplement XVIII to *Gallia* (Paris, 1965).

A. N. Zadoks-Josephus Jitta, W. J. T. Peters and W. A. van Es, *Roman Bronze Statuettes from the Netherlands* I *Statuettes Found North of the Limes* (Groningen, 1967).

A.N. Zadoks-Josephus Jitta, W. J. T. Peters and W. A. van Es, *Roman Bronze Statuettes from the Netherlands* II *Statuettes Found South of the Limes* (Groningen, 1969).

CHAPTER FOUR
Wall Painting and Stucco

Italy

a) Wall Painting

As the literature is so extensive, only a selection of the most recent and most useful publications is included here. Many other works are listed in their bibliographies, and illustrations of most of the paintings cited can

be found in M. Borda, *La Pittura Romana*.

S. Augusti, *I Colori Pompeiani* (Rome, 1967).

F. L. Bastet and M. de Vos, *Proposta per una classificazione del terzo stile pompeiano* (Arch. Studien. van het Nederlands Instituut te Rome; The Hague, 1979).

H. G. Beyen, *Die pompejanische Wanddekoration vom zweiten bis zum vierten Stil* (The Hague, vol. I 1938, vol. II 1960).

P. H. von Blanckenhagen and C. Alexander, *The Paintings from Boscotrecase* Mitt. Deutsches arch. Inst. röm. Abt, Ergänzungsheft 6 (Heidelberg, 1962).

P. H. von Blanckenhagen, 'The Odyssey Frieze', *Röm. Mitt.*, 70, 1963, 100–46.

M. Borda, *La Pittura Romana* (Milan, 1958).

P. du Bouguet, *Early Christian Painting* (London, 1965).

A. Carandini, *Schiavi e padroni nell'Etruria romana: La Villa di Sette Finestre dallo scavo alla mostra* (Bari, 1979).

J. M. Croisille, 'Natures Mortes dans la Peinture Pompéienne', *Archéologia*, no. 54, Jan. 1973, 17–24.

W. Dorigo, *Late Roman Painting* (London, 1971). *Dossiers de l'Archéologie*, no. 19. Nov.-Dec. 1976, 'Catacombes juives et chrétiennes'.

O. Elia, *Pittura di Stabia* (Naples, 1951).

M. M. Gabriel, *Masters of Campanian Painting* (New York, 1952).

M. M. Gabriel, *Livia's Garden Room at Prima Porta* (New York, 1955).

A. Grabar, *Christian Iconography and a Study of its Origins* (London, 1969).

M. Gough, *The Early Christians* (London, 1961).

M. Gough, *Origins of Christian Art* (London, 1973).

W. F. Jashemski, *The Gardens of Pompeii, Herculaneum and the Villas destroyed by Vesuvius* (New York, 1979).

K. Lehmann, 'Ignorance and Search in the Villa of the Mysteries', *JRS*, LII, 1962, 62–8.

P. W. Lehmann, *Roman Wall Paintings from Boscoreale in the Metropolitan Museum of Art* (Cambridge, Mass., 1953).

R. Ling, 'Studius and the Beginnings of Roman Landscape Painting', *JRS*, LXVII, 1977, 1–16.

A. Maiuri, *Roman Painting* (Geneva, 1953).

R. Meiggs, *Roman Ostia* (2nd edn., Oxford, 1973), 436–46.

Sister Charles Murray, *Rebirth and Afterlife. A Study of the Transmutation of some Pagan Imagery in Early Christian Funerary Art*, BAR Int. Ser. 100 (Oxford, 1981).

W. J. T. Peters, *Landscape in Romano-Campanian Mural Painting* (Assen, 1963).

G. C. Picard, *Roman Painting* (London, 1970).

G. M. A. Richter, *Perspective in Greek and Roman Art* (London [1970]), 49–55.

K. Schefold, *Pompejanische Malerei, Sinn and Ideengeschichte* (Basel, 1952).

K. Schefold, *Vergessenes Pompeji. Unveröffentliche Bilder römischer Wanddekorationen in geschichtlicher Folge herausgegeben* (Bern and Munich, 1962).

K. Schefold, *La peinture pompéienne. Essai sur l'évolution de sa signification*, Collection Latomus, 108 (Brussels, 1972).

J. Stevenson, *The Catacombs* (London, 1978).

M. L. Thompson, 'Monumental and Literary Evidence for Programmatic Painting', *Marsyas*, IX, 1960–1, 36–77.

J. M. C. Toynbee and J. Ward-Perkins, *The Shrine of St. Peter and the Vatican Excavations* (London, 1956).

F. Wirth, *Römische Wandmalerei vom Untergang Pompejis bis ans Ende des Dritten Jahrhunderts* (Darmstadt, 1968).

b) Stucco

N. Blanc, 'Le décor de stuc dans l'art romain', *Archéologia*, no. 138, Jan. 1980, 48–53.

R. Ling, 'Stucco Decoration in Pre-Augustan Italy', *PBSR*, XL, 1972, 11–57.

R. Ling, 'Stucco Decorations at Baia', *PBSR*, XLV, 1977, 24–51.

R. Ling, 'The Stanze di Venere at Baia', *Archaeologia* CVI, 1979, 33–60.

H. Mielsch, *Römische Stuckreliefs* (Heidelberg, 1975).

D. Strong and D. Brown, *Roman Crafts* (London, 1976), 109–221.

E. L. Wadsworth, 'Stucco Reliefs of the First and Second Centuries still Extant at Rome', *MAAR*, IV, 1924, 9–102.

Wall Painting in the Western Empire

Africa

S. Aurigemma, *L'Italia in Africa. Le Scoperte Archeologiche. Tripolitania. I. ii. La Pittura d'Età Romana* (Rome 1962).

Austria

H. Kenner, in R. Egger, 'Die Ausgrabungen auf dem Magdalensberg', *Carinthia* I, no. 153, 1963; I, no. 156, 1966.

H. Kenner, in H. Vetters and G. Piccottini (eds.), *Magdalensberg–Grabungsbericht, 14, 1973–4* (Klagenfurt, 1980), 143–80.

C. Praschniker and H. Kenner '*Die Wandmalereien und Stuckdekorationen*' – *Der Bäderbezik vòn Virunum* (Vienna, 1947), 173–235.

Britain

B. Cunliffe, *Excavations at Fishbourne 1961–1969*, II, *The Finds*, Society of Antiquaries of London Research Report XXVII (Leeds, 1971), 50–82.

N. Davey, 'The Conservation of Romano-British Painted Plaster', *Britannia*, III, 1972, 251–68.

N. Davey and R. Ling, *Wall-Paintings in Roman Britain*, Britannia Monograph 3 (London, 1981).

J. Liversidge, *Britain in the Roman Empire* (London, 1968).

J. Liversidge, in J. Munby and M. Henig (eds.) *Roman Life and Art in Britain* (i), BAR 41 (i) (Oxford, 1977), 75–103.

J. Liversidge in A. L. F. Rivet (ed.) *The Roman Villa* (London, 1969), 127–53.

J. Liversidge, in I. M. Stead, *Rudston Roman Villa* (Yorkshire Archaeological Society, Leeds, 1980), 139–45.

J. Liversidge, in I. M. Stead, *Excavations at Winterton Roman Villa* (London, 1976), 272–87.

J. Liversidge, in S. S. Frere, *Verulamium*, III, Society of Antiquaries of London Research Report (London, forthcoming).

J. Liversidge, in G. W. Meates, *The Roman Villa at Lullingstone*, II (forthcoming).

G. W. Meates, *Lullingstone Roman Villa* (London, 1955).

France

A. Barbet, 'Peintures de second style "schématique" en Gaule et dans l'Empire Romain', *Gallia*, XXVI, 1968, 146–76.

A. Barbet, 'Peintures murales de Mercin-et-Vaux (Aisne): Étude comparée', *Gallia*, XXXII, 1974, 107–35; XXXIII, 1975, 95–115.

A. Barbet, *Recueil Général des Peintures Murales de la Gaule* I *Narbonnaise i Glanum*, Éditions du Centre Nationale de la Recherche scientifique (Paris, 1974).

A. Blanchet, *Étude sur la décoration des édifices de la Gaule romaine* (Paris, 1913).

R. Forrer, *Argentorate* II (Strasbourg, 1927).

Germany

F. G. Andersen, 'Eine römische Wanddekoration aus Mainz', *Mainzer Zeitschrift*, LXXIII/IV, 1977, 293–9.

D. Baatz, 'Wandmalereien aus dem Limes-Kastell Eckzell', *Germania*, XLV, 1968, 40–52.

O. Doppelfeld, 'Von Postumus zu Konstantin'. *Wallraf-Richartz-jahrbuch*, XVIII, 1956, 17–26.

T. K. Kempf, 'Konstantinische Deckenmalerei aus dem Trierer Dom', *Trierer Zeitschrift*, XIX, 1950, 45–51.

T. K. Kempf, 'Das Haus der heiligen Helena', *Neues Trier Jahrb.* (Trier, 1978).

A. Linfert, *Römische Wandmalerei der nordwestlichen Provinzen*, Römisch-Germanisches Museum, Cologne, 1975.

K. Parlasca, *Römische Wandmalereien in Augsburg* (Munich, 1956).

W. Reusch, 'Wandmalereien und Mosaikboden eines Peristylhauses im Bereich der Trierer Kaiser-thermen', *Trierer Zeitschrift*, XXIX, 1966, 187–235.

W. Schleiermacher, *Cambodunum-Kempten* (Bonn, 1972).

Hungary

H. Brandenstein, 'Wandmalerei aus Carnuntum', *Carnuntum Jahrbuch*, 1958, 10–29; 1961/2, 5–21.

L. Nagy, 'Die römisch-pannonische dekorative Malerei' *Röm. Mitt.*, XLI, 1926, 79–131.

E. B. Thomas, *Römische Villen in Pannonien* (Budapest, 1964).

Netherlands

J. H. F. Bloemers, 'Wandmalereien aus der römischen Siedlung te Rijswijk', *Festoen Bussum*, 1976, 75–108.

J. E. Bogaers, *De Gallo–Romeinse Tempels te Elstin de Over Betuwe* (The Hague, 1955).

W. J. Peters, 'Mural Painting Fragments found in the Roman Castra at Nijmegen' *Berichten van de Rijksdienst voor het Oudheidkundig Bodemonderzoek*, 4, XV–XVI, 1965-6, 113–44; XIX, 1969, 53–91; XXIX, 1979, forthcoming.

Switzerland

W. Drack, *Die römische Wandmalerei der Schweiz* (Basle, 1950).

B. Kapossy, *Römische Wandmalerei aus Münsingen und Holstein* (Berne, 1966).

The Eastern Empire

M. Colledge, *The Art of Palmyra* (London, 1976).

C. Kraeling, Excavations at Dura-Europos, VIII, 1, *The Synagogue* (New Haven, 1956).

A. Perkins, *Art of Dura-Europos* (Oxford, 1973).

T. A. S. Tinkoff-Utechin, 'Ancient Painting from South Russia: The Rape of Persephone at Kerch', *Inst. of Classical Studies Bulletin*, XXVI, 1979, 13–26.

Mummy-Portraits

K. Parlasca, *Mumienporträts und verwandte Denkmäler*, Deutsches Archäologisches Institut (Wiesbaden, 1966).

A. F. Shore, *Portrait Painting from Roman Egypt* (London, 1962, revised edition 1972).

CHAPTER FIVE
Mosaics

M. A. Alexander and M. Ennaïfer, *Corpus des Mosaïques de Tunisie I: Utique* (Tunis, 1973).

M. A. Alexander, *et al.*, *Corpus des Mosaïques de Tunisie III: Utique* (Tunis, 1976).

F. Baratte, *Mosaïques Romaines et Paléochrétiennes du Louvre* (Paris, 1978).

X. Barral I Altet, *Les Mosaïques Romaines et Médiévales de la Regio Laietana: Barcelona* (Barcelona, 1978).

G. Becatti, *Scavi di Ostia IV: Mosaici e Pavimenti Marmorei* (Rome, 1961).

C. Belz, *Marine Genre Mosaic Pavements of North Africa* (Ph. D. dissertation, Univ. of California, Los Angeles; University Microfilms International, Ann Arbor, Michigan, and London, 1981).

M. E. Blake, 'The pavements of the Roman buildings of the Republic and early Empire', *MAAR*, VIII, 1930, 7–159.

M. E. Blake, 'Roman mosaics of the second century in Italy', *MAAR*, XVI, 1936, 67–124.

M. E. Blake, 'Mosaics of the late Empire in Rome and vicinity', *MAAR*, XIII, 1940, 31–120.

M. Blanchard-Lemée, *Maisons à Mosaïques du Quartier Central de Djemila (Cuicul)* (Paris, 1975).

A. Carandini, *Ricerche sullo Stile e la Cronología della Villa di Piazza Armerina* (Rome, 1964).

M. Chehab, *Mosaïques du Liban* (Paris, 1958).

J. R. Clarke, *Roman Black-and-White Figural Mosaics* (New York, 1979).

B. Cunliffe, *Excavations at Fishbourne 1961–1969* (London, 1971).

C. Dulière, *et al.*, *Corpus des Mosaïques de Tunisie II: Utique* (Tunis, 1974).

K. M. D. Dunbabin, *The Mosaics of Roman North Africa* (Oxford, 1978).

R. Farioli Campanati (ed.), *Atti del III Colloquio*

Internazionale sul Mosaico Antico (Ravenna, forth-coming).

D. Fernández-Galiano, 'Notas sobre talleres musivarios en Hispania', *Anales de Historia Antigua y Medieval* (Buenos Aires), 20, 1980, 100–50.

L. Foucher, *Inventaire des Mosaïques ... Sousse* (Tunis, 1960).

A. B. Freijeiro, *Corpus de Mosaicos Romanos en España 1: Mérida* (Madrid, 1978).

A. B. Freijeiro, *Corpus de Mosaicos Romanos en España 2: Italica* (I) (Madrid, 1978).

G. V. Gentili, *La Villa Erculia di Piazza Armerina: I Mosaici Figurati* (Rome, 1959).

S. Germain, *Les Mosaïques de Timgad* (Paris, 1969).

V. von Gonzenbach, *Die Römischen Mosaiken der Schweiz* (Basel, 1961).

H. Kähler, *Die Villa des Maxentius bei Piazza Armerina* (Berlin, 1973).

A. Kiss, *Roman Mosaics in Hungary* (Budapest, 1973).

I. Lavin, 'The hunting mosaics of Antioch and their sources', *DOP*, 17, 1963, 180–286.

D. Levi, *Antioch Mosaic Pavements* (Princeton, London, The Hague, 1947).

D. Levi *et al.*, *Mosaico e Mosaicisti nell'Antichità* (abstracts from the *Enciclopedia dell'Arte Antica, Classica e Orientale*; Rome, 1967).

M. L. Morricone Matini, *Mosaici Antichi in Italia: Regio I-Roma: Regio X-Palatium* (Rome, 1967).

D. S. Neal, *Roman Mosaics in Britain: an Introduction to their Schemes and a Catalogue of Paintings* (Gloucester, 1981).

K. Parlasca, *Die Römischen Mosaiken in Deutschland* (Berlin, 1959).

E. Pernice, *Hellenistische Kunst in Pompeii VI: Pavimente und Figürliche Mosaiken* (Berlin, 1938).

G. Picard and H. Stern (eds.), *La Mosaique Gréco-Romaine* (Paris, 1965).

Recueil des Mosaïques de la Gaule (Paris, 1957–).

J. W. Salomonson, *La Mosaïque aux Chevaux de l'Antiquarium de Carthage* (The Hague, 1965).

D. J. Smith, 'Three fourth-century schools of mosaic in Roman Britain', *MGR* I (see Picard), 95–114.

D. J. Smith, 'The mosaic pavements', Ch. 3, pp. 71–125, in A.L.F. Rivet (ed.), *The Roman Villa in Britain* (London, 1969).

D. J. Smith, 'Roman mosaics in Britain before the fourth century', *MGR* II (see Stern), 269–89.

D. J. Smith, 'Mythological figures and scenes in Romano-British mosaics', Ch. 6, pp. 105–93, in J. Munby and M. Henig (eds.), *Roman Life and Art in Britain*, BAR 41 (Oxford, 1977).

D. J. Smith, 'Roman mosaics in Britain: a synthesis', in R. Farioli Campanati (q.v.).

H. Stern and M. Leglay (eds.), *La Mosaïque Gréco-Romaine* II (Paris, 1975).

CHAPTER SIX
The Luxury Arts

Silver Plate

D. E. Strong, *Greek and Roman Gold and Silver Plate* (London, 1966).

J. P. C. Kent and K. S. Painter, *Wealth of the Roman World AD 300–700*, British Museum (London, 1977).

A. Oliver, *Silver for the Gods. 800 Years of Greek and Roman Silver* (Toledo, Ohio, 1977).

Furniture

G. M. A. Richter, *The Furniture of the Greeks, Etruscans and Romans* (London, 1966).

Gems

A. Furtwängler, *Die antiken Gemmen* (Berlin and Leipzig, 1900).

M. Henig, *A Corpus of Roman Engraved Gemstones from British Sites*, BAR 8 (Oxford, 2nd edn., 1978).

G. M. A. Richter, *Engraved Gems of the Romans* (London, 1971).

M. L. Vollenweider, *Die Steinschneidekunst und Ihre Künstler in Spätrepublikanischer und Augusteischer Zeit* (Baden-Baden, 1966).

M. L. Vollenweider, *Die Porträtgemmen der römischen Republik*, catalogue (Mainz, 1972); text (Mainz, 1974).

Jewellery

R. Higgins, *Greek and Roman Jewellery* (London, 1961, 2nd edn., 1980).

F. H. Marshall, *Catalogue of the Jewellery, Greek, Etruscan and Roman in the Department of Antiquities, British Museum* (London, 1911, reprinted 1969).

B. Pfeiler, *Römischer Goldschmuck des ersten und zweiten Jahrhunderts n. Chr. nach datierten Funden* (Mainz, 1970).

Vessels of Precious Stone

H. P. Bühler, *Antike Gefässe aus Edelsteinen* (Mainz, 1973).

Amber

D. E. Strong, *Catalogue of the Carved Amber in the Department of Greek and Roman Antiquities, British Museum* (London, 1966).

General

Dossiers de l'archéologie, no. 28, May–June 1978, 'Les Bronzes de l'Occident Romain' (articles by F. Baratte and S. Tassinari on bronze vessels and L. Lerat on *fibulae*).

J. M. C. Toynbee, *Art in Britain under the Romans* (Oxford, 1964), Chapters VII, VIII and X.

J. Ward-Perkins and A. Claridge, exhibition catalogue, *Pompeii AD 79* (London 1977, New York 1978).

G. Zahlhaas, *Römische Reliefspiegel* (Munich, 1975).

CHAPTER SEVEN
Coins and Medals

M. Crawford, *Roman Republican Coinage* (Cambridge, 1974).

J. P. C. Kent, *Roman Coins* (London, 1978).

C. H. V. Sutherland, *Roman Coins* (London, 1974).

J. M. C. Toynbee, *Roman Medallions*, Numismatic Studies V (New York, 1944).

For reference

H. Mattingly and R. A. G. Carson, *Coins of the Roman Empire in the British Museum*, vols. I–VI (London, 1923–64).

H. Mattingly, E. A. Sydenham, C. H. V. Sutherland and R. A. G. Carson, *Roman Imperial Coinage*, vols. I–IX (X is forthcoming) (London, 1923–81).

CHAPTER EIGHT
Pottery

General

R. J. Charleston, *Roman Pottery* (London, 1955).

M. Beltran Lloris, *Ceramica Romana* (Zaragoza, 1979).

Techniques

D. Brown, in D. Strong and D. Brown (ed.), *Roman Crafts* (London, 1976), Chapter 6.

M. Picon, *Introduction à l'Étude Technique des Céramiques Sigillées de Lezoux* (Dijon, 1973).

A. Winter, *Die Antike Glanztonkeramik. Praktische Versuche* (Mainz, 1978).

Pottery during the Republic

P. Mingazzini, *Catalogo dei Vasi della Collezione Castellani II* (Rome, 1971).

M. Moeus, 'Italo-Megarian Ware at Cosa', *MAAR*, XXXIV, 1980, 161–227.

R. Pagenstecher, 'Die Calenische Reliefkeramik', *JDAI, Ergänzungsheft* 8 (Berlin, 1909).

G. Siebert and J.–P. Morel, *Annales Littéraires de l'Université de Besançon* 242, 1980, 55–83, 85–122.

Arretine Pottery

(a) Catalogues

A. C. Brown, *Catalogue of Italian Terra Sigillata in the Ashmolean Museum* (Oxford, 1968).

G. H. Chase, *The Loeb Collection of Arretine Pottery* (New York, 1908).

G. H. Chase, *Catalogue of Arretine Pottery* (Museum of Fine Arts), (Boston, 1916).

Corpus Vasorum Antiquorum, USA fasc. 9 Metropolitan Museum New York fasc. 1 (Harvard, 1943).

H. Dragendorff and C. Watzinger, *Arretinische Reliefkeramik* (Reutlingen, 1948).

A. Oxé and H. Comfort, *Corpus Vasorum Arretinorum* (Bonn, 1968).

A. Stenico, *La Ceramica Arretina* I and II (Varese, 1960, 1966).

(b) Articles

C. Goudineau, *Annales Littéraires de l'Université de Besançon*, 242, 1980, 122–33.

A. Stenico, *I Problemi della Ceramica Romana di Ravenna, della Valle Padana e dell'Alto Adriatico* (Bologna, 1972), 15–23.

Red-gloss Pottery

M. Bulmer, *An Introduction to Roman Samian Ware with Special Reference to Collections in Chester and the North West* (Chester, 1980). Reprinted from *Journ. Chester Arch. Soc.*, 62, 1979, 5–72.

J. Dechelette, *Les Vases Céramiques Ornés de la Gaule*

Romaine (Paris, 1904).

C. Johns, *Arretine and Samian Pottery* (London, 1977).

P. Karnitsch, *Die Reliefsigillata von Ovilava* (Linz, 1959).

R. Knorr, *Terra-sigillata-gefässe des ersten Jahrhunderts mit Töpfernamen* (Stuttgart, 1952).

M. Lavizzari Pedrazzini, *La Terra Sigillata tardo-Italica...* (Milan, 1972).

F. Mayet, G. Pucci, H. Vertet; various articles in *Annales Littéraires de l'Université de Besançon*, 242, 1980.

M. Mezquiriz de Catalan, *Terra Sigillata Hispanica* (Valencia, 1961).

F. Oswald and T. Pryce, *An Introduction to the Study of Terra Sigillata* (London, 1920, repr. 1966).

H. Ricken and C. Fischer, *Die Bilderschüsseln der römischen Töpfer von Rheinzabern* (Speyer, 1948, Bonn, 1963).

J. W. Salomonson, *BABesch*, 43, 1968, 80–154; 44, 1969, 4–109.

J. Stanfield and G. Simpson, *Central Gaulish Potters* (Oxford, 1958).

Eastern Relief Wares

D. Bailey, *Rei Cretariae Romanae Fautores Acta* 14/15, 1973, 11–25; 19/20, 1979, 257–72.

D. Spitzer, *Hesperia* 11, 1942, 162–92.

Colour-coated and Painted Pottery

E. Gose, *Gefässtypen der römischen Keramik im Rheinland* (Cologne, 1975).

K. Greene, *Report on the Excavations at Usk 1965–76. The pre-Flavian fine wares* (Cardiff, 1979).

M. Moeus, 'Aco in northern Etruria: the workshop of Cusonius at Cosa', *MAAR*, XXXIV, 1980, 231–80.

A. Negev, *The Nabataean Potter's Workshop at Oboda* (Bonn, 1974).

F. Oelmann, *Die Keramik des Kastells Niederbieber* (Frankfurt, 1914).

Glazed Pottery

P. Arthur in P. Arthur and G. Marsh, *Early Fine Wares in Roman Britain* BAR 57 (Oxford, 1978).

R. Charleston, *op. cit.*, Chapter 3.

Late Roman Pottery

G. Chenet, *La Céramique gallo-romaine d'Argonne...* (Mâcon, 1941).

J. Hayes, *Late Roman Pottery* (London, 1972), and *Supplement* (London, 1980).

C. Young, *The Roman Pottery Industry of the Oxfordshire Region* BAR 43 (Oxford, 1977).

CHAPTER NINE
Terracotta Revetments, Figurines and Lamps

Roman Terracottas

S. Besques, *Musée du Louvre, Catalogue Raisonné des Figurines et Reliefs en Terre-Cuite Grecs et Romains* 3 (Paris, 1971).

A. H. Borbein, *Campanareliefs* (Heidelberg, 1968).

L. Gatti lo Guzzo, *Il Deposito Votivo dell'Esquilino detto di Minerva Medica* (Florence, 1978).

H. Goldman, et al., *Excavations at Gözlü Kule, Tarsus* 1 (Princeton, 1950).

C. Grandjouan, *The Athenian Agora* 6, *Terracottas and Plastic Lamps of the Roman Period* (Princeton, 1961).

R. A. Higgins, *Greek Terracottas* (London, 1967).

C. M. Kaufmann, *Ägyptische Terrakotten* (Cairo, 1913).

S. Mollard-Besques, *Musée du Louvre, Catalogue Raisonné des Figurines et Reliefs en Terre-Cuite Grecs et Romains* 2 (Paris, 1963).

M. Rouvier-Jeanlin, *Les Figurines Gallo-Romaines en Terre-Cuite au Musée des Antiquités Nationales* (Paris, 1972).

E. Tudot, *Collection de Figurines en Argile* (Paris, 1860).

Roman Lamps

D. Alicu, and E. Nemes, *Roman Lamps from Ulpia Traiana Sarmizegetusa* (Oxford, 1977).

D. M. Bailey, *Catalogue of the Lamps in the British Museum* 2 (London, 1980).

O. Broneer, *Corinth* 4, 2, *Terracotta Lamps* (Cambridge, Mass., 1930).

E. Buchi, *Lucerne del Museo di Aquileia* 1 (Aquileia, 1975).

E. M. Cahn-Kleiber, *Die antiken Tonlampen des Archäologischen Instituts der Universität Tübingen* (Tübingen, 1977).

J. Deneauve, *Lampes de Carthage* (Paris, 1969).

A. Ennabli, *Lampes Chrétiennes de Tunisie* (Paris, 1976).

C. Farka, *Die römischen Lampen vom Magdalensberg* (Klagenfurt, 1977).

F. Fremersdorf, *Römische Bildlampen* (Bonn, 1922).

J. W. Hayes, *Ancient Lamps in the Royal Ontario Museum* (Toronto, 1980).

A. Leibundgut, *Die römische Lampen in der Schweiz* (Bern, 1977).

S. Loeschcke, *Lampen aus Vindonissa* (Zürich, 1919).

H. Menzel, *Antike Lampen im römisch-germanischen Zentralmuseum zu Mainz* (Mainz, 1969).

J. Perlzweig, *The Anthenian Agora* 7, *Lamps of the Roman Period* (Princeton, 1961).

T. Szentléleky, *Ancient Lamps* (Budapest, 1969).

CHAPTER TEN
Glass

S. H. Auth, *Ancient Glass at the Newark Museum* (Newark, N. J., 1976).

L. Berger, *Römische Gläser aus Vindonissa* (Basel, 1960).

M. C. Calvi, *I Vetri Romani del Museo di Aquileia* (Aquileia, 1968).

B. Czurda-Ruth, *Die römischen Gläser vom Magdalensberg* (Klagenfurt, 1979).

O. Doppelfeld, *Römisches und fränkisches Glas in Köln* (Cologne, 1966).

Fitzwilliam Museum, Cambridge, *Glass at the Fitzwilliam Museum* (Cambridge, 1978).

F. Fremersdorf, *Römisches Buntglas in Köln* (Cologne, 1958).

F. Fremersdorf, *Das naturfarbene sogenannte blaugrüne Glas in Köln* (Cologne, 1958).

F. Fremersdorf, *Römische Gläser mit Fadenauflage in Köln* (Cologne, 1959).

F. Fremersdorf, *Römisches geformtes Glas in Köln* (Cologne, 1961).

F. Fremersdorf, *Die römischen Gläser mit aufgelegten Nuppen in Köln* (Cologne, 1962).

F. Fremersdorf, *Die römischen Gläser mit Schliff, Bemalung, und Goldauflagen aus Köln* (Cologne, 1967).

F. Fremersdorf, *Antikes, islamisches und mittelalterliches Glas*, Catalogo del Museo Sacro, V (Vatican City, 1975).

W. Froehner, *La Verrerie Antique: Description de la Collection Charvet* (Le Pecq, 1879).

W. Froehner, *Collection Julian Greau, Verrerie Antique, Émaillerie et Poterie Appartenant à John Pierpont Morgan* (Paris, 1903).

K. Goethert-Polaschek, *Katalog der römischen Gläser des Rheinischen Landesmuseums Trier* (Mainz, 1977).

S. M. Goldstein, *Pre-Roman and Early Roman Glass in the Corning Museum of Glass* (Corning, 1979).

D. F. Grose, 'Early Blown Glass: The Western Evidence', *Journal of Glass Studies*, XIX, 1977, 9–29.

D. B. Harden, *Roman Glass from Karanis* (Ann Arbor, 1936).

D. B. Harden 'Ancient Glass, I: Pre-Roman' *Arch. J.*, CXXV, 1968, 46–72.

D. B. Harden, 'Ancient Glass, II: Roman', *Arch. J.*, CXXVI, 1969, 44–77.

D. B. Harden and J. Price, 'The Glass', 317–68, in B. Cunliffe, *Excavations at Fishbourne 1961–1969. II – The Finds*, Society of Antiquaries of London Research Report, no. XXVII (Leeds, 1971).

J. W. Hayes, *Roman and Pre-Roman Glass in the Royal Ontario Museum* (Toronto, 1975).

D. E. L. Haynes, *The Portland Vase* (British Museum, London, revised edn., 1975).

L. Ibrahim, R. Scranton and R. Brill, *Kenchreai, Eastern Port of Corinth, II. Panels of Opus Sectile in Glass* (Leiden, 1976).

C. Isings, *Roman Glass from Dated Finds* (Groningen, 1957).

C. Isings, *Roman Glass in Limburg* (Groningen, 1971).

A. Kisa, *Das Glas im Altertüme* (Leipzig, 1908).

P. La Baume, *Glas der Antiken Welt, I* (Cologne, n.d. –1973).

G. Lehrer, *Ennion – A First Century Glassmaker* (Ramat Aviv, 1979).

C. R. Morey, *The Gold-Glass Collection of the Vatican Library* (Vatican City, 1959).

Morin-Jean, *La Verrerie en Gaule sous l'Empire Romain* (Paris, 1913).

K. S. Painter, 'Roman Glass' in D. B. Harden, K. S. Painter, R. H. Pinder-Wilson, Hugh Tait, *Masterpieces of Glass* (British Museum, London, 1968), 36–90.

G. Platz-Horster, *Antike Gläser – Ausstellung im Antikenmuseum Berlin* (Berlin, 1976).

J. Price, 'Glass' in D. Strong and D. Brown, *Roman Crafts* (London, 1976), 110–25.

A. von Saldern, B. Nolte, P. La Baume and T. E. Haevernick, *Gläser der Antike: Sammlung Erwin Oppenlander* (Hamburg, 1974).

E. Simon, *Die Portlandvase* (Mainz, 1957).

R. W. Smith, *Glass from the Ancient World* (Corning, N. Y., 1957).

E. M. Stern, *Ancient Glass at the Fondation Custodia* (Groningen, 1977).

N. Thomas, *Ancient Glass: The Bomford Collection of Pre-Roman and Roman Glass on Loan to the City of Bristol Museum and Art Gallery* (Bristol, 1976).

M. L. Trowbridge, *Philological Studies in Ancient Glass* (Urbana, Ill., 1930).

M. Vigil Pascual, *El Vidrio en el Mundo Antiguo* (Madrid, 1967).

E. Wilhelm, *La Verrerie de l'Époque Romaine au Musée d'Histoire et d'Art, Luxembourg* (Luxembourg, 1969).

Also numerous papers on ancient glass in the *Journal of Glass Studies* (Corning, N. Y.) and in the *Bulletins* and *Annales* of the *Journées Internationales du Verre*, later the *Association Internationale pour l'Histoire du Verre* (Liège, Belgium).

CHAPTER ELEVEN
Epigraphy

Technique and Style
I. Calabi Limentani, *Epigrafia latina* (Milano-Varese, 1968).

E. M. Catich, *The Origin of the Serif: Brush Writing and Roman Letters* (Davenport, Iowa, 1968).

J. Mallon, *Paléographie romaine* (Madrid, 1952).

E. Meyer, *Einfuehrung in die lateinische Epigraphik* (Darmstadt, 1973).

G. Susini, *Il lapicida romano* (Bologna, 1966). Available in English translation by A. M. Dabrowski as *The Roman Stonecutter* (Oxford, 1973).

Photographs and Drawings
A. Degrassi, *inscriptiones latinae liberae rei publicae: imagines* (Berlin, 1965).

A. E. and J. S. Gordon, *Album of Dated Latin Inscriptions: Rome and the Neighborhood.* Vol. I, Augustus to Nerva; vol. II, AD 100–199; vol. III, AD 200–525 (Berkeley, Los Angeles, 1958–65).

E. Huebner, *exempla scripturae epigraphicae latinae, a Caesaris dictatoris morte ad aetatem Iustiniani: auctarium corporis inscriptionum latinarum* (Berlin, 1885).

CHAPTER TWELVE
Art in Late Antiquity

R. Bianchi Bandinelli, *Rome, the Late Empire* (London, 1971).

J. Beckwith, *Early Christian and Byzantine Art* (Harmondsworth, 1970; integrated edition 1979).

G. Bovini, *The Mosaics of Ravenna* (London, 1969).

P. Brown, *The World of Late Antiquity* (London, 1971).

P. Brown, *Religion and Society in the Age of St. Augustine* (London, 1972).

W. Dorigo, *Late Roman Painting* (London, 1971).

E. K. Gazda 'A Marble Group of Ganymede and the Eagle from the Age of Augustine' in J. H. Humphrey, *Excavation at Carthage conducted by the University of Michigan* VI (Ann Arbor 1981) 125–78.

A. Grabar, *The Beginnings of Christian Art* (London, 1967).

A. Grabar, *Byzantium from the Death of Theodosius to the Rise of Islam* (London, 1966).

R. Krautheimer, *Early Christian and Byzantine Architecture* (Harmondsworth, 1965; second integrated edition 1975, third edition 1979).

S. G. MacCormack, *Art and Ceremony in Late Antiquity* (Berkeley and Los Angeles, 1981).

F. van der Meer and C. Mohrmann, *Atlas of the Early Christian World* (London, 1966).

Sister Charles Murray, *Rebirth and Afterlife. A Study of the Transmission of Some Pagan Imagery in Early Christian Funerary Art*, BAR Int. Ser., 100 (Oxford, 1981).

W. Oakeshott, *The Mosaics of Rome from the third to the fourteenth centuries* (London, 1967).

J. Onians, 'Abstraction and Imagination in Late Antiquity'. *Art History*, III, 1980, 1–24.

K. J. Shelton, *The Esquiline Treasure* (London, 1981).

W. F. Volbach, *Early Christian Art* (London, 1961).

K. Weitzmann, *Late Antique and Early Christian Book Illumination* (London, 1977).

K. Weitzmann (ed.) *Age of Spirituality. Late Antique and Early Christian Art. Third to Seventh Century. Catalogue* (New York, 1979); *Symposium* (New York, 1980).

Index

5417 40